Black Women and Music

**AFRICAN AMERICAN MUSIC
IN GLOBAL PERSPECTIVE**

Portia K. Maultsby and
Mellonee V. Burnim, Series Editors

*Archives of African American Music
and Culture, Indiana University*

Black Women and Music

MORE THAN THE BLUES

EDITED BY

Eileen M. Hayes
and Linda F. Williams

FOREWORD BY INGRID MONSON

UNIVERSITY OF ILLINOIS PRESS

Urbana and Chicago

Library of Congress Cataloging-in-Publication Data
Black women and music : more than the blues / edited by
Eileen M. Hayes and Linda F. Williams ; foreword by Ingrid Monson.
p. cm. — (African American music in global perspective)
Includes bibliographical references and index.
ISBN-13: 978-0-252-03184-7 (cloth : alk. paper)
ISBN-10: 0-252-03184-9 (cloth : alk. paper)
ISBN-13: 978-0-252-07426-4 (pbk. : alk. paper)
ISBN-10: 0-252-07426-2 (pbk. : alk. paper)
1. African American women—Music—History and criticism.
2. African American women musicians.
I. Hayes, Eileen M. II. Williams, Linda F.
ML82.A37 2007
780.82—dc22 2006022586

In memory of
Isadora S. Williams
and to our families

Contents

Part II. When and Where She Enters: Black Women in Unsung Places

Part III. Revisiting Musical Herstories

Foreword

INGRID MONSON

During a class discussion in my jazz history course, I asked my students to give me the names of people they thought were hip. We had just finished a unit on bebop and watched the relevant segments of the Ken Burns *Jazz* documentary, which provide a strong visual impression of the 1940s.[1] I asked them to draw from their own favorites and not feel obliged to limit themselves to jazz or historical figures. The first five students who raised their hands to speak gave me a list of names that was all male and predominantly black. When, after ten minutes of discussion, I pointed out that no one had mentioned a female name, some quickly added a woman or two to rectify the omission. "Too late!" I said, because they had already illustrated their first associations. They had fallen right into my trap. For the object of the question had been to demonstrate that although women have in some respects gained access to formerly all-male domains, our default understandings of who best exemplifies a particular category often places women in the backseat.

This volume places African American women in not only the front seat, but the driver's seat. In so doing, the authors make plain that race never comes without gender and that, consequently, intersectional analysis has to be the point of departure for a deeper understanding of African American music. The authors included here come from several disciplinary backgrounds, including musicology, ethnomusicology, women's studies, music theory, and theater. Their aim is to expand our understanding of the musical experiences of African American women.

The contributors to *Black Women and Music* are committed to looking

beyond the expected places for the creativity of black women. If we have come to expect attention to African American women as blues singers, hip-hop divas, and soul singers, the authors presented here also examine the role of black women in gospel narration, experimental jazz, classical music, and contemporary blues. The contributions of women to the formation of African American musical aesthetics are perhaps most strong in precisely those areas that have been outside the spotlight that has always been focused most brightly on African American secular popular music. The legacy of sacred singing that has been so movingly documented by authors such as Bernice Reagon, James Weldon Johnson, and Eileen Southern forms one such stream of female influence in African American music, and the achievements of African American women in classical music, from Florence Price to Leontyne Price and Jessye Norman, forms another.

The essays in this volume—which extend our understanding of the experiences of black women as composers, members of the hip-hop generation, jazz instrumentalists, and participants in the women's music scene—illustrate that no partial understanding will sufficiently account for the rich diversity of musical activities undertaken by African American women. Rather than proposing an alternative canon, this volume seeks to unveil some of the often-overlooked pathways through which African American women have shaped and contributed to African American music and culture. The stories told here greatly expand our awareness of the diversity of African American women and remind us to *never* underestimate their creativity and resourcefulness.

Note

1. Ken Burns, *Jazz*, vol. 7, PBS Home Video, Florentine Films and WETA, 2000.

Acknowledgments

Much of the credit for *Black Women and Music* goes to the contributing authors, whose analyses, indefatigability, and insights into black women's negotiation of their racial and gendered identities through performance have made this collection possible. Linda F. Williams conceptualized this volume, recognizing the necessity for a cross-disciplinary compilation of essays that would provide a wide range of perspectives on black women and music. She ushered the manuscript through its nascent stages. Eileen M. Hayes was responsible for the substantive work on the volume and brought the project to fruition. We extend our special thanks to Portia K. Maultsby and Mellonee V. Burnim, whose vision of an African American Music series under the auspices of the University of Illinois Press this volume inaugurates. For her encouragement and effectiveness at team coordination, we owe a debt of gratitude to Portia Maultsby. We are grateful to the close readings of Mary Hunter and others for their critical feedback on the project in its various stages. Ingrid Monson provided critical intervention and strong enthusiasm for the project. This book would not have been possible without the editorial staff at the University of Illinois Press, especially Laurie Matheson and Joan Capatano, whose dedication to this project has been remarkably steadfast. Likewise, much thanks is owed to ethnomusicologist Cornelia Fales, who gave generously of her copyediting expertise and keen eye for detail. She has our deep respect and gratitude for her critical reading of the manuscript and substantive comments. Over the course of five years, as the volume was emerging, the series's editors and authors were unyielding in their belief in the book's importance and in our ability to bring the project to fruition. They have our highest regard.

Black Women and Music

New Perspectives in Studies
of Black Women and Music

EILEEN M. HAYES

Black women's negotiation of race and gender in music is as significant as their achievements as performers, creators, listeners, and educators. *Black Women and Music* is perhaps the first anthology devoted to black women's cultural production in music and verbal performance. It is not an exhaustive study, nor is it intended to be. Rather, it contributes to ongoing conversations about black female gendered experiences in music and verbal performance and offers refreshing glimpses of how race and gender are written into studies of music. This book reveals ways that black women's voices and bodies are implicated in racialized and gendered discourses and that many of our assumptions about black women, gender, and music are deeply embedded in racialist thinking.

Black Women and Music provides a meeting place for scholars who take black women seriously as social actors and as artists contributing to African American thought. These studies of black women and music traverse disciplines fueled by methodologies and theoretical understandings gleaned from feminist musicology, political philosophy, ethnomusicology, sociology, anthropology, feminist theory, black cultural studies, and theater.[1] Likewise, the influence of scholars engaged in "theorizing black feminisms" is felt throughout the collection.[2] Contributors to this volume examine the historical and current experience of black women in rap/hip-hop, art music, jazz, musical theater, and electric blues as well as in underexamined performance contexts such as "women's music" festivals and gospel music tributes. At least half of the contributors to this book devote attention to black women's

formulations about the intersections of their experiences of race, gender, and successive movements of black liberatory struggle.

The phrase that gives this book its title recalls two legacies in the history of African American music and its study in the academy. Readers will recognize the allusion to Irene V. Jackson's edited volumes, *More than Dancing: Essays on Afro-American Music and Musicians* (1985) and *More than Drumming: Essays on African and Afro-Latin American Music and Musicians* (1985).[3] Both volumes were prepared under the auspices of the Center for Ethnic Music at Howard University. It would be difficult to underestimate the significance of these compilations in both subject matter and approach. In anticipating subsequent examinations of music in Africa and black music in the Caribbean and the Americas, the essays in Jackson's volumes not only helped establish black music making as a legitimate field of inquiry but also validated the intellectual contributions of black scholars studying music of "their own" societies as well as black musics throughout the diaspora.[4] As influential as these collections have been, very few contributors considered the musical experiences of black women specifically or conducted gender analyses in their essays.[5]

The enthusiastic reception for Jackson's volumes owes a symbolic debt to the conceptual spaces opened by musicologist Eileen Southern's *Music of Black Americans: A History* (1971).[6] Musicologist Guthrie Ramsey observes that "Southern's work broke new ground in its focus, method, and scope, inspiring others (both directly and indirectly) to similar inquiry and helping to establish black music as a legitimate scholarly specialty."[7] Though Southern's significance as the preeminent African American musicologist is uncontested, gender was not her concern. According to Ramsey, in reclaiming significant black contributions to Western art music, Southern establishes "the notion of a unified, cohesive, and essentially male 'blackness,' using terms such as 'the' black community and the Black man often."[8] Well into the late 1980s, scholars addressing African American music worked within traditional or "gender-neutral" frameworks that often obfuscated as much as illuminated the knowledge of black women as composers, performers, audience members, producers, consumers, historians, journalists, and so on. Invaluable literature that celebrates and documents the "hidden histories" of black women's participation in music, such as Antoinette Handy's *Black Women in American Bands and Orchestras,* precedes an interdisciplinary focus on the ways race and gender discourse operates either historically or at present.[9] Likewise, other literature or compilations that attempt to move beyond a celebratory mode by including the "voices" of black women through interviews do not,

in Sherrie Tucker's words, "guarantee a departure from the ways in which race discourse operates" in music analyses.[10]

The subtitle of this volume pays homage to the notion of black women's blues as a discursive index to the musical and social experiences of black women. Revealed in the writings of a number of activist intellectuals (Patricia Hill Collins, Angela Davis, and Hazel Carby) is the idea that black women's blues is a metonym for black women's critical engagement with African American feminist thought.[11] Acknowledging hard-won fights in the late 1970s within women's studies and African American studies to establish black women's culture as a valid field of inquiry, social movement theorist Robin D. G. Kelley credits the interventions of second-wave black feminists and other women of color in opening conceptual spaces for studies of black women's cultural production: "The radical black feminist movement . . . also redefined the source of theory. It expanded the definition of who constitutes a theorist, the voice of authority speaking for black women, to include poets, blues singers, storytellers, painters, mothers, preachers, and teachers."[12]

Influenced by—but more to the point, shaping—black feminist critique across the disciplines, scholars such as Angela Davis (1971), Hazel Carby (1986), and bell hooks (1990 and earlier; 1992) drew on feminist and black activist praxis in their writings about black women's cultural experiences.[13] Suggesting that critics should not privilege black women's literary production over other modes, Carby observed that "within feminist theory, the cultural production of black women writers" has been "analyzed in isolation from other forms of women's culture and cultural presence and has neglected to relate particular texts and issues to a larger discourse of culture and cultural politics."[14] Arguing that "different cultural forms negotiate and resolve very different sets of social contradictions," Carby demonstrated "how the representation of black female sexuality in black women's fiction and in women's blues is clearly different."[15]

The work of many scholars theorizing black feminisms has come to be characterized by its concern with black women as the "focus of studies" and as agents of knowledge.[16] As a corrective to earlier disciplinary practices that privileged gender over and above concerns of race, class, and nationality, in the 1970s scholars began to adopt intersectional paradigms that recognized the "notion of race, class, and gender as mutually constructing systems."[17] At least one perspective of black feminism has assumed the interrelatedness of the social constructions of race, gender, and other variables.[18] In recent years, this mode of analysis has been central in examinations of black expressive culture.[19] Although African American women's concerns figure prominently

in race, class, and gender studies, it should be noted that intersectional approaches, frequently conflated with black feminist critique, are not the sole intellectual property of black women scholars.

In the late 1980s to early 1990s, scholars brought the challenges of feminism to the disciplines of musicology and ethnomusicology. The efforts of feminist musicologists to examine issues of gender and music, and to recover archaeologies of women's varied musical experiences, have had a lasting impact on the ways we think about, write about, and experience music. Inspired by efforts within feminist musicology and music criticism to recover "women's voices," important anthologies began to include chapters about black women and music, many of which reflected an emphasis on recovery and synthesis. Studies of black women and the blues figured prominently in these collections.[20]

Whereas studies of black women and popular music reflect the engagement of scholars from across the disciplines, studies of black racial identity, gender, and Western art music reflect a narrower commitment on the part of scholars. With few exceptions, musicologists have failed to problematize the scarcity of black women musicians and composers in Western art music. Although musicologists are beginning to bring concerns of black cultural studies, critical race theory, and/or postcolonial theory to their work on Western art music, the overall output is still in its formative stages.[21] Music scholars have addressed subjects such as the circulation of world pop musics, race, and orientalism in "European music," and European music and the construction of whiteness, but by and large, black women have not figured prominently in these studies, as either subjects or contributors to theory.[22]

It might be argued that the history of Western art music would look very different if the literature theorized black feminisms in its critiques. As exemplified by essays in important gender and music anthologies, feminist ethnomusicologies have yet, by and large, to incorporate "multivocal, interdisciplinary thinking" regarding "race" in a way that makes a difference both politically and intellectually.[23] Given the outspoken advocacy in the 1990s of intersectionality as a mode of analysis, it is striking that the influx of postmodern and poststructural studies during the same era only infrequently devoted attention to race, even in studies of American music and white women musicians. Patricia Hill Collins, drawing on the work of Ruth Frankenberg and others, offers a possible explanation for this discrepancy:

> Despite their comfort with identifying themselves as women, many White women in the United States have difficulty seeing themselves as already part

of Whites as a group. Although African-American women and White Ameri-can women participate in the same system of institutionalized racism and sexism, each group assigns a different salience to race and gender. Race and class and gender may all be present in all social settings in the United States, yet groups will experience and "see" them differently.[24]

Although the development of sophisticated approaches to feminist criti-cism in musicology fundamentally changed the field, beyond opening up spaces for additional recovery and synthesis of black women's music his-tory, the impact of feminist musicology, especially before the mid-1980s and with regard to black women's involvement in "classical music culture," is difficult to identify.[25] Musicologist Suzanne Cusick reminds us of the need for a more inclusive concept of feminist critique in regard to musicology: "We have seen that the exclusive focus on one kind of feminist critique as if it subsumed all possible feminist musicologies serves ends that contradict the political goals of feminism."[26] Harbingers of black feminism's possible contributions to musicology are apparent if one reads Cusick's "Gender, Musicology, and Feminism," substituting the words "black feminist" for "feminist" throughout.[27]

In the writings of various scholars we can begin to identify a number of issues that a critique of musicology focusing on the interactions of race, gender, and class might address, among them, parallel tendencies by observ-ers to romanticize black musical experience (Radano 2003) and to disregard the work of black women musicians as labor (Tucker 2000), as well as the failure of some to contextualize notions of talent (Kingsbury 1988).[28] Such a critique could also address the mechanisms that regulate the dissemina-tion of classical music through symphony orchestra performances, many of which black young people and their parents are unlikely to attend. What blacks and others in underserved communities will remember, however, is the use of art music to "restore calm" in public spaces such as gas stations and malls. Ironically, this practice does not bode well for the expansion of an audience for classical music across lines of generation, ethnicity, and class.[29] Supporting the suggestion that black access to elite musical systems remains a problem, contributors to this volume point to the continued effect of rac-ism in foreclosing opportunities for black women in music production and consumption. Countless numbers of young people of all backgrounds have experienced the evacuation of their public education system's programs in music; many will never have access to trombone or piano lessons, or to rel-evant media. The essays in this collection point to a need for black women

and girls (and members of other underrepresented groups) to gain access to opportunities that might help level the field in their pursuit of careers in music and/or in opportunities to become more informed consumers or musicking beings, regardless of musical genre.[30]

Beyond recognizing that black women have participated in and helped shape American musical experience, this volume charts major themes that have issued from the scholarship on black women and music over the past decade. These issues include the consequences of certain types of intersectionality (e.g., race, gender, and, most often, heterosexuality), the significance of generation, and black women's engagement with feminism.[31] For example, in her study of the "all-girl" swing bands of the 1940s, Sherrie Tucker brings a critical perspective to racialized and gendered discourses in jazz, providing invaluable counternarratives to the traditional big band discourse before and during World War II. Extending lines of investigation suggested earlier by hooks, Tricia Rose ("Bad Sistas: Black Women Rappers and Sexual Politics in Rap Music") has addressed the ambivalence with which many black women rappers regard feminism. Building on the work of scholars writing earlier (Darlene Clark Hine, Patricia Hill Collins, Evelyn Higginbotham), Rose and others contextualize black women's engagement of feminism within noncontinuous lines of thought regarding black women's respectability and social activism. Hip-hop feminist scholars and critics such as Gwendolyn Pough, Joan Morgan, and other observers acknowledge the neglect of lesbian voices in hip-hop and the homophobia and heterosexism that undermine the liberatory potential of the culture they love.[32] Although scholars writing earlier alluded to lesbian sexuality in the blues, the themes explored in this literature concerned primarily the circulation and reception of vaudeville blues as directed toward the heterosexual mainstream; ethnomusicologist Maria Johnson offers valuable case studies on contemporary black women's blues and the performance of lesbian identity.[33] Each of these efforts are indebted in some way to valuable leads Carby pursues in her article on the sexual politics of black women's blues of the 1920s.[34] The most productive of the collective literature that builds on the scholarship of Carby, Harrison, hooks, and Davis is not significant for creating an alternative canon of black and feminist musicians; indeed, it does not do that. Rather, it demonstrates the utility of and potential for studies that meld black cultural and feminist theories with rigorous modes of investigation that incorporate a focus on race, gender, and music.

Black Women and Music is a corrective to discursive practices that inadvertently make invisible as much as illuminate the heterogeneity of black

women's musical experience. As important as examinations of black women's blues are, their positioning in anthologies—particularly in music but also in women's culture anthologies—as the sole representation of black women's musical experience has the unintended effect of muting analytical treatments of black women, race, and gender in opera, gospel music, rock, country, jazz, or, for that matter, electro-acoustic music.[35]

Rightly, the new black musicologies do not call for the formation of an alternative canon of black musicians in any genre. Hence, the essays in this collection avoid the practice of singling out individuals as exceptions against the representation of the undifferentiated black masses—even if they are black women.[36] At the same time, this collection does not purport "to draw simple relations" between the musical expressions of Sissieretta Jones, Maud Cuney-Hare, Harriet Gibbs Marshall, Deborah Coleman, Edna Tatum, the Ward Singers, Shirley Scott, Iqua Colson, Sweet Honey in the Rock, Leontyne Price, Mary J. Blige, and Foxy Brown without taking into account "the enormous range of contingencies that divide them."[37]

Feminist critique is not the only lens through which the experiences of African American women are examined in this collection. For example, Deborah Smith Pollard's discussion of gospel announcer Edna Tatum's narrations (chapter 4) highlights the gospel emcee's competence in predominantly black milieus; attention to her negotiation of gender is a secondary consideration. Pollard's discussion reminds us of sociologist Patricia Hill Collins's admonition that "institutionalized racism constitutes such a fundamental feature of lived Black experience that, in the minds of many African American women, racism overshadows sexism and other forms of group-based oppression."[38] The overriding concern of countless numbers of African American women with the exigencies of race complicates the writing of "feminist biography."[39]

Contributors to this volume stop short of positing a black women's monolithic, interpretive community, choosing rather to engage the work of social scientists and others concerning the social construction of black collective identities through music.[40] Analyses grounded in close readings of black social history, reflecting an understanding of a gender-inclusive African American thought, are necessary for the type of work that a project interrogating Western art music's discursive practices or "*black* feminine endings" would require.[41]

This collection is organized into three parts. The first, "Having Her Say: Power and Complication in Popular Music," addresses black women artists in popular music, highlighting power and complication, if not containment,

in hip-hop, blues, and musical theater. Riffing on historian Paula Giddings's book title of the same name, the essays in part II, "When and Where She Enters: Black Women in Unsung Places," address black women's performances in contexts underexamined by scholars.[42] Part III, "Revisiting Musical Herstories," posits that feminist musicology has succeeded in recovering histories of women's involvement in music and is therefore in a position to argue against the formation of a canon of women composers of art music. Nevertheless, there remains a need to explicate "the history of conditions that have consistently served to exclude or marginalize [black] female participation in music."[43]

Part I begins with Gwendolyn Pough's "Hip-Hop Soul Divas and Rap Music: Critiquing the Love That Hate Produced," excerpted from her book (2004). Pough brings a necessary dimension to the discussion of black women, hip-hop culture, rap music, and feminism. She explores at least four issues in her essay. First, inspired to revisit bell hooks's notion of an ethic of love in black communities, Pough examines the representation of heterosexual love in rap songs and suggests that black feminist inquiry be directed toward interrogating rap "as a site for political change."[44] Second, she postulates that "hip-hop soul divas" such as Mary J. Blige have opened up a discursive space for women in hip-hop that was previously unavailable to them. Third, reflecting on the seeming contradictions that her own cultural practices embody (i.e., reading romance novels, being deeply engaged with black feminism/womanism theories, and listening to rap music, some of which is misogynistic), Pough critiques "a love that grows in spite of the oppression but holds unique characteristics because of it" (2004, 169). Fourth, moving beyond black cultural critique at the level of image, Pough suggests that, based on the "dual and conflicting" representations of rappers Lil' Kim and Foxy Brown, black feminism has failed to teach "younger Black women about sex, feminism, and power" (2004, 192).

Maria V. Johnson, in "Black Women Electric Guitarists and Authenticity in the Blues," considers the careers of four performers of instrumental blues as they negotiate performances in a male-defined genre. Johnson has read exhaustively through blues magazines to assess how performers construct their personas in the context of a recording industry that, since its inception, has regarded women's blues as categorically different from blues performed by men. Focusing on Beverly Watkins, Barbara Lynn, Deborah Coleman, and BB Queen, the author documents the creative expression of women electric guitarists and demonstrates that dominant conceptions of blues authenticity in terms of race and gender have ensured that this group remains small and relatively unknown.

With Charles I. Nero's "Langston Hughes and the Black Female Gospel Voice in the American Musical," the anthology moves toward issues of "the voice." Scholars "have used the word 'voice' to refer to a wide range of aspirations: cultural agency, political enfranchisement, sexual autonomy, and expressive freedom, all of which have been historically denied to women."[45] By focusing on the audible female voice and notions of black authenticity, Nero participates in a conversation with numerous other scholars.[46] Without overstating Hughes's role, Nero charts the poet's efforts to represent blackness on the Broadway stage through the incorporation, first, of gospel music and, later, of black women singers whose voices, in Nero's words, are "gospel-trained." Hughes's collaboration with black gospel composers and singers introduced an aural idiom to the stage that had been unimagined in black musicals prior to the late 1950s. The predominance of the black female gospel-influenced singing style in Broadway musicals, Nero suggests, signals the acceptance of gospel music by producers, writers, composers, and audiences as the most authentic representation of black femininity on Broadway.

Part II begins with Deborah Smith Pollard's discussion of the work of Edna Tatum, a pioneering gospel narrator. Like Nero's, Pollard's essay, "That Text, That Timbre: Introducing Gospel Announcer Edna Tatum," uncovers alternate venues for the performance of gospel sensibilities. Her performance-centered analysis concerns the work of a prominent radio announcer and gospel concert emcee based in Los Angeles. The author argues that Tatum has earned a place of high honor within the gospel community because of her adept manipulation of a range of elements associated with black aesthetics. Situating gospel narration within the tradition of the black sermon, Smith Pollard introduces readers to a fascinating context for women's verbal performance.

Linda F. Williams's "Black Women, Jazz, and Feminism" is based on her conversations with contemporary jazz musicians about their subjectivities in terms of race, gender, and feminism. Interspersed with reflexive accounts of Williams's own history as a professional jazz saxophonist, the essay contributes to ethnographic research on female gendered experiences in jazz. The author's exchanges with jazz instrumentalists and vocalists add to an ongoing conversation that has identified age and generation as significant variables in black women's identifications with feminism.[47]

Nanette de Jong's essay, "Women of the Association for the Advancement of Creative Musicians: Four Narratives," contextualizes the participation of four women musicians affiliated with this Chicago-based organization. The AACM emerged from the black music collectives movement of the 1960s. The author's thoughtful account balances analysis of the historiographical

erasure of women associated with this important collective with attention to the individual subjectivities of each musician. De Jong's essay exemplifies the significance of the individual biography to ethnomusicological studies of the Great Black Music.

In "Black Women and 'Women's Music,'" I highlight issues that emerge in the study of race and the politics of sexual identity in women-identified music, a relatively unknown musical sphere that emerged as a subculture of lesbian feminism in the early 1970s. After a brief introduction to women's music festivals, primary venues for the performance of this music, I discuss the elements that contribute to the underrepresentation of black women in scholarly and popular accounts of the genre. This study expands the parameters of black lesbian ethnography and is a corrective to an area of research that has been overlooked by scholars of lesbian, queer, and African American music cultures.

To begin part III, Teresa L. Reed surveys the history of women as performers, composers, teachers, and conductors of Western art music in "Black Women in Art Music." Drawing on a valuable history of compensatory scholarship concerning African Americans in classical music, Reed traces the participation of black women musicians from the mid-eighteenth century to the present, demonstrating, for example, ways composers such as Florence Price infused their musical compositions with black idioms and singers such as soprano Marian Anderson enacted blackness through their performances of Negro spirituals.

In "Leontyne Price: Prima Donna Assoluta," Elizabeth Amelia Hadley is concerned about the representation of black women opera singers in the popular press and in African American historiography, convincingly arguing that typically, such narratives highlight the contributions of some artists while eclipsing others. Having read extensively through critics' reviews of Price's concerts, Hadley frames the diva's reception in the opera world in the context of the civil rights movement and, later, the black power movement. For Hadley, Price's biographical narrative and career trajectory must be contextualized in regard to African American political culture.

Concluding part III, Sarah Schmalenberger in "Harriet Gibbs Marshall and Three Musical Spectacles," charts the professional evolution of the early music educator and patron of the arts who, with the goal of making music instruction available to local black residents, founded the Washington Conservatory in 1903. Schmalenberger shows how for middle-class blacks participation in classical music milieus figured as a musical counterpart to racial uplift, a "contested concept" espoused by leading black figures such

as Anna Julia Cooper and W. E. B. Du Bois.[48] Through her analysis of three of Marshall's musical spectacles, Schmalenberger demonstrates how the educator's programing of black music concerts upheld Eurocentric biases as it inspired pride in black musical history. Schmalenberger, Hadley, and Reed expose the contradictions of Western art music's discursive practices, an ideological product of the Enlightenment, as far from being either gender neutral or "color blind."

Black feminist thinking about, in, and through music, to paraphrase Valerie Smith, has the potential to complicate monolithic notions of Americanness, womanhood, blackness, and black womanhood.[49] To this list we might add that black feminist thinking also has the potential to interrogate black women's practices as music creators, performers, listeners, and consumers. The essays contained herein anticipate the potentialities and challenges of this venture. Contributors address the lacunae in the literature concerning black women's activity in musical arenas that pre- and postdate the emergence of vaudeville blues singers in the 1920s. An important collective legacy of the early blueswomen is revealed through the cross-disciplinary scholarship about black women and music. This legacy, neither tidy nor without complication, is this: Black women can and have forged, often, but not always—and not everywhere the same across time—identities that are supple enough to accommodate a sense of female empowerment through musicking in tandem with their sensitivities to black racial allegiances.

Notes

My thanks to Deborah Wong, Sarah Schmalenberger, Portia K. Maultsby, Cornelia W. Fales, Suzanne Cusick, and John Michael Cooper for their close readings of this introduction.

1. The chapters in this volume do not address the representation of black women's "voices" and recurring tropes of black music in African American literature. For an example of this mode of exploration, see Karla F. C. Holloway, "The Lyrical Dimensions of Spirituality: Music, Voice, and Language in the Novels of Toni Morrison," in *Embodied Voices: Representing Female Vocality in Western Culture*, ed. Leslie C. Dunn and Nancy A. Jones (Cambridge: Cambridge University Press, 1994), 197–211.

2. Although I am unaware of the origins of this phrase, it appears in the writings of several authors. See Stanlie M. James and Abena P. A. Busia, eds., *Theorizing Black Feminisms: The Visionary Pragmatism of Black Women* (London: Routledge, 1993); Beverly Guy-Sheftall and Johnnetta B. Cole, eds., *Words of Fire: An Anthology of African American Feminist Thought* (New York: New York Press, 1995); and Smith, *Not Just Race, Not Just Gender*.

3. Jackson, *More than Dancing;* Jackson, *More than Drumming.*

4. See Dell Hymes, *Reinventing Anthropology* (New York: Vintage Books, 1974); Soraya Altoriki and C. Fawzi El-Solh, eds., *Arab Women in the Field: Studying Your Own Society* (Syracuse: Syracuse University Press, 1988); Harrison, *Decolonizing Anthropology.* Critical intellectual ventures in folklore and anthropology during the 1970s opened significant conceptual spaces for ethnomusicological research in subsequent periods. The work in the late 1980s and early 1990s of folklorists and anthropologists of color to legitimate the practice of "studying one's own society" extended the concerns of scholars writing decades earlier. Contributors to Jackson's edited volumes went on to mentor scholars of the next "generation."

5. Among the contributions to *More than Drumming,* Jacqueline DjeDje's "Women and Sudanic Africa" devotes sustained attention to women's music making, and Bennetta Jules-Rosette devotes brief attention to women's experiences in "Ecstatic Singing: Music and Social Integration in an African Church." Of the contributions to *More than Dancing,* Doris McGinty's essay, "The Black Presence in the Music of Washington, D.C.," includes a discussion of black female concert singers of the late nineteenth century, a topic upon which she elaborates in subsequent publications. For essays that feature women as participants in feedback interviews, see Mellonee Burnim, "The Black Gospel Music Tradition: A Complex of Ideology, Aesthetic, and Behavior." See also James B. Stewart's discussion of relations between black men and women as reflected in his textual analysis rhythm and blues songs in "Relationships Between Black Males and Females in Rhythm and Blues Music of the 1960s and 1970s."

6. Southern, *Music of Black Americans.* See also the important scholarship by musicologists Josephine Wright and the late Doris McGinty (d. 2005), to whose work Sarah Schmalenberger refers in her chapter on Harriet Gibbs Marshall.

7. Ramsey, *Race Music,* 156.

8. Ibid., 157.

9. See also Handy, *International Sweethearts of Rhythm;* Handy, *Black Women in American Bands and Orchestras;* Placksin, *American Women in Jazz;* and Dahl, *Stormy Weather,* which, in the words of musicologist Sherrie Tucker, provide "indispensable groundwork for anyone studying women's participation on all instruments and in all eras of jazz." Tucker, *Swing Shift,* 20.

10. Tucker, *Swing Shift.* For an example of scholarship on women and rock that incorporates interviews with black women musicians such as Mary Wells, Martha Reeves, Missy Elliott, Linda Tillery, Mary Watkins, and Asian Americans June Millington and Magdalen Hsu-Li but that stops short of providing a rigorous analysis of the race and gender discourses through which the creativity of these artists is consumed, see Mina Carson, Tisa Lewis, and Susan M. Shaw, *Girls Rock: Fifty Years of Women Making Music* (Lexington: University Press of Kentucky, 2004). See also Laura Post, *Backstage Pass* (Norwich, Vt.: New Victoria, 1997).

11. I agree with Ann DuCille's caution against the tendency of some in black cul-

tural studies to make the blues "the metonym for authentic blackness." I am not suggesting that here. See Ann DuCille, "Blue Notes on Black Sexuality: Sex and the Texts of Jessie Fauset and Nella Larsen," *Journal of the History of Sexuality* 3 (January 1993): 426.

12. Kelley, *Freedom Dreams*, 154.

13. Carby, "It Jus Be's Dat Way Sometime," 9–22. Reprinted in *Unequal Sisters: A Multicultural Reader in U.S. Women's History,* ed. Ellen Carol DuBois and Vicki L. Ruiz, 1st ed. (New York: Routledge, 1990). See Harrison, *Black Pearls.* See also bell hooks, *Black Looks;* and bell hooks, *Yearning.*

14. Carby, "It Jus Be's Dat Way Sometime," 238.

15. Ibid. The frequent citing of Carby's path-breaking article provides an opportunity for me to visit a related topic. Recently, a reviewer of my work amended a citation I had attributed to the appropriate scholar but dated incorrectly. This editorial correction brought to mind how often the scholarly literature on black women has perpetuated a historical misdating that has a significant bearing on the scholarly recovery of black women's knowledge. Though Carby's "It Jus Be's Dat Way Sometime" was published originally in 1986, for example, the foundational role of her contribution is sometimes inadvertently misrepresented, especially in the case of the article's successive reprintings. An example—though not the only one—is a citation for Hazel Carby found in Bernstein's anthology (2004, 12 n. 13). Bernstein cites the article's inclusion in Warhol and Herndl's *Feminisms: An Anthology of Literary Theory and Criticism* (1991). Sherri Tucker identifies a similar practice in regard to the writing of black women into the history of feminist activism that has the effect, she observes, of obscuring the involvement of black women with second-wave feminism at its earliest stages. As a result, black women are erroneously documented as having made their mark "after" the contributions of their white counterparts. See Tucker, *Swing Shift,* 353. Errors such as this are easy to make, but black women and music studies can only benefit as the timeliness of writers' publications is appropriately acknowledged.

16. Collins, *Fighting Words.*

17. Ibid., 116.

18. Contributors to this collection do not address theories of *womanism,* except by way of passing. I suggest that Alice Walker's deployment of the term in her discussion in *In Search of Our Mothers' Gardens: Womanist Prose* (New York: Harcourt Brace, 1983) is an expansion upon, but not necessarily a rejection of, "feminist" understandings as articulated by a long line of black women thinkers, including members of the Combahee River Collective in "A Black Feminist Statement" (written in 1977 and published in 1979). See also Collins, *Fighting Words,* for a candid discussion of the value of and challenges posed by the terms *black feminism* and *womanism* (61–65).

19. See Dent, *Black Popular Culture;* Smith, *Representing Blackness;* and Smith, *Not Just Race, Not Just Gender.* See also numerous essays by bell hooks, including those already cited.

20. For representative examples of the best of the scholarship on black women and blues included in notable anthologies, see Tera Hunter's "Sexual Pantomimes"; Bowers, "Writing the Biography"; and Kernodle, "Having Her Say."

21. Here it is not my intent to delimit the concerns of *postcolonialism*, a term I am using in a very loose sense to refer to a wide range of ideas about the impact of colonialism and its continuing effects. See Anne McClintock, "The Angel of Progress: Pitfalls in the Term 'Post-Colonialism,'" *Social Text* 31/32 (1992): 1–15; and Stuart Hall, "When Was 'The Post-Colonial'? Thinking at the Limit," in *The Post-Colonial Question: Common Skies, Divided Horizons*, ed. Iain Chambers and Lidia Curti (New York: Routledge, 1996). Moreover, numerous factors contribute to the containment of black women and music studies in the academy, although I do not pursue that discussion here. Several contributors to Cook and Everist, *Rethinking Music*, address issues that those theorizing black feminisms (might) pose to musicology.

22. See Born and Hesmondhalgh, *Western Music*, and Bohlman and Radano, *Music and the Racial Imagination*.

23. See Cusick, "Gender, Musicology, and Feminism," 498. See also Ingrid Monson, "Music and the Anthropology of Gender and Cultural Identity," *Women and Music* 1 (1997): 24–32.

24. Collins, *Fighting Words*, 208.

25. Cusick, "Gender, Musicology, and Feminism," 490. See also Cusick, "Eve . . . Blowing in Our Ears?"

26. Cusick, "Gender, Musicology, and Feminism," 491. The original focus of Cusick's remarks are the early misreadings and misinterpretations of McClary's *Feminine Endings*.

27. Of course this is meant to be a provocative suggestion, but I think it says something important about the silence of black feminist critique in musicology.

28. Here, I am referring to the work of the following scholars: Tucker, *Swing Shift*; Radano, *Lying Up a Nation*; and Kingsbury, *Music, Talent, and Performance*.

29. See "Classical Music as Crime Stopper," *Los Angeles Times*, February 18, 2005, and "Living in Harmony: Music Soothes the Savage Breast—but Choose the Right Tune," *Financial Times* (London), January 15, 2005, 8.

30. Christopher Small introduces the term *musicking* in his discussion of African American music, *Music of the Common Tongue*. By *musicking*, Small refers to "not only performing and composing" but "also listening and even dancing to music." In other words, "all those involved in any way in a musical performance can be thought of as musicking" (50). See also Small's *Musicking: The Meanings of Performance and Listening* (Hanover, N.H.: University Press of New England, 1998).

31. For discussions of black women musicians and their relationship to feminism, see Keyes, "We're More than a Novelty, Boys," 201–20. Rose, *Black Noise*; Morgan, *When Chickenheads Come Home to Roost*. For analysis by scholars of hip-hop/rap music and feminism, see Pough, *Check It While I Wreck It*. See chapter 7 in Keyes, *Rap Music and Street Consciousness*; Berry, "Feminine or Masculine." See also Kyra

Gaunt, *The Games Black Girls Play: Learning the Ropes from Double Dutch to Hip-Hop* (New York: New York University Press, 2006); and Kyra Gaunt, "Dancin' in the Street to a Black Girl's Beat: Music, Gender, and the 'Ins and Outs' of Double-Dutch," in *Generations of Youth: Youth Cultures and History in Twentieth-Century America,* ed. J. Austin and M. Willard, 272–92 (New York: New York University Press, 1998).

32. Intriguing also was news of the Spellman College–Essence Magazine Hip-Hop Town Meeting in the aftermath of Nelly's cancellation of his concert at the black women's liberal arts college after it was announced that members of the Spellman community would protest, during his appearance, the negative depictions of black women in his (and other rappers') music videos (February 2005).

33. For examinations of black racial identities, gender, sexuality, and music, see Johnson, "Pouring Out the Blues," 93–100, and Johnson, "Jelly Jelly Jellyroll," 31–52. See also Carmen Mitchell, "Creations of Fantasies/Constructions of Identities: The Oppositional Lives of Gladys Bentley," in *Homosexuality in Black Communities: The Greatest Taboo,* ed. Delroy Constantine-Simms (Los Angeles: Alyson Books, 2000), 211–25. Additional articles that address race and sexuality vis-à-vis black women's "voices" include Ellie M. Hisama's "Voice, Race, and Sexuality in the Music of Joan Armatrading," in *Audible Traces: Gender, Identity, and Music,* ed. Elaine Barkin and Lydia Hamessley (Los Angeles: Carciofoli, 1999). See also Currid's "We Are Family," and Martha Mockus, "MeShell Ndegeocello: Musical Articulations of Black Feminism," in *(Un)Making Race, Re-Making Soul: Transformative Aesthetics and the Practice of Freedom,* ed. Christa Acampora and Angela Cotton (Albany: SUNY Press, 2006).

34. Carby credits Hortense Spillers's intervention in the *Pleasure and Danger* (1984) anthology as critical to the formulation of her own critique of black women's sexuality and black women's literary criticism.

35. A panel devoted to black feminist rock criticism featuring Daphne Brooks, Kandia Crazyhorse, Laina Dawes, and Sonnet Retman at the conference of the Experience Music Project in Seattle in 2005 portends favorably for discussions among scholars, journalists, community activists, cultural workers, and listeners interested in rock, black women's musicking, and feminism.

36. A wide range of scholars in musicology, history, sociology, anthropology, women's studies, cultural studies, and literature have argued persuasively for deconstructing canons of all sorts; at the same time, scholars have acknowledged their possible value at the historical moment of their emergence.

37. Radano, *Lying Up a Nation,* 7.

38. Collins, *Fighting Words,* 208.

39. Musicologist Jane Bowers pursues this path of inquiry in her discussion of Chicago blues singer Estelle "Mama" Yancey (1896–1986). See Bowers, "Writing the Biography." Bowers discusses biographies of women whose personal narratives or conceptualizations of themselves do not seem to comply with the "requirements" of feminist biographical construction. For a discussion of issues raised by "feminist/

auto/biography," see Liz Stanley, "Moments of Writing: Is There a Feminist Auto/bi-ography?" *Gender and History* 2, no. 1 (Spring 1990): 58–67, reprinted in Terry Lovell, ed., *Feminist Cultural Studies*, vol. 1 (Aldershot, U.K.: Elgar, 1995). Stanley maintains that "the general run of 'feminist biography' fails to problematise what is or might be 'feminist' about it" (59). For an example of critical biographical writing and research in jazz studies, see Kernodle's *Soul on Soul.*

40. See Gilroy, *Black Atlantic;* see also Radano's *Lying Up a Nation.*

41. This is a nod to the title of McClary's *Feminine Endings.* This play on the title of her book might suggest that McClary does not address issues of race, gender, and racism in her book when, in fact, she does.

42. Giddings borrows her book's title from the first essay in *A Voice From the South,* a compilation of essays by the nineteenth-century black intellectual Anna Julia Coo-per. In her essay (1892) on the rape of black women, Cooper writes, "Only the Black Woman can say 'when and where I enter, in the quiet, undisputed dignity of my wom-anhood, without violence and without suing or special patronage, then and there the whole Negro race enters with me.'" From Gaines, *Uplifting the Race,* 134–35.

43. See McClary, *Feminine Endings,* 5.

44. These citations refer to the pages of Pough's *Check It While I Wreck It.* This particular reference is found on page 164.

45. See Leslie C. Dunn and Nancy A. Jones, introduction to *Embodied Voices: Rep-resenting Female Vocality in Western Culture,* ed. Leslie C. Dunn and Nancy A. Jones (Cambridge: Cambridge University Press, 1994), 1.

46. For example, see Farah Jasmine Griffin's "When Malindy Sings: A Medita-tion on Black Women's Vocality," in *Uptown Conversation: The New Jazz Studies,* ed. Robert G. O'Meally, Brent Hayes Edwards, and Farah Jasmine Griffin (New York: Columbia University Press 2004), 102–25.

47. Among scholars addressing the difference age and generation make in regard to black feminist identification, see a wide range of scholarship, including contribu-tions of Tricia Rose, Gwendolyn Pough, and Joan Morgan. See also Springer, "Third Wave Black Feminism"; Walker, *To Be Real;* Walker, "Becoming the Third Wave"; Hernández and Rehman, *Colonize This!*

48. See Gaines, *Uplifting the Race.*

49. Smith, *Not Just Race, Not Just Gender,* xv. For valuable discussion of the rami-fications of black feminist thinking in the social sciences, see Irma McClaurim, ed., *Black Feminist Anthropology: Theory, Politics, Praxis, and Poetics* (New Brunswick: Rutgers University Press, 2001).

Bibliography

Altorki, Soraya, and C. Fawzi El-Solh, eds. 1988. *Arab Women in the Field: Studying Your Own Society.* Syracuse: Syracuse University Press.

Bernstein, Jane, ed. 2004. *Women's Voices Across Musical Worlds.* Boston: Northeast-ern University Press.

Berry, Venise T. 1994. "Feminine or Masculine: The Conflicting Nature of Female Images in Rap Music." In *Cecillia Reclaimed: Feminist Perspectives on Gender and Music,* edited by Susan C. Cook and Judy S. Tsou, 183–201. Urbana: University of Illinois Press.

Bohlman, Philip, and Ronald Radano, eds. 2000. *Music and the Racial Imagination.* Chicago: University of Chicago Press.

Born, Georgina, and David Hesmondhalgh, eds. 2000. *Western Music and Its Others: Difference, Representation, and Appropriation in Music.* Berkeley and Los Angeles: University of California Press.

Bowers, Jane. 1993. "'I Can Stand More Trouble than Any Little Woman My Size': Observations on the Meanings of the Blues of Estelle 'Mama' Yancey." *American Music,* Spring, 28–53.

———. 2000. "Writing the Biography of a Black Woman Blues Singer." In *Music and Gender,* edited by Pirkko Moisala and Beverley Diamond, 140–65. Urbana: University of Illinois Press.

Carby, Hazel. 1986. "'It Jus Be's Dat Way Sometime': The Sexual Politics of Women's Blues." *Radical America* 20, no. 4 (June–July): 9–22. Reprinted in *Unequal Sisters: A Multicultural Reader in U.S. Women's History,* 2nd ed., edited by Ellen Carol DuBois and Vicki L. Ruiz, 330–41. London: Routledge, 1994.

Cole, Johnnetta B., and Beverly Guy-Sheftall. 2003. *Gender Talk: The Struggle for Women's Equality in African American Communities.* New York: One World/Ballantine Books.

Collins, Patricia Hill. 1990. *Black Feminist Thought: Knowledge, Consciousness, and the Politics of Empowerment.* Boston: Unwin Hyman.

———. 1998. *Fighting Words: Black Women and the Search for Justice.* Minneapolis: University of Minnesota Press.

Combahee River Collective. 1981. "A Black Feminist Statement." Reprinted in *This Bridge Called My Back: Writings by Radical Women of Color,* edited by Cherrie Moraga and Gloria Anzaldúa. Watertown, Mass: Persephone Press. Reprinted from Zillah Eisenstein, ed., *Capitalist Patriarchy and the Case for Social Feminism.* New York: Monthly Review Press, 1979. Reprinted also in Beverly Guy-Sheftall and Johnnetta B. Cole, eds., *Words of Fire: An Anthology of African-American Feminist Thought.* New York: New Press, 1995.

Cook, Nicholas, and Mark Everist. 1999. *Rethinking Music.* Oxford: Oxford University Press.

Currid, Brian. 1995. "'We Are Family': House Music and Queer Performativity." In *Cruising the Performative: Interventions into the Representation of Ethnicity, Nationality, and Sexuality,* edited by Sue-Ellen Case, Philip Brett, and Susan Leigh Foster. Bloomington: Indiana University Press.

Cusick, Suzanne. 2001. "'Eve . . . Blowing in Our Ears'? Toward a History of Music on Women in the Twentieth Century." *Women and Music,* Annual.

———. 1999. "Gender, Musicology, and Feminism." In Cook and Everist, *Rethinking Music.*

Dahl, Linda. 1984. *Stormy Weather: The Music and Lives of a Century of Jazzwomen.* New York: Pantheon Books.

Davis, Angela. 1998. *Blues Legacies and Black Feminism.* New York: Pantheon Books.

———. 1971. "Reflections on the Black Woman's Role in the Community of Slaves." *Black Scholar* 3 (December): 4–15.

Dent, Gina, ed. 1992. *Black Popular Culture.* Seattle: Bay Press.

Gaines, Kevin. 1996. *Uplifting the Race: Black Leadership, Politics, and Culture in the Twentieth Century.* Chapel Hill: University of North Carolina Press.

Giddings, Paula. 1984. *When and Where I Enter: The Impact of Black Women on Race and Sex in America.* New York: Bantam Books.

Gilroy, Paul. 1993. *The Black Atlantic: Modernity and Double Consciousness.* Cambridge, Mass.: Harvard University Press.

Handy, Antoinette. 1981. *Black Women in American Bands and Orchestras.* 2nd ed. Metuchen, N.J.: Scarecrow Press, 1998.

———. 1983. *The International Sweethearts of Rhythm.* Metuchen, N.J.: Scarecrow Press.

Harrison, Daphne Duval. 1987. *Black Pearls: Blues Queens of the 1920s.* New Brunswick, N.J.: Rutgers University Press.

Harrison, Faye V., ed. 1991. *Decolonizing Anthropology.* Washington, D.C.: Association of Black Anthropologists/American Anthropological Association.

Hernández, Daisy, and Bushra Rehman. 2002. *Colonize This! Young Women of Color on Today's Feminism.* Emeryville, Calif.: Seal Press.

Higgenbotham, Evelyn. 1993. *Righteous Discontent: The Women's Movement in the Black Baptist Church, 1880–1920.* Cambridge, Mass.: Harvard University Press.

Hine, Darlene Clark. 1989. "Rape and the Inner Lives of Black Women in the Middle West: Preliminary Thoughts on the Culture of Dissemblance." *Signs* 14, no. 4 (Summer): 912–20. Reprinted in *Unequal Sisters: A Multicultural Reader in U.S. Women's History,* 2nd ed., edited by Ellen Carol DuBois and Vicki L. Ruiz, 342–47. London: Routledge, 1994.

hooks, bell. 1992. *Black Looks: Race and Representation.* Boston: South End Press.

———. 1990. *Yearning: Race, Gender, and Cultural Politics.* Boston: South End Press.

Hunter, Tera W. 2000. "'Sexual Pantomimes': The Blues Aesthetic and Black Women in the New South." In Bohlman and Radano, *Music and the Racial Imagination.* 145–64.

Jackson, Irene V., ed. 1985. *More than Dancing: Essays on Afro-American Music and Musicians.* Westport, Conn.: Greenwood Press.

———. 1985. *More than Drumming: Essays on African and Afro-Latin American Music and Musicians.* Westport, Conn.: Greenwood Press.

Johnson, Maria. 2003. "'Jelly Jelly Jellyroll': Lesbian Sexuality and Identity in Women's Blues." *Women and Music: A Journal of Gender and Culture* 7:31–52.

———. 2004. "'Pouring Out the Blues': Gwen 'Sugar Mama' Avery's 'Song of Freedom.'" *Frontiers: A Journal of Women's Studies* 25 (1): 93–110.

Kelley, Robin D. G. 2002. *Freedom Dreams: The Black Radical Imagination.* Boston: Beacon Press.

Kernodle, Tammy. 2004. "Having Her Say: The Blues as the Black Woman's Lament." In *Women's Voices Across Musical Worlds,* edited by Jane Bernstein, 213–31. Boston: Northeastern University Press.

————. *Soul on Soul.* 2004. *The Life and Music of Mary Lou Williams.* Boston: Northeastern University Press.

Keyes, Cheryl. 2002. *Rap Music and Street Consciousness.* Urbana: University of Illinois Press.

Kingsbury, Henry. 1988. *Music, Talent and Performance: A Conservatory Cultural System.* Philadelphia: Temple University Press.

————. 1993. "'We're More than a Novelty, Boys': Strategies of Female Rappers in the Rap Music Tradition." In *Feminist Messages: Coding in Women's Folk Culture,* edited by Joan Newlon Radner, 201–20. Urbana: University of Illinois Press.

Lieb, Sandra. 1981. *Mother of the Blues: A Study of Ma Rainey.* Amherst: University of Massachusetts Press.

McClary, Susan. 2000. *Conventional Wisdom: The Content of Musical Form.* Berkeley and Los Angeles: University of California Press.

————. 1991. *Feminine Endings: Music, Gender, and Sexuality.* Minneapolis: University of Minnesota Press.

Monson, Ingrid. 1997. "Music and the Anthropology of Gender and Cultural Identity," *Women and Music* 1 (1997): 24–32.

Morgan, Joan. 1999. *When Chickenheads Come Home to Roost: A Hip-Hop Feminist Breaks It Down.* New York: Simon & Schuster.

Placksin, Sally. 1982. *American Women in Jazz: 1900 to the Present.* New York: Wideview.

Pough, Gwendolyn D. 2004. *Check It While I Wreck It: Black Womanhood, Hip-Hop Culture, and the Public Sphere.* Boston: Northeastern University Press.

Radano, Ronald. 2003. *Lying Up a Nation: Race and Black Music.* Chicago: University of Chicago Press.

Ramsey, Guthrie. 2003. *Race Music: Black Cultures from Bebop to Hip-Hop.* Berkeley and Los Angeles: University of California Press.

Rose, Tricia. 1994. *Black Noise: Rap Music and Black Culture in Contemporary America.* Hanover, N.H.: Wesleyan University Press.

Small, Christopher. 1987. *Music of the Common Tongue: Survival and Celebration in African American Music.* Hanover, N.H.: Wesleyan University Press.

Smith, Valerie. 1998. *Not Just Race, Not Just Gender: Black Feminist Readings.* New York: Routledge.

————, ed. 1997. *Representing Blackness: Issues in Film and Video.* New York: Routledge.

Southern, Eileen. 1971. *The Music of Black Americans.* Reprint, New York: W. W. Norton, 1997.

Springer, Kimberly. 2002. "Third Wave Black Feminism." *Signs,* Summer, 1059–89.

Tucker, Sherrie. 2000. *Swing Shift: "All-Girl" Bands of the 1940s.* Durham, N.C.: Duke University Press.

Walker, Rebecca. 2001. "Becoming the Third Wave." In *Identity Politics in the Women's Movement,* edited by Barbara Ryan. New York: New York University Press.

———, ed. 1995. *To Be Real.* New York: Anchor Books.

———. 2000. "When Subjects Don't Come Out." In *Queer Episodes in Music and Modern Identity,* edited by Sophie Fuller and Llyod Whitesell, 293–310. Urbana: University of Illinois Press.

Having Her Say: Power and Complication in Popular Music

Hip-Hop Soul Divas and Rap Music: Critiquing the Love That Hate Produced

GWENDOLYN POUGH

> As Fanon says, "Today, I believe in the possibility of love, that is why I endeavor to trace its imperfections, its perversions." Dialogue makes love possible. I want to think critically about intellectual partnership, about the ways black women and men resist by creating a world where we can talk with one another, where we can work together.
>
> —bell hooks, "Feminism as a Persistent Critique of History: What's Love Got to Do With It?"

In her article "Love as the Practice of Freedom," bell hooks discusses the need for an "ethic of love" in the fight against oppression.[1] For hooks, love has liberating potential and can free us from oppression and exploitation. She believes that until we revere love's place in struggles for liberation, we will continue to be stuck in an "ethic of domination."[2] I believe that Hip-Hop culture and rap music provide a starting place for us to begin talking about and implementing an "ethic of love," love meant to liberate. The dialogue that bell hooks believes makes love possible is the kind of dialogue that I am searching for, a dialogue that will extend the possibilities of bringing wreck to a project capable of combating racism, sexism, and homophobia. Black feminist criticism, if it goes beyond admonishing rap for its sexist and misogynist lyrics, can aid in starting the dialogue. As third-wave Hip-Hop feminists such as Joan Morgan and Eisa Davis remind us, there is a public dialogue between male and female rappers and between Black men and women. Therefore, rap music and Hip-Hop culture can be used as a springboard for various kinds of conversations and actions. Feminism needs to change its focus in order to take full advantage of the possibilities

in rap music. Instead of admonishing rappers, it is time to do something that will evoke change. Here I probe the public dialogue about love found in rap songs; furthermore, I challenge Black feminism to interrogate rap as a site for political change.

How is love expressed in the Hip-Hop community? And what kind of love is this? My aim here is to look at love and Hip-Hop as a place to further the dialogue between Black men and women and create a space for more progressive conversations about gender and sexuality. My aim is also to look at the ways this dialogue can be used to bring wreck and help us reconsider some longstanding notions about gender and sexuality.[3]

My Need for Love and Hip-Hop

I remember the first time I heard LL Cool J's soulful rap ballad "I Need Love" (1987). While it was the first rap love song I had ever heard, it will not be the last. Rap and rap artists' never-ending quest to "keep it real" is not limited to the struggles on American streets. Some rappers show a dedication to exploring aspects of love, the struggles of building and maintaining intimate relationships between Black men and women, and maintaining a public dialogue about love, life, and relationships. The beginnings of this public dialogue can be seen in the love raps of the 1960s made famous by Isaac Hayes, Barry White, and Millie Jackson. As William Eric Perkins notes, these love raps were essentially monologues, recorded over a simple melody, that spoke to matters of the heart. Millie Jackson, thought of today as the mother of women rappers, got her start in this genre by recording love raps from a female perspective.[4]

Her raps were often X-rated and she held her own in duets with Isaac Hayes.[5] Talking about love and romance over melodious beats is nothing particularly new in the world of Black music. Black men and women have before and after the 1960s publicly hammered out their differences through song. In the blues tradition of Black music, Angela Davis finds that the mother of the blues, Gertrude "Ma" Rainey, participated in the call-and-response tradition in that many of her songs about love and sex were meant to be responses to the songs of male country blues singers.[6]

In rap, this dialogue can be viewed in the answer/"dis" raps of the 1980s, which gave rise to the women rap stars Roxanne Shante and Salt-N-Pepa.[7] These women paved the way for other women rappers by recording very successful songs that were responses to the hit records of men who were their contemporaries. Shante gave the woman pursued in UTFO's "Roxanne,

Roxanne" a voice and ultimately let it be known that women would no longer suffer insults and degradation in silence.

Salt-N-Pepa's "Showstopper" was a direct refutation to Doug E. Fresh and Slick Rick's "The Show," a song in which women are portrayed as objects of conquest. As I argue in the first chapter of my book, some have described the process of shedding light on the things Blacks have had to do to obtain and maintain a presence in the larger public sphere as bringing wreck. *Wreck* is a Hip-Hop term that connotes fighting, recreation, skill, boasting, or violence. Some would argue that the response or talking-back element of "Showstopper" is an example of bringing wreck that appears to be reactionary and therefore limiting. I argue, however, that at that particular moment in Hip-Hop, when female voices were few and far between, the response or answer raps performed by Roxanne Shante and Salt-N-Pepa added a missing part of the conversation. By adding this part, they paved the way for the women who would later initiate their own conversations. Songs such as TLC's "Scrubs," Destiny's Child's "Bills, Bills, Bills," Alicia Keys's "Woman's Worth," and Lauryn Hill's "Doo Wop: That Thing" represent contemporary initiations of the conversation about men, women, and relationships. The public dialogue between men and women can also be seen in contemporary elements of Hip-Hop culture and rap songs.[8] The dialogue surfaces when observing the construction of male and female gender identities and sexualities as well as expressions of love. And although love in the traditional romantic sense is not the first thing to come to mind when one thinks of Hip-Hop culture and rap music, it is important to note that the Hip-Hop generation does talk about and express love. While it may be a different manner of expression than the love that is found in the romantic melodies of the 1960s and 1970s, with their sweet harmonies and equally sweet lyrics—more in line, perhaps, with the rugged and raw sex-filled lyrics such as those performed by contemporary crooners such as Ginuwine, Blackstreet, and B2K—it is still a form of love.

The need for Black men and women to take these private issues into the public sphere is not a new phenomenon. The legacy of racism in the United States made it impossible for Blacks to obtain the luxury of a clearly defined public/private split. The public discussions about love, sex, and identity found in the lyrics of Hip-Hop soul divas and rap artists bring wreck and flip the script on Habermas's notions of the public/private split and identity formation.[9] The necessities that Habermas says are taken care of in the private sphere are the very necessities Black people have been fighting for in the public sphere. These necessities also become a site of public struggle

for Black men and women. The issue of identity formation, which is not a concern of Habermas, also becomes a matter for public debate for Blacks participating in the public sphere. Blacks in America have constantly struggled against stereotypes and tried to define themselves against labels put forth by American racism. In fact, the quest for self-definition, self-actualization, and self-determination has been a guiding theme in classical and modern Black nationalism. These themes all lead back to Black Americans' determination to define themselves in the absence of a clearly located homeland. For all of these reasons, then, the struggle for identity becomes a matter of public debate.[10] By using rap lyrics about love, sex, and identity to have an effect on public debate and at the same time shape the subjectivity of listeners and performers, the Hip-Hop generation sheds new light on the possibilities of the public sphere.

Tricia Rose notes four dominant themes in the works of Black women rappers: "heterosexual courtship, the importance of the female voice, and mastery in women's rap and black female public displays of physical and sexual freedom."[11] While men rap artists cannot claim rapping about heterosexual courtship as a dominant theme, the release of "I Need Love" (1987) and other rap love songs crooned by Black men suggest that when the rapper is a man, the discourse about relationships, courtship, and love is predominantly, if not exclusively, heterosexual. Hip-Hop, just like the larger society, is guilty of heterosexism and homophobia. With the exception of rapper Queen Pen, whose duet with Me'Shell NdegéOcello, "Girlfriend," deals with a woman pursuing another woman, rappers have yet to expand the discourse beyond male-female courtship.

Queen Pen's "Girlfriend," unlike the ballads of the Hip-Hop soul divas, which offer strictly heterosexual tales of love and relationships, tells the story of a very confident woman who will woo a woman right off the arm of a man. "Girlfriend," while it was never released as a single, became popular in various clubs in New York and Florida. Making the song was very much a political act with personal implications. Realizing that women rappers have constantly had their sexual orientation called into question because of various reasons too ridiculous to name, Queen Pen decided to record "Girlfriend" on her debut album in order to squelch rumors about her sexuality before they even got started.[12] However, she has yet to officially come out. She simply says, "I'm black. I'm a female rapper. I couldn't even go out of my way to pick up another form of discrimination. People are waiting for this hip-hop Ellen to come out of the closet. I'd rather be a mystery for a minute."[13] Thus her political act loses some of its momentum. While she is

clearly the first rapper to rap about a homosexual experience, she waffles on completing her stance.

The lyrics of "Girlfriend" are very similar to the boastful lyrics found in the raps of men. The woman in the song raps about having a lot of bitches that all want her and how her sex is good enough to pull someone out of the closet. She brags that she has women leaving their men and giving her their phone numbers.[14] While Queen Pen's lyrics are boastful, derogatory toward women, and objectifying in some of the same kinds of ways found in the lyrics of men, they break free of the heterosexist hold currently on Hip-Hop culture and rap music by recognizing that same-sex courtship exists in society. As Queen Pen asks in a *New York Times* interview, "Why shouldn't urban lesbians go to a club and hear their own thing?"[15] Perhaps one day more rappers will take a stance similar to Queen Pen's and expand the definition of love to include same-sex relationships.

Even if rap has not reached a stage where it is ready to critique its heterosexism, it is particularly fertile ground for observations and conversations about male-female relationships and the fight against sexism. Rap music can be viewed as a dialogue—between rappers and a racist society, between male rappers and female rappers, and between rappers and the consumer—and the dialogue on love and relationships between the sexes is a productive location for inquiry.[16]

As a woman born in 1970—I was nine years old when the first rap record, the Sugar Hill Gang's "Rapper's Delight," hit the airwaves—I pretty much grew up on rap music. Reading Tricia Rose's discussion of the evolution of Hip-Hop culture through the changes in clothing commodified by rappers and Hip-Hop audiences reminds me of my own evolution from a teenage b-girl in Lee jeans, Adidas sneakers with fat laces, LeTigre shirts, gold chunk jewelry, and a gold tooth to a college freshman in leather jacket, baggy jeans, sweat hood, and fake Louis Vuitton. My relationship with Hip-Hop changed when I stopped consuming the female identities put forth by men rappers. Once willing to be LL Cool J's "Around the Way Girl" (1989), I took issue with the very notion of Apache's "Gangsta Bitch" (1992). Today, while I still consume the music, I have begun to question the lyrics and constructed identities.

Like many of the academics and Black popular critics writing about rap, I have a love for Hip-Hop culture and rap music. This love at one time stopped me from writing about rap, but now it prompts me to critique and explore rap in more meaningful ways. I am no longer the teenage girl who spent Friday nights listening to Mr. Magic's "Rap Attack" and writing

rhymes, Saturdays reading her mama's Harlequin or Silhouette romance novels, and Sundays writing rhymes and short stories. Now I am *all grown up*, and although I still listen to rap music and read a romance novel every time I get a chance, Black feminist and womanist theories and politics inform my listening and reading. When I think about the definition of a womanist—"committed to the survival of a whole people, male and female"—I cannot help but wonder how that kind of commitment can be achieved, or even if it can be achieved, in rap.[17] Frantz Fanon's and bell hooks's hope for the possibility of love, quoted in the epigraph to this chapter, urges me to look for it in Hip-Hop. June Jordan's poignant question, "Where is the love?" haunts me. In her article of the same title, Jordan discusses the need for a "self-love" and "self-respect" that would create and foster the ability to love and respect others. She writes, "I am talking about love, about a steady-state of deep caring and respect for every other human being, a love that can only derive from a secure and positive self-love."[18]

As I think about Hip-Hop and the images of "niggas" and "bitches" that inhibit this kind of "self-love" and "self-respect," I am faced with questions concerning the forming of a subject that cannot only survive but must become a political subject—someone who can evoke change in the larger public and disrupt oppressive constructs. All of these issues inform my critique of Hip-Hop. I am concerned particularly with rap and the love that hate produced—the love that is fostered by a racist and sexist society. This is the kind of love that grows in spite of oppression but holds unique characteristics because of it. In many ways it is a continuation of the way Black men and women were forced to express love during slavery and segregation.

It is common knowledge that during slavery Black people were not allowed to love one another freely. Family members could be taken away at any moment. African American historian Lerone Bennett notes in his book *The Shaping of Black America:*

> Slave marriages had no standing in law; the slave father could not protect his wife and children and the planter could separate slave families at his convenience. This had at least three devastating results. First of all, the imposed pattern of mating limited the effectiveness of the slave family and had a sharp impact on slave morale. Second, it isolated the black woman and exposed her to the scorn of her peers and the violence of white women. Third, it sowed the seeds of sexual discord in the black community.[19]

Lerone Bennett's work is thought provoking because it recognizes the influence that the enslaved past has had on the way Black men and women relate

to one another in the present. It is fascinating to me that they continued to build family units even as they were torn apart, and they went looking for lost family members as soon as they were free to do so. Black people found ways to love each other and be together during the era of slavery despite separations and sales of partners. During the days of segregation and Jim Crow, Black people, especially Black parents, had to practice tough love in order to ensure that loved ones would live to see another day and not become the victims of Klan violence.

While strands of these kinds of love persist and the Hip-Hop generation has the legacy of African American history to build on, it also has its own demons. As Kevin Powell writes in *Keepin' It Real: Post-MTV Reflections on Race, Sex, and Politics,* the Hip-Hop generation, plagued by AIDS, drugs, guns, gangs, unemployment, and a lack of educational opportunities, faces more obstacles in their quest to love than other generations.[20] Powell offers the acknowledgment that life for young Black Americans is different, and the very nature of relationships within Hip-Hop culture is necessarily going to represent both the historical struggle and the unique aspects of the Hip-Hop generation. What continues to fascinate me is that in spite of all the historical baggage and contemporary struggles, these young Black people are still trying to find ways to love, just as their ancestors did.

A new direction for Black feminism would aid in the critique and exploration of the dialogue across the sexes. Black feminists such as dream hampton, Tara Roberts, Joan Morgan, and Eisa Davis have begun to explore the relationship between love and Hip-Hop. Joan Morgan maintains in *When Chickenheads Come Home to Roost: My Life as a Hip-Hop Feminist,* "Any feminism that fails to acknowledge that black folks in 90's America are living and trying to love in a war zone is useless to our struggle against sexism. Though it is often portrayed as part of the problem, rap music is essential to that struggle because it takes us straight to the front lines of the battlefield."[21] Rap music and Hip-Hop culture in general, along with Black feminism as an activist project, can be a part of the solution. It is not just about counting the "bitches" and "hoes" in each rap song. It is about exploring the nature of Black male and female relationships. These new Black feminists acknowledge that sexism exists in rap music. But they also recognize that sexism exists in America. Tricia Rose and other Black critics of popular culture argue that rap music and Black popular culture are not produced in a cultural and political vacuum. The systems of oppression that plague the larger public sphere plague Black public spheres as well.

Michele Wallace and bell hooks examine the larger society's role in Hip-

Hop's sexism and encourage Black women to speak out against sexism in rap. The new Black feminists, however, are looking for ways to speak out while starting a dialogue right on the "front lines of the battlefield." In "Some Implications of Womanist Theory," Sherley Anne Williams notes that womanist inquiry assumes a proficiency in talking about men and that this assumption is necessary because stereotyped and negative images of Black women offer only part of the story. In order to get the full story, we have to be able to acknowledge and interrogate what Black men are saying about themselves.[22] While Williams is looking at the potential of womanism for examining the work of Black men writers, she offers a useful lens for understanding Black men rappers as well. Some of the questions that form my analysis of Black men rappers are, What are they saying about themselves? What kind of lover is described in the Hip-Hop love song? What is the potential for meaningful and productive dialogue found in the lyrics? What are the implications of a real and continued dialogue in this new direction? What impact do the songs of these men rappers have on the songs of Black women rappers? How have women rappers begun to internalize the images put forth by the men? How do all of these songs impact other young Black women? What is its political and rhetorical relevance? What happens when we really begin to critique and explore the love that hate produced?

Hip-Hop Meets R&B

My reason for using Hip-Hop soul divas' lyrics is threefold. First, the blending of Hip-Hop and R&B has added a new dimension to rap, which is already noted for the way it makes connections with and takes from other forms of Black music via sampling.[23] Thus the Hip-Hop soul diva is helping rap evolve to yet another level of crossover appeal. Second, the Hip-Hop soul diva has changed the nature of the rap love song. We can now hear a soulful singing voice on many rap love songs. During the time of LL Cool J's "I Need Love," this use of R&B singing was not as prevalent as it is today. Third, the love songs on the albums of Hip-Hop soul divas open up the floor for questions about love, thus providing a starting point for dialogue between the sexes.

Hip-Hop soul has opened the largely masculine discursive space of Hip-Hop culture to include more women. In fact, there are now more recorded women Hip-Hop soul artists than there are recorded women rap artists. It has always been a struggle for women to disrupt the masculine space of Hip-Hop, but the success of Hip-Hop soul offers more possibilities for women's voices and issues to be heard. Rap magazine writer Dimitry Leger notes that

the "singing sisters" of Hip-Hop soul use the gained space to sing about their lives as members of the Hip-Hop generation. These women come from all regions of the country in which Hip-Hop has a presence, and their music reflects that regional influence with shades of hard-core reality.[24]

The release of Michel'le's 1989 self-titled album marks the beginning of a new era: that of the Hip-Hop soul diva who skillfully blends R&B soul melodies with gritty urban beats. While many credit Mary J. Blige and Puff Daddy with the creation of Hip-Hop soul—Mary J. Blige's *What's the 411?* was the first complete album with R&B lyrics over Hip-Hop beats throughout the entire album—her predecessor, Michel'le, shares some of the credit. Her career makes evident key elements of what constitutes a Hip-Hop soul diva. And her career and work helped lay the foundation for Mary J. Blige's success. The criteria include the backing of a male rapper entourage, a rap record label, and the influence of male producers largely known for their work in the field of rap. In Michel'le's case, the entourage included her labelmates Niggas with Attitudes (N.W.A.); they appear in her videos and set up the Hip-Hop soul diva as queen bee surrounded by a hive of men rappers. The record label for Michel'le's first album was the late Eazy E's Ruthless Records. The male influence is Dr. Dre, the producer of her album, and he can be heard rapping and talking throughout the various numbers. Indeed, the fact that her album was financed by Eazy E, a known womanizer with seven children by six different women who is now deceased due to complications from AIDS, and produced by Dr. Dre, who attacked rap video hostess Dee Barnes and was rumored to be the cause of Michel'le performing at concerts with black eyes, calls forth many questions about the way a woman rises to the top of a male-dominated field such as rap. Michel'le's on-again, off-again career is also a testament to how hard it can be.

The acclaimed queen of Hip-Hop soul, Mary J. Blige, started out with a slew of male rappers and singers as part of her entourage but has since gotten rid of the men who surrounded her early in her career. Perhaps this is why her career has outlasted Michel'le's. Many of Blige's early songs and remixes feature men rappers, not women rappers. Her first label, Uptown Records, started as a largely rap label but found more success with Hip-Hop soul acts such as Jodeci and herself. In Fact, Blige, like Jodeci, got her start singing backup for Uptown rap artist Father MC. The producer of her first two double platinum albums, *What's the 411?* and *My Life,* Sean "Puffy" Combs, got his start at Uptown and now has his own rap label, Bad Boy Records. Puffy, like Dr. Dre on Michel'le's album, can be heard talking throughout Blige's entire album, and he and his Bad Boy rappers are in many of the

videos from the *My Life* album. Former Bad Boy rappers such as Craig Mack and the late Biggie Smalls rapped on many of Mary J. Blige's early remixes.

Similar to Michel'le, Blige's career reveals how a dominant male influence can sometimes overshadow the accomplishments of women in the world of Hip-Hop. Numerous magazine articles about Blige mention Combs's role in shaping, molding, and creating her, as if she were a lump of clay and not an extraordinarily talented woman. There is also evidence of mental if not physical abuse. In several interviews Blige talks about getting rid of all the negative people and negative influences around her because the men she was working with made her feel bad about herself.[25] "I had a lot of people around me who were trying to hurt me—who were able to hurt me because I couldn't see that I meant something. Now my family is more involved in my career. There's nothing but love surrounding me. I don't allow anything else."[26] She also says that "when you love people, you don't wanna let them go because you love them. It's hard to let them go—family members, boyfriends, girlfriends—but you just gotta because if you keep them around, they'll drain you and try to hold you back. You gotta cut them off, because it's important. I'm important to me now."[27] Mary J. Blige started out as the classic ghetto girl with an attitude. She has evolved into a spiritual person who values herself and her life more than the things she almost let destroy her, namely, men and drugs. She speaks so openly and honestly about the things she believes that she has become a voice for young women in the Hip-Hop generation.

Mary J. Blige has undeniable talent, as Joan Morgan notes in her interview with her, "Hail Mary." Blige offers a different kind of blues that caters to a Hip-Hop generation devastated by crack, AIDS, and Black-on-Black violence. Her voice offers the reality of a ghetto that is simultaneously beautiful and ugly. And Blige can be credited with bringing the entire Hip-Hop generation back to R&B.[28] Even renowned Hip-Hop activist Sister Souljah recognizes Blige's talent and what she brings to the Hip-Hop community. Sister Souljah credits Blige for the issues she brings to public attention about the state of Black communities in her lyrics and notes that Blige brings to light the real implications of our future if we continue to lose sight of love and family. Although Sister Souljah states that Mary J. Blige is not a revolutionary in the tradition of Harriet Tubman or Angela Davis, she notes that Blige has managed to accomplish in her music what other divas have not: She stayed true to herself. She sang in her own rough voice and opened up her own bruised heart to the world. "She pronounced her words in unashamed Black English and she danced her un-choreographed unladylike steps with class."[29]

Mary J. Blige represents the average Black woman from the projects who shared her message with the world through song, managed to get her voice heard, and in doing so brought wreck to the glamorous notions and stereotypes of the recording industry. She also helped make it possible for other young Black women to share their voices. Blige has basically paved the way for other Hip-Hop soul divas such as Sisters with Voices (SWV), Xscape, Total, Adina Howard, Monifah, and Faith Evans. And she offers many women born and raised on Hip-Hop a representation of Black womanhood they can relate to. Former Uptown president Andre Harrell sums her up best when he says that "her interpretation of soul has given women in the inner-city pride. She took the girl from around the way and made her something cool to be."[30]

Mary J. Blige's music becomes the outlet of expression for many of the wants and needs of young Black women. Michael Eric Dyson aptly notes the strength of Blige's voice and music in relation to Hip-Hop culture when he compares her to Aretha Franklin. While Blige represents the gritty explicitness of Hip-Hop culture, Dyson finds that Blige and Franklin are saying similar things in different ways. "Blige's hip-hop soul feminism seeks 'real love.' But it remakes edifying love confessions into gut-wrenching pleas of faithfulness," he notes. "It makes self-love the basis of loving others. And it bitterly, defiantly refuses to accept sexual infidelity."[31] In interview after interview Blige offers advice on relationships and love to her fans. She stresses the importance of self-love and of staying away from abusive relationships: "I believe in love. I believe good relationships do exist, but you've got to have a love affair with yourself first and really know yourself from the inside out before you can have a good relationship with a man or anyone else."[32] It is as if through her music and her interviews, especially the later ones, Blige is trying to heal a generation and open them up for the possibilities of love.

There is really no other artist to use as a guide when coming up with questions about love that are relevant for the Hip-Hop generation. No other soul artist has had such an enormous impact on the Hip-Hop generation. Blige's Hip-Hop understanding of the yearning for love can clearly be seen in her first two albums. In her songs "Real Love" and "Be Happy," we get a glimpse of what the Hip-Hop soul diva is looking for in a mate. In "Real Love," Blige sings about wanting a lover who will satisfy her every need and give her inspiration and real love.[33] In "Be Happy," she questions how she can love anyone else without loving herself enough to leave when things are not going right in the relationship. She sings about finding a love that belongs only to her and being happy.[34] At first glance, Blige's requests seem simple: love and happiness. But anyone familiar with the lyrics of Al Green knows

to wait a minute. The questions may appear simple, but can the Hip-Hop lover love? Can he make her happy? The notion of "real love" is not that uncomplicated. What is real love to a Hip-Hop soul diva? What can we find in the lyrics of rap love songs that testify to the fulfillment of every need? Are the love needs expressed by Hip-Hop soul divas different from those of women in mainstream America?

In the introduction to her book *Wild Women Don't Wear No Blues,* Marita Golden notes that Black girls of every class and complexion grow up believing that there are no Prince Charmings in their neighborhoods. Golden questions the possibility of love existing without fairy tales, because in our society the two, fairy tales and love, are so intimately connected.[35] I think it is important to note that society has indeed made fairy tales and love inseparable. And because living in and taking part in mainstream society influences Hip-Hop divas and indeed all Black women, various versions of the fairy tale do exist. The success of novels such as Terry McMillan's *Waiting to Exhale* attests to some Black women's need to find Mr. Right. Assuming that Black women do not believe in and internalize mainstream images of love and romance promotes essentialist notions of Blackness that claim romantic love does not affect or is not important to Black people.[36] An example of a young Black woman's view of the fairy tale comes from Lesley D. Thomas: "I know gangsta bitches that believe in princes and shining armor. Like them, I interpret 'hard-core' as an earned status qualifying Black men to rescue Black women from all this pain and bullshit. The desire to be freed is not a result of being weary and worn. And no, fantasizing as a Black woman is not unrealistic. . . . Hoes, tramps, bitches, whatever, we want our men, at home, being fathers and lovers—not making excuses and angry babies."[37]

Clearly some Black women, to quote Julia Roberts in *Pretty Woman,* "want the fairy tale." It might be a slightly different fairy tale, but it is a fairy tale all the same, with heterosexual relationships, "real" love and happiness, being saved from a life of strife, a man at home being a father and a lover, and living happily ever after. This same need is echoed in the writing of dream hampton, who decided to spell her name in lowercase letters like her feminist role model bell hooks. Like Thomas, hampton envisions a future with a Black man who would marry her and give her beautiful brown babies.[38] The political implications are important to note. Given the lack of clarity on gender roles, these dreams of heterosexual romance hint at a firmly established patriarchy—indeed, what comes to mind are the dreams of the normal bourgeois family described by Habermas, where all the necessities of life are met. However, these descriptions of strong Black male-female re-

lationships also offer possibilities for a united struggle against oppression; a divided house cannot stand, but Black men and women united offers other alternatives. Perhaps a way to use this vision as a base without reinventing the patriarchy would be to do so with what Michele Wallace calls "black feminism with a nationalist face." Black women and men would need to look at their relationship as working together against oppression and not as men being the head of the family.

With the Hip-Hop soul diva's (and, by extension, Hip-Hop culture's) unique relationship to love in mind, I turn now to the songs of the rapping lovers. What kind of lover do we find in the lyrics of rap love songs? What does the man say about himself? What, finally, is the potential for a meaningful productive dialogue, let alone a relationship with the man we find? What happens when we really begin to critique and explore the love that hate produced?

Critiquing the Love That Hate Produced

Third-wave feminist cultural critic Joan Morgan gives a probing reason for her continuing to listen to and grapple with rap music. She maintains that she exposes herself to the sexism of rappers like Snoop Doggy Dogg and Notorious BIG as a move toward understanding who her brothers really are as people. She listens as a Black woman and a feminist so that she can be clear about what she is dealing with.[39]

I believe that rap love songs can tell us things about what Black men and women of the Hip-Hop generation have to deal with as they seek to build relationships with one another. Two of the songs on the late Biggie Smalls's debut album, *Ready to Die,* can be classified as rap love songs, although they are very different models of love songs.[40] "Me and My Bitch" is an ode to a deceased girlfriend that begins with Sean "Puffy" Combs and an unidentified woman having a discussion. Puffy asks the woman if she would kill for him. The woman hesitates and then responds in the affirmative. He then questions what took her so long to answer, to which she replies she does not know. Puffy then asks, "What the fuck wrong with you bitch?"[41] In the background, Biggie says, "The act of making love, ha ha . . ." Instead of a sung chorus on this cut, there is Puffy and the woman's discussion. At the end of each of Biggie's stanzas we are taken back to the talking couple. It is through the dialogue between lovers that we get our first glimpse of the rapping lover and what kind of lover he wants. "Would you kill for me?" he asks in the first chorus. "Would you ever fuck around on me?" he asks in

the second chorus. It would appear that the rapping lover wants a faithful woman who would kill for him.

We get a clearer picture in the lyrics of Biggie Smalls. Is the fairy-tale lover desired by the Hip-Hop soul divas and Black women present here? Biggie lets us know that moonlit strolls are not his thing. And while he admits that he will treat women right if they behave the way he wants them to, he also acknowledges that he will beat them if they do not.[42] And what does Biggie have to say about the possibility for marriage and beautiful brown babies? Biggie asserts that his notion of a wife does not include rings and traditional marriage but involves "main squeeze" status and a set of keys to his home.[43] So what makes this a love song? Besides Biggie paying homage to his "main squeeze" and "best friend," and in spite of the constant repetition of "Just me and my bitch, me and my bitch" throughout the song, the song gives an insightful look at a relationship between a young thug and hustler and his woman, trying to survive in postindustrial New York City—a city with few opportunities for Black people.

However, what really makes the song problematic is that while giving respect to the woman who lost her life because she was murdered in order to get to him, Biggie's "love" for her is defined solely by all the things she did for him and how she made him feel as a man. Undoubtedly it is her love that is the "real" love in this rap love song, a love she dies for. He loves her because she loves him. She helps him in his drug business by bagging up marijuana for him, while he admits he was unfaithful. And he did not have to worry about her telling the authorities about him, because she loved him broke or rich. Even though Biggie raps, "And then we lie together, cry together, I swear to God I hope we fucking die together," he is the one who lives to rap about it, because she is killed by men seeking revenge against him.[44]

We get an even clearer picture of the kind of rapping lover Biggie is in his song "One More Chance," which features his then-estranged wife, Hip-Hop soul diva Faith Evans, singing the background chorus. This song is different from "Me and My Bitch" because of its use of Hip-Hop soul. However, just as in "Me and My Bitch," the woman is doing all the loving. The song starts with Faith singing a remixed version of "Stay with Me" by the 1980s group DeBarge. The chorus is sung in the same melody. This use of the R&B classic is an example of what Russell Potter calls "sonic signifying"—rap's sampling of other Black music forms—and thus sets up a dialogue across generations in Black music. The use of an old-school love song provides familiarity for the listener; it is "repetition with a difference; the same and yet not the same."[45] Sonic signifying helps give the rap love song validity as a love song.

During the chorus Biggie can be heard repeating that he has the good love.[46] But what exactly is his good love? What picture of the rapping lover are we viewing in "One More Chance"? Biggie's lyrics offer some insight. He raps about the many women he has sex with. He raps about how he will essentially have sex with any kind of woman.[47] And he marvels over his own ability to attract and have sex with all these women because he describes himself as Black and ugly and not a heartthrob.[48] He brags about his player skills and his ability to steal another man's girl, because he is both member and president of the players' club.

While his lyrics may be viewed as simply boasting rap, it is important to look at and critique the things he chooses to boast about, his sexual prowess and promiscuity. This is not a stay-at-home, faithful kind of guy. However, what makes this a rap love song is that Biggie uses this boasting as a method to secure female companionship. He is wooing the ladies with promises of all he can do for them. He raps about how wonderful sex with him is and how deep he can go in order for women to have the kind of orgasm that their men cannot give them. He offers cruises, pearls, gator boots, crush linen, Cartier wrist wear with diamonds, luxury cars, diamond necklaces, and cell phones.[49] If fulfilling a woman's every need were based only on material things, Biggie would have been Mr. Wonderful. But somehow I think the love Mary J. Blige sings about is a little deeper than that. Judging Biggie by what he has said about himself in the two songs discussed (he's a womanizing, woman-beating thug who wants a "real bitch" who can take everything he puts out, who would kill and die for him), what does this say or mean to the woman who would love him?

Method Man's Grammy Award–winning "I'll Be There for You/You're All I Need," featuring Mary J. Blige, is perhaps a more hopeful example of love in Hip-Hop. And it offers perhaps a somewhat better picture of the rapping lover. However, Method Man displays more similarities than differences with Biggie. Even though it has been acclaimed as a classic rap love song and has won several music awards—not to mention high praise and accolades from Black women, who cried out, "Finally, a rapper rapping about loving and being with one woman"—"I'll Be There for You/You're All I Need" has room for critique.

Like Biggie's "One More Chance," "I'll Be There for You/ You're All I Need" makes use of sonic signifying by using Marvin Gaye and Tammi Terrell's Motown classic, thus placing Method Man and Blige within a larger tradition of Black love songs and validating "I'll Be There for You/You're All I Need" as a love song.

It also creates a space for dialogue across generations. This dialogue is jokingly hinted at in the Coca-Cola commercial in which an older Black man turns on the Gaye and Terrell version and sits down to enjoy his Coke only to be interrupted by the booming bass of his teenage son upstairs, who is also enjoying a Coke but bopping to the Method Man and Mary J. Blige version of the song. The possibility for dialogue is stifled, however, when the angry father bangs on the ceiling with a broom as if to say, "Turn down that noise." The Coca-Cola commercial sets the scene for possible conversations between younger and older generations, and sonic signifying is the rapper's first move toward such a dialogue.

I will focus on the Puff Daddy razor mix here because it has a hypnotizing rap beat and a longer second stanza by Method Man. I believe that while this is truly a sweet and gripping urban love song, it does not quite fill the model of what the Hip-Hop soul divas and many Black women are looking for. As with Biggie's "Me and My Bitch," we get the sense that the love expressed in "I'll Be There for You" is more a description of her love, and he loves her because she loves him. For example, Method Man raps about her making him feel like somebody even before he became a star and notes that he loves her because she did so. He makes it known that because she was with him through the bad times, she has shown herself to be real and true. He also warns her not to give her sex away and to keep her vagina tight for him.[50] The love that is "real" to the rapping lover in this song is the same kind of put-up-with-everything love expressed in "Me and My Bitch." And interestingly enough, a sample from Biggie's "Me and My Bitch" is used as a second chorus in the song. In addition to Mary J. Blige singing the Motown classic, we have Biggie's lyrics: "lie together, cry together, I swear to God I hope we fucking die together." As an answer to that, we have Mary J. Blige's soulful lyrics, "I'll sacrifice for you, dedicate my life to you." We get the sense that, like Biggie's bitch, she is the one who gives the ultimate love, sacrificing her life for him.

Again, if we keep in mind the questions about love and the fairy-tale-like qualifications that were discussed earlier, Method Man shares a lot of answers with Biggie. In response to the husband question, he too makes it clear that rings and traditional wedding vows are not for him.[51] But in his favor, at least he professes to always be there for his woman and not go out tricking like Biggie. But just like Biggie in response to the romance question, Method Man lets us know that hugs, kisses, Valentine cards, and birthday wishes are romantic crap that he and his woman are far above.[52] I find it interesting that Method Man's rap ends with a request for her to show her love.

While the two express similar views on marriage and romance, they differ in matters of fidelity. Method Man feels that he does not have to shop around because he already has the best. And although they both express unromantic pet names for their women—Biggie's "bitch" and Method Man's "shorty," "boo," and "you my nigga"—Method Man's pet names show much more love. It is a high form of respect—"giving props"—to say "you my nigga" or "that's my nigga" in most Hip-Hop communities. And Method Man, unlike Biggie, expresses some elements of his love in the song—his mad love that he intends to share only with her.[53] One gets the feeling that this love goes deeper than the physical. As if to show this mad love, the video for "I'll Be There for You" shows Method Man getting evil looks from his girlfriend's mother, being hassled on the streets of New York, running from the cops, and a host of other things just to bring her a box of tampons. In the male mind that might just be the highest form of love. The possibility for a love that somewhat resembles what the Hip-Hop soul diva is looking for seems attainable with the man we find in Method Man's song. Maybe that is why "Real Love" songstress Mary J. Blige is singing the chorus.

Lil' Kim and Foxy Brown

The conversation in rap is complicated even more when we take the work of women rappers Foxy Brown (Inga Marchand) and Lil' Kim (Kimberly Jones) into consideration. Their songs work as a direct response to the lyrics of the men. They take on many of the characteristics that men rappers put forth. Lil' Kim becomes the bitch Biggie raps about. In fact, as the title of her song suggests, she is the "Queen Bitch." And the lyrics remind listeners that she will indeed "stay dat bitch." She has no plans of changing. It is clear that like Biggie's lost love, who would kill to save her lover's life, Lil' Kim would readily kill for her man. Some feel that the reclamation of the word *bitch,* like the reclamation of the word *nigger* or *nigga,* is an empowering act. Indeed, listening to the lyrics of Lil' Kim as she forcefully raps, "I'ma stay dat bitch" exudes a certain sense of power. She comes off as a woman in control—assertive and sexually assured. She is tough, not someone to mess with. She re-creates herself as the bad Black momma from 1970s blaxploitation flicks. Not only is she sexy but she is tough; she will kill you if she has to.

In other songs, Lil' Kim exhibits the same tough but sexy image. She raps about her sexual exploits. And like many of the men rappers, she uses boasting as a method. She raps explicitly about her sexual exploits and the things she is willing to do in order to be sexually satisfied. However, Lil' Kim is not

about sex for the sake of sex alone. She reminds listeners that she likes to be compensated by her lover with money, jewelry, designer clothing, furs, and expensive cars. In her song "We Don't Need It," Lil' Kim raps about her desire for good sex, her irritation with men who cum too fast, and her ability to masturbate and please herself if the man is not giving her what she needs.[54] Lil' Kim's songs offer a woman who knows what she wants sexually—to experience pleasure and to cum—even if she has to satisfy herself.

The public image that Lil' Kim grants the listeners is of a strong, self-assured woman who knows what she wants and knows how to get it. That image also seemingly falls in line with the image of a woman that the rappers discussed earlier want. What is interesting in the case of Lil' Kim is that she has constructed dual and conflicting public images: the sexy, self-assured rapper that surfaces in her music and the vulnerable girl with low self-esteem that surfaces in her magazine interviews. Her parents spilt up when she was young, and her mother left her with an abusive father. She left home as a teenager and used men to support her. She has mentioned in interviews that she grew up thinking that she was not pretty. While she now believes she is beautiful because she has a beautiful heart, she still slips into self-consciousness about her looks: "But, like Halle Berry, Salli Richardson, Stacy Dash, Jada Pinkett Smith? I used to wish I looked like them motherfuckers!"[55]

The fact that each of these actresses is fair-skinned and has what is called in Black colloquial expression "good hair" should not be dismissed when thinking about Lil' Kim's desire to look like them. In fact, some might think that she has taken her desire to look like light-skinned, straight-haired Black women to another extreme, with her blonde wigs and blue contacts. She also notes that "when I was young, I didn't feel like I got enough attention."[56] Because she left home when she was fifteen years old, Lil' Kim learned the art of tricking at a young age in order to keep a roof over her head. She talks about living with a man for eight months the first time she left home. "I had a Panamanian boyfriend. I thought he was just so cute. He had a lot of money because he was illegally involved. He was taking care of me and I was living with him."[57] Any critique of Lil' Kim, her sexualized image, and her explicit lyrics must take both of her public images into consideration. The things that come out in her interviews about her abusive father, relying on men for food and shelter, and not feeling pretty complicate our understanding of the things she says on wax and require that we look at her in a more critically engaged way.

Similarly, Foxy Brown expresses tough and sexy lyrics. Like Lil' Kim and Biggie's bitch, Foxy helps her man with his drug business. Like Lil' Kim and

Biggie's bitch, she would kill and die for her niggas. In "Holy Matrimony," she raps about being married to her male crew, the Firm, and being willing to lie and die for them.[58] Foxy Brown and Lil' Kim fit very well into the image of Biggie's dearly departed bitch. But they appear to be bitches with agency. Foxy Brown, like Lil' Kim, is very expressive about her sexuality and very boastful about her sexual exploits. In "Get You Home," she lets men know exactly where to kiss her and how to get her excited sexually.[59] She boasts that she has no problem getting her "swerve on." Both of these women combine sex and materialism in their lyrics. Sex and money constitute the good life. Indeed, the woman they construct would be more than happy with the man Biggie constructs in "One More Chance."

Like Lil' Kim, the public images that Foxy Brown puts out are dual and conflicting. In addition to the self-assured sexy rapper, in interviews we get the vulnerable Black girl with low self-esteem, a darker sister who did not feel pretty growing up. However, that is where the similarities between Foxy Brown and Lil' Kim end. Foxy Brown lived a fairly pampered life compared to Lil' Kim's homelessness, abusive father, and having to use men to keep a roof over her head. While her parents also split when she was young, Foxy Brown grew up having her wants and needs taken care of by her family. She did not have to trick to earn a living. There was no physical abuse in her family. She remembers, "In our family, we said 'I love you' every night."[60]

Even though she felt nothing but love in her mother's home, she yearned for her father. His absence influenced her relationships with men: "I thought it was normal for a guy to mistreat me. My father wasn't there to show me the right way."[61] She also grew up not feeling pretty because of her complexion: "My number one insecurity is being a dark female. If you take any beautiful dark-skinned sister nowadays, guys are like, 'Oh she's beautiful.' But back in the day, it was not the cool thing. That was just something I had to get over, because for a while I couldn't stand myself."[62] The estranged relationships with their fathers, ill-fated relationships with other Black men, and uncertainty of self-worth are things that Lil' Kim and Foxy Brown have in common. Their stories fit a lot of young women coming of age in an era of Hip-Hop, though to some extent these are age-old problems for Black girls. We could no doubt find some connections and similarities between their stories and the stories of the girls in the hood discussed earlier. And like the girls in the hood, Lil' Kim's and Foxy Brown's stories beckon Black feminism to find more meaningful ways to intervene in the lives of young Black women.

Ultimately, behind the sex and glamour of their songs and public personas we see the public dialogue about love and relationships in Hip-Hop

coming full circle. Just as the men rappers can be read in response to the Hip-Hop soul diva, Lil' Kim and Foxy Brown can be read in response to the men rappers. And while there were some questions about the men rappers presenting what the Hip-Hop soul diva wants, the same cannot be said of these women rappers. The representations of Black womanhood put forth by men rappers are internalized and surface in ways some view as problematic. The questions about Lil' Kim and Foxy Brown being too sexy, too raunchy, too pornographic, and so on have been addressed in every Black popular magazine currently in print. Along with these questions go the charges that Lil' Kim and Foxy Brown are puppets, victims of their male crews—the late Biggie Smalls, Junior M.A.F.I.A., and Puff Daddy in Lil' Kim's case and Jay-Z, Nas, AZ, and Cormega in Foxy Brown's case. Some feel that because Biggie wrote some of Lil' Kim's lyrics and Jay-Z and Nas penned some of Foxy Brown's hits, these women are not legitimate rappers; their use of the word *bitch* in their lyrics is not an empowering act because a man wrote the lyrics, and they are not exploiting their own sexuality but are being exploited.

Angela Davis discusses this issue of agency and the woman performer in her work on the blues woman. In her discussion of Gertrude "Ma" Rainey and the song "Sweet Rough Man," Davis maintains that although the song was written by a man, Rainey's enthusiastic rendition rescued the issue of men's violence against women from the private sphere and gave the issue prominence as a public discourse.[63] For Davis, the issue is not who wrote the song but how the women blues artists used them to bring women's issues into the public sphere. Even the blues woman's sexually frank lyrics are read as women taking control and having a stance that spoke to their freedom as sexual beings. Another example of the way a woman performer exhibits her own sense of agency when performing songs that were written by men can be seen in Aretha Franklin's "Respect." Otis Redding may have written the lyrics, but no one is going to question Franklin's strong presence or her agency when she sings the lyrics. She performs the lyrics so forcefully that the song has become an anthem for women's liberation.

Therefore, rather than belabor the question of who is exploiting whom, I would like to look at all of the lyrics discussed as a fertile ground for dialogue and communication aimed at evoking change—at how the conflicting public images of Foxy Brown and Lil' Kim can be used to bring wreck and help destroy existing notions and stereotypes about Black womanhood and help improve the lives of young Black women. Joan Morgan notes in her article "The Bad Girls of Hip-Hop" that when Hip-Hop is truly significant and meaningful, it gives us images of Blackness that we refuse to see and dares us

to get mad enough to do something about them.[64] What the conflicting images of Lil' Kim and Foxy Brown represent is clear if we choose to see it. They have based their womanhood and sexuality on the images that men rappers rapped about, just as I tried to be LL Cool J's "Around the Way Girl" many years ago. With no real constructive conversations going on about sex, Black female identity, and the shaping of public gendered subjects outside of the academy, their lyrics and images are inevitable. As Morgan notes, the "success of these baby girls speaks volumes about the myth shrouding feminism, sex, and black female identity."[65] The success of Lil' Kim and Foxy Brown is a direct result of a Black community consumed with saving the male and not about the problem facing young Black women. Very few people, Morgan points out, are aware of or alarmed by the fact that Black girls growing up in America's inner cities, surrounded by violence and materialism, will suffer their own pathologies. She notes that Black women die disproportionately of AIDS, cancer, and drugs, that the female prison population is exploding, and that teenage pregnancy rates have skyrocketed for Black women. And she asks a very important question: "Is it really surprising that some female MCs (like their male counterparts) would decide to get paid by glamorizing that reality?"[66]

We are constantly bombarded with discourse about the situation of young Black men in America. And while that is a legitimate and worthwhile cause for concern, few are noticing that young Black women are living and trying to grow in the same oppressive environments as these young Black men. If the Black man is endangered, what about the Black woman? No one stops to ask. This neglect is the plight of the Black woman. It has been around since the days of the Black power movement and definitely gained momentum with Daniel Patrick Moynihan's 1965 report on the Black family.[67] The stereotype of the strong Black woman, because we refuse to dismantle it, prevents us from seeing the very real danger that young Black women are in.

Lil' Kim's and Foxy Brown's lyrics help bring light to things once ignored. They can also help Black women face and maybe even get rid of some of the myths and stereotypes about Black women's sexuality and Black female identity that have existed in one form or another since the days of slavery and continue to influence the way Black women live their lives and express themselves. The fear of being labeled sexually promiscuous or always sexually available plagues many Black women. It is a legacy passed down from generation to generation. Foxy Brown's and Lil' Kim's acknowledgment that they are sexual beings who enjoy sex, and lots of it, is hard to face when one is taught to be ashamed of such desire.

What these rappers offer is the opportunity to embrace the sexuality of the self. Their boldness does exhibit a kind of freedom. Ironically, it is this same freedom that exposes the myths surrounding feminism. Morgan suggests that "their success drives home some difficult truths. The freedom earned from feminist struggle is often a double-edged sword. Now that women are no longer restricted to the boundaries of gender expectations, there will be those who choose to empower themselves by making some less-than-womanist choices—and they are free to do so."[68] While I take issue with Morgan on the exact extent to which women have broken the boundaries, I do acknowledge the fact that women have far more choices today than they did thirty years ago.

I contend that the sexually explicit lyrics of these women rappers offer Black women a chance to face old demons and not let the stereotypes of slavery inform or control their lives. After years of Black women being read as supersexual—or asexual, in the case of the mammy stereotype—the lyrics of these women rappers offer Black women a chance to be proud of, and indeed flaunt, their sexuality. And after the images of the Black bitch that have stifled assertiveness in Black women, it is almost nice to have a line such as "I'ma stay dat bitch." It does create a certain amount of agency.

In an era when men rappers are presenting problematic images of Black womanhood—ones that encourage the kind of "ride or die"/"kill a nigga for my nigga" mentality and an obsessive focus on sex, drugs, and materialism—we cannot simply cast aside artists such as Lil' Kim and Foxy Brown because they are not as positive as we would like them to be. The lifestyles they rap about are a reality for some women, who were never told any different. The images young Black women get from contemporary Hip-Hop culture and rap music tell them that they should be willing to do anything for their men. The "ride or die" chick who will do anything and everything for her man is placed on a Hip-Hop pedestal as the ideal woman. From Ice Cube and Yo-Yo's "Bonnie and Clyde Theme" and "Bonnie & Clyde II" to Jay-Z and Beyonce's "'03 Bonnie & Clyde," rap shows a warped obsession with remixing and remaking the tale of the white criminal couple who went out in a blaze of bullets. At first glance this appears to be just another obsession with gangster culture, but it is much more than that. The obsession with Bonnie and Clyde tells us a lot about the state of Black male-female relationships in America. Nowhere is this more telling than in Ja Rule's "Down Ass Bitch" and "Down 4 U."

The video of Ja Rule's "Down Ass Bitch" is very problematic. It is yet another video all about how women should stand by their men and be down

for whatever. His rough voice croons, "Every thug needs a lady. Would you ride for me? Would you die for me?"[69] In the video, Ja Rule and female rapper Charlie Baltimore remix the Bonnie and Clyde theme with Hip-Hop flavor. They rob the mansion of an unidentified rich person, taking a safe full of diamonds. However, before they can make off with the bag full of diamonds, the alarm sounds and they try to escape. Charlie Baltimore is caught. The cops really want Ja Rule, but she, being a "good bitch" and a "down ass chick," does not snitch. She does the time. We see her in her prison-issue orange jumpsuit. She goes from being scared to running the other women prisoners. She becomes a survivor in jail. We see her pushing around the very women who pushed her around when she first entered the prison. When she is released, presumably years later, Ja Rule picks her up. All is well. The message that this video sends to young women, specifically young Black women, is very troubling because it essentially tells them it is okay to commit crimes for their men. It tells them that even if they spend time in jail, it will pay off in the end when their man picks them up from jail in a luxury car and flies them off to a remote island to lavish them with tropical drinks and beautiful clothes. The video tells young women that the only way to obtain material possessions is to let some man use them to commit crime and then depend on him for their reward.

The fastest-growing prison population in this country is Black women. They are going to jail for things like smuggling drugs largely because of their relationships with men who are involved with criminal activities. The recently pardoned Kemba Smith simply fell in love with the wrong man and was too afraid to leave. She recounts, "At age 24, without so much as a parking ticket on my record, I was sentenced to more than 24 years in prison—without parole. Technically, I was convicted of conspiracy to distribute crack cocaine, but I contend that I went to jail for dating a drug dealer."[70] She was finally pardoned as a last-minute act by President Clinton, but she still feels that justice was not served: "You'd think I'd have been doing cartwheels when I was released. Truthfully, my feelings were in conflict. It was tough to leave behind the incredible women I met in prison—especially since many of them were victims of the same laws that put me away."[71]

Of another woman, who like Kemba Smith (and the others still in jail) did time for drug-related crimes, dream hampton writes that she "used to be so fly, the first girl in Detroit with her own Benz. Candy-apple red and convertible, with customized plates that spelled CASH. She bought red boots to match. . . . She liked to make the trip back then. She could drive all the way without stopping (he never did like to drive long distances), but he'd

keep her awake with promises about the next forty years."[72] This woman, like Charlie Baltimore in Ja Rule's video, did not snitch on her man. "She's proud of the fact that she never snitched. Doesn't seem suspicious that he served 18 months, went home, and has forgotten to put money on her books for the past ten years."[73] She brags that "little girls like [Lil'] Kim are rhyming about her life."[74] However, the Black female prison population is rising because of stories like these—because of the messages young women are getting from the videos.

Ja Rule's message to women about being a "down ass chick" would not be so bad if it was the only one. But the message is everywhere, and it is not just coming from men. Women rappers such as Lil' Kim and Foxy Brown also rap about the illegal things they would do for their men. And even though Alicia Keys's video for the hit single "Fallin'" somewhat flips the script on this message by having the woman out of jail and visiting the male inmate, the message of the song is eerily similar to those discussed above. She sings, "I keep on fallin' in and out of love with you. I'll never love no one the way I love you."[75] In the video we see a field of women in prison-issue orange jumpsuits, mostly Black and Latina, singing the lyrics. Instead of falling in and out of love with these men, the young Black women need to love themselves. They need to love themselves enough to recognize that no love is worth going to jail for.

The remix of "Down Ass Bitch," the Inc.'s "Down 4 U," is just as problematic as the first version. It features the entire Inc. roster, Ja Rule, Ashanti, Charlie Baltimore, and Vita. The video is the typical beach-and-yacht party scene of which most rap videos trying to showcase a rich and glamorous lifestyle take advantage. The video has lots of bikinis and objectified women. The video also ironically features a cameo appearance by the contemporary R&B incarnation of Bonnie and Clyde, Whitney Houston and Bobby Brown. There are no robberies and prisons, just lots of fun and frolicking in the sun and lots of people living the glamorous life on the beach. The carefree nature of the video is what makes it even more problematic than the video for "Down Ass Chick." Combined with the lyrics, the video sends a false message to young Black women about love, life, and money.

The down ass chick is both an image and a reality that Black feminism needs to deal with. It has a lot of Black women serving time and countless others taking incredible risks with their lives. It is the inevitable conclusion of a community that does not value Black womanhood. Joan Morgan offers the perceptive observation that Foxy Brown's and Lil' Kim's success reflects Black feminism's failure to teach younger Black women about sex,

feminism, and power. For both Morgan and myself, Black feminism needs to be accountable to young Black women, saving their lives and widening their world view and the choices they feel they can make.[76]

In order to accomplish this—in order to reach young Black women—feminism needs to come down from its ivory tower. Young Black women, like it or not, are getting their life lessons from rap music. And because voices like Queen Latifah, Salt-N-Pepa, and Queen Pen are few and far between, it is up to Black feminism to pick up the slack. In short, there are many ways that Black feminism can begin to work with Hip-Hop. The first step is to recognize the tremendous possibilities Hip-Hop culture and rap music have to offer.

Notes

This chapter was originally published as "Hip-Hop Soul Mate? Hip-Hop Soul Divas and Rap Music: Critiquing the Love that Hate Produced," in *Check It While I Wreck It: Black Womanhood, Hip-Hop Culture, and the Public Sphere,* by Gwendolyn D. Pough. Copyright 2004 by Gwendolyn D. Pough. Reprinted with the permission of Northeastern University Press.

1. In addition, bell hooks has written several books on love in a series she calls "the love trilogy": *All About Love: New Visions* (New York: William Morrow, 2000), *Salvation: Black People and Love* (New York: William Morrow, 2001), and *Communion: The Female Search for Love* (New York: William Morrow, 2002).

2. bell hooks, "Love as a Practice of Freedom," in *Outlaw Culture: Resisting Representations,* by bell hooks (New York: Routledge, 1994), 243.

3. As Paul Gilroy argues in "'After the Love Has Gone': Bio-Politics and Etho-Poetics in the Black Public Sphere," there is a lack of substantial analysis in relation to gender and sexuality in the scholarship on rap music, and the phenomenology of musical forms is not critiqued as much as the lyrics and video images are analyzed. He suggests that critics pay more attention to issues of gender and sexuality (in *The Black Public Sphere: A Public Culture Book,* ed. Black Public Sphere Collective [Chicago: University of Chicago Press, 1995], 56). I concur with Gilroy's suggestions for critics of Hip-Hop culture and rap. Both are rich with possibilities and open up spaces from which to interrogate issues of identity.

4. Sprite, known for its Hip-Hop-inspired commercials, had a string of Hip-Hop/ kung fu commercials in the late 1990s that highlighted the female legacy in rap. Female MCs who were then new to rap, such as Eve and Mia X, fought men rappers karate-style, and their leader was pioneering female rapper Roxanne Shante. While true Hip-Hop fans appreciated the Sprite commercials paying homage to the legacy of women in rap, the "obey your thirst" drink took things to an entirely different level when they showed who the top leader of the group was in the last segment of

the series, when the "Big Momma" ended up being Millie Jackson. Again Sprite's marketing department showed they knew a thing or two about Hip-Hop, particularly women's legacies.

5. William Eric Perkins, "The Rap Attack: An Introduction," in *Droppin' Science: Critical Essays on Rap Music and Hip-Hop Culture,* ed. William Perkins (Philadelphia: Temple University Press, 1996), 4.

6. Angela Davis, *Blues Legacies and Black Feminism: Gertrude "Ma" Rainey, Bessie Smith, and Billie Holiday* (New York: Vintage, 1998), 20.

7. The word *dis* is Hip-Hop terminology for "disrespect." These answer raps penned by women artists turned the dis around when men made records that disrespected women.

8. Hip-Hop culture has also expanded to include elements such as Hip-Hop soul, rapso (rap and calypso), gospel rap, and hip-house.

9. *Flip the script* is Hip-Hop terminology for the act of changing the agenda or evoking a different path than the one already set out.

10. Craig Calhoun notes Habermas's limited view on identity formation in his introduction to *Habermas and the Public Sphere* (Cambridge: Massachusetts Institute of Technology Press, 1996). He notes that Habermas weakens his own theory when he treats identities as if they were fully formed in the private world and equipped for the public realms based on that private formation. Calhoun offers an example from Habermas that contradicts the idea of identity being formed in the private sphere by looking at the way the literary public sphere and fiction enabled discussions about selfhood and subjectivity (35).

11. Tricia Rose, *Black Noise: Rap Music and Black Culture in Contemporary America* (Hanover, N.H.: Wesleyan University Press, 1994), 147.

12. Rappers such as Queen Latifah, MC Lyte, and Da Brat have all been accused of being lesbians because they have hard-core lyrics and rock the crowd better than some men rappers.

13. Laura Jamison, "A Feisty Female Rapper Breaks a Hip-Hop Taboo," *New York Times,* January 18, 1998, B34.

14. Queen Pen, "Girlfriend," *My Melody,* Lil' Man Records, 1997.

15. Jamison, "Feisty Female Rapper."

16. For discussion of the various dialogues in which rap music participates, see Rose, *Black Noise;* Russell Potter, *Spectacular Vernaculars: Hip-Hop and the Politics of Postmodernity* (Albany: State University of New York Press, 1995).

17. Alice Walker, *In Search of Our Mothers' Gardens: Womanist Prose* (New York: Harcourt Brace, 1983).

18. June Jordan, "Where Is the Love?" in *Civil Wars,* by June Jordan (Boston: Beacon, 1981).

19. Lerone Bennett, *The Shaping of Black America: The Struggles and Triumphs of African-Americans, 1619 to the 1990s* (New York: Penguin, 1993), 156.

20. Kevin Powell, *Keepin' It Real: Post-MTV Reflection on Race, Sex, and Politics* (New York: Ballantine, 1997), 6.

21. Joan Morgan, *When Chickenheads Come Home to Roost: My Life as a Hip-Hop Feminist* (New York: Simon and Schuster, 1999), 72.

22. Sherley Anne Williams, "Some Implications of Womanist Theory," in *Within the Circle: An Anthology of African-American Literary Criticism from the Harlem Renaissance to the Present,* ed. Angelyn Mitchell (Durham, N.C.: Duke University Press, 1994), 517.

23. For a discussion of rap music and sampling, see H. Baker, *Black Studies, Rap and the Academy* (Chicago: University of Chicago Press, 1993); N. George, *Hip Hop America* (New York: Viking, 1998); Potter, *Spectacular Vernaculars;* and Rose, *Black Noise.*

24. Dimitry Leger, "Hip-Hop/R&B Divas: The New 411," *Source: Magazine of Hip-Hop Culture and Politics,* July 1995, 43.

25. See K. Chappell, "The New Mary J. Blige Tells How Drugs and Attitude Almost Ruined Her Sizzling Career," *Ebony,* January 1999; J. E. Davis, "Proud Mary," *Honey,* October 2001; dream hampton, "All Woman," *Vibe,* April 1997; C. Hancock Rux, "Mary Full of Grace," *Honey,* Summer 1999; P. Johnson, "Mary J's Moment of Peace," *Essence,* July 1999; Joan Morgan, "What You Never Knew About Mary," *Essence,* November 2001; and Joan Morgan, "Hail Mary," *Essence,* April 1997.

26. Morgan, "Hail Mary," 76.

27. Rux, "Mary Full of Grace," 56.

28. Morgan, "Hail Mary," 76.

29. Sister Souljah, "Mary's World: A Former Public Enemy Follows the Career of the Queen of Hip-Hop Soul," *New Yorker,* October 4, 1999, 58.

30. Johnson, "Mary J's Moment of Peace," 138.

31. Michael Eric Dyson, *Race Rules: Navigating the Color Line* (New York: Vintage, 1997), 130.

32. Morgan, "What You Never Knew about Mary," 135.

33. Mary J. Blige, "Real Love," *What's the 411?* Uptown MCA, 1992.

34. Mary J. Blige, "Be Happy," *My Life,* Uptown MCA, 1994.

35. Marita Golden, introduction to *Wild Women Don't Wear No Blues: Black Women Writers on Love, Men and Sex,* by Marita Golden (New York: Anchor, 1993), xi.

36. I'm thinking specifically of Molefi Asante's notion of Afrocentricity and his discussion of love and romance in the African and African American novel. M. K. Asante, *The Afrocentric Idea* (Philadelphia: Temple University Press, 1987).

37. Lesley D. Thomas, "What's Love Got to Do with Hip-Hop? An Original Screenplay," *Source: Magazine of Hip-Hop Culture and Politics,* February 1994, 54.

38. Cheo Coker, dream hampton, and Tara Roberts, "A Hip-Hop Nation Divided," *Essence,* August 1994, 115.

39. Morgan, *When Chickenheads Come Home to Roost,* 72.

40. The late Christopher Wallace went by several rap names: Notorious BIG, Biggie Smalls, and Big Poppa. For the purpose of this chapter, I will use Biggie Smalls and the shorter Biggie.

41. Notorious BIG, "Me and My Bitch," *Ready to Die,* Bad Boy Records, 1994.

42. Ibid.

43. Ibid.

44. Ibid.

45. Potter, *Spectacular Vernaculars,* 27.

46. Notorious BIG, "One More Chance," *Ready to Die,* Bad Boy Records, 1994.

47. Ibid.

48. Ibid.

49. Ibid.

50. Method Man, "I'll Be There for You / You're All I Need to Get By," *Tical,* Def Jam, 1995.

51. Ibid.

52. Ibid.

53. *Mad* is Hip-Hop terminology for "a lot" or "an enormous amount."

54. Lil' Kim, "We Don't Need It," *Hard Core,* Big Beat/Undeas Recordings, 1996.

55. Robert Marriott, "Blowin' Up," *Vibe,* June/July 2000, 132.

56. Lola Ogunnaike, "Hip-Hop's Glamour Girl," *USA Weekend,* June 28–30, 2002, 4.

57. Jaime Foster Browne, "Lil' Kim," *Pride,* April 2000, 69.

58. Foxy Brown, "(Holy Matrimony) Letter to the Firm," *Ill Na Na,* Def Jam, 1996.

59. Foxy Brown, "Get Me Home," *Ill Na Na,* Def Jam, 1996.

60. Michelle Burford and Chris Farley, "Foxy's Dilemma: Dignity or Dollars?" *Essence,* August 1999, 76.

61. Ibid.

62. Ibid.

63. Davis, *Blues Legacies and Black Feminism,* 32.

64. Joan Morgan, "The Bad Girls of Hip-Hop," *Essence,* March 1997, 134.

65. Ibid., 77.

66. Ibid.

67. Daniel Patrick Moynihan, *The Negro Family: The Case for National Action* (Washington, D.C.: U.S. Department of Labor, 1965).

68. Morgan, "Bad Girls of Hip-Hop," 77.

69. Ja Rule featuring Charlie Baltimore, "Down Ass Bitch," *Pain Is Love,* Universal, 2001.

70. Kemba Smith as told to Stephanie Booth, "Pardon Me," *Honey,* September 2001, 86.

71. Ibid.

72. dream hampton, "Free the Girls; or, Why I Really Don't Believe There's Much of a Future for Hip-Hop, Let Alone Women in Hip Hop," in *Hip Hop Divas,* by Vibe Magazine (New York: Three Rivers, 2001), 2.

73. Ibid.

74. Ibid.

75. Alicia Keys, *Songs in A Minor,* J. Records, 2001.

76. Morgan, "Bad Girls of Hip-Hop," 134.

2

Black Women Electric Guitarists and Authenticity in the Blues

MARIA V. JOHNSON

> The fact is, I'm an African American female playing what I do, and that is quite a feat in itself. . . . I don't know why there aren't that many of us. . . . It's important for people to know that, yeah, African American women do play guitar and do play blues and rock and roll.
>
> —Deborah Coleman

> People are surprised when a Black woman can play the guitar like a man. . . . I say, "Just wait until showtime comes." Then when I go on and come off they say, "Damn, I ain't never seen nothing like you."
>
> —Beverly "Guitar" Watkins

> Let's get together just you and me
> Let's sing the blues . . . then you will see
> Why I'm everybody's favorite, qualified and able
> Everybody's favorite, ready when you call my name.
>
> —BB Queen, "Everybody's Favorite (Qualified and Able)"

African American women such as Memphis Minnie (1897–1973) and Rosetta Tharpe (1915–73) were among the pioneers of the electric guitar. Recording prolifically for three decades in an evolving style, Minnie was one of the most influential blues performers ever to record. She was one of the first to use a National resonator guitar and one of the first to plug in. Living and working in Chicago beginning in 1930, Minnie first used an electric instrument on eight sides recorded in December 1941. Pete Welding cites these records as "among the earliest signposts to the electrically amplified

[postwar] ensemble blues style."[1] Witnessing Minnie in a Chicago club on New Years Eve 1942, Langston Hughes, entranced by the blues she conjured on the cutting edge of the latest technology, vividly describes Minnie's bridging of urban and rural, old and new, downhome blues in the city:

> Memphis Minnie sits on top of the icebox at the 230 Club in Chicago and beats out blues on an electric guitar. [She] sings through a microphone and her voice—hard and strong anyhow for a little woman's—is made harder and stronger by scientific sound. . . . Through the smoke and racket of the noisy Chicago bar float Louisiana bayous, muddy old swamps, Mississippi dust and sun, cotton fields, lonesome roads, train whistles in the night. . . . Big rough old Delta cities too. . . . Northern cities, W.P.A., Muscle Shoals. . . . All these things cry through the strings on Memphis Minnie's electric guitar, amplified to machine proportions—a musical version of electric welders plus a rolling mill. . . . Negro heartbeats mixed with iron and steel.[2]

The dazzling guitar work, powerhouse vocals, and riveting performance style of Sister Rosetta Tharpe, the controversial but undisputed queen of gospel blues in the 1930s and 1940s, likewise influenced performers across a wide variety of genres.[3] Mavis Staples says, "I used to love to hear her and see her too 'cause she would come up on one leg and she would just rock it, you know!"[4] A pioneer of the Nashville steel guitar in the 1930s, Tharpe switched to an electric instrument in the 1940s. Performing in a wide variety of contexts—solo, big band, R&B, and doo-wop—Tharpe played the guitar with an unmatched authority and percussive power.[5] Of her early recordings with the Sammy Price trio in 1944, critic Ken Romanowski writes:

> Their first release was a huge influence on the budding white and black boogie styles that eventually coalesced into rock and roll. . . . Her guitar introductions and solos certainly sound as if they had an impact upon the guitarists who came of age after the Second World War, with extensive use of triplets against the eight-to-the-bar boogie underpinning, double-stops, and dramatic slurs—all utilized with an uncanny sense of when and where to place each riff for maximum effect.[6]

Tharpe's powerful stage presence and command of the electric guitar is demonstrated in a video of her performing "Down by the Riverside" with a male vocal group behind her.[7] She moves around the stage as if the guitar is a part of her. When she takes a solo, she cocks her head to one side, crosses her legs, and deftly executes a rapid-fire succession of notes. She repeats a riff, then bends a note expressively, lifting her guitar into the air. Moving from

the lower frets and register to high up on the neck, she arrives at another bent note, which she sustains with the left hand while waving her right hand back and forth to the beat.

Today, despite the perseverance and success of women such as Minnie and Tharpe in transgressing the gender divide, the blues is still largely male dominated, especially with respect to instrumentalists, and most especially electric guitarists. As in jazz and pop music in general, there has always been a place for female singers, a smaller place for female piano players, and, more recently, a place for female solo singers with acoustic guitar. But while electric-guitar-wielding blues women slowly gain visibility, African American women like Deborah Coleman, who sing and play hard-driving styles, remain an anomaly.[8] This is not to say that other Black blues women playing electric guitar do not exist. Barbara Lynn and Beverly "Guitar" Watkins, for example, have been playing since the late fifties/early sixties, but only recently have their lead capabilities even been hinted at on recordings. There are also a few younger players, such as BB Queen of Detroit, who with the support of Koko Taylor recorded her debut album in 1997, and child prodigy Venessia Young of Clarksdale, Mississippi, whose talent was discovered and nurtured through the Blues Education Program at the Delta Blues Museum.[9]

While White women blues guitarists from Bonnie Raitt to Susan Tedeschi and Black women blues singers from Koko Taylor and Etta James to Shemekia Copeland have received considerable attention, Black female electric guitarists (with the exception of Deborah Coleman) remain relatively unknown. How is it that, though African American women were among the first to plug in sixty years ago, one critic describes Deborah Coleman as an "African-American Bonnie Raitt"?[10] How is it that a White woman becomes the measuring stick for female guitarists within a Black cultural form? And why are critics are so unused to seeing Black women playing electric guitar? Why are they not more numerous and/or visible today?

To address these issues, several important factors must be considered: (1) entrenched notions of authenticity cultivated in blues scholarship and journalism that from the outset have determined who gets recognized, recorded, and studied as well as how they are perceived and received; (2) longstanding conventions about gender roles in music, and in blues and jazz in particular, that from the beginning have mitigated against women's involvement, particularly as instrumentalists; and (3) the diminishing involvement of African Americans in the blues starting in the 1960s, the simultaneous increase in the interest and involvement of Whites, and the issues surrounding these phenomena.

Extending my work on Black female guitarists in the blues, this chapter examines how the discourse of authenticity, inflected by notions about race, gender, class, color, age, and style, pervades the critical perception, reception, and self-presentation of blues performers such that African American female electric guitar players continue to be seen as anomalies.[11] Focusing on four contemporary Black female electric blues guitarists, I demonstrate how dominant conceptions of authenticity in the blues coupled with mainstream constructions of race and gender have ensured that this group remains small and invisible. Moreover, I bring into view and begin to document the creative expression of African American female electric guitarists.[12]

Authenticity and the Blues

The history of blues scholarship and journalism is characterized by a concern with authenticity and a strict code of what qualifies as "authentic" blues. In an early classic text, *Urban Blues* (1966), Charles Keil dubbed this tendency "the moldy fig mentality."[13] In discussing why contemporary urban blues had received so little scholarly attention, Keil humorously delineated the requirements for "real" blues implicit in blues scholarship. These same qualities are reflected in a joke that has circulated in varied forms on the Internet as "a primer for singing" or "how-to kit for writing The Blues."[14] In sum, to be authentic, a musician must be Black, male, old, born into poverty on a farm in the rural South, and taught by a legend on a cheap mail-order or home-made guitar; they must also perform in a rustic, "rough-hewn" acoustic style and have struggled, suffered, and remained broke and obscure. Keil lists these characteristics with tongue clearly in cheek, but current views of authentic blues often verge on the same kind of caricature.

Traditional definitions of blues have justified a lack of attention to women's blues for many years. Scholars have dismissed women's blues as inauthentic because women were primarily associated with vaudeville blues, which was urban, professional, theatrical (performed on stages), and glamorous. Since rural blues performers were assumed to be male, women who played rural blues were not "seen." Memphis Minnie, one of the few whose success earned her notice, transgressed the gender divide by playing the part of the hard-drinking, rough-talking, tobacco-chewing blues *man* and by performing with her male partners.[15] Scholars' gendered dichotomization and periodicization of blues history has obscured the existence of an ongoing sustained tradition of women's blues—a tradition that has included instrumentalists as well as singers and performers and composers in a whole range of styles, including rural, vaudeville, urban, R&B, boogie woogie, and contemporary.[16]

Traditional notions of blues authenticity are as entrenched today as they were forty years ago. In a 1997 review of an album of women's blues called *Barrelhouse Women, 1925–1930, Living Blues* writer Peter Aschoff notes:

> While Evelyn Brickey and Katherine Adkins come dangerously close, both musically and lyrically, to crossing the line separating the barrelhouse from the vaudeville stage, Bertha Ross, Frances Wallace, and Clara Burston are all roots blues singers whose work stands up solidly against better-known down-home blueswomen. . . . Burston and Wallace sing in a strong, gutsy juke-joint style light years removed from the polished, vaudeville-influenced manner so common among blues women singers of the period.[17]

In the traditional blues canon, created largely by White male scholars, "Down-home" (i.e., "strong, gutsy juke-joint style") singing is valued and considered authentic, while vaudeville (i.e., "polished") singing is not. These styles are seen as dichotomous, and any mixing of styles is perceived as transgressive.[18] These categories were also implicit in the division of music papers at the 2001 Delta Blues Symposium, where some of the material in this chapter was first presented.[19] Papers were divided into two sessions, one titled "'Strictly' the Blues," and the other, where this paper was scheduled, "The Blues and Beyond the Blues." The response of one White male to the paper made it clear that the questions, mode of analysis, and subject itself tread upon forbidden ground. The respondent objected to the introduction of what he perceived to be "academic" categories of race, class, and gender into what he viewed as simply "a matter of taste." According to his reasoning, if Black women guitarists are incapable of garnering an audience, they must ultimately lack the talent. And since these artists did not "do anything" for him, we should not impose our tastes on others.[20]

In her article "Women and the Electric Guitar," Mavis Bayton demonstrates that traditional gender socialization provides numerous obstacles to women taking up the instrument even today.[21] The genres dominated by electric guitars (rock and blues) as well as jazz have been strongly male-identified. As arenas historically for the assertion of masculinity, blues, jazz, and rock performance have been most resistant to accepting women. While adolescent boys are encouraged and even expected to play guitar as part of their social/sexual identity, girls, who have not been privy to these social spaces, typically lack role models and family support, along with the necessary training and experience.

In terms of gender, women in blues, jazz, and rock/pop have functioned primarily as objects for the male gaze. Female performers have often been hired more for their looks than for their musicianship, typically, according

to a European American standard of beauty, requiring a slim "sexy" figure with light skin. In addition to racism and class discrimination, colorism has been a factor in women's blues from the start. For example, as Bessie Smith's first recordings were rejected for sounding "too black," she was also fired from a show early in her career, the theme of which was "Glorifying the Brown Skin Girl," because her skin was deemed too dark.[22] African American women have had to negotiate prevalent stereotypes reflected in images like the mammy and the jezebel perpetuated by the minstrel tradition. In blues and jazz, female vocalists have been much more readily accepted than instrumentalists, as there is no external instrument obstructing the view of their body. Piano has been the most acceptable instrument for a woman to play, as it was an essential part of the preparation for "ladyhood" among the White middle class starting in the nineteenth century. Horns have been off limits for women because they distort the face, and drums and the electric guitar have been taboo because they are considered power instruments. The electric guitar has been especially threatening because of its phallic associations and potential for intensity and volume.[23]

In the 1960s, the period of the so-called blues revival, many White college students became interested and involved in the blues. Black blues performers from the past were "rediscovered" and brought out of obscurity and retirement to perform at coffee houses and folk festivals, and Whites began learning to perform old blues styles from records and sometimes from the masters themselves.[24] At the same time, Black young people were drawn in the direction of soul and Motown, then funk and disco, and, finally, hip-hop.

Gaye Adegbalola, founding member of the middle-aged interracial trio Saffire—The Uppity Blues Women, suggests several reasons African Americans in general are not as involved in the blues today:

> Number one: it's just been here and gone. In the same way that rap is here now and it might not be 50 years from now. But it's here now because the technology is [such] that you can create beats and you can say more with poetry than you can in a song. . . . In the Black community one dance would only be around for a year. . . . I think you have to have music for the dance and I think part of what's missing in the blues world [today] is the dance. Everything is so technical and crisp . . . and the dance is missing. I think that the blues was prominent too because you had a guitar and a harmonica, and you could bring it to a house party and lots of folks didn't have big stereos. . . . [Now] you hop into a house party and you put on a disc. It's changing times. . . . More Black women are starting to come to our concerts, but you would think, given the nature of the material, that there would be a lot of Black women at our shows. . . . What radio station is gonna play our music?

Well it might be a college station at two in the morning. Black folks don't listen to that.[25]

As the audience for the blues became whiter, the context, function, and aesthetics of blues performance shifted. This trend began in the 1950s, when rhythm and blues transitioned to rock 'n' roll, moving from the Black community into the White mainstream, where multi-performer concerts in big cities replaced intimate dance-oriented shows on makeshift stages. In the 1960s, blues music began to be separated from the dancing. Since then, an emphasis on technical precision has sometimes eclipsed the centrality of total involvement by performers and audience. And yet, despite the changing color of the blues, there have been and continue to be African Americans interested and involved. Many African Americans, while hidden from the limelight, have been instrumental in keeping the traditional aesthetics of blues performance (call and response, dance, full participation) alive. In an interview, Taj Mahal noted that when he was coming up in the 1960s, "very few of the young Black kids were interested in that kind of stuff [the blues]." At the same time, he insisted "there were a lot" of other Black kids involved.[26] Deborah Coleman commented in one recent interview that "African Americans for the most part don't embrace the blues."[27] However, in another interview, she did acknowledge a growing African American female presence in the blues.[28] Like many in Black communities, both these artists reflect a general ambivalence about the historical involvement of African Americans in the blues. Among those keeping the blues alive with their electrifying and engaging performances are Beverly "Guitar" Watkins, Barbara Lynn, Deborah Coleman, and BB Queen.

Beverly "Guitar" Watkins (b. 1939)

> Listen up now people, let me tell you 'bout the headline news . . .
> Red mama's back in town and sure 'nuff she's gonna play you
> some blues
> —"Red Mama Blues"

> You don't need no shots, you don't need no pills;
> let my guitar cure all your ills
> They call me Miz Dr. Feelgood, I said hey hey hey
> Well it's my time now, gonna rock your blues away
> —"Miz Dr. Feelgood"

Beverly "Guitar" Watkins is indeed "back in business," as the title of her 2000 solo debut album asserts, thanks to the Music Maker Relief Fund and

Taj Mahal's endorsement. Actually, she has never been out of business, just out of view, for she has performed professionally since the late fifties, when she first played rhythm guitar in Piano Red's bands—the Meter-Tones, the Houserockers, and Dr. Feelgood and the Interns.[29] In the latter band, she wore a nurse's uniform while her band mates dressed in doctor suits.[30] A caretaker image that derives from the mammy stereotype, the nurse outfit no doubt helped to neutralize the gender boundary Watkins crossed by playing electric guitar in public with a band of men. Back then, she says, "I didn't do nothing but looked pretty and played rhythm."[31] After the Interns disbanded, Watkins performed in a long succession of different bands, and somewhere along the way she started singing and playing lead guitar. Her perseverance seems to have been fueled by her early experiences. "I kept on," she says. "Blues is about just like I came up. My mother passed when I was three months old. I was raised up with different aunties. A lot of people have to drink to play. . . . I don't have to do that, because the blues are already in me."[32] Watkins was also inspired early on by the records of Rosetta Tharpe: "There was something about this woman playing the guitar. . . . It was surprising."[33]

Today, as a leader of her own band, Watkins "surprises" as Tharpe did over fifty years ago, pulling out all the stops and playing the guitar, in her words, "like a man." Peter Cooper describes a 1999 performance:

> Beverly "Guitar" Watkins comes out of nowhere. And she's led by a Fender Mustang guitar. . . . She leaps and points the guitar neck and shouts and struts and poses. Then she runs and drops to her knees. . . . [She] gets a standing ovation after each song. Then all of a sudden she turns her back and lifts that red guitar up and over her head. . . . She sets it behind her head and plays it like it's a normal thing for a 59–year old woman to do on a Thursday night in Charlotte.[34]

On *Back in Business* (fig. 2.1) her first recording in forty years, Watkins tells the world that she is heré, here to stay, and here to be reckoned with. In typical blues fashion, she "talks back" to her colleagues and mentors as she pays homage to the tradition. The CD's opening song, "Miz Dr. Feelgood," for example, references Piano Red's hit, "Doctor Feelgood," acknowledging her time with him while telling everyone, "It's my time now" to be in the spotlight. At the same time, Watkins tips her hat to soul-blues queen Aretha Franklin and performs a moving personalized interpretation of Red's song. In "I'm Gonna Rock Some More" (by Joe Thomas and Howard Biggs), Watkins gives a respectful nod to vaudeville blues foremothers such as Lillian Miller

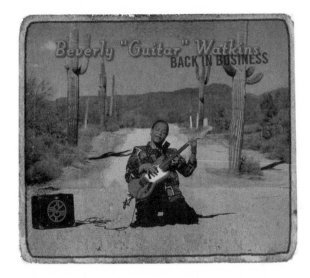

Fig. 2.1. The cover of Beverly "Guitar" Watkins's CD *Back in Business,* 2000. Music Maker 91007-2. Front cover by Paul Markow. Photo courtesy of Tim Duffy.

when she sings, "You can't keep a good woman down / Where there's rockin' I'll be around."[35] Finally, in "Red Mama Blues," the highlight of the album, Watkins announces her presence and that of her trademark red guitar, dishing up a good portion of her assertive, no-holds-barred instrumental work.

Complementing the message of the music, the CD's cover photo is a striking image of Watkins, center stage, alone, eyes closed and on her knees, playing her electric guitar through an amp on a corky, sand-colored carpet. Behind her, a dirt road lined with tall cactuses extends back into the desert, purple hills and blue sky in the background. This dramatic image seems to simultaneously embody isolation and visibility, freedom and vulnerability— Watkins center stage in a solo venture on a road few have traveled before.

Barbara Lynn (b. 1942)

> There's no one as great as Aretha, but other than maybe Etta James there's no one even near as good as Barbara Lynn. And no one walks on earth that is a better entertainer. I've been booking her since the first year of the club. Her SXSW set two years ago was the best one of the whole festival.
> —Antone of Antone's Blues Club, Austin, Texas

> R&B vocalist, left-handed guitarist and East Texas native Barbara Lynn—fifty seven years young . . . reprised her 1962 hit, "You'll Lose a

> Good Thing" . . . with undiminished grace and poise, pouring a lifetime
> of blues and wisdom into her delivery and punctuating her climactic
> testifying with exclamatory stabs of lead guitar.
> —David Fricke, review of 1999 SXSW conference

A left-handed guitar player from a "distinguished family of Beaumont [Texas] Creoles,"[36] Barbara Lynn started on piano but was inspired by Elvis Presley to take up the guitar. "I wanted to do something odd," she says. "I thought it would be odd for a lady playing guitar."[37] "I felt if he could fake playing guitar, then surely I could do it for real."[38] Impressed with her quick mastery of the ukelele, Lynn's parents bought her a Gibson guitar.[39] In high school she fronted an all-girl band, Bobby Lynn and the Idols, doing Elvis covers: "I swung my instrument and we all wore pants." She also started writing her own songs and was picked up by Huey Meaux, with whom she sang and recorded her first and greatest hit, "You'll Lose a Good Thing," which topped the R&B charts in 1962. Subsequently, the Rolling Stones recorded another Lynn song, "Oh Baby (We Got a Good Thing Goin')," she appeared on Dick Clark's *American Bandstand* twice, and she toured with Stevie Wonder, Gladys Knight, Smokey Robinson, and Tina Turner. Lynn's parents, who had been eager for her to go to college, began to encourage her musical pursuits.

In spite of these early successes, Lynn's lead guitar playing was not recorded until 1994, when she was fifty-two years old.[40] Over the last few years Lynn has finally been getting some long-overdue recognition. In 1999, she won the Rhythm and Blues Foundation's Pioneer Award and was featured in an interview-portrait in *Living Blues* magazine. In 2000, she released a new CD, *Hot Night Tonight,* on Antone's Records that showcases her soulful singing and funky, understated guitar playing alongside her son's hip-hop vocals.

The few critics who have written about Lynn conjure her authenticity in contradictory ways. In Bill Dahl's interview feature, for example, both interviewer and interviewee seem eager to establish at the outset a sense of Lynn's authenticity by focusing on her blues roots. Dahl begins by quoting Lynn, who says she was "raised around the blues. That's all I ever heard. We'd turn on our little radio and we'd hear these blues singers from way back. I can remember my mother and father dancing off that music. So I couldn't help but be inclined to do . . . the blues."[41] The fact that Lynn was exposed to the blues first seems to legitimate her move to soul/R&B. Dahl mentions Elvis's influence only after establishing Lynn's blues and then R&B (i.e., Black) roots. In contrast, the accounts of Lynn given on her CD liner notes begin with Elvis Presley's influence. In his liner notes to Lynn's latest recording,

John Nova Lomax is also quick to emphasize Lynn's "distinguished" Creole background (read: light skin, higher-class status),[42] an image reflected in the photo of her on the album's cover. On the front cover of *Hot Night Tonight*, Lynn sits on one side of a table/booth, hands and legs crossed, wearing an elegant sleeveless dress, high heels, and short wavy hair; her guitar sits across from her, leaning against the wall. Most every reviewer includes her youthful good looks and sex appeal as among Lynn's assets as a performer, and her CD covers reflect a conscious marketing of this aspect. On the front cover of *So Good* (1994), for example, Lynn's bare shoulder is prominent as she caresses her instrument and smiles at the camera.

Barbara Lynn has received more attention than Beverly Watkins, undoubtedly due to her "youthful good looks" and early singing and songwriting successes, but also, probably, because her guitar playing is more restrained and less in-your-face (i.e., more traditionally feminine). Appealing to the racialized hierarchy of socioeconomic status based on skin color, Lynn's visual and aural self-presentation also project a higher class background than that of Beverly Watkins. Whereas Watkins's vocals are smoky with a pronounced dialect and her guitar solos free and filled with distortion, Lynn's vocals are smooth and her guitar work clean and controlled.

Beverly Watkins and Barbara Lynn epitomize the contradictions of the marketplace that mitigate against the perception of African American women as "real" blues performers. Blues authenticity requires performers to be Black, old, and poor, while gender socialization demands that female performers look young, beautiful, light-skinned, sexy, and glamorous (i.e., "classy"). Watkins may be Black, old, and working class, but she is not sexy, young looking, beautiful, or glamorous by the dominant society's standards. Lynn may be old, young-looking, and beautiful, but could a woman of her class background have sufficiently suffered?

Deborah Coleman (b. 1956)

In reviews and interviews, Deborah Coleman is often presented as the *only* Black women electric blues guitarist. She is by far the most visible and prolific songwriter/performer, with seven solo albums and thirty-four original songs to her credit in ten years, including five recordings for the "mainstream" blues label Blind Pig. She is an attractive, personable performer, full of energy, and is often described as looking younger than her age. As many writers have noted, Coleman's route to the blues was quite removed from the prescribed one. She grew up in predominantly White neighborhoods on military bases

in Virginia, California, Illinois, and Washington state. Seeing the Monkees on television inspired her to take up the guitar; hearing Jimi Hendrix inspired her to learn to play lead. She listened to and played rock first, then R&B, then blues. And yet, moving from town to town and school to school, she had her own brand of blues growing up. Coleman often felt alone and isolated, and the guitar provided comfort and solace. Despite discouragement from family members and partners, sexism, and having to raise a daughter by herself, she persevered. At first, her goal was to be a side person (guitarist) on others' records. But she also wrote songs, and she wanted to see them recorded. Thus she began to work on her singing, too. While she hasn't come to the blues in the prescribed way, her struggle, dedication, and determination seem to authenticate her, along with the fact that she has always been true to herself, respectful of her elders, and an ongoing student of the tradition. Coleman's recordings reflect a wide range of influences, including funk, jazz, soul, gospel, rock, and an array of blues styles.

For many observers, a performer's inclusion of rock elements into his or her playing conflicts with preconceived notions of blues authenticity. Critics who regard Coleman as *the* Black female electric blues guitarist have a hard time accepting her rock influences. Frank John Hadley, for example, praises Coleman's first Blind Pig CD, *I Can't Lose* (1997), for the way she "balances the reserve and control of the blues with the extreme personal involvement of soul music." He notes that her "guitar breathes fire without sacrificing musicality, and her singing packs authentic blues feeling."[43] On her next CD (*Where Blue Begins*), however, according to Hadley "she moves away from subtlety, finesse, sensitivity and creativity to join in the testosterone-driven grandstanding of the James Solberg Band." Coleman's originals, Hadley says, "would speak more clearly and eloquently in a cooler blues climate."[44] He also has a problem with her third Blind Pig CD (*Soft Place to Fall*), on which "she makes a bid for mainstream attention [throttling] her Telecaster with more musical intelligence and character than most any testosterone-jacked guitar man." Hadley also feels that "none of the [just three] originals offers insight into the life of a middle-aged African American woman trying to realize her dreams while laboring on the pitiless blues highway."[45] Actually, the subjects and themes of the CD's original songs both resonate traditional blues themes and seem plausible reflections of Coleman's life experience.[46] Ingrained notions of "authenticity," however, give Hadley the audacity to insinuate that he knows better than Coleman herself about the "true" nature of the experience of someone in her shoes. As Coleman has said, "The songs I write are true . . . I don't know any other way to write."[47]

Hadley is not the only critic who "can't take the heat." Bill Dahl finds Coleman's voice unable to adapt to the "unsubtle surroundings" of the most rock-influenced songs on *Soft Place to Fall*. Similar to Hadley's reaction to *Where Blue Begins,* Dahl feels that Coleman "was trying too hard to strut her stuff in a macho milieu."[48] Dahl finds Coleman's voice just fine, however, on her original songs, which he describes as "less aggressively electrified but [retaining] a tough resonant edge."[49] Apparently, Dahl's real problem is with the CD's rock influence (not authentic enough) and, especially, with heavy metal sounds coming from a petite African American woman. It is not Coleman's voice that is unable to adapt, however; rather, it is Dahl's expectations of her that aren't budging. While *Soft Place to Fall* (fig. 2.2) may be more reflective of Coleman's rock background than previous CDs, the range of styles it encompasses is no less wide.

The more obvious bid the CD makes for mainstream attention comes in its visual presentation. Promoters were attempting to catch the attention of potential buyers with the sexy cover photos by Marc Norberg. On the front cover is a closeup profile in black and white of Coleman from her eyebrow to just above her chin, against a black background, lips parted slightly in a serious look, braids hanging over her face, eye lashes peeking through the hair. On the back cover, also in black and white, Coleman, topless, hugs a

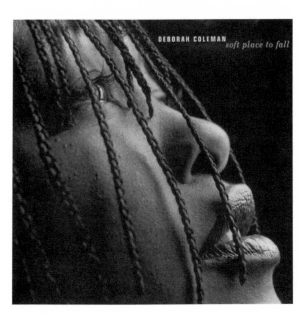

Fig. 2.2. The cover of Deborah Coleman's CD *Soft Place to Fall,* 2000. Blind Pig BPCD 5061. Photo by Marc Norberg. Courtesy of Blind Pig Records.

guitar to her chest. Another album cover by Norberg, the front cover of *Livin'
on Love* (2001), shows Coleman lying on a bright red pillow or comforter in
a plush purple zip-up shirt, lips closed in a smile, braids scattered provoca-
tively on the red bedding, one hand clasping the guitar neck in front of her.
The back cover is similar except that her shirt is open, her eyes are closed,
and the guitar is gone. In reviews, critics regularly mention Coleman's good
looks as an asset and often offer sexualized descriptions of her performance.
One reviewer, for example, noted that the "petite Coleman swiveled her hips
and tossed her braided hair as she solicited quivering notes from her guitar
on several solos."[50]

What locates Coleman's blues within the tradition is the fact that she bares
her soul, gives all she's got, draws her audience in, and gives them music to
dance to.[51] In other words, it is the aesthetics of her performance style (total
involvement, audience engagement, and integral role of dance), her energy,
and her down-to-earth approach that locate Coleman's blues within the
tradition. "I want people to feel something when I play," Coleman says. "I
want my music to be danceable when I'm in clubs."[52] Edward Chemelewski,
president of Blind Pig Records, says, "She plays with such passion and feeling.
. . . If you see her perform, you see it's the real thing. Once she steps onstage,
the audience is rooting for her. The audience senses she really feels it."[53] Critic
Michael Paoletta concurs: "She's at her most intense and fluent when she's
working for a crowd."[54] Coleman's commitment to performance and to her
audience is shown in her release of a live CD, *Soul Be It!* (2002), and in her
move to the Telarc label for her latest CD, *What About Love?* (2004). Of the
live CD, she writes, "As far back as I can remember I have been captivated by
the 'live' performance. For me, it is nothing short of mesmerizing. With this
recording I hope that we have brought you a glimpse of that experience."[55]
Of her choice of Telarc (known for the exceptionally clear, "natural" sound
of its recordings), Coleman says, "I have a need to keep it real and to keep
it live and spontaneous. That's what matters to me, and I think that's what
matters most to my audience."[56]

In the last few years, Coleman has been recognized with several W. C.
Handy Award (the "blues grammy") nominations, and her photo has graced
the cover of two top American blues magazines, *Living Blues* and *Blues Revue*.
A several-time nominee for Contemporary Blues Female Artist of the Year,
in 2000 Deborah Coleman was the first woman to be nominated for Best
Blues Instrumentalist—Guitar, and in 2002 she was nominated for Best En-
tertainer of the Year. She won the Orville H. Gibson Award from the Gibson
guitar company for Best Female Blues Guitarist in 2001.

BB Queen (b. 1964)

BB Queen grew up in a large musical family in Detroit.[57] Starting first on clarinet, then tenor sax, she took up the guitar at age thirteen. The youngest of the performers discussed here, Queen's youth undoubtedly works against her claims to authenticity and contributes to her being perceived as a novelty. Like Watkins, Queen is known for her stage antics—going out into the audience and playing with her teeth, for example, and with the guitar behind her back.

BB Queen arrived on the scene in 1997 with the CD *Everybody's Favorite: Qualified and Able.* Stylistically, Queen stays more within a classic blues structure and idiom than either Lynn or Coleman and exhibits less stylistic variation than Watkins.[58] At the same time, she employs the contemporary practice of including dance mixes of three earlier songs at the end of her CD. While this reflects her youth and interest in appealing to young people, it also resonates with the integral role of dance in traditional blues culture.[59] More than the other performers, Queen's focus is on guitar soloing. While her vocals are adequate, neither her lyrics nor her vocal delivery are particularly compelling. While the CD appears to have been well received by radio DJs in different parts of the country, she has been given little coverage in the major blues magazines to date.

On her debut CD, BB Queen attempts to establish authenticity through her own testimony as well as that of her mentors, fans, and critics. In her first-person liner notes, for example, Queen tells us that she grew up in the poor, Black, blues part of Detroit, and that from an early age she hung out in the same low-life blues places that had been frequented by legendary blues performers. Queen's narrative, which includes tropes of struggle and perseverance, possibly to convey lower-class status, suggests to the reader that the musician has paid her dues. She also alludes to the sexism she encountered and challenges the gender status quo by talking back to those who tried to keep her down. "I grew up on the East Side of Detroit. The Black Bottom. Danced and sang in the juke joints and blind pigs with younger sister and dad at age 5. Probably the same places John Lee Hooker frequented. I started guitar at age 13. . . . I gigged [*sic*], got bumped, ego bruised and a few guys told me to go home and bake cookies. Well!!! BB Queen has arrived. Here I am fellas—Deal with it!! Tell everybody BB Queens [*sic*] In Town!"[60]

On the CD itself, Queen introduces herself via the classic song "Let the Good Times Roll." Like B. B. King and Louis Jordan before her, she boastfully sings herself into the blues pantheon ("Hey everybody, tell everybody, BB

Queen's in town"). On the song "Nowhere Road," the voice of her inspiration and mentor, veteran blues growler Koko Taylor, helps authenticate Queen. The two blues queens trade off lyrics while Koko provides encouragement for BB's guitar solo: "Squeeze them strings BB Queen . . . come on girlfriend . . . I know you can do it." Moreover, the title track, "Everybody's Favorite (Qualified and Able)," asserts Queen's credentials and boasts her prowess and popularity by simulating a live performance with a "crowd" chanting "BB Queen, BB Queen!"[61] Finally, on the tenth track, "Psychic Lady," a male "audience" voice "checks Queen out" and ultimately "approves" her: "They call you BB Queen? You a singer? You play that guitar too? Go on, play me a song, your bad self!"

When she takes a solo, Queen says, "Let me play it for you." And after her solo, the male voice responds, "Girl you bad—you not old enough to be playin' like that." She may be young, but apparently she also already has the endorsement of B. B. King, who, according to Queen's notes, "[accepts her] as BB Queen."

The practice of female players being subjected to extra scrutiny for approval, the phenomenon of women having to prove themselves again and again before being accepted is something that Queen, Watkins, and Coleman discuss in interviews. Queen relates, "I'd go to jam sessions with my husband and they'd invite him up no questions asked. But with me it would be, 'Are you any good? Who do you sound like? Can you play this song?' [And] before I would play they'd say, 'Why don't you go home . . . ? Aren't you married?' and after I'd play they'd say, 'That's my best friend [pointing to Queen]. I been knowin' her a long time!' Every time I pick up the guitar I have to prove myself again."[62] Coleman relates a similar experience: "There have always been female players 'allowed' in. . . . But it isn't easy and I've still got a ways to go. The guys in blues are suspicious. 'Can she really play?' 'Can she really sing?' 'Does she really feel it?' Your peers have to check you out and give their approval before you're going anywhere."[63]

Conclusion

In some ways, the situation for Black female guitarists has not changed much since Memphis Minnie and Rosetta Tharpe first plugged in. Racism, sexism, classism, colorism, ageism, and stylism (if you will) permeate the discourse of authenticity, influencing the critical reception of blues performers such that Black female electric guitarists continue to be seen as anomalies and continue to be discussed in isolation. The problem is that as long as there is

just one axe-wielding Black blues woman, a sense of community and support is lacking.[64] Budding African American women guitarists need Black female role models as they need opportunities to gain experience and training. "I'm looking around and I don't see any others," Deborah Coleman says. "It's especially odd considering that in the early days the blues featured plenty of black female guitarists alongside the males. . . . It never occurred to me that I'd be the only one. . . . I'm in a very unique position that plays in my favor. At least the marketing folks think so."[65]

At the same time, the evidence also suggests that change *is* on the way. The four solo debuts and ten solo CDs produced collectively by Watkins, Lynn, Coleman, and Queen are one indication of this.[66] In addition, the Blues Education Program at the Delta Blues Museum and the Blues-in-the-Schools programs being developed around the country, along with organizations such as the Music Maker Relief Fund, are bringing opportunities, visibility, and support to Black female performers (among others), exposing young women and men (potential performers) to the blues and educating them about its history. Through education and increased visibility, attitudes about race and gender and notions of authenticity are being challenged and may be shifting.

The Black female guitarists who are performing and recording today are providing role models for the next generation. Deborah Coleman, for example, told an interviewer, "I've had women come up to me in tears, telling me how much I inspired them. It's like, girl power! You're a role model for the women, and they're very sincere about it. . . . Girls who are 14 and 15 come to my shows—they can't even get into the club—but I talk with them before the show."[67] Coleman also relates: "I've heard that there's a little black girl down in the Delta in Mississippi who's playing electric guitar. . . . They asked her who her influences were, and she said, 'I want to play like Deborah Coleman.' I thought that was very cool."[68]

Despite the tokenism that typically precludes it, occasionally more than one Black female guitarist can be seen on the same stage together. Taj Mahal tells of a show sponsored by the Music Maker Relief Fund, for example, at the end of which BB Queen and Beverly "Guitar" Watkins jammed together. Knowing the kind of antics of which Queen and Watkins are capable, let us imagine what the two must have "conjured" onstage together that night, and how they inspired women and girls in the audience (and empowered Black women in particular), and let us work to envision and enact changes that will increase the presence and visibility of axe-wielding Black women in the blues. "I'm gonna tell about a night that BB Queen and Beverly were

on stage—these young girls just went crazy—[they] flocked to the front of the stage," Taj Mahal says. "They were like, 'Oh my God! You mean you can do that!?' It was nice to see. Because in less than two generations we've completely wiped out that women can do stuff. . . . How did that happen?"[69]

Notes

1. Pete Welding, liner notes, *I Ain't No Bad Gal,* CBS Portrait Masters RJ44072, 1988.

2. Christopher C. De Santis, ed., *Langston Hughes and the Chicago Defender: Essays on Race, Politics, and Culture* (Urbana: University of Illinois Press, 1995), 195–96.

3. Ken Romanowski, liner notes to *Sister Rosetta Tharpe: Complete Recorded Works 1938–1944 in Chronological Order, Volume 2, 1942–1944,* Document DOCD-5335, 1995; Barry Martyn, liner notes to *Sister Rosetta Tharpe: Live in 1960,* Southland SCD-1007, 1991.

4. Quoted in Charles Wolfe, *American Roots Music* (New York: Palm Pictures, 2001).

5. Tharpe is pictured with an electric guitar on the cover of *Sister Rosetta Tharpe: Complete Recorded Works in Chronological Order, Volume 3, 1946–1947,* Document DOCD-5607, 1998.

6. Romanowski, liner notes to *Sister Rosetta Tharpe: Complete Recorded Works in Chronological Order, Volume 3.*

7. Wolfe, *American Roots Music.*

8. Although not primarily associated with the blues genre or with the electric guitar, Joan Armatrading, Tracy Chapman, and Toshi Reagon are Black female composer-performers all of whom sometimes play blues, sometimes play electric guitar, and sometimes really "rock."

9. John Rusky, "Venessia Young—Singing Like a Bird," *Blues Revue* 61 (October 2000): 66–67; "Blues Girl, Way Out Front She's 16, Got a Voice that Sparkles, and She's from Clarksdale," *Commercial Appeal,* July 16, 2000.

10. Eric Feber, "New CD Shows Deborah Coleman's Time Has Come," *Virginian Pilot,* March 31, 2000, E10.

11. Maria V. Johnson, "'I Was Born to Be a Musician Too': Female Guitarists in the Blues," *Arkansas Review: A Journal of Delta Studies* 33.3 (December 2002): 214–26.

12. All too often critics have avoided serious engagement with women's creativity by focusing on their looks and/or personal life.

13. Charles Keil, *Urban Blues* (Chicago: University of Chicago Press, 1966), 34.

14. Variants of this joke can be found on hundreds of Internet sites. According to Joe Kesselman ("How to Sing the Blues," http://www.lovesong.com/people/keshlam/filk/blues.html [2006]), it was first published in essay form as "How to Sing the Blues," by Judith Podell writing as "Memphis Earline Gray," in the Washington, D.C., publication *Wordrights Magazine* (1997) and subsequently circulated without her permission on the Internet.

15. Paul and Beth Garon, *Woman with Guitar: Memphis Minnie's Blues* (New York: Da Capo, 1992), 12; Nancy Levine, "'She Plays Blues Like a Man': Gender Bending the Country Blueswomen," *Blues Revue Quarterly* 7 (Winter): 37.

16. Marcus Charles Tribbett, "'Everybody Wants to Buy My Kitty': Resistance and the Articulation of the Sexual Subject in the Blues of Memphis Minnie," *Arkansas Review: A Journal of Delta Studies* 29.1 (April 1998): 42–44.

17. Peter Aschoff, "Record Review of Barrelhouse Women, 1925–1930," *Living Blues,* September/October 1997, 100–101.

18. For a discussion of authenticity in the blues, the intolerance for the mixing of styles and its relation to racial identity politics, see Christopher Waterman, "Race Music: Bo Chatmon, 'Corrine Corrina,' and the Excluded Middle," in *Music and the Racial Imagination,* ed. Ronald Radano and Philip V. Bohlman (Chicago: University of Chicago Press, 2000), 177–81.

19. Maria V. Johnson and Nathan J. Hill, "'The Day It Comes': Turning Up the Volume on African American Women Plugging In," presented at the Delta Blues Symposium 7, Arkansas State University, March 30, 2001.

20. Nathan Hill, "Postmodern Plasticity and Concrete Practice," unpublished MS, 6–7.

21. Sheila Whiteley, *Sexing the Groove: Popular Music and Gender* (London: Routledge, 1997), 37–49.

22. Chris Albertson, *Bessie* (New York: Stein and Day, 1972), 27, 37–38.

23. For discussions of these issues in jazz, see Linda Dahl, *Stormy Weather: The Music and Lives of a Century of Jazzwomen* (New York: Pantheon, 1984) and Sherrie Tucker, *Swing Shift: All Girl Bands in the 1940s* (Durham, N.C.: Duke University Press, 2000); in blues, see Johnson, "I Was Born to Be a Musician Too."

24. This was also the period of the so-called British Invasion in which White male electric guitarists from Britain (e.g., Eric Clapton) and their aggressive rock music, inspired by the blues music of Robert Johnson, Muddy Waters, and others, were introduced to the American mainstream.

25. Gaye Adegbalola, interview with the author, July 10, 2002.

26. Taj Mahal, interview with Brett Bonner and Scott Barretta, *Living Blues,* March/April 2000, 35.

27. Qtd. in Curtis Ross, "Coleman's Not Singing the Blues," *Tampa Tribune,* May 19, 2000, 20

28. Bret Kofford, "Deborah Coleman: Blues with a Passion," *Blues Revue* 33 (December 1997): 30.

29. Her only time "out of business" was a brief period in the mid-1960s, after Eddie Tigner of the Ink Spots, for whom she was working, had a stroke.

30. Although she did not want to wear the nurse's cap, she acquiesced; however, she refused to wear nurse's shoes.

31. Beverly "Guitar" Watkins, quoted in liner notes, *Back in Business,* Music Maker 91007-2, 2000, 5.

32. Ibid., 9.

33. Ibid., 6.

34. Peter Cooper, liner notes, Beverly "Guitar" Watkins, *Back in Business,* Music Maker 91007-2, 2000, 4.

35. Lillian Miller, "You Just Can't Keep a Good Woman Down," *Country Girls, 1926–29,* Matchbox Bluesmaster Series MSE 216, 1984.

36. John Nova Lomax, liner notes to *Barbara Lynn Hot Night Tonight,* Antone's TMG-ANT 0047, 2000.

37. Ibid.

38. Tony Mathews, liner notes, *Barbara Lynn So Good,* Rounder Bullseye Blues CD BB 9540, 1994.

39. Gibson is a well-respected and coveted brand that not many aspiring blues players could afford.

40. Mathews, liner notes, *Barbara Lynn So Good.* And here, on Lynn's guitar debut, her solo work is prominent only on her cover of B. B. King's "Sweet Sixteen."

41. Bill Dahl, "Barbara Lynn: Still a Good Thing," *Living Blues,* November/December 1999, 34.

42. In New Orleans from 1724 to 1861, the French occupied a privileged class, Blacks were slaves, and mixed-race Creoles made up a free middle class. Families of Creoles can be found today throughout southwestern Louisiana and along the Gulf Coast.

43. Frank John Hadley, review of *I Can't Lose, Down Beat* 64.6 (June 1997): 62.

44. Frank John Hadley, review of *Where Blue Begins, Down Beat* 65.12 (December 1998): 92.

45. Frank John Hadley, review of *Soft Place to Fall, Down Beat* 67.7 (July 2000): 74.

46. The title cut, "Soft Place to Fall," is about what it feels like being on the road all the time with a hectic touring schedule ("I can hardly catch my breath . . . caught in this whirlwind life"); "Another Hoping Fool" is about a woman who has been left by a lover but keeps hoping it is not true; "What Goes Around" is about a woman with "a lover on the side" who "lost the cake and the cookies too when everything crumbled away."

47. Katie Johnston, "A Woman's Best Friend: Guitar Becomes Constant Companion for Deborah Coleman," *Colorado Springs Gazette Telegraph,* November 20, 1998.

48. Bill Dahl, review of *Soft Place to Fall, Living Blues,* May/June 2000, 56.

49. Ibid.

50. "Always Hot, Heatwave Goes for Edgy Series," *St. Petersburg Times,* May 22, 2000.

51. This is true of all the artists discussed here. All are consummate live performers committed to a high level of audience engagement.

52. Kofford, "Deborah Coleman," 30.

53. Ibid.

54. Michael Paoletta, review of *Soul Be It! Billboard* 114.43 (December 26, 2002): 19.

55. Liner notes, *Soul Be It!* Blind Pig BPCD 5079, 2002.

56. Liner notes, *What About Love?* Telarc Blues CD-83595, 2004.

57. There are no specific references to age or birth date in the scant information I have found on Queen. In her liner notes she says that she started guitar at thirteen, and a 2002 article states that she has been playing for twenty-five years. She also has a teenage daughter and another daughter, who died at age ten, to whom her CD is dedicated.

58. All songs employ the standard twelve-bar blues structure, except for "Movin' and Shakin'," which is harmonically static with a funky groove. The latter structure is traditionally found in the rural blues of northern Mississippi and in the urban blues of John Lee Hooker.

59. See Tera W. Hunter's discussion of working-class Black women and public dancing in dance halls around the turn of the century in "'Sexual Pantomimes': The Blues Aesthetic, and Black Women in the New South," in *Music and the Racial Imagination,* ed. Ronald Radano and Philip V. Bohlman (Chicago: University of Chicago Press, 2000), 145–64.

60. BB Queen, liner notes, *Everybody's Favorite: Qualified and Able,* Mystic Blue Label MCDT 1001, 1997.

61. The boastful proclamation of one's skills and assertion of one's place in the tradition is also a strategy used by female hip-hop artists. I think, for example, of Queen Latifah's "Come into My House" and Salt-N-Pepa's "Expression."

62. Marissa Winegar, "B. B. Queen: Meet the Newest Blues Monarch," *Carbondale Nightlife,* September 27, 2002.

63. Rebecca Coudret, "Singing the Blues: They're Changing, Says Deborah Coleman, Who Plays Them, Sings Them, and Writes Them," *Evansville Courier and Press,* June 17, 1999, C1.

64. I use "axe-wielding Black blues woman" as an alternative to the often-used "African American female electric guitarist." The phrase is meant to connote powerful electric guitarists, evoking the metaphoric lingo of performers, which is sometimes taken up by critics. A performer "wood sheds" (practices and practices) on their axe (musical instrument) to become proficient (in other words, a formidable soloist).

65. Marty Jones, "Crashing the Glass Ceiling," *Westword,* June 28, 2001.

66. In addition, Lynn and Watkins have each had a new CD become available while this book has been in press.

67. Ed Ivey, "Deborah Coleman Can't Lose the Blues," *Blues Revue* 53 (December 1999): 9.

68. Jones, "Crashing the Glass Ceiling." The girl to which Coleman refers is probably Venessia Young.

69. Taj Mahal interview, 39.

3

Langston Hughes and the Black Female Gospel Voice in the American Musical

CHARLES I. NERO

Langston Hughes revealed a remarkable ability to identify with black women in his writings. Early poems such as "Mother to Son" and "The Negro Mother," as well as the later "Madam" series, reveal that this propensity began early and endured throughout his career. Perhaps this deft identification with black women prompted Hughes's most recent biographer, Arnold Rampersad, to conclude that Hughes had a "latent" self-image of himself "in his most intimate role as a poet, as mother (hardly father) to the race, rather than its princely child."[1]

Not surprisingly, then, it was Hughes, along with his collaborators, who introduced gospel music and, in particular, the black female gospel-inflected voice as a signifier of blackness to the New York stage and to the musical comedy form. In a string of musicals beginning in the late 1950s and continuing until his death in 1967, Hughes introduced audiences to the female singer with a gospel sensibility as a legitimate voice on the American stage. Collaborations between Hughes and female gospel singers had a lasting impact on the American musical. Until the 1990s, in fact, the female gospel voice was the most culturally "authentic" voice for African American female performers in the American musical.

This chapter focuses on Hughes as a designer of vehicles that showcased black female voices adept in gospel music vocal stylings. Black women singers, I suggest, infused into the theater a sense of black pride that Hughes believed was missing from earlier black-cast musicals.

Performing Black Female Exoticism

During the "golden age" of the American musical, from the early 1940s until the mid-1960s, black women singers on the American stage came from either the operatic or torch-singing traditions. Torch singing, or the performance of standard love songs, had become a staple in nightclubs and was popularized via radio, movies, and sound recordings. The casting of singers from these music traditions suggested that the only legitimate expression of African American femininity on the American musical stage was the woman unassimilated to urban U.S. culture. She was either the foreign exotic or the rural, southern woman. This is demonstrated by the theme of the hugely popular musical *Carmen Jones,* set in a parachute factory in the American South during U.S. involvement in World War II. The musical's composer, Oscar Hammerstein II, regarded African American southerners as analogous to the gypsies of southern Spain, whom the French composer Bizet's sensual music evoked. Hammerstein II provided new lyrics to *blacken* Bizet's *Carmen,* so, for example, the famous habanera "L'amour est un oiseau rebelle" became "Dat's Love" and the seguidilla "Près des ramparts de Seville" became "Beat Out Dat Rhythm on a Drum." The lead female singers, Muriel Smith, June Hawkins, and Carlotta Franzell, were all trained classical musicians. Smith, a former student at the Curtis Institute, went on to perform in Hughes's operas *Troubled Island* and *The Barrier.*

Former Julliard students Juanita Hall and Carol Brice, who had considerable classical training, achieved their greatest successes on the New York stage playing exotic women: Brice, a contralto, as the Creole servant Kakou in *Saratoga* (1959); and Hall as the Polynesian Bloody Mary in *South Pacific* (1949), as the Caribbean brothel owner Madame Tango in *House of Flowers* (1954), and as the Chinese American mother in *Flower Drum Song* (1958). The contralto Brice even had a career as a concert performer and did a fabulous turn as Maria in Houston Grand Opera's celebrated revival of Gershwin's *Porgy and Bess* (1976).

Singers Lena Horne, Eartha Kitt, Pearl Bailey, Diahann Carroll, Leslie Uggams, and Josephine Premice achieved early successes as nightclub performers of American popular music. Most often identified with the torch tradition, they too, were usually cast as exotic women in musicals. Horne and Premice played Caribbean women in the musical *Jamaica.* The music for *Jamaica* was by Harold Arlen, who had begun his career, in the 1920s, writing music for revues at Harlem's Cotton Club, where Ethel Waters proved to be a superlative interpreter and popularizer of his songs. Arlen had a considerable

talent for transforming musical styles derived from European operetta and the black Americas into productions appealing to mainstream audiences. When he brought this ability to *Jamaica*, his music for Horne ranged from popular U.S. styles to the fake-calypso "Push de Button" and the equally contrived gospel ditty, "Ain't It the Truth." Nevertheless, Horne triumphed in what most critics agree was a Broadway-sized nightclub revue.

Bailey, who had achieved some degree of fame in nightclubs, made her Broadway debut in Harold Arlen and Johnny Mercer's *St. Louis Woman* (1946) playing the barmaid Butterfly. Although set in turn-of-the-century St. Louis, the libretto, by African Americans Arna Bontemps and Countee Cullen, emphasized many of the images associated with rural blacks, such as superstition and closeness to nature. The latter is reflected in the fact that the male characters are jockeys who communicate with animals better than they do with humans. Arlen and Mercer's "Leavin' Time," a faux spiritual, further emphasized the rural dimensions of the characters. The show contained songs that have become classics in the torch and jazz repertoire, such as "Any Place I Hang My Hat Is Home," "I Had Myself a True Love," and "Come Rain or Shine," all of which were introduced by either Ruby Hill or the concert singer June Hawkins. Bailey, however, was the most memorable performer of the show, belting out "Legalize My Name" and deftly handling the double entendre of "It's a Woman's Prerogative." After *St. Louis Woman*, Bailey's greatest successes were as the exotic brothel owner Madame Fleur, Juanita Hall's rival in *House of Flowers*. The capstone of her career was the supposedly raceless Dolly Levi in an ironically all-black version of *Hello, Dolly!*

Eartha Kitt so successfully played sensual exotics in *New Faces of 1952* and in the fable *Shinbone Alley* (1957) that many believed, as I once heard *Tonight Show* guest host Robert Klein remark to Kitt, "I didn't know that you were an American!"[2] In her greatest hit, *New Faces of 1952*, Kitt performed the double-entendre "Monotonous" and "Bal Petit Bal" in French. Kitt's contemporaries, Carroll and Uggams, also excelled at playing exotic black women who performed American standards. Carroll began her career as a naïve Caribbean prostitute in *House of Flowers* and won a Tony Award as the American-born Parisian fashion model Barbara Woodruff in Richard Rodger's *No Strings* (1962), a show that contained no songs that might mark Carroll's character as culturally "African American" but permitted her to display her considerable belting skills. *No Strings* contained only one indication that Carroll's character might be from a black community: a lyric about living "up north of Central Park"—that is, in Harlem. Carroll and Kitt, in particular, parlayed their stage successes into even greater careers in nightclubs.

Uggams began her career in 1960s television as a teen singer of American popular music, including ballads and saccharine arrangements of spirituals. The former teen star won a Tony Award playing the naïve southern entertainer Georgina *in Hallelujah, Baby!* and later starred as Cleopatra in *Her First Roman* (1968), Ervin Drake's failed attempt to recreate the earlier success of Lerner and Loewe's adaptation of Shaw's *Pygmalion* as *My Fair Lady.* This show, too, featured Uggams's talents as a belter and a ballad singer but contained no music that might point to her black heritage through the use of traditional black vocal stylings.

As this brief survey shows, the roles available to African American women in musicals from the early 1940s to the mid-1960s were usually typed as exotic women with little or no connection to the United States or as women from groups unassimilated into modernity. Composers employed both classical and popular singing styles to successfully communicate these representations to American audiences. Hence, African American femininity in many musical comedies of the time usually meant a disconnection from both modernity and urban U.S. cultures.

Gospel Music and the Modern Black Female and Feminine Voice

Langston Hughes first became interested in musical theater in 1921, when he moved to New York. "Night after night," Arnold Rampersad writes, Hughes "sped downtown to pay 50 cents for the pleasure of sitting high in the gallery at the Sixty-third Street Theater and watching Florence Mills, Caterina Jarboro, and other gifted black entertainers dazzle audiences in *Shuffle Along.*"[3] With a memorable score by Eubie Blake and Noble Sissle and a book by Flournoy Miller and Aubrey Lyles, *Shuffle Along,* the first successful musical written, directed, and acted by black people, inaugurated a string of black musicals on Broadway during the 1920s. Although Hughes did not contribute to any of these early successful black musicals, he worked briefly with J. Rosamond Johnson on an unproduced effort, *O Blues!*

Throughout much of his career, Hughes provided libretto for musicals and operas. Notably, he worked with William Grant Still on the Haitian Revolution opera *Troubled Island,* which was produced by the New York City Opera in 1949.[4] His work with Jan Meyerowitz resulted in several operas, including *The Barrier* (1950), based on his earlier Broadway success *Mulatto,* and *Esther* (1957), which was based on the Old Testament heroine. Hughes's contentious collaboration with Elmer Rice and Kurt Weill resulted in the operetta *Street*

Scene, a work that, although seldom revived, provided arias for contemporary concert singers Audra McDonald, Harolyn Blackwell, and Teresa Stratas.

In the spring of 1957, Hughes produced *Simply Heavenly,* the first of a series of works that attempted to present musical entertainment based on black sources with black casts to black audiences. These productions differed from earlier shows, which had depicted blacks as unmodern or exotic. *Simply Heavenly,* a musical comedy, featured Hughes's familiar characters Jesse B. Semple (Simple) and the patrons of Harlem's Paddy's Bar. Simple, a Chaplinesque black working-class man, and his comrades had their origins in 1942 in a popular column Hughes wrote for the *Chicago Defender,* a weekly black newspaper. Fortunately, the move to a Broadway theater meant that the cast album would be recorded, so it is now possible to hear in the original cast political implications that Hughes associated with vocal styles.[5]

Simply Heavenly featured three black female singing roles (Joyce, Zarita, and Miss Mamie). It is instructive to compare the actresses' voices with the "subjectively described" account of each role provided by Hughes in the "Character Notes" that preceded the published script.[6] Joyce was played by Marilyn Berry, a light soprano. According to Hughes, Joyce (Simple's fiancée) "is a quiet girl more inclined toward club work than bars, toward 'culture' rather than good-timing. . . . She is not snobbish or cold. She is tall, . . . and she cries easily. Her charm is her sincerity."[7] The character of Zarita (Anna English) called for a singer with a more traditionally Broadway-voice type—one that is perfectly suited to sing Harold Arlen or Rodgers and Hammerstein jazz and easily capable of "belting," Hughes writes, "a tune." Zarita is "not a prostitute," but she is "brassy voiced, good-hearted, good looking, playing the field for fun and drinks . . . [and] lives a come-day-go-day existence, generous in accepting or giving love, money, or drinks."[8]

Finally, Miss Mamie (Claudia McNeil) is "a hard-working domestic, using biting words to protect a soft heart and a need for love too often betrayed." Hughes believed that hers should be a "big, deep richly dramatic blues-gospel voice," recalling the recordings of classic blues singers such as Bessie Smith and Gertrude "Ma" Rainey or post–World War II gospel singers such as Mahalia Jackson and Sister Rosetta Tharpe. Few remember that McNeil was an accomplished singer who had a fairly successful nightclub career. Instead, most people know of McNeil's work as Mama (Mrs. Lena Younger) in Lorraine Hansberry's 1959 drama *A Raisin in the Sun* and its 1961 film version.[9]

The casting of McNeil as Miss Mamie ingeniously brings together Hughes's concept of "voice" and "politics of black pride." McNeil has the voice that most nearly approximates the early voices that helped popularize traditional

black musical genres such as the blues and gospel. Her character, Miss Mamie, has the speeches in *Simply Heavenly* that most clearly articulate black pride. Miss Mamie shows her racial pride most obviously during a scene in Paddy's Bar when the snobbish, culturally confused man known only as "Character" accuses her and her suitor of being "disgraceful stereotypes" because they discuss the pleasures of eating watermelons. Miss Mamie responds to Character, "Mister, you better remove yourself from my presence before I Stereo your type! I like watermelons and I don't care who knows it. That's nothing to be ashamed of, like some other colored folks are. Why, I knowed a woman once was so ashamed of liking watermelons that she'd make the clerk wrap the melon up before she'd carry it out of the store. I ain't no pretender, myself, neither no passer."[10] When Bodiddly (a fellow customer at Paddys) asks Miss Mamie to clarify what she means by a "passer," Miss Mamie defiantly says, "Chitterlings passer—passing up chitterlings and pretending I don't like 'em when I do. I like watermelon and chitterlings both, and I don't care who knows it."[11] Given a speech about loving chitterlings and watermelon, it would be easy to consider Miss Mamie, herself, a stereotype. She is a woman of considerable girth and her name slyly hints at the negative image of "Mammy." Hughes even seems to revel in the possibility of Miss Mamie as a stereotype as he makes Melon her romantic pursuer. Melon, who actually sells watermelons for a living, recalls the street vendor from *Porgy and Bess* who sells his produce from a pushcart while improvising street cries to advertise his wares. However, Miss Mamie rises above a stereotype when, for example, she describes in a moment of exasperation how tough it is to be simultaneously oneself and yet mindful of the negative images of black people.

Through Miss Mamie, Hughes seems to warn his audience not only of the dangers of denying oneself pleasure in order to combat stereotypes but also of the importance of celebrating self-love. The importance of the latter is reinforced by the confluence of Miss Mamie's part as written and the quality of McNeil's gospel music vocal styling, which is commonly regarded as explicitly evocative of black performance traditions.

Claudia McNeil received the show's best reviews. Thomas R. Dash, the critic for *Women's Wear Daily*, wrote that McNeil "continues to be the show's most tangible asset. With her cavernous and sultry voice, which she can pitch to resonantly low registers, she wows the audience with her delivery."[12] *Simply Heavenly* proved to be a popular musical comedy; it moved from Broadway to a theater in Greenwich Village, then to productions in London and Hollywood, and eventually to television production in December 1959.[13]

Hughes's next work for the stage, *Black Nativity*, made explicit a claim

only implicit in casting Claudia McNeil as Miss Mamie; urban black musical forms could serve as a basis for a black musical theater about modern black people. For his next piece, Hughes chose gospel music as the medium, a genre for which he had cultivated an interest in his teenage years in Chicago, where he first heard the music of the Holiness and Sanctified churches. It is significant that Hughes explained his interest in gospel music by reference to its secular counterpart, the blues, and, in particular, a female blues performer. Hughes wrote, "I was entranced by their stepped-up rhythms, tambourines, hand clapping, and uninhibited dynamics, rivaled only by Ma Rainey singing the blues."[14]

On December 11, 1961, Hughes's *Black Nativity: A Gospel Song-Play* opened off Broadway. Set during a church service, *Black Nativity* used gospel music, pantomime, and dance to tell the story of the birth of Jesus. The title itself reflects the pride that Hughes felt about his race and its urban cultural forms. Yet the title was controversial. Originally called *Wasn't It a Mighty Day,* the title was changed to *Black Nativity* during rehearsals, at which point the dancer, Carmen de Lavallade, resigned because she found the new title in "bad taste."[15]

Black Nativity was something new; it was neither a musical comedy nor a drama with music. The musical was a compilation of many gospel songs already in existence. Since it capitalized upon the audience's familiarity with the tunes, it most nearly reflected what literary critic Kimberly W. Benston referred to as the movement in black theater from "*mimesis,* or representation of an action to *methexis,* or communal 'helping-out' of the action by all assembled."[16] The music encouraged "call and response," more commonly associated with traditional black churches. The use of gospel music was, Arnold Rampersad writes, a "major breakthrough" for Hughes, for he "deliberately allowed black music and religion to overwhelm the traditional play form."[17]

The use of gospel music was innovative. New York shows prior to *Black Nativity* had featured African American sacred music, such as in Paul Green's Pulitzer-winning and phenomenally successful *The Green Pastures* and Hall Johnson's underrated *Run, Little Chillun.* But as I have mentioned, these shows transformed this music with classical arrangements, effectively locating African Americans in an unchanging rural South where they remained outside of modernity. Hughes believed that these arrangements did not allow for the improvisation that he thought gospel performances afforded. Rather romantically, he explains the importance of improvisation in gospel arrangements in an essay he wrote for the *New York Herald Tribune Magazine* in 1963:

In the formal sense, they do not rehearse songs. They absorb them. They never look at printed music. They listen to the melodies over and over. They hum them. Then croon them, harmonize them without consciously harmonizing, weave one voice behind another, sit and rock and sing, or maybe stand and improvise and laugh and cry and love and enjoy a song together while they are learning it. Then in public performance, often some one in the group will do something no one thought of in rehearsals. But nobody is thrown off the track, and the song retains its overall entity. This is what the old time jazz musicians call 'head arrangements,' right out of themselves—or else from outer space. Like the best of jazz, much of gospel singing defies notation.[18]

This explanation, of course, belies the fact that gospel musicians have many years of rehearsals and performances behind them.

The cast of Black Nativity included a veritable cornucopia of talented gospel singers: Alex Bradford and the Bradford Singers, Marion Williams and the Stars of Faith, and the blind former singer Princess Stewart. At the beginning of the show, a narrator recited the story of the birth of Jesus. A second section abandoned the narrative and gave full rein to the gospel singers. Horace Boyer, the gospel music historian, wrote that "although each of these groups and soloists sang separately; when they formed a chorus, they turned New York's 41st Street Theater into a Pentecostal church."[19] Arnold Rampersad anticipated Boyer when he described the opening night: "Aroused by the musical and religious fervor on stage, the capacity audience yelled and cooed ecstatically. One White woman sprang from her seat with a cry, then fainted dead away; and in honor of God and in defiance of Equity, the singers sang for about half-an-hour past the prescribed end of the show."[20] The reviews from critics foreshadowed the role that the black female gospel-influenced singers would play in the rock musical, with its indebtedness to both gospel and rhythm and blues, at the end of the decade. Notably, critics pointed to musical elements such as rhythm and improvisation, and, more specifically, to gospel music's call-and-response form, which establishes community with transactional rapport between audience and performers. For white male critics, it is the female voice that most memorably established this rapport. Howard Taubman, reviewer for the New York Times, commented on the effect of Marion Williams and her female quartet: "When Marion Williams and the Stars of Faith, gowned in black, exploded into 'We Shall be Changed,' they can scarcely contain their elation. As they sing, they beat time with their hands and feet, and one of the women moves into the aisle, dancing and shouting the great hope of immortality. Some of the parishioners in the audience clap their hands, too, and a voice up front cries out, 'That's right!'"[21] At this time,

the experimental theater had not dissolved theater's imaginary "fourth wall," so for Taubman, such intimate interaction between audience and performers was indeed innovative. Taubman's remarks further suggest that he had little familiarity with urban black gospel performance traditions.

In his next Broadway show, *Tambourines to Glory* (1963), Langston Hughes departed from the ritual-type production. *Tambourines to Glory* was a more traditional book musical which used gospel songs to further the action of the story. Hughes understood the significance of using gospel music when he correctly stated this was "the first time gospel songs have been woven into a Broadway drama, as an actual part of the play itself."[22] *Tambourines to Glory* was unlike *Black Nativity* because it actually had a book as opposed to being a pageant or unfolding in narrative style. And it was unlike *Simply Heavenly* because it used gospel, rather than gospel-like, music.

The show's story is about good triumphing over evil. Two women, the devout Essie and the opportunistic Laura, form a storefront church that becomes a financial success through its connections with gangsters. Laura finds redemption after she kills her gangster lover, the phallically named Big-Eye Buddy Lomax. Although the story is simple, the libretto's gospel music setting gives *Tambourines to Glory* its verve and complexity. Hughes wrote the lyrics and Jobe Huntley provided the music. A talented singer with a solid reputation in Harlem, Huntley's gospel experience emerged early in his life: his father was a minister, he had directed church choirs, and as a World War II army recruit, he conducted a gospel quartet. Huntley and Hughes began their collaboration in 1956, shortly after they met at a Carnegie Hall concert given by Mahalia Jackson. Seven years later, when the show finally appeared on Broadway, the critics disapproved its production but raved about the gospel music. A critic for the *New York Morning Telegraph* declared that the "libretto sags" but otherwise it was a "musical feast" with voices "coming at you in a torrent of foot-tapping, nerve-tingling melody."[23]

Howard Taubman was even more critical, declaring that "the story drags foolishly and gets in the way of the singing." Taubman called particular attention to the more participatory aspects, or the more *methexic* qualities, of the music: "When the Little Theater . . . becomes the Tambourine Temple and the company beatifically pounds out 'I'm Gonna Testify,' a theatergoer feels like joining the rejoicing. For this company knows how to communicate the jubilation of a gospel song's ecstatic rhythms." John Chapman was equally enthusiastic, though he found it necessary to use a stereotypical remark in his praise for the show. "The story is pretty scattered," he wrote, "but this is all right because it does serve to give the singers their cues. Whether they

are offering a standard like 'Motherless Child' or one of Huntley's numbers they sing magnificently—for they are mostly Negroes."

The show did not require that all of the singers have expertise with gospel. Micki Grant and Robert Guillaume, who played the show's young lovers, were more classically trained singers, and the songs assigned them were the more traditional Broadway pop. Whitney Bolton called attention to this disparity between the pop and gospel songs when he singled out only Guillaume's rendition of "The Moon Outside My Window" as having the potential to be "a vast hit, a great hit."[24] None of the other critics used the language of commerce—"a hit"—to describe the gospel music, which suggests that whites, or at least white critics from mainstream New York papers, were unaware both of the growing commercial appeal of gospel music and increasing black consumer potential.[25]

The show's female gospel singers got the lion's share of critical enthusiasm. Reviewers pointed to the music led by the female gospel singers as especially encouraging of communal participation and movement. For instance, critics singled out for praise the great gospel singer and composer Clara Ward and the gospel-trained singer, actress, and future Broadway musical producer Rosetta Le Noire. Martin Gottfried wrote that when Le Noire and Ward "got going—and they did frequently—the Little Theatre nearly bounced over into 45th Street from 44th."[26]

Hughes would continue to write more shows until his death in 1967. His impact on the American musical form was significant. On one level, his influence substantially changed the content of the musicals, as theater historian Allen Woll points out:

> White musicals in the Broadway mainstream tended to avoid questions about race. Often the predominant reaction was a flight to exotic themes and foreign shores. New black musicals, particularly those by Langston Hughes, remained firmly ensconced in Afro-American life and culture. Rather than ignoring the real problems of race relations in the 1950s and 1960s, Hughes . . . addressed those concerns for American blacks in musical comedy form. While the white-created musicals might have provided a blissful escape from the growing civil rights movements of the 1950s, by the 1960s these shows became increasingly anachronistic. As a result, the works of such Broadway masters as Richard Rodgers, Richard Adler, and Jule Styne were unable to please the critics with their renditions of black musicals while lesser-known theatrical artists, such as Hughes . . . began to surprise both critics and audiences with a new form of black musical that responded to the dominant issues of the age.[27]

On another level, *Simply Heavenly, Black Nativity,* and *Tambourines to Glory* signaled the advent of a new type of singing voice for the Broadway stage: the female gospel-trained voice (or at least a voice that could give a reasonable approximation of it). Male singers with gospel training would also find a place on the Broadway stage, but they would not equal the popularity or inspire fans in quite the same way as their female counterparts did and continue to do. What Hughes accomplished in his musicals was that he created a mainstream musical theater vehicle for the singer with a gospel sensibility.

But although Hughes created the lyrics and fashioned a context in which black female gospel singers could attain the musical stage, the singers themselves developed the style and audience rapport that determined their success. Theater historian John Chum describes a method by which singers find the audience denied them by mainstream entertainment in order to perfect their craft. Writing in the very different milieu of the 1990s, he remarks that since the diva Bette Midler never got her own Broadway star-making show, "she created her own vehicles and took them on the road. Her concert tours, really more musical extravaganza than concert, played to predominantly gay audiences around the country."[28] Excluded from mainstream success because of their race and their choice of music, gospel singers created their own star-making vehicles and took them on the road, performing in tents, churches, and auditoriums. They developed individualized sounds and rapport with their audiences, and they developed the style and attitude of the diva. Consider Clara Ward's defiantly unpious style from the 1950s: mile high wigs; dangling, diamond-crusted earrings and other jewelry; tight, sequined fish-tail dresses; stiletto pumps; and a shiny gold tooth right in the front of her mouth. Black singers such as Clara Ward and Marion Williams brought their genuinely earned star personas as divas to the New York stage and the American musical. While Hughes provided the vehicle, these divas gave performances that announced that the black female gospel singing voice in the American musical had arrived.

Black Musical Theater after Hughes

In *Not a Day Goes By,* E. Lynn Harris, the popular black gay novelist, pins the success of the black Broadway "diva deluxe" Yancey Harrington Braxton on her ability to perform gospel music: "In the close-knit world of New York entertainment, Yancey was known as the replacement queen. She had stepped into many leading roles on Broadway when established actresses

took vacation or suddenly fell ill. Yancey had performed in *The Lion King, Rent, Chicago, Smokey Joe's Cafe,* and was currently appearing in *Fosse.* These shows added not only to her bank account but also to her reputation as a talented performer who could play the virginal beauty and belt out a soul-stirring gospel tune as well."[29] In this brief characterization, Harris points out an assumption that contemporary audiences make. In the American musical, an authentic voice for a black female singer is one that can "belt out a soul-stirring gospel tune." Hughes's pioneering collaborations allowed for the gospel-inflected female voice to emerge as a marker of black urban identity. His collaborations specifically used gospel music, as projected by black female singers, to situate African Americans in modernity.

Hughes's musicals coincided with profound shifts in cultural tastes. The 1960s announced that gospel and its secular forms, first rhythm and blues and then soul, had become markers of modernity. The Broadway musical kept up with this trend, as female gospel-influenced singers dominated the New York stage from the 1970s until the early 1990s. Consider that from 1968 until 1993, eight of the ten black women who won the Antoinette Perry (Tony) Award had a background in gospel music specifically, or in secular music (soul or rhythm and blues) written for a singer with expressive capabilities in soul or gospel music stylings: Melba Moore in *Purlie* (1970), Linda Hopkins in *Inner City* (1972), Virginia Capers in *Raisin* (1974), Delores Hall in *Your Arms Too Short to Box with God* (1977), Nell Carter in *Ain't Misbehavin'* (1978), Jennifer Holliday in *Dreamgirls* (1982), Ruth Brown in *Black and Blue* (1989), and Tonya Pinkins in *Jelly's Last Jam* (1992). Further, I note that most of these shows revealed an awareness of blacks as subjects of modernity, because of either their urban settings (*Inner City, Raisin, Ain't Misbehavin', Dream Girls*) or their parodic, postmodern sensibilities (*Purlie, Jelly's Last Jam*). *Your Arms Too Short to Box with God,* in which gospel music told the story of the last days of Jesus Christ, was an update of the ritual musical *Black Nativity.* Only *Black and Blue,* a European import, fit the bill of "othering" blacks into exotica.

Only two black women singers who did not perform in gospel or R&B traditions earned Tony Awards between 1970 and 1990: jazz singer Dee Dee Bridgewater and Lena Horne.[30] It should be noted, though, that Horne in her Tony Award–winning show *The Lady and Her Music* surprised and delighted audiences with a previously unheard belting style that gave a gospel feeling of struggle and defiance to her signature tune, Harold Arlen's "Stormy Weather," and to newer songs, "If You Believe" from *The Wiz* and "Yesterday, When I Was Young." While Horne certainly had no experience as a gospel

singer, she did make remarks in the 1970s that she had been listening to soul music and, in particular, Aretha Franklin. During this period I recall Horne telling an interviewer that a Leontyne Price or an Aretha Franklin was inside of every black woman! One senses the impact of gospel-derived soul and rhythm and blues in some of Horne's albums of the 1970s, which included for the first time in her career electric instruments (such as guitars and organ), rhythm and blues musicians as back-up singers, and covers of songs by soul artists. In fact, one of Horne's mid-1960s albums was titled *Soul*, which was apparently her way of alerting listeners to the fact that she, a famed Hollywood and nightclub singer, was trying out music with a more contemporary, urban feel.

It could even be argued that from the 1970s to the 1990s there was a bias in the New York theater community against black women who could not belt a "soul-stirring gospel tune," to use E. Lynn Harris's words. Consider the case of Debbie Allen, who achieved her greatest Broadway fame during this period. Allen has a light soprano voice, but she never received a Tony, although she was nominated twice for performances in revivals of *West Side Story* (1980) and *Sweet Charity* (1986) and gave an acclaimed performance as a replacement for Charlaine Woodward in *Ain't Misbehavin'*. Even more remarkable, she was not even nominated for a Tony for her performance as Beneatha in the musical *Raisin* (1974), an adaptation of Lorraine Hansberry's pioneering *A Raisin in the Sun*. The awards committee preferred the gospel belter Ernestine Jackson (as the character Ruth Younger), who received the nomination but did not win for featured performer. Perhaps because of the lack of validation that the Tony Award provides, Allen is acknowledged solely as a dancer and a choreographer, while her singing skills are ignored, disparaged, and considered "inauthentic." While serving as cohost of Spike Lee's New York set documentary *Spike & Co. Do It A Cappella*, Allen was seen pleading with Lee to allow her to sing. Most of the performers sang gospel or rhythm and blues. Lee simply rolled his eyes and said no to all of Allen's requests.[31] It is as though Lee mirrored the larger New York theater community by considering Allen's nongospel voice a joke.

The predominance in musicals of black women singers with gospel music vocal sensibilities suggests that producers, writers, composers, and audiences have come to accept soulful music as the most authentic representation of a black feminine voice on the New York stage. This acceptance contrasts sharply with the experiences of earlier singers such as Eartha Kitt, Diahann Carroll, Pearl Bailey, and Josephine Premice, who progressed through the business in non-black-cast musicals or, if they were in black-themed shows and were

expected to be belters or torch singers, were not expected to perform in a gospel style. This point is especially evident in the cases of Kitt and Premice, who continued to perform in musicals after the 1970s. For example, Kitt continued to be cast as an exotic in the lead role in *Timbuktu* (1978), Geoffrey Holder's reimagining of *Kismet,* and Premice had a leading role in the revue *Bubbling Brown Sugar* (1976), a retrospective of Harlem entertainment in the 1920s. *Bubbling Brown Sugar* created a "false past," however, in which the gospel-influenced performances of Vivian Reed, Carolyn Byrd, and Ethel Beatty overshadowed Premice and male performers such as Avon Long and Joseph Attles, whose singing styles were actually more representative of the black revues that appeared on Broadway and in Harlem nightclubs in the 1920s. A similar argument could be made for the glorious tribute to 1920s black vaudeville, *One Mo' Time* (1980), in which the entire cast of female singers (and many of their subsequent replacements in the show's North American and European tours) came out of the New Orleans gospel singing tradition.

Perhaps by the 1970s audiences and even directors, writers, and others responsible for casting assumed that the black female gospel-inflected voice had always been on the New York stage. I became vividly aware of this assumption while watching the recent revival of Stephen Sondheim's *Follies* (2001), a show set in the late 1960s in which characters playing former stars of a hit revue with editions from the 1920s through the 1940s recall their experiences. The African American Carol Woods did an anachronistic gospel turn as the character Stella Deems, a featured performer during the 1930s run of *The Follies.* Deems's big number, "Who's That Woman?" had always been sung in a straightforward belting style in the original cast and in the numerous recordings of this cult show. Not only did Woods belt, but the gospel-like melisma and shadings she added to the song's final line, "Lord, Lord, Lord, that woman is me," brought the most sustained applause for any of the musical performances. Clearly, contemporary audiences at the production I saw of *Follies* were willing to accept an identifiably black woman in this traditionally all-white cast as well as one who performed in a style that would not have been possible in a 1930s Broadway show.

I'd like to speculate about what the acceptance and popularity of the black female gospel-trained voice on the New York stage means. As noted earlier, gospel-styled singing has had a profound influence on urban American popular music such as rhythm and blues, soul, disco, and, now, hip-hop. Some strains of interpretation hold that gospel-based music is a more authentically black style than jazz, classical, or torch singing. Theater audiences—black

and nonblack—expect that female African American roles will be performed by singers with gospel sensibilities.[32] The phenomenal success of a show like *Dreamgirls* demonstrates the enormous impact of gospel musical styles on white Americans. The show ran for over fifteen hundred performances on Broadway and continues to have professional revivals. Its white creators, Henry Krieger (music), Tom Eyen (lyrics and book), and Michael Bennett (director and choreographer), created a show that featured a profusion of gospel and gospel-influenced musical styles. But without a doubt, their most notable creation was the character Effie (Jennifer Holliday), the singer with the big, powerful gospel voice who is pushed out of the spotlight by the more kittenish sounding Deena (Sheryl Lee Ralph). Deena has greater career success, and the show implies that her more commercially viable voice is less "authentic" in terms of black culture. Undeniably, though, the best songs in the show belong to Effie. In fact, critics hailed Effie's gospel shout number, "And I Am Telling You I'm Not Going," as simply the best showstopper since "Everything's Coming Up Roses" from the 1959 classic *Gypsy*. Jennifer Holliday won a Tony and launched a successful career as a gospel singer after her landmark performance.[33]

While a well-crafted character like Effie clearly moves audiences, it is apparent that the well-placed sound of the female voice sensitive to gospel music stylings can excite audiences, too. This ability is most clearly noticeable in the rock musical. Since the 1968 production of *Hair,* rock has assumed a significant role in the American musical. Rock, of course, is one more genre influenced by gospel and other black musical forms. However, since the casts of rock musicals often mirror their white suburban constituencies, African American women have not always had major roles in them (there are some exceptions, such as Melba Moore, who worked her way up through the ranks of *Hair* to become the first black woman to play the lead character Sheila, or the black female singers who have assumed the title character in Elton John's recent *Aida*). However, even in the recordings of these rock musicals, the black female gospel-trained voice has often played a significant, if disembodied, role in their success. Consider Loleata Galloway, Melba Moore, and Ronnie Dyson's falsetto in the original cast recordings of *Hair* (1968), Sheila Gibbs's memorable, cool gospel melisma in the opening of "Summer, Summer" from *Two Gentlemen of Verona* (1971), or, more recently, the soaring, wordless, gospel obbligato in the crowd-pleasing "Seasons of Love," which opens the second act of *Rent*. These brief snippets of gospel-inspired singing by often uncredited women singers provide audiences with enormous pleasure that can propel a show during a slow moment or lift audiences to heights of ecstasy.

I suggest that the gospel-tinged voices of women singers represents something about the culture of black people that is important and universal but often misidentified. I go back to Hughes's discussion of the female gospel-inflected voice in *Simply Heavenly*. Remember that Hughes imagined the character with the gospel voice (Miss Mamie) as "hard-working" but "using biting words to protect a soft heart and a need for love often betrayed." Hughes's remark recalls three activities at the very core of black experiences in modernity: labor ("hard work"), resistance ("using biting words to protect a soft heart"), and the ceaselessly repeated promise of love ("a need for love often betrayed"). Hughes was prescient, I believe, in suggesting that there is something enduring and worthy of pride in expressions from black communities. The continued training of women in the church represents this ongoing and shared sense of values represented over time. Hughes is "odd" insofar as he is a man who identifies women as the carriers of black communal values about labor, resistance, and love. I believe that the persistence of this vocal style on the New York stage, more often than not, contains the elements or associations that Hughes attributed to the black female gospel-trained voice.

Notes

1. Arnold Rampersad, *The Life of Langston Hughes*, vol. 2, *1941–1967: I Dream a World* (New York: Oxford University Press, 1988), 240. For a further discussion of Rampersad's statement, see my essay, "Re/Membering Langston: Homophobic Textuality and Arnold Rampersad's *Life of Langston Hughes*," in *Queer Representations: Reading Lives, Reading Cultures*, ed. Martin Duberman (New York: New York University Press, 1997), 188–96.

2. *The Tonight Show*, NBC, dir. Robert Ostberg, April 17, 1978.

3. In Arnold Rampersad, *The Life of Langston Hughes*, vol. 1, *1902–1941: I, Too, Sing America* (New York: Oxford University Press, 1986), 55.

4. William Grant Still is typically regarded as the "Dean" of African American composers in the classical music tradition.

5. *Simply Heavenly*, Columbia Records OL 5240, n.d.

6. Langston Hughes, *Simply Heavenly*, in *Five Plays by Langston Hughes*, ed. Webster Smalley (Bloomington: Indiana University Press, 1968), 115.

7. Ibid.

8. Ibid.

9. See Donald Bogle's *Blacks in American Film and Television: An Encyclopedia* (New York: Simon and Schuster, 1988), 174.

10. Hughes, *Simply Heavenly*, 115.

11. Ibid.

12. Brooks Atkinson, review of *Simply Heavenly*, by Langston Hughes, *New York Times*, May 22, 1957, 28.

13. Faith Berry, *Langston Hughes: Before and Beyond Harlem* (Westport, Conn.: Lawrence Hill, 1983), 314.

14. Langston Hughes, "Gospel Singing: When the Spirit Really Moves," *New York Herald Tribune Magazine*, October 27, 1963, 12–13.

15. In Rampersad, *Life of Langston Hughes* 2:347; Allen Woll, *Black Musical Theatre: From Coontown to Dreamgirls* (Baton Rouge: Louisiana State University Press, 1989), 237; Original Cast Recording, *Black Nativity: Gospel on Broadway*, Vee-Jay Records 8503, 1962.

16. See Kimberly W. Benston, "The Aesthetics of Modern Black Drama: From *Mimesis* to *Methexis*," in *The Theater of Black Americans*, vol. 1, *Roots and Rituals/The Image Makers*, ed. Errol Hill (Englewood Cliffs, N.J.: Prentice-Hall, 1980), 62.

17. Rampersad, *Life of Langston Hughes*, 345.

18. Hughes, "Gospel Singing," 13.

19. Horace Clarence Boyer, *How Sweet the Sound: The Golden Age of Gospel* (Washington, D.C.: Elliott and Clark, 1995), 252.

20. Rampersad, *Life of Langston Hughes*, 347.

21. Howard Taubman, review of *Black Nativity*, by Langston Hughes, *New York Times*, December 12, 1961, 51.

22. Hughes, "Gospel Singing," 13.

23. Whitney Bolton, "'Tambourines to Glory' Is Musical Feast: Libretto Sags," *New York Morning Telegraph*, November 5, 1963, 2.

24. Bolton, "Tambourines to Glory," 2.

25. For instance, the Ward Singers—of which Clara Ward was a member—had been earning gold records for million-selling recordings since 1949. Horace Clarence Boyer, foreword to *How I Got Over: Clara Ward and the World-Famous Ward Singers*, by Willa Ward-Royster as told to Toni Rose (Philadelphia: Temple University Press, 1997), ix–x.

26. Martin Gottfried, review of *Tambourines to Glory*, by Langston Hughes, *Women's Wear Daily*, November 4, 1963, 45.

27. Woll, *Black Musical Theatre*, 247.

28. John Clum, *Something for the Boys: Musical Theater and Gay Culture* (New York: St. Martin's Press, 1999), 141.

29. E. Lynn Harris, *Not a Day Goes By* (New York: Doubleday 2000), 14–15.

30. Bridgewater, a well-known jazz singer in the tradition of Carmen McRae and Sarah Vaughn, received her Tony for the role of Glinda in *The Wiz* (1975). Lena Horne received a special Tony Award for her phenomenal one-woman show, *The Lady and Her Music* (1981).

31. *Spike & Co. Do It A Cappella*, dir. Spike Lee, Elektra Video, 1990.

32. Audra McDonald and Vanessa Williams are notable exceptions. Williams has had success as a replacement throughout 1993 for Chita Rivera in *Kiss of the Spider*

Woman; she assumed the role Ruby Hill created in a concert version of *St. Louis Woman* and received a Tony nomination in 2002 in a revival of Stephen Sondheim's *Into the Woods.* The gifted McDonald appears not to have discovered vocal limits. McDonald has benefited from roles that make use of her opera training. She won a Tony for her role as Carrie Pipperidge in the 1994 revival of *Carousel,* which used color-blind casting. It is interesting that the black women who had featured roles in this production had opera-trained voices. The opera superstar Shirley Verrett was cast as Nettie Fowler, who sings the powerful hymn "You'll Never Walk Alone." MacDonald displayed her vocal talents and received a second Tony for her performance as the opera student Sharon in *Master Class* (1995). She won a third Tony in the musical *Ragtime,* playing Sarah, the role Debbie Allen had played in an earlier, filmed version. She has also played in John LaChiusa's *Marie Christine,* a black Creole version of Euripides' *Medea* that pushes the boundary between opera and musical. MacDonald surprised many when she played Deena in a concert version of *Dreamgirls* (2001). In 2004, McDonald won a fourth Tony, this time in a nonmusical role as Ruth Younger in a star-studded revival of the Hansberry play *A Raisin in the Sun.*

33. It is interesting to contemplate this issue of "authenticity" in the 2001 recording of a concert version of *Dreamgirls* with the Audra McDonald as the less-authentic Deena and the gutsy Lilias White as Effie. McDonald's background is in concert and classical music; White is straight out of the church.

When and Where She Enters:
Black Women in Unsung Places

4

That Text, That Timbre: Introducing Gospel Announcer Edna Tatum

DEBORAH SMITH POLLARD

The date was October 29, 1990. Thousands had come from across the United States to celebrate the Reverend James Cleveland's fiftieth anniversary in gospel music. And as she had masterfully done countless times before, gospel announcer and narrator Edna Tatum dramatically conveyed the sense of the occasion. Those assembled were there, she explained, because they were "members of the household of faith," co-workers in gospel music ministry with the award-winning singer, composer, producer, and convention founder. As such, they had assembled to commemorate in grand style a man whose accomplishments, tenure, and impact on gospel music had earned him such affectionate titles as "Crown Prince of Gospel Music" and "King of Gospel Music."

Many of the estimated fourteen hundred gospel announcers in the United States would have been honored to take Tatum's place in the Dorothy Chandler Pavilion that evening.[1] However, center stage belonged to the woman who, for a decade and a half, had performed on some of the world's most prestigious stages as narrator for Cleveland. Tatum's mastery of text, timing, and timbre that evening, as well as the audience's thunderous approval, underscored her status as one of the most sought-after gospel announcers in the country.[2]

Edna Tatum's artistry is achieved through her adherence to a complex of Black aesthetics encompassing a range of rituals, behaviors, and speech acts that are similar to or adapted from the performances of traditional Black preachers and gospel singers. Like other gospel announcers, Tatum displays her creativity in re-creating aspects of the Black church experience in con-

cert settings or on radio. She accomplishes this by employing performance techniques that reflect her understanding of African American sacred and secular traditions.

Whether she is performing during a broadcast or on a concert stage, Tatum manipulates a variety of elements, including

1. text, a category that includes a variety of rhetorical devices—repetition, parallelism, and figurative language—as well as the use of solicitational devices (words that encourage participation) and metanarration (commentary on the proceedings);
2. qualities of the sound, such as timbre, volume, and pitch;
3. the physical realm, including attire and kinetics (appropriate movements, hand gestures, and facial expressions); and
4. time as it relates to the physical realm, text, and programming.[3]

The musical events that gospel announcers are most frequently asked to emcee include all or most of the following elements:

1. Praise and worship or devotional segment, consisting of congregational songs, Scripture reading, and prayer[4]
2. Words of welcome
3. A response to those words from someone in the congregation
4. Introduction of the emcee

If the announcer has been invited to serve as the emcee, particularly in the fairly relaxed atmosphere of an "A&B program" (several groups are invited to sing two—the A and the B—selections), he or she usually has to juggle several duties as described by folklorist and ethnomusicologist Ray Allen:

> The emcee's role is not only to announce each group, but also to help the sponsor in ordering the program, to see that each group is present and ready to go on at the appropriate time, to acknowledge distinguished guests, and to keep the audience's attention between groups with stories, jokes, and announcements. Like the devotional leader, the emcee reminds the audience of the spiritual nature of the event and praises and chastises them depending on the extent to which they are participating in the service. (87)

In a more formal concert in which two or several professional artists are featured, the announcer is called upon to introduce them in a manner that reflects the artists' longevity and status within the gospel industry and larger culture.

As an emcee in a relaxed afternoon church program setting, Tatum is expected to bring artists before the congregation as any announcer would, but even for this kind of service she has been known to write at least some special introductions for the occasion. This act of preparing a text, while not unheard of among gospel announcers, sets her apart from most, particularly those who gain their reputation by taking the pulse of the audience and flowing with their needs.

As a narrator, her job requires setting the tone for the event, which she does by writing and delivering unique pieces that intertwine the history of the artist with biblical and Black cultural references. The focus of this chapter is Tatum's manipulation of text and sound quality in the execution of her work. These are elements that can and often do assist Tatum in invoking the spiritual ambience her audience expects and demands. Critical examination of her work reveals that Tatum is deeply cognizant of Black struggle and achievement, the victories realized through individual labor as well as through community efforts, and gospel music's role in providing spiritual support.

Tatum's name is not as well known in the gospel music community as those of the top artists with whom she has associated, such as Walter Hawkins, Kurt Carr, Daryl Coley, and the late Billy Preston. However, many of those performers, record label personnel, and a growing number of gospel fans recognize her recorded work because of her distinctive sound and imaginatively written and delivered texts. Tatum's continued popularity within the gospel music tradition, her long association with the Reverend Cleveland, and the success she has achieved after his death make her an important focus for anyone interested in performance-centered scholarship and the Black gospel music tradition.

History of Gospel Announcers

The history of radio broadcasts of Black sacred music can be traced to the earliest days of the medium, which consisted of church broadcasts and music programs and in which live performances of sacred quartets were a regular part of the local and national broadcast week. By the 1930s, gospel music was so popular among both Black and White audiences that there was a demand for more programming. By 1953, gospel, along with the blues, was referred to by *Sponsor* magazine as "the backbone of Negro radio" (69). Initially, hosts were disc jockeys who served in various capacities at their respective stations—play-

ing blues and other Black popular music and hosting talk shows, for instance. Eventually, announcers emerged with the sole responsibility of presenting gospel music on radio.[5] Over time, their tasks have expanded to include

1. presenting gospel music and hosting on radio as well as in live set-tings, including church musicals and banquets, outdoor festivals, and concerts in major indoor venues;
2. recreating aspects of the Black church experience through their speeches and behaviors wherever and whenever they serve; and
3. linking advertisers and consumers, audiences and gospel artists, and congregations and the Holy Spirit.[6]

Performance-Centered Analysis

This study is influenced by the work of folklorist Richard Bauman and oth-ers who, in their critical evaluation of speech within specific ethnic and cultural groups, combine research techniques from various disciplines, in-cluding anthropology, linguistics, ethnomusicology, folklore, and semiotics.[7] In *Verbal Art as Performance* (1984) Bauman describes performance as an artistic event (that is, the situation, including the performer, the audience, the occasion, and the setting) and artistic action (that which the performer actually does). In Edna Tatum's case, her announcing or narration style is as performative as any of the choirs or preachers she introduces. Perfor-mance is always culturally specific, reflective of a prevalent aesthetic and of unique rules for the production of oral literature (5). Each performance is unique, or "emergent" as Bauman labels it, based on the specifics of time, place, the goals of those involved, and the level of artistry being displayed. Consequently, the competence of a performance that occurs during Sunday morning worship would be measured differently than one that takes place during a talent contest at a local banquet hall. While individuals from various ethnic and racial backgrounds may be able to enjoy a particular performance, audiences from the same culture as that of the performer are the ones who determine the competency of that performance by viewing it through the aesthetic lens of that culture.[8]

Bauman attributes to Gregory Bateson (1955) and Erving Goffman (1974) the development of the concept of "frame," that is, the "interpretive context" for a given communication act. One act could include several frames: in-sinuation, joking, or imitation, for instance.[9] Performance, another of these communication frames, always contains "keys" or indicators that are unique

to specific ethnic cultures and their events. Those keys can encompass such devices as parallelism, figurative language, and special codes and phrases (15–16). The keys to performance used by gospel announcers coincide very closely with this list. An additional characteristic, definitive of the performance style of announcers, is their use of interspersed metacommunication to speak directly to listeners and to comment on what is transpiring during the performance. These referential comments, along with the kind of music that is presented (gospel), and the prayers that are issued help alert the audience to the nature of what is unfolding and how it is to be interpreted.

The establishment of frames often results in the patterning that can be observed within performance. Each cultural community determines (1) which of its events require performance; (2) the setting, sequence, and ground rules; and (3) the communication modes that are required.[10] Because gospel music was born within the setting of the Black church, competent gospel announcers, including Tatum, must perform in a manner that reflects their knowledge of and connection to the rituals and behaviors of that institution.

With every performance, the announcer negotiates the ground rules so that each event and act is unique. The variances are determined by factors ranging from the audience to the locale. The ability to vary aspects of the performance is important since gospel announcers are often called upon to work within secular settings, such as radio broadcasts and amphitheaters, that must be transformed into the more conducive sacred ground of "church." Often this constitutes the most creative part of their work and is generally required by audience members who respond to gospel as part of the worship experience more than as a cultural art form.

A Pervasive Black Aesthetic

Gerald L. Davis (1985), Mellonee V. Burnim (1988), and Geneva Smitherman (1986) have examined the distinct Black aesthetic as revealed in African American religious preaching, music, and speech. Despite the important role announcers serve within Black gospel music communities, little critical analysis of their work has been conducted. Existing analyses fall into two categories. The first is comprised of biographies and profiles of the announcers and their programs.[11] The second category includes work that delineates the duties gospel announcers perform.[12]

An essential element in understanding African American performances, especially those that are centered on language, is comprehending the Black church in general and the performed Black sermon in particular.[13] After

evaluating sermons by a number of Black preachers, Davis (1985) reported that there are indeed specific characteristics of the performed traditional Black sermon. These sermonic elements (with some latitude allowed for individual innovation) include

1. a primary focus on language and meter as exemplified by the studied use of synonyms, repetition, and parallelism (51–53);
2. the use of independent narrative blocks (stories, anecdotes) that are linked to the sermon by thematic "bridges" (56, 101);
3. the use of vernacular language and references to contemporary culture (61, 105);
4. the employment of "sermonphones," special sounds found within the performed Black sermon, including the single word and phrase, as well as what Davis calls the "nonarticulated sermonphone," that is, grunts, groans, and hums; and
5. the sound-absent sermonphone.[14]

All of these serve a variety of semantic purposes within the performed Black sermon (98–100).

Similarly, Burnim demonstrated that gospel singers are judged to be competent or incompetent to the extent that they manipulate various aspects of attire and movement, structure, rhythm, text, and melodic units in a manner that is culturally sanctioned yet uniquely personal.[15] Because gospel announcers carry out their duties for the same audiences for which preachers and gospel singers perform, they are held to the same criteria for successful performance.[16]

Biographical Profile

Edna Tatum, who declines to give her birth date, was born in Nacogdoches, Texas, into a family that migrated to Los Angeles in 1957. She earned a degree in business education from the University of Southern California.[17] Raised in the Zion Hill Baptist Church, where T. M. Chambers Sr. was the pastor, Tatum remembers being "forbidden" to go to churches with the stronger gospel influence. However, she made friends with individuals who were part of early gospel history, and subsequently, her interest in and knowledge of that history grew through those associations.[18]

Tatum began her broadcast career by occasionally welcoming guests and reading announcements on her church's radio program when the regular announcer was absent. She performed in a similar capacity on broadcasts

for New Greater Harvest Baptist Church, where T. M. Chambers Jr. was the minister. One evening she attended service at the Cornerstone Institutional Church, founded (1970) and pastored by Rev. James Cleveland. Neither the regular nor the assistant announcer was present. Her friend, Annette May Thomas, asked Tatum if she would help that evening. The next week, the choir director, Alonzo Atkins, suggested to Cleveland that Tatum be allowed to do the broadcast again.

Tatum began changing the scripts for the broadcasts and creative narrations emerged from those changes. "I wanted to make [my narrations] different; I wanted to make a contribution that would make a difference," she remembers.[19] Tatum's narrations made an impact on thousands, including Cleveland, a central figure in gospel music with whom she formed an association that lasted from the mid-1970s until his death in 1991. Tatum announced for both of his broadcasts—a half-hour morning program featuring his Southern California Community Choir (Southern Cal) and a one-hour program featuring a full church service. She also performed with him in concert around the country. In most instances, Cleveland relied on her to introduce him to the audience and set the stage for various songs he, his singers, and choirs would perform.[20] In other settings, such as at the Fiftieth Anniversary Salute, Tatum was required to provide a stunning narrative that would set the tone for the historic occasion. Whether her performance was situated at the beginning or featured throughout a musical event, Tatum earned the nickname the "Voice."[21]

Today Tatum is in such demand that she has been flown to Chicago, New York, Detroit, Oakland, and other cities to perform at the McDonald's GospelFests and similar events. She has even taken center stage at the Sultan's Pool in Tel Aviv. She is currently affiliated with Baptist Church of the New Covenant in Norwalk, California, where Rev. L. Daniel Williams is pastor. About the celebrated work she does, she has said simply, "Any time you can present good news, any time you are allowed to share the message of good news, that is a blessing."[22]

Tatum writes her narrations; sometimes the words come to her quickly while she is in a car or on a plane. Her focus is on clarity, meaning, and inspiration. She draws on her experiences, her knowledge of the history of gospel music and Black culture, and her sense of what she likes to hear from an announcer when she is in the audience. Asked to explain how she is able to create such powerful narrations, Tatum responded in an interview, "I know God, so along with the gift he's allowed me, I use my prayer time" in order to receive direction.[23] She explained that she also considers the occasion and

the setting and believes that part of what makes the best announcers and narrators successful is knowing "when to come in and when to come out" of their introductions without losing the attention of the audience.[24]

The Performance Contexts

Among the most significant occasions for which Tatum provided narrations for Cleveland was his 1977 concert at Carnegie Hall, where only a handful of gospel artists had appeared as headliners. Cleveland's performance there—occurring twenty-six years after announcer and promoter Joe Bostic Sr. first rocked the great hall by presenting Mahalia Jackson in 1951—is of historical significance.[25] The commercial recording from that evening remains a "must have" item for many gospel music aficionados today.[26] Tatum recalls that she was "shocked and moved" by the fact that Cleveland had asked her to introduce his songs. Once he had secured her for the task, the only direction he gave her was to attend the choir rehearsals and listen to some of the songs. This, Tatum says, demonstrated a great deal of trust, especially since, at that point, she had performed in Cleveland's presence only a few times. Tatum recalls that when she finally delivered one of her introductions during a preconcert rehearsal, the choir members were so moved by her delivery that they began crying and shouting—an indication that her narrations were effective.[27]

Tatum opened that evening with a basic introduction: "Ladies and gentlemen, the King of Gospel Music, Reverend James Cleveland." Cleveland opened by lining out an "old one hundred" hymn by Dr. Isaac Watts, "Father, I Stretch My Hands to Thee," during which Cleveland's "call" was answered by the choir's "response." Following that, Tatum delivered five of her unique "recitations," as they are called on the album label; each one is either a poetic image of the artist or a language-dense historical or biblically based lead-in to a particular song.[28]

Because many of Tatum's performances have been commercially recorded, other announcers have used them as introductions for gospel songs on their own broadcasts. For several years, Tatum herself hosted a program called *Moments of Meditation* on KMAX in Los Angeles under a brokerage agreement with the station in which she paid for air time and, in turn, sold sponsorships to various advertisers. After a self-imposed leave of several years, she is currently broadcasting Sunday mornings, 6:00 to 8:30 A.M., as host of *Gospel Classics* on KPFK in north Hollywood.

Since Cleveland's death in 1991, Tatum has continued to create narrations

for other gospel singers. In 1996, she recorded her meditations on some of the great hymns of the church. The late R&B and gospel organist Billy Preston provided the accompaniment.[29] She is also one of the performers highlighted each year during the annual Gospel Music Workshop of America (GMWA) convention, founded by Cleveland in the late 1960s.[30] In 1999, GMWA attracted eighteen thousand delegates from as far away as Japan. Tatum was in the spotlight once again, among a handful of announcers including Al "the Bishop" Hobbs and Merdean Fielding-Gales.

The recorded broadcasts Tatum submitted to me for use in this study include her personal copy of the KMAX Mother's Day show from 1993. Among the songs she played for mothers were "Thank You, Lord," "No Charge," and "God Be with You 'Til We Meet Again."[31] In January 1994 she recorded another program so that it could be broadcast on WTLC in Indianapolis while her friend and fellow gospel announcer, Delores "Sugar" Poindexter, was recuperating from a heart attack. The second broadcast was directed to Poindexter—and to any of her listeners who were sick or otherwise going through a challenging time. A focus on those to whom the program was addressed reveals that Tatum's broadcasts serve as a ministerial tool while also achieving an intimate, meditative tone. The songs were selected with special attention to Poindexter's illness ("He'll Never Let You Down," "I Won't Complain," and "Blessed Assurance"). Tatum's succinct lead-ins were further evidence that this was a broadcast with the specific aim of providing spiritual encouragement.[32]

The Physical Dimension

Since attire is the first aspect of a performance that an audience encounters, it is a critical dimension that can enhance or detract from the performer's work.[33] What audiences notice first about Tatum is that she dresses in a manner that is understated or, as one GMWA official put it, "conservatively neat." Unlike some central figures in gospel music and narration, Tatum is intentional in her modest presentation of self. This is not to suggest that she does not take care in selecting her clothing for her performances; in fact, she always looks polished and appropriate for the setting. Although she wants her attire to be attractive, she says, "I never want to take away from what I am representing . . . Jesus." With that in mind, she dresses in "classic colors" and lines and, unlike many of her counterparts, will not wear hats while performing or glittery attire before 5:00 P.M.[34]

While for an increasing number of choirs that choreograph their perfor-

mances, movement is a key component, Tatum is known throughout the gospel music industry for standing "flat-footed." That is, she rarely incorporates anything other than the most basic movements—a turn of her head, a finger pointed for emphasis—as she delivers texts that move other people to clap, applaud, "talk back," cry, or even shout. All of these responses she finds "humbling," particularly when audience members make such remarks as, "You said what I needed to hear" and "How did you know I was thinking that?" Tatum's focus is on presenting what she has written in a manner that is conducive to the setting in which she finds herself and doing so in a way that has a spiritual impact on the audience.[35]

The Mastery of Text

Because the artful manipulation of text is one of the defining features of both Black expressive culture and the gospel music tradition,[36] the emergence of the gospel announcer was inevitable.[37] Like a range of other individuals within the African American community, including preachers and gospel singers,[38] gospel announcers articulate the concerns and emotions of Black audiences. Through what they say before, after, and sometimes during the presentation of a recording or of a live performance, they verbalize the joys and pains of being human, African American, and Christian.

Rhetorical Devices

Tatum's performances provide an opportunity to study rhetorical devices such as parallelism, repetition, and metaphor. These devices are employed singly or in "stacks" to achieve a variety of effects from keying (signaling) and patterning (structuring) performance to affirming Black culture and "inspiring greater reliance on God."

One of the defining characteristics of Tatum's narrations is her use of repetition, an important rhetorical strategy used by both gospel singers and preachers.[39] When spoken aloud, repeated phrases allow the speaker to present a particular "figure of sound" and to create the patterning that is critical to sustaining audience involvement.[40] An admirer of the enunciation and "color" the late congresswoman Barbara Jordan brought to her speeches, Tatum enjoys listening to speakers who know how to "toy" effectively with a word. She apparently appreciates those who can set a pattern with repetition until audiences follow her anywhere, figuratively speaking. Of the many introductions Tatum has recorded, one of her favorites is "It Was Love."

Delivered at Carnegie Hall, it includes an example of repetition through patterning. In it, Tatum explains that everything Jesus did was dictated by his love for humanity. He laid aside his divinity and traveled through forty-two generations to be born in a manger. He spent his brief adult life preaching to, healing, and feeding the masses—all because of love. She reminds fellow Christians that theirs is a call to spread that gospel message of love around. Tatum ends with the rhetorical question: "Do *you* love everybody?"[41]

The audience responded strongly to this passage for several reasons. The text is dynamic in part because Tatum sets up several patterns—through repetition ("love," "it was love," and "like a") as well as through parallelism ("cry like a baby/play like a child"). The audience recognizes biblical narratives creatively presented when they hear them; in the case of Tatum's presentation, they immediately identify her patterned phrases as a "call" to which they voice their "response."

Another example of Tatum's use of repetition comes from her hosting of the Southern California Community Choir's twenty-fifth anniversary celebration. While introducing the song "What Shall I Do?" she tells the audience that everyone will go through experiences that can only be described as "midnight," dark times when they will have tried everything possible and fallen short of their desired end with no personal means of altering the circumstances.[42]

The repetition in this passage of "you," "how do you," and "do" arrests the listener's attention and provokes a response from the audience, one that builds with the assonance, that is, the repeated vowel sound. But it does more; it emphasizes the continuous effort in terms of time, love, and energy that audience members have undoubtedly expended in the pursuit of their dreams. In short, it is the perfect lead-in for a song whose key lyric encourages believers to turn to God for the ultimate solution to life's challenges.

Tatum employed repetition and parallelism also as she prepared her listeners for the song "I Won't Complain," which she played during one of her radio broadcasts. After acknowledging that there are those in the world who are facing such challenges as homelessness and illness, Tatum reminds her audience that most of them are enjoying several blessings: good health, life itself, and the beginning of another day in which they can thank and glorify God. In this case, the parallelism commences with a phrase she uses twice, "But then we still have . . ." That in turn is followed by the phrase "We're still able to . . . ," which she uses three times in succession.[43] Tatum provides no room for grumbling on the part of her listeners who are believers because she provides them with a formidable list of reasons they can still be grateful.

Not one of the items on the list is a material item that believers can secure for themselves. According to Tatum's introduction, the basis of listener contentment should be for that which "only God can provide." After hearing Tatum's live narrations, every one of the feedback respondents for my study asked, "Is she a preacher?"[44] Though she does not "whoop, holler, or squall" in the manner used by many traditional preachers, Tatum's employment of "emphatic repetition," in which a base phrase is repeated in a variety of tones and with increased intensity, makes her delivery reminiscent of that performance style.[45] Respondents came to the consensus that Tatum's phrasing is conceived with the anticipation of an audience response. While it is effective on radio, there is usually a palpable energy in the auditorium when Tatum is performing. Listeners can affirm together that what they are hearing is inspirational, effective, well crafted, and thought provoking.

Metaphorical Language

One of the hallmarks of Tatum's verbal artistry is her extensive use of metaphorical language. This device assists her in speaking accepted truths in unique ways. In one of her finest narrations, she conveys the hope of the faithful that the "unsaved" or backsliders will "submit their lives to God" as a result of being in the evening's service. It is their desire that nonbelievers and those who have walked away from God will experience God in such a way that any false pride or egocentrism they possess will be fractured. As a result, they will surrender to Jesus, who like a surgeon will mend what has been wounded and heal what needs to be cured under the watchful eye of the ultimate attending physician, the Holy Spirit.[46]

Many people involved in Christian ministry embrace the convictions embodied in these words. One feedback respondent, who is a commercial art director and gospel singer, said he appreciated that Tatum avoids using hackneyed phrases. On the other hand, another seasoned announcer, who agrees that Tatum "just has a way with words," wondered if the audience actually *heard* Tatum's carefully honed text or were responding to her sound alone. Though sound will be examined later, in this instance it is safe to conclude that the combination of figurative language and an evocative sound resulted in the heightened responses from the audience.

During the fiftieth anniversary celebration for Cleveland, Tatum's introduction is marked by highly figurative language through which she conveys the excitement that she imagines electrified the atmosphere in the place and on the day a very young Cleveland stepped into gospel music ministry.[47] She

takes the biblical narrative of Jesus' baptism and adapts it to Cleveland's "baptism" into gospel music fifty years earlier. Her rendition is replete with a voice from heaven and a visitation by the Holy Spirit.

Unlike Tatum's other introductions, which received unanimous approval when I played them during the feedback interviews, three of the eight respondents expressed reservations about the Cleveland presentation. Their discomfort centered on what they felt amounted to a "deification" of Cleveland, which they saw as unwarranted and as placing too much emphasis on the messenger (Cleveland) and not on God.

The difference between their response to the other introductions and to this one may have been contextual. Removed from the excitement of the evening's tribute, including the devotional service that preceded it, these particular gospel announcers may have found it difficult to visualize the effectiveness of Tatum's delivery in that highly charged atmosphere. They went on to describe the need for their colleagues (and all public speakers) to take care in considering the implications of their metaphorical language. Although I was not in the audience for Cleveland's Fiftieth Anniversary Salute, while listening to the tape, I never perceived that Tatum's intent was "deification." The other gospel professionals in my feedback groups also responded positively. They suspected, as did I, that Tatum had endeavored to find a unique way to say that "God had blessed James Cleveland" for a special work, utilizing imagery with which the audience would have been familiar. Most important, the recording from that evening indicated that Tatum's narration received resounding applause from the audience to whom it was delivered.[48]

Metacommunication

Wherever a speech community exists, metacommunication, that is, commentary about what is being said, points to the speech event as "performance" and defines the interpretive context ("frame") by which the performance is to be judged. Once the audience members know the boundaries of the performance, they understand their role in the event. Performers can signify how their performances should be interpreted in a number of different ways.[49] Within the Black church and gospel music communities, preachers and gospel singers find ways to communicate that their musical or sermonic performances are about to commence and that audience members should conduct themselves accordingly. For example, some gospel announcers signal their intentions with phrases such as "I don't know what you've come

to do, but I've come to praise the Lord!" This disclaimer of entertainment, invoked almost universally by performers within the church, is also found in the lyrics of a number of gospel songs. The frequent iteration of this phrase assists the speaker in reaffirming the purpose for the gathering: worshiping with other believers. Tatum has offered similarly succinct disclaimers during her introductions: "We did not come here to entertain. We didn't come here for show time. You can find that anywhere."[50]

As she performs for radio, Tatum also informs the audience of her purpose: "How happy I am to join you from Los Angeles, California, on radio station WTLC as we lift up Jesus and give Him the glory and thank Him for all that He's done for us." Tatum wrote and delivered one of her most stunning metanarrative texts for the annual board meeting of the GMWA in 1993. In this instance, she deftly and succinctly describes the patronizing responses "unsaved, educated" individuals often have to the exuberant, participatory experience she and thousands of GMWA members frequently have, not only at the convention but whenever they worship. They are uninhibited in glorifying God because they know they will not be on this earth forever and their charge is to praise God while they can do so.[51] As at other times, some of the members of the audience may have been responding to the sheer sound of Tatum's words, or her voice, as she imitated the cool, dismissive tones with which some people speak about the kind of gospel performance she was introducing. Others were probably impressed with her unhalting delivery of the polysyllabic phrases. Tatum displays her artistry in this piece by counterbalancing the high-toned, esoteric-sounding dismissal ("negative compensatory reaction formation . . .") with the down-to-earth, easily accessible rebuttal ("And we just call it singing, shouting, and giving God the glory"). Similarly, during the anniversary celebration for Southern Cal, she refers to the service and flows spontaneously with the moment as she comments on the joy both she and the singers have displayed. Tatum explains that they never apologize for their often passionate displays of gratitude that sometimes find them removing their jewelry and shoes. All of this is done so that they can more freely and completely express themselves. Since God has blessed them abundantly during their twenty-five years together, they find it mandatory to sing and shout without reservation. At the heart of it all is Tatum's commentary on what is taking place and will continue to transpire during the evening—just in case someone is unclear about the agenda.

Solicitational Frames

Call and response is a critical mode of discourse employed by gospel announcers; it incorporates "all three elements of stimulus, structure, and manner of participation (response) into a working relationship with one another."[52] A fundamental sense of balance and harmony (Smitherman 1986, 104) is reached as the artist and audience work together to create an optimum performance. Because audience members and artists adhere to an aesthetic system that requires audience participation, neither entity is solely responsible for the success or failure of the performance (Davis 16). Call and response places the audience "on stage" and provides a mechanism through which they can be pulled into the action—or back into the event—should their energies sag or minds wander.

Tatum's acclaim is based largely on her ability to create one-of-a-kind introductions. Most often, she does this without the overt use of call and response. Apparently, audiences find it easy to involve themselves in her performances by responding to her metaphoric language, parallelism, repetition, etc. However, when she is performing in the role of concert host, she solicits the participation of the audience, as she did while introducing the choir director and choir during Southern Cal's anniversary:

> And, of course, one of the best in the business—
> He's a little man with little arms, but darling,
> He's somebody's director: Mr. Alonzo Atkins. (R)[53]
> Come on! (R) Come on! (RR) Come on! (RRR) Alright!
> And didn't you enjoy the Southern California Community Choir? (R)
> Huh? (RR) Come on! Yeah! (RRR)[54]

Besides specific words of encouragement ("Come on!" and "Alright!"), here Tatum employs the vocable "Huh," which serves as a "call," in this instance, for the audience to indicate more emphatically its approval of what the performers had done during the service. While the overt use of call and response is not a defining element of Tatum's work, it is another rhetorical device she can and does implement competently.

Sound

The manipulation of sound encompasses several aspects: the ability of gospel announcers, as well as gospel singers and traditional Black preachers, to maintain a sense of intensity, fullness, and energy while subtly manipulating

shading and contrast. These nuances, often unrecognized by those unfamiliar with the traditions, may be created several ways. A given performer can produce a range of sounds and timbres, a choir or group can feature two or more voices of contrasting timbres in one song, or both voice(s) and instrument(s) can be contrasted for effect (Burnim 1985, 158). This category also incorporates the manipulation of three other closely related elements: pitch, intonation, and what Smitherman calls "songified speech."[55]

A comparison of Tatum's recordings from the 1970s and the 1990s reveals that the basic pitch of her voice has dropped. Thus she now has a lower, slightly raspy vocal quality. What has remained constant is its mellow, almost hushed character that she accentuates through inflection and clear enunciation.[56] During the "It Was Love" introduction Tatum prepared for Carnegie Hall, she used several different timbres. The intensity of her delivery increased as she read the list of nine ways in which Jesus showed love, concluding with three consecutive lines that begin with "he" followed immediately with an appropriate verb ("healed," "fed," "walked").

The audience showed its appreciation for the content, parallelism, and rhythm by "boosting" her until the pinnacle of the piece, "Speak like a mighty God," was reached. The last three lines, which follow, shift the focus from Jesus to the listener. Here, Tatum decreases her volume and stops the rhythmic pattern. By the time she gets to the last line, she whispers, allowing the audience to focus on the question she believes they must ask themselves concerning their love for others.[57]

During the anniversary for Southern Cal, Tatum utilized a wide range of vocal timbres as she presented or "talked through" the song "What Shall I Do?" The choir sings the song softly as Tatum talks to the audience about going through tough situations and about the necessity of waiting for God, who will come through for them every time. As the congregation begins to join the choir in singing this popular song, the intensity builds in their voices and in Tatum's:

> Anybody in need of a blessing? Stand on your feet.
> If you need a blessing, come on! (R). Help us sing this.
> I know He'll come through. Yes, He will. (RR).
> Come on! Yes! (RR), Thank you.
> *All you have to do is wait on Him.*
> *Oh, yeah! He'll come through.* (RRR)
> *HE'LL—COME—THROUGH!*[58]
> [A woman is heard shouting.]

The emphatic changes in Tatum's timbre indicated here parallel the building intensity within the service, beginning with the very first devotional songs that were sung before the choir was introduced and climaxing at the point at which her delivery was most dramatic. Further enhancing the moment is the fact that her words served as a descant to an equally powerful musical performance.

Many in the audience may have found Tatum's delivery reminiscent of a longstanding tradition in both Black radio and the Black church, that is, "talking through."[59] The technique involves keeping two channels of sound (the microphone and music levels) modulated for an effect that is as compelling on radio as it is in the live concert setting. When gospel announcers perform as Tatum did that evening, they borrow simultaneously from the preacher and the disc jockey as they layer two different timbres and produce a combination of sounds that commands, and receives, the attention of the audience. That evening, Tatum's sound quality was intensified as the audience remembered the times they had been "brought through" by God.

Closely related to the variance of vocal timbre is the manipulation of intonation, the deliberate use of rising and falling vocal pitches. This is an essential aspect of Tatum's concert performances and results in her production of "songified speech," a combination of intonation and set rhythmic patterns, reminiscent of the cadences associated with preachers. Just before bringing the Southern Cal choir to the stage of Carnegie Hall in 1977, she named several triumphant biblical figures, from Daniel to Jesus, and the physical locations at which they demonstrated their faith, from the lions' den to the Garden of Gethsemane.[60]

Tatum utilized changing intonation along with several other devices in presenting this narration. Besides varying her pitches, she incorporated parallelism, utilizing the phrase "We don't have . . ." repeatedly while stacking the names of characters and places in the biblical narrative. She varied the timing, as the ellipses suggest, letting the audience think about what she had just said and how she had said it before moving on to the next line. Though intonation can assist a speaker in sounding inquisitive, challenging, and spiritually moved, in this instance it provides Tatum with an emphatic lead-in. While it appears to focus on the negative ("We don't have . . ."), the cumulative effect is positive: "We may not have those beloved entities from the past, but here is a beloved aggregation talented enough to be mentioned in the same paragraph: The Southern California Community Choir." Generally, Tatum's "easy to listen to" voice, as Bertha Harris called it, along with her unique text, intonation, and timing, is what grabs her audiences.[61] It is not unusual for

her to be greeted at the end of a performance by admirers who say, "The choir didn't have to sing. I could have listened to you all night."[62]

Functional Dimensions

More important than the words gospel announcers speak are the functions of the performances within the African American community. Burnim maintains that "gospel music reflects and transmits a sense of the historical past for Black Americans" and "is simultaneously an agent for spiritual sustenance and an agent for reinforcement of cultural identity."[63] The words spoken by gospel announcers can function in the same manner. In fact, Tatum's narrations operate on several levels—historical, spiritual, and cultural.

Tatum frequently links social and spiritual references. During the Cleveland anniversary salute, she employed signification as described by numerous Black cultural theorists, to speak not only about the honoree and the rejection he had to endure in the early days of his music career but also about Black people and the racial barriers to which they were repeatedly subjected. She mentions the often-repeated comments about his vocal and instrumental limitations; Cleveland had a Louis Armstrong–like raspiness to his voice and, some charged, he played the piano in only one key. Yet Tatum and the others assembled exulted in the fact that God had chosen him to become an agent of change within gospel music despite these alleged shortcomings.

The audience could easily read between these spoken lines and know that Tatum was referring to the group and the individual simultaneously. Cleveland's closed doors were not unlike the denials other Black individuals had encountered in America, and many of his most famous lyrics ("I Don't Feel No-ways Tired") can be interpreted as spiritual and social commentaries in light of the struggle for civil rights. Tatum even added a little twist at the end, a cultural wink at the fact that some African Americans and others often say, "Black folks are always late." That's not a problem when God is the one in charge of your opportunities and blessings, she insisted.

Tatum made references to both a biblical narrative and a popular song during this introduction. She told the audience that a voice from heaven called Cleveland "my beloved Son," the same words that were heard on the day Jesus was baptized by John. Then she transitioned immediately to a popular cultural reference with the words, "You can't touch this." This line from MC Hammer's top-selling recording of the same name was a major catch phrase in 1990, the year of the Cleveland tribute. While many interpreted the line as a commentary on Hammer's notable dance skills, within the context of

Cleveland's fiftieth anniversary, the phrase highlighted Cleveland's unprecedented contributions to gospel music and celebrated the "untouchable" creativity of Black people.

Though Tatum draws material from secular culture, even more often she includes some aspects of "divine dialect," that is, the idioms Black church members have used for years. For example, during Cleveland's anniversary salute, she describes his traditional way with a gospel song as being able to fix hearts, minds, and souls. During her radio broadcasts, she implores the audience to be grateful because they still have "the blood running warm in their veins" and that the God who made that possible "didn't have to do it ... but He did." All of these are phrases frequently spoken or sung within the Black church; they are familiar to those outside the church as well. Tatum's ability to juxtapose the secular and the sacred, the contemporary and the historical helps to ensure that audiences will listen and respond strongly to the texts she delivers.

As a student of Black sacred music history, Tatum tries to incorporate aspects of it when it is appropriate for the occasion. One noteworthy example comes from her presentation at the 1993 GMWA board meeting. In it, she celebrated the roots of gospel music, which, according to Tatum, conveys the creativity and spirituality of a people whose bodies were enslaved but whose minds were wondrously connected to the Divine. They had no formal musical education, but they did know God intimately enough to create the Negro spirituals, music that sustained the enslaved and provided a base on which today's Black sacred music rests.[64]

Within the context of a gospel song service, Tatum's narrative functions as a cultural/historical marker, a reminder to the audience and performers that the music they are about to hear and sing is not a recent phenomenon, not just an "art form" as some would suggest. Spirituals and gospel music, which Tatum mentions in the passage above, are part of the continuum of expressive culture that bears witness to the techniques Blacks employed historically to challenge slavery and segregation. Through gospel music, singers offer testimony about the God to whom they pray and in whom they believe. Tatum's use of historical and cultural allusions is further evidence of her ability to create narrations that are both creative and functional.

Three decades after she first began narrating for the King of Gospel, Edna Tatum continues to perform in a manner that reflects her understanding of the cultural aesthetic embraced by her audiences. She does so with a flair that makes them conclude repeatedly, "The choir didn't have to sing; I could have listened to you all night."

Notes

An earlier version of Deborah Smith Pollard's chapter appeared as "Edna Tatum: Gospel Announcer and Narrator in Performance," *Womanist Research and Theory* 3.2/4.1 (Spring/Summer 2001/2002): 34–45. It is reprinted with permission of the publisher.

1. The term *gospel announcer* is used throughout this chapter to refer to anyone who plays recorded gospel music on radio and hosts live performances in churches, amphitheaters, and so on. We (I have been a gospel announcer in Detroit since 1982) are also called *gospel disc jockeys, personalities,* and *religious announcers.* However, I use *gospel announcers* because it is the name used by the Gospel Announcers Guild (GAG), an auxiliary of the Gospel Music Workshop of America, the largest gospel music convention in the world. An estimate of the number of gospel announcers was provided by Elder Samuel Williams, vice chair of the Gospel Announcers Guild of the GMWA, a gospel announcer himself on WBLS-FM in New York. Samuel Williams, telephone interview with the author, March 10, 1999.

2. Just as a preacher communicates through a sermon and the gospel singer through a song, the announcer is capable of creating text that can be pertinent to the historical, spiritual, social, or cultural concerns of the audience members. The announcer's words can spring from his or her own creativity and/or it can be culled from the community's bank of sacred and secular phrases and words (Smitherman 1986, 42–43). Regardless of the source, the right text, produced in the proper setting and combined with the appropriate timbre (vocal quality) and kinetics, can transcend the restrictive status of being "mere words." A gospel announcer's speech acts can reflect an understanding of African American struggle, affirm the strength and transcendence of the people, and acknowledge religion's role in their survival—much the way Burnim has identified these characteristics within gospel music itself. See Burnim, "Functional Dimensions," 112.

3. The manipulation of these key elements is explored by several scholars, including Burnim, "Black Gospel Music Tradition," 147–67; Davis, *I Got the Word in Me,* 49–64; and my unpublished dissertation written under the name Deborah Smith Barney, "Gospel Announcer," 167–264.

4. See Arthur Paris's description of the elements of the devotional service in "Ritual," in *Black Pentecostalism: Southern Religion in an Urban World,* by Arthur Paris (Amherst: University of Massachusetts Press, 1982), 45–79.

5. For examinations of the development of gospel music on radio, see, for example, Maultsby, "Impact of Gospel Music," 19–33; and Lornell, *Happy in the Service of the Lord,* 20–21.

6. For a summary of the history of gospel announcers and an exploration of their roles and responsibilities, see Barney, "Gospel Announcer." It is also the core issue in my article, "Gospel Announcers (Disk Jockeys): What They Do and Why It Matters," *Arkansas Review: A Journal of Delta Studies* 31.2 (August 2000): 87–101.

7. See John Miles Foley, ed., *Teaching Oral Traditions* (New York: Modern Language Association, 1998) to gain a sense of the range of the scholarship being devoted to this topic. For a discussion of a wide spectrum of lenses through which oral literature has been examined, see Rosemary Levy Zumwalt, "A Historical Glossary of Critical Approaches," 75–94, in that same anthology.

8. Bauman, *Verbal Art as Performance,* 38; Burnim, "Black Gospel Music Tradition," 156.

9. Goffman, *Frame Analysis,* 10.

10. Bauman, *Verbal Art as Performance,* 25–27.

11. Heilbut, *Gospel Sound,* 265–75; Young, *Woke Me Up This Morning,* 141–85.

12. Allen, *Singing in the Spirit;* Cantor, *Wheelin' on Beale,* 11–36; Landes, "WLAC," 67–82; Pollard, "Edna Tatum," 87–101.

13. Davis, *I Got the Word in Me,* 11, 46.

14. A sound-absent sermonphone involves a preacher opening his or her mouth without producing an audible sound. However, because of the context, the congregation clearly "hears" something communicated—the continuation of an idea or the frustration with a particular mode of behavior, for example. The congregation, then, responds as if actually words have been spoken ("Go ahead, preacher, I hear you"). See Davis, *I Got the Word in Me,* 100.

15. Burnim, "Complex" 162.

16. Barney, "Gospel Announcer," 1994.

17. Tatum works for the state of California in disability services management.

18. For example, she made friends with Annette May Thomas, daughter of Brother Joe May, one of the most popular performers during gospel's Golden Age, 1945–60, and Cora Martin Moore, a noted gospel composer and daughter of the great gospel publisher and pioneering performer, Sallie Martin.

19. Edna Tatum, telephone interview with author, October 9, 1993.

20. Ibid.

21. Ibid.

22. Edna Tatum, telephone interviews with author, October 9, 1993, and 7 March 1994.

23. Tatum interview, October 9, 1993.

24. Ibid.

25. Boyer, CD booklet notes, *Mahalia Jackson,* 20.

26. Tatum, narrator, *James Cleveland "Live" at Carnegie Hall.*

27. Tatum interview, October 9, 1993.

28. Cleveland, *James Cleveland "Live" at Carnegie Hall.*

29. Tatum, *Words and Music.*

30. Tatum interview, October 9, 1993.

31. Tatum, *Moments of Meditation.*

32. Tatum, *Higher Ground.*

33. For a comprehensive discussion of the importance of clothing within gospel music performance, see Burnim, "Black Gospel Music Tradition," 147–67.

34. The clothing possibilities for women who perform or attend performances within the church/gospel music setting currently include suits, dresses, and gowns, often enhanced with beading, metallic threads, and the like. Sometimes described as an "after-five" look, it was introduced to the gospel arena by the Ward Singers in the mid-twentieth century. See Horace Boyer, *How Sweet the Sound* (Washington, D.C.: Elliott & Clark, 1995), 106, 110. But the possibilities also include pantsuits, leather trousers, and even midriff-baring tops on some younger performers and consumers, a relaxed contemporary style that has been received with mixed reviews. In the book I am completing on gospel music at the turn of the twenty-first century, I look in-depth at this aspect of gospel music and the controversy the changing silhouette has generated. For the performance at Carnegie Hall, Cleveland asked if Tatum could wear black since that was the color that had been selected for the choir. She chose a long black dress with multicolored metallic threads running through it, accessorized by black leather pumps, and crystal and black earrings. Tatum chose an equally monochromatic white ensemble for the Dorothy Chandler Pavilion.

35. Tatum interview, October 9, 1993.

36. Smitherman, *Talkin' and Testifyin'*, 76–80; Williams-Jones, "Afro-American Gospel Music," 383.

37. Gospel music, which was part of church broadcasts in radio's earliest days (the 1920s), was initially offered by disc jockeys when Jack Cooper, the first Black disc jockey on a commercial station, played a variety of musical forms on his programs beginning in 1926. Subsequent Black disc jockeys often followed his model of making gospel part of a mixture of Black music they played. Others programed the blues or jazz on one show under one name and then played gospel on another program using a different religious-sounding name ("brother" or "reverend"). Eventually, the increasing popularity of gospel music created a demand by the community for radio programs entirely devoted to gospel and for announcers who could help create the atmosphere of church during a live concert. The gospel announcers, those who solely played gospel music and/or emceed gospel programs, first appeared in the late 1930s. See Barney, "Gospel Announcer." Also see Pollard, "Gospel Announcers (Disk Jockeys)," 87–101.

38. Davis, *I Got the Word in Me*, 67; Allen, *Singing in the Spirit*, 156–57.

39. Burnim, "Complex," 167; Raboteau, *Slave Religion*, 236.

40. Austin, *How to Do Things with Words*, 118.

41. Tatum, narrator, *James Cleveland "Live" at Carnegie Hall*.

42. Tatum, *Moments of Meditation*.

43. Tatum, *Higher Ground*.

44. In order to assess and gain insights into the performances of gospel announcers, I used the feedback interview, a strategy utilized since the 1950s and further defined and applied by ethnomusicologists Ruth M. Stone and Verlon L. Stone. See Stone

and Stone, "Event, Feedback, and Analysis," 215–25. The technique can include a variety of media and is used to determine the meanings constructed by those who perform and the meanings received by those in the audience (215).

For my study, I assembled eight gospel music professionals, including singers, musicians, and gospel announcers, and asked for their feedback on the performances I had on audiotape and videotape. As those tapes were running, I had a separate audiotape recorder ready to capture their responses to what they were experiencing. Whether they registered a response verbally or physically, I stopped the performance tape and asked them to elaborate on their reactions. See my dissertation (29–33) for further details of how these interviews were conducted and applied.

45. Davis, *I Got the Word in Me*, 80.

46. Tatum, *Savoy Records Presents*.

47. Tatum, introduction, Fiftieth Anniversary Salute.

48. Since I refer to a noncommercial tape recorded on site by a consultant for private use, there is no reason to believe that the recording has been manipulated.

49. Bauman, *Verbal Art as Performance*, 15–16.

50. Tatum, *Savoy Records Presents*.

51. Tatum, Gospel Music Workshop of America, Inc., board meeting.

52. Kochman, *Black and White Styles in Conflict*, 109.

53. This notational system is adapted from Peter Gold, who during his investigation of the performed sermon on St. John's Island, South Carolina, demonstrated the variety of rhetorical and paralinguistic devices that marked the text by reproducing the vocal and musical interaction between the preacher and the congregants. In his notation system, large type indicates stressed syllables and lower-case type indicates the unstressed (as in "MORning"). In my adaptation, the number of letter *R*s indicates the level of response from the audience. See Gold, "Black Sermon," 173–204.

54. Tatum, Southern California Community Choir's anniversary concert, n.d.

55. Smitherman offers the famous quatrain from the Reverend Jesse Jackson as an example of songified speech: "Africa would if Africa could / America could if America would / But Africa cain't / and America ain't." *Talkin' and Testifyin'*, 3.

56. Two of the feedback respondents from two different groups commented that Tatum reminded them of Nikki Giovanni, a Black poet and activist who, beginning in the 1970s, recorded several albums of poetry backed by the New York Community Choir, including *Truth Is on Its Way* and *Like A Ripple on A Pond*. I agree; the vocal timbres and styles of delivery are in fact very similar.

57. Cleveland, *James Cleveland "Live" at Carnegie Hall*.

58. Tatum, Southern California Community Choir's anniversary concert, n.d.

59. Beginning in the 1940s, Black secular disc jockeys would often incorporate a practice called "talking through a record." They would speak while the music, including the lyrics, was still playing. "Talking through" resulted in two distinct sources, the speaker's voice and the music, working on the listeners' senses at once. Rather than the music lessening the impact of the speaker's words, the effect, when the music

was not allowed to overpower the speaker, was that of the music enhancing and making the speaker's voice seem even more dramatic, full, and/or intense. If there are lyrics in the song, and if the volume of the music and of the speaker's voice is balanced, a kind of call-and-response motif can be created. For anyone who values both aural and oral stimuli, as many African Americans do, this can be an exciting combination. See Spaulding, "History of Black-Oriented Radio in Chicago," 81.

However, long before there were Black radio DJs, the minister "talked through" music at several points of the service. Those points included the sermon's end (as the keyboardist supported his conclusion); the invitation to join the church's fellowship, and the benediction (in both of these latter cases, the choir and/or congregation sings, usually with accompaniment, as the minister talks). Gospel announcers who utilize this device—keeping their microphone and music levels modulated—can masterfully create a compelling segment on radio as well as in the live concert setting.

60. Cleveland, *James Cleveland "Live" at Carnegie Hall.*

61. I have discovered that pitch is evocative to listeners. As a professional gospel announcer myself, I have had to control the pitch of my voice so that it is not construed as being "sexy." When I used my lowest pitch on the air, I got comments such as "Whatever you're selling, baby, I want some of that!" By using a more midrange pitch, I have been able to avert regular comments of that sort and to keep my (male) listeners focused on the message and not the messenger's voice.

62. Tatum interview, October 9, 1993.

63. Burnim "Functional Dimensions," 112.

64. Tatum, Gospel Music Workshop of America, Inc., board meeting.

Bibliography

Allen, Ray. *Singing in the Spirit: African American Sacred Quartets in New York City.* Philadelphia: University of Pennsylvania Press, 1991.

Austin, J. L. *How to Do Things with Words.* 1962. Reprint, Oxford: Oxford University Press, 1978.

Barney, Deborah Smith. "The Gospel Announcer and the Black Gospel Music Tradition." Ph.D. diss., Michigan State University, 1994.

Bateson, Gregory. *Steps to an Ecology of Mind.* 1955. Reprint, New York: Ballantine, 1972.

Bauman, Richard. *Verbal Art as Performance.* Prospect Heights, Ill.: Waveland, 1984.

Boyer, Horace Clarence. CD booklet notes. *Mahalia Jackson: Gospels, Spirituals, and Hymns.* Columbia/Legacy C2K 47083, 1991.

Burnim, Mellonee V. "The Black Gospel Music Tradition: A Complex of Ideology, Aesthetic, and Behavior." In *More than Dancing: Essays on Afro-American Music and Musicians,* edited by Irene Jackson, 147–67. Westport, Conn.: Greenwood Press, 1985.

———. "The Black Gospel Music Tradition: Symbol of Ethnicity." Ph.D. diss., Indiana University, 1980.

———. "Functional Dimensions of Gospel Music Performance." *Western Journal of Black Studies* 12.2 (1988): 112–21.

Cantor, Louis. *Wheelin' on Beale.* New York: Pharos Books, 1992.

Davis, Gerald L. *I Got the Word in Me and I Can Sing It, You Know.* 1985. Reprint, Philadelphia: University of Pennsylvania Press, 1987.

Goffman, Erving. *Frame Analysis.* New York: Harper and Row, 1974.

Gold, Peter. "The Black Sermon and the Communication of Innovation." In *Discourse in Ethnomusicology II: A Tribute to Alan P. Merriam,* edited by Caroline Card, Jane Cowan, Sally Carr Helton, Carl Rahkonen, and Laurie Kay Sommers, 173–204. Bloomington: Ethnomusicology Publications, 1981.

Halliday, M. A. K., and Ruqaiya Hasan. *Cohesion in English.* London: Longman Group, 1976.

Harrington, Brooksie. "Shirley Caesar: A Woman of Words." Ph.D. diss., Ohio State University, 1992.

Heilbut, Anthony. *The Gospel Sound: Good News and Bad Times.* New York: Limelight, 1985.

Kochman, Thomas. *Black and White Styles in Conflict.* Chicago: University of Chicago Press, 1981.

Landes, John L. "WLAC, the Hossman, and Their Influence on Black Gospel." *Black Music Research Journal* 7 (1987): 67–82. Center for Black Music Research, Columbia College, Chicago.

Lornell, Kip. *Happy in the Service of the Lord.* 2nd ed. Knoxville: University of Tennessee Press, 1995.

Maultsby, Portia K. "The Impact of Gospel Music on the Secular Music Industry." In *We'll Understand It Better By and By,* edited by Bernice Johnson Reagon, 19–33. Washington, D.C.: Smithsonian Institution Press, 1992.

"Negro Radio: Keystone of Community Life." *Sponsor,* August 24, 1953, 68–69, 72–73, 78–82.

Raboteau, Albert J. *Slave Religion: The "Invisible Institution" in the Antebellum South.* New York: Oxford University Press, 1978.

Smitherman, Geneva. *Talkin' and Testifyin': The Language of Black America.* 1977. Reprint, Boston: Houghton Mifflin, 1986.

Spaulding, Norman W. "History of Black-Oriented Radio in Chicago." Ph.D. diss., University of Illinois at Urbana-Champaign, 1981.

Stone, Ruth M., and Verlon L. Stone. "Event, Feedback, and Analysis: Research Media in the Study of Music Events." *Ethnomusicology,* May 1981, 215–25.

Tedlock, Dennis. "On the Translation of Style in Oral Narrative." In *Towards New Perspectives in Folklore,* edited by Richard Bauman and Americo Paredes, 114–22. Austin: University of Texas Press, 1972.

Young, Alan. *Woke Me Up This Morning: Black Gospel Singers and the Gospel Life.* Jackson: University Press of Mississippi, 1997.

Williams-Jones, Pearl. "Afro-American Gospel Music: A Crystallization of the Black Aesthetic." *Ethnomusicology* 19 (1975): 373–85.

PERSONAL AND FEEDBACK INTERVIEWS WITH THE AUTHOR

Craig, Joyce Cooper. Feedback interview. Detroit, February 19, 1994.
Ford, Darryl. Feedback interview. Detroit, February 19, 1994.
Grant, Allen Duane. Feedback interview. Detroit, February 24, 1994.
Harris, Bertha. Feedback interview. Detroit, February 15, 1994.
McMurtry, Larry. Feedback interview. Detroit, February 24, 1994.
Smith, Tim. Feedback interview. Detroit, February 15, 1994.
Tatum, Edna. Telephone interviews. October 9, 1993; March 7, 1994.
Wilks, E'lon Eloni. Feedback interview. Detroit, February 19, 1994.
Williams, Samuel. Telephone interview. March 10, 1999.
Wynn, Timothy. Feedback interview. Detroit, February 2, 1994.

EDNA TATUM PERFORMANCES

Gospel Music Workshop of America, Inc., board meeting. Narrator. March 1993. Audiocassette.

The Higher Ground. Guest announcer with Delores Poindexter. WTLC-AM, Indianapolis, February 6, 1994. Audiocassette.

Introduction. Fiftieth Anniversary Salute for the Reverend James Cleveland. Dorothy Chandler Pavilion, October 29, 1990. Audiocassette.

James Cleveland "Live" at Carnegie Hall. Narrator. Savoy DBL 7014, 1977.

Moments of Meditation. Host. May 1993. KMAX-AM, Los Angeles. Audiocassette.

Savoy Records Presents Reverend James Cleveland and the Northern and Southern California Choirs of the GMWA. Gospel announcer/narrator. Gospel Music Workshop of America, n.d. Savoy 9506. VHS.

Words and Music: Levitical Worship. Accompanied by Billy Preston. PepperCo Music Group PMG/12022-2, 1996.

5

Black Women, Jazz,
and Feminism

LINDA F. WILLIAMS

As a counterpart to examining cultural images and public or performative representations of African American women musicians, I would like to focus on the ways in which race, class, and gender are implicated in musicians' self-understandings of feminism. I draw on conversations with black women jazz musicians and my own experience as a performer in tandem with the writings and changing consciousness of African American women writers and critics influential since the 1970s. The interventions of these writers laid the groundwork for the fact that considerations of race and gender together have gone from a position of marginality within African American studies and American studies to a mainstream position that cannot be ignored. Since some of the most compelling black feminist writings tread the boundaries between gender, race, and class analyses, it is appropriate, in a discussion of black women's musical experiences, to emphasize the interdependence of these factors.[1]

Recent books by writers such as Eric Porter (*What Is This Thing Called Jazz?*) and Guthrie Ramsey (*Race Music*) are welcome contributions to the where? jazz literature, in part because of their inclusion of gender issues and women in discussions of jazz's racial politics.[2] Sherrie Tucker (*Swing Shift*) addresses the exclusionary practices of the "dominant swing discourse," its marginalization and fetishization of female musicians and bands, and the inordinate value critics and historians place on recordings, a disciplinary practice that disadvantages appraisals of female jazz instrumentalists and vocalists. Yet in spite of advancements such as these in intellectual circles, black women continue to fight battles in terms of gender and race on the bandstand.

Scholars have noted black women's ambivalence historically toward successive waves of (white) women's movements. Evelyn Brooks Higginbotham and Darlene Clark Hine situate black women's social engagement historically within the framework of the politics of respectability. This approach offers a mode of analysis for an investigation of black women musicians' advocacy of both gender and racial concerns.[3] Although a dedication to a broader set of social concerns predates black women's engagement with contemporary notions of either feminism or womanism, I use informal discussions to tease out musicians' conceptualizations of feminism and glean valuable insight into their negotiation of race and gender.

My research in Harare, Zimbabwe, into the reception of American jazz has further stimulated my thinking about black women in jazz cross-culturally. Yet when I shared my experiences on the bandstand with students, they had no comparable case studies to review. How could it be that I was in touch with a vibrant community of black women making music together while my students were completely unfamiliar with these musicians? I soon realized that the feminist and jazz literatures alike only rarely made reference to contemporary black women jazz musicians and their negotiation of race and gender in performance venues.[4] Realizing that there was a significant lacuna to be filled, I decided to take steps toward an investigation of contemporary black women musicians and their conceptualizations of feminism.

I would like to distinguish three basic positions that are invoked in African American feminist criticism (and by the women I interviewed) that serve to illustrate a general historical trajectory. The first, which I call *Speaking blackness*, is a position that prioritizes issues of race over issues of gender. Indeed, African American women who hold this perspective are often critical of the white racism endemic to much of early feminist movements. The second perspective I call *Speaking feminist*. By this I refer to the perspectives of African American women who argue that racism and sexism coexist and should be critiqued on equal terms. The third perspective, which I call *Speaking of class*, emphasizes that class plays an enormous role in shaping the experiences of black women in regard to racism and sexism. An intersectional mode of analysis that looks at how class cross-cuts the experiences of race and gender is suggested here.[5]

I have found that there are strong generational differences associated with each perspective. African American women born before 1945 emphasize the prioritization of racial empowerment over sexual liberation. This discourse indicts traditional feminism as racist and, in fact, as an inverted form of white patriarchy. Many African American women musicians born between

1945 and 1965 put forward the notion that racism and sexism coexist and should be critiqued and analyzed on equal terms. Younger African American women musicians, born between 1965 and 1985, many of whom are college trained in women's and gender studies courses, view class as a major factor affecting both racism and sexism. In short, age, status, and class play a major role in shaping African American women's viewpoints on and experiences of racism and sexism.

My investigation centered on the following questions: How does a self-conscious awareness of femaleness on the part of musicians translate according to the generation to which they belong? What does positioning ourselves in the masculinized musical culture of jazz entail? As one musician put it, how do "male chauvinists" and women with more feminist sensibilities negotiate their divergent musical and social perspectives on stage during performances, and what are the consequence of such encounters? How are musical sensibilities and goals shaped by associations of class, and how do these intersect with alliances along the lines of race and gender? These questions are intended to serve as an introduction to an area of gender and music research that is ripe for investigation by scholars of jazz, cultural studies, gender studies, and African American studies.

Speaking Blackness

Historically, some musicians have expressed their allegiances to black liberatory politics through their choice of repertoire. This has been particularly challenging for vocalists since so many of the "standards" vocalists might interpret are love songs. In his discussion of singer Abbey Lincoln as a social activist, Eric Porter describes the vexed position vocalists faced in cases where they wanted to sing socially relevant songs instead of typical love songs. He recounts how, having made the transition from a "supper club singer" to a serious "jazz artist," Lincoln, inspired by the civil rights movement, appeared on Max Roach's "landmark" album *We Insist! The Freedom Now Suite* in 1960. In 1961, she put out her own album, *Straight Ahead.*[6] Writes Porter: "Lincoln would not record again under her own name until 1973—the hiatus a product of both hostility to her politics and the ill fortunes of the jazz industry—but she remained among the most vocal of socially oriented jazz artists for much of the 1960s."[7] Porter lucidly traces Lincoln's "musical transformation as she publicly found her voice as an artist and as an African American woman during the politically charged period of the late 1950s and 1960s."[8] Porter writes, "The sense of womanhood she tried to express in her

music was in part based on a social and aesthetic commitment to a global black freedom struggle; it was a way of understanding her personal search for self-respect as part of a collective effort by black men and women to do the same. Jazz offered the opportunity to articulate her identity as a socially aware and responsible African America woman and to tap into the culture of the people she saw herself representing."[9]

My interactions with many black women musicians confirm that although African American female musicians may not profess an identifiably feminist rhetoric, throughout their careers they have advocated on their own behalf as women, blacks, and musicians. This holds true for women of the "speaking blackness" generation who came of age during the late 1950s and 1960s. Issues of equality and justice endemic to the nascent U.S. civil rights movement helped shaped their conceptualizations of identity.

Renowned Philadelphia jazz organist/pianist Shirley Scott emphasizes that the racism of mainstream society has played a more determining role in her professional and personal lives than gender discrepancies she has experienced in the jazz world. "I cannot change being black nor can I change being a woman," she states. "One thing for sure, I have not had a problem being a black woman on stage with a group of black males, but I have indeed experienced problems in being a Black person in American society."[10] One of the most successful jazz organist/pianists of her generation, Scott gained early experience during the mid-1950s playing piano in Philadelphia's thriving club scene with renowned tenor saxophonist John Coltrane. In the late 1950s, she became prominent as an organist with the Eddie "Lockjaw" Davis Trio. While many of her recordings consisted of trio sessions, it was her collaboration with Stanley Turrentine that brought her even more into the limelight. Scott's solo career encompassed over forty albums.[11]

I have also shared the stage with jazz and classical music organist and pianist Trudy Pitts, who for her lifetime achievements in the field was named "A Living Legend" by International Women in Jazz in 1996.[12] Pitts's views are informed by a lengthy career in which she has performed with John Coltrane, Lionel Hampton, Ben Webster, Erskine Hawkins, Sonny Stitt, Rahsaan Roland Kirk, James Moody, Stanley Turrentine, Pat Martino, Randy Brecker, and many more. Emphasizing a point of view underscored by her contemporary, Scott, Pitts states, "Blackness is more important than feminism of any kind. When white entrepreneurs close the door on black male musicians, they close the door on me too. In other words, my overall blackness is much more important to me, in my opinion, than black feminism or white feminism. As the strength of feminism continues to take hold, gain acceptance and validity,

thereby garnering the respect that it should have had all the time, I shall still be *black!* Nothing can change that, nor would I have it be changed. As an African American woman, I pay the dues of a woman without being a feminist."[13]

Although Pitts's partial dismissal of feminism might seem jarring by today's standards, it is important to bear in mind that Pitts and Scott came into their own at a time when second-wave feminism—black or white—had not yet emerged. Later, in the 1970s and early 1980s, Pitts and Scott, like many others, informally critiqued second-wave feminism's insensitivity to racial equality as many activists and academics engaged in a politic that privileged gender and attempts to overcome institutional sexism to the exclusion of a more-inclusive program that could address gender, race, and class issues. Although neither Pitts nor Scott identifies as a "feminist," their views on gender and race find resonance in the writings of feminists of color who critiqued totalizing formulations of the universal woman. Pitts and Scott acknowledged that African American women experience institutionalized racism still today, albeit in contrast to the overt racism experienced by an earlier generation of jazz singers and instrumentalists.

Speaking Feminist

Many female musicians born between 1945 and 1965 regard race and gender as comparable arenas for advocacy in their professional lives. Vocalist Raye Jones shared the view that race and gender were inseparable. Jones, who like most of the musicians interviewed has performed most often with black male musicians, spoke of the importance of her racial and gendered identities. She underscored her concern with the objectification of women musicians by her male counterparts and their sometimes hostile and condescending attitudes toward women performers.[14]

I asked saxophonist Fostina Dixon-Kilgoe if she had any particular coping mechanisms for relating in the predominantly male jazz world. She replied, "My professional colleagues do not define my femaleness. What defines my femaleness is how I interact in my personal relationships. I've grown to understand that people you work with are in one category and those in your personal life are in another. In other words, my survival has been my growth in spiritual awareness. This has been key. I can't allow the world's opinion of me to define my peace."

As we continued our conversation, Dixon-Kilgoe addressed the need for the jazz industry to welcome diversity. She said, "Jazz has limited its success because of not including diverse groups, including women. As a black

woman, I've had wonderful experiences with black men. A number of them have helped me develop my career, yet the business of jazz has limited itself by not having enough female voices out there. People have always said that I play like a man. When I was a child, that was a compliment. Now that I am an adult, it is not. I play like a competent woman. As a woman, there is a unique fabric I bring to music because of my spirit—it's just the voice of a woman.... The business of jazz over the years has done a disservice to itself by people not handling business. If you look at every other musical field (R&B, pop), they have all kinds of people. The jazz industry is the least successful financially. I've always said this is because we are not inclusive enough."[15]

Contemporary women singers have adopted various coping strategies for negotiating sexism and racism and the tensions between conservative male attitudes and black feminist ones. Recognizing racism and sexism as equally denigrating, Jones states, "I have worked with highly competent and loving African American and white male musicians who have spent significant time teaching and helping to prepare me as a vocal musician. I have also performed in various concerts with men who, in a sense, are egotistical and, moreover, in some ways, chauvinistic. In many ways, the performance is enhanced because while performing on stage with them, I consider myself equal to them."[16]

Illustrating her point with a recent incident, Jones adds:

> Just recently I heard through someone else that a musician with whom I work "liked the band," on my cd implying that he didn't care for me as the vocalist. I don't personalize these things, but then I am also not going to hire him again. What I am saying is that these types of slights continue to go on in the industry. Some men still exhibit an air of superiority in regard to women musicians. You know, we live in such an entertainment-driven culture that the spiritual aspect of life and human interactions is lost. Sure, formal musical training is important, but if your spirit is not right, then things don't happen for you. The backdrop of this story is that at age fifty, I have a debut cd out (*Sistah Girl's Lament*) and I have received rave revues in Finland and in Germany, and yet this level of disrespect continues.[17]

By "flipping the script" and adopting a temporary attitude of superiority toward musicians with whom she is playing, Jones has been able to interrupt the sexism directed toward her by sidemen either on the bandstand or at rehearsals. Political theorist Cathy Cohen and others have described the power dynamics Jones, Dixon-Kilgoe, and others depict as a process of "secondary marginalization." Marginalization, in general, is a process by which a

dominant group delegates secondary or inferior status to another group via ideologies, institutions, and social relationships. Secondary marginalization is a process of marginalization exercised by the more privileged members of marginal groups within the same society.[18]

Regard for the cultural context of black jazzwomen's experiences of sexism enhances our analysis. Vocalist Lucinda Jügen, a native of St. John, Virgin Islands, reported having to continually reject the roles of both caretaker and potential sex partner while performing as the band's female vocalist: "Unlike the British Caribbean with issues of class as predominant in society, and different from America with problems of racism, St. John, Virgin Island [predominantly black] is not loaded so much with race issues, but undeniably sexism weighs heavily in contemporary culture."[19] Ultimately, Jügen decided that her path to liberation was to resign and to begin organizing her own bands. In contrast to the arguments of some Afrocentric theorists, such as Clenora Hudson-Weems, that black women do not need to "find their voices," Jügen related that she felt that most of her life had been invested in remaining silent and "looking ladylike" in order to maintain credible rapport with her audience.[20] The irony of being the mouthpiece of the ensemble while using silence as a means of self-preservation suggests the difficulties black women musicians face in finding their voices in such a context of inequity.

I can relate my own experiences as a performer and as an ethnomusicologist researching jazz improvisation in Zimbabwe to Jügen's determination to "maintain credible rapport" with her audience. Previous studies about music making in Zimbabwe had suggested that women instrumentalists were often regarded as "disreputable."[21] However, as a saxophonist performing in one of the clubs in Harare where jazz bands appear nightly, I unexpectedly received the audience's support. Reflecting on this experience from my vantage point as an African American, I wrote:

> While observing and listening to the band for more than twenty minutes, I felt confident that I could express myself musically with the group. I unpacked my saxophone and spoke with the bandleader. Soon I was invited onto the platform to perform with the musicians. As I walked toward the bass player to get in tune, I noticed most of the people in the club had their eyes fixed on me. My heart pounded rapidly while I walked toward the microphone to test the volume level. Unexpectedly, a young woman in the audience stood up and shouted, "Carry that cross Sister; show them what *we* can do!" The young woman's expression of what I interpreted as pro-woman solidarity inspired

the dissipation of my fear, and despite the emotionally charged atmosphere, my feeling of dread was replaced with confidence. This sensation brought me into the larger social arena, causing me not to be absent from that world but to emerge as an active part of it.

Despite my initial trepidation, I recognized that social relations between men and women were mitigated by the intent of the audience. I soon realized that audience members, both male and female, welcomed my participation as a performer.

Jügen's desire to appear "ladylike" is consistent with the objectification experienced by some blues and many jazz women musicians. Elements of this objectification include "lighter skin" and a variety of components necessary for the performance of a "particular brand of femininity," including "the use of high heels, make-up, low necklines, an emphasize on thinness, gowns revealing plenty of bosom, and holding horns aloft as if the tools of the trade."[22]

As Raye Jones emphasized in our interview:

> The social constructs of race, gender, and class, etc. are exacerbated in the music field for women (primarily singers) who haven't studied music and who have limited [music] literacy. Formally trained musicians exhibit a general lack of respect and disregard for women who cannot read music. So sex appeal becomes the highest value placed on the female presence in the band, and their singing ability becomes secondary.[23]

In a related vein, Farrah Griffin observes that Billie Holiday "paved the way for the sepia chanteuses of the cabaret set—Lena Horne, Dorothy Dandridge, and Diahann Carroll."[24] Griffin discusses the myths that surrounded the artist, and in suggesting counternarratives to those that conjure the singer as a beautiful but tragic figure, she offers a new context for the appraisal of Holiday's talent and her influence on subsequent singers. She reminds us that Holiday "emerged at a time when the dominant cultural stereotypes of black women were mammy and the tragic mulatto."[25] Scholars concur that Holiday continues to be celebrated more for her tragic private life than for her contributions to modern jazz.[26] In the context of a racially demarcated jazz industry that reflected the country's ideological preoccupation with lighter skin and an idealized jazz artist usually imagined as male, Billie Holiday came to represent "the pinnacle of jazz vocal artistry as well as the marginalization of African Americans, women, and artists in American society."[27]

Abbey Lincoln, according to Porter, worked to cultivate a persona that

positioned her as an object of male desire.[28] Technologies of gender employed by Lincoln included not only her repertoire of "sexually suggestive popular songs and stage antics" but also her participation in photo shoots that made frequent visual allusions between Lincoln and film icon Marilyn Monroe, including, in 1954, a bikini centerfold in *Jet* magazine. Porter notes that "a writer for *Variety* called her a 'sultry dish with a lissome figure,' and *Time* observed that 'through her pouting lips floats out her sad, sexy lyrics in a voice smoky with longing.'"[29]

Although Lincoln's onstage sexuality was eventually replaced by her commitment to voicing a political and social conscience, her tactics model a pattern Sherrie Tucker has observed in which "women have combined or overshadowed their musical expertise with skilled performances of gender in order to make themselves palatable to the public."[30] Since maintenance of the beauty myth amounted to additional labor for women musicians, Tucker theorizes this complex of activity as "glamour as labor."[31] My own experience corresponds with Tucker's findings in that at one point during the 1970s, I began wearing dresses onstage just to prove that a woman could be feminine and "still play." My response contrasts with a strategy employed by Anita O'Day, a white jazz singer, who, as Tucker relates, in 1941 "attempted to counteract the 'different presence' of girl singers by wearing a band uniform instead of a gown."[32]

Speaking of Class

In the U.S. system of class, race, sex, social status, and education are inextricably linked. Disparate class backgrounds and positionalities among musicians reveal themselves in different ways: in the divergent perspectives between African American scholars and critics and talented performers with less formal education; in the differences between formally trained musicians and other performers who come up through the ranks, sometimes continuing to play mainly or entirely by ear; in the value assigned to formal training and education in various genres of music and performance; and in associations of performers and their dress, language, diction, style, and presentation. Some of these issues emerged during my conversations with jazz musicians; the writings of some black feminist theorists and other cultural critics also inform this discussion.

Race and class intersect in complex ways on different issues. African American female musicians who fit "middle-class standards" on the basis of their advanced education and professional credentials are more likely to think of

themselves foremost in terms of their occupational or professional standing. A college education facilitates access to forms of knowledge to which those who do not have access to university studies are precluded. For example, many who have not gone to college remain outside formal feminist teachings. As Joan Morgan explains, "Lack of college education explains why 'round-the-way girls aren't reading bell hooks."[33]

It might be argued that black women of certain class-status and educational backgrounds experience separation from, as bell hooks writes, "women who are daily beaten down, mentally, physically, and spiritually."[34] Within this context, the position of scholars and jazz artists may be recognized as distinct from the "'round-the-way" black women Joan Morgan alludes to in her argument. Although status markers are significant, it is nevertheless important to be mindful of the myriad ways racism affects black women's full participation in all aspects of music.

Morgan found that even older women who had lived through the women's movement of the 1970s had adverse reactions when informed about her new book on a younger generation of African American women and black feminism: "When I told older heads that I was writing a book, which explored, among other things, my generation of black women's precarious relationship with feminism, they looked at me like I was trying to re-invent the wheel. I got lectured ad nauseam about 'the racism of the White Feminist Movement,' 'the sixties and the seventies,' and 'feminism's historic irrelevance to black folks.'"[35] The older generation made sure that she was reminded of how feminism's ivory tower elitism excludes the masses . . . and that black women simply 'didn't have time for all that shit.'"[36]

Although it is clear that many African American women musicians are class conscious in the sense that they understand the factors governing where they stand and who benefits the most from the social system, my interviews reflect that for some black women elders coming of age in a segregated society, family values and a sense of community are more significant than class. Jazz organist Shirley Scott says, "Like many black people during the 1940s, we were black folks with humbling beginnings. We cared less about class and status because love, family values, and close community ties were embedded in our lives. . . . Respect and love became a substitution for class and status during the time I grew up."[37]

Coming of age and initially performing in the 1970s (unlike Shirley Scott and Trudy Pitts, who began their professional careers during the 1950s), jazz guitarist Monnette Sudler argues for an understanding of the specificity of black women's experiences: "To say, like our men, black women experience

racism as blacks, and like white women, we experience sexism as female, erases our total life experiences." Legal studies scholar Kimberle Crenshaw amplifies Sudler's point when she states: "Intersectionality captures the way in which the particular location of black women in dominant American social relations is unique and in some ways unassimilable into the discursive paradigms and gender and race domination."[38]

As I interviewed female musicians about their identities in terms of feminism, I noticed that some women referenced class issues and the role that "controlling images" of black women had on their self-conceptualizations.[39] For singer Raye Jones, Hoagy Carmichael's "Georgia on my Mind" carries connotations of a racialized history of class, gender, and status oppression. She says, "When I am on stage, I am mostly conscious and aware of my status, class, and sexuality. I feel fulfilled, until someone in the audience stands up and says, 'Oh, could you please sing "Georgia on My Mind" for me?' A song such as 'Georgia on My Mind' is stereotypical to me because it invokes a mammy-type-gutsy-style on stage. And I do not feel that way. As a woman, certainly I feel there are many songs that invoke these negative images of class and gender."[40] The mammy image represents a multifaceted oppression and is pivotal to connecting subordinate forces such as class, race, and gender. With its roots in the realities of the antebellum South and the popular discourse of that period, the mammy figure was created to position black women in a subordinate position by virtue of their race and sex. Like other controlling images (the sexually overpowering Jezebel, controlling matriarchs, and, later, undesirable welfare queens), "mammy" also served to maintain class subordination and to confine black women to disadvantaged, compromising positions. Given that musicians such as Ray Charles popularized "Georgia on My Mind" decades ago, I asked Jones if she would choose to remedy the situation by excising the song from her repertoire. She replied, "By no means. I just remember that years ago when I sang in predominantly white environments there was a body of songs audiences associated with black people and that's what they wanted to hear versus the music I had prepared to perform for them. They did not call for 'Afro Blue' or Nina Simone's 'Four Women.'"

Suggestions for Future Research

Future researchers could expand the study of black women musicians by interviewing broadly and by examining the musical repertoire of black women jazz musicians in relation to their politics or social engagement. Case stud-

ies of jazz singers Billie Holiday (see Davis and Griffin) and Abbey Lincoln (Porter) are touchstone examples of how jazz musicians—singers in particular—have embraced jazz as a "means to artistic fulfillment . . . and as a social statement."[41]

It will also be important to conduct critical ethnographic fieldwork with black women jazz musicians and consumers born between 1965 and 1985. Given that rap music and hip-hop are now considered mainstream in American popular culture, it is not surprising that the feminist representation and/or mischaracterizations of women in hip-hop and rap have outpaced by far parallel representations of black women jazz musicians such as contemporary female vocalists Carla Cook, Erykah Badu, and Cassandra Wilson. Perhaps this has as much to do with the prevailing interests of music investigators and the promotional strategies of popular music as it does with the need for a heightened awareness of race and gender in jazz circles. Compelling forces both within and outside the music industry have inspired hip-hop artists and critics to speak out about the ambivalent position in which they find themselves as women in the male-centered world of hip-hop.[42] And while some hip-hop artists sample jazz standards and draw on jazz compositional practices of experimentation, improvisation, and the creative expression of the spoken word, the "voices" of black women jazz musicians of the "now" generation remain underrepresented in the critical literature today.

Perhaps because of its perceived sophistication or inaccessibility in terms of harmonic vocabulary and approach, and its removal from the dance hall scene, jazz is seen as a more specialized genre requiring acquired knowledge or expertise on the part of the consumer. Jazz performance competence takes many years to achieve, often through private instrumental or vocal lessons and participation on a regular basis in jazz ensembles. Opportunities to major in jazz performance studies at the college level abound; unfortunately, many young aspiring musicians who might otherwise be interested in pursuing this path can not afford to participate in the music-related (and extracurricular) activities that would prepare them for studies at the undergraduate level. There has been a significant shift in contexts for "learning the changes" in jazz: from the nightclub to the classroom.[43]

Programs based in music departments or music schools however, are not the only places for teaching, learning, and conducting research about jazz. Women's studies and cultural studies courses are home sites from which students can design and carry out independent research projects on contemporary black women jazz musicians. In an essay calling for African American studies programs to incorporate more studies of jazz and other types of Af-

rican American music into their curricula, Nancy Dawson reports the results of a survey she administered to two hundred African American students at a midwestern university.[44] Dawson's survey results suggest that additional course offerings in jazz appreciation, combined with the broadcasting of diverse types of jazz radio programming ("smooth," bebop, avant-garde), will go a long way in facilitating consumer appreciation for this art form. Both course offerings and broadcasting will expose listeners and potential audience members to the music of more contemporary black women jazz musicians. Clearly, more compensatory scholarship remains to be undertaken. Future studies might explore the genre's internal contradiction in regard to women musicians; that is, throughout its history, the culture of jazz has embraced innovation, as reflected in compositional/creative processes, while at the same time circumscribing opportunities for black women through the perpetuation of race and gender ideologies. I suggest that a chapter has yet to be written about contemporary younger black women musicians and the particularities of their race, gender, feminist—and jazz—identities.

As I have suggested in this chapter, black women musicians have complicated relationships to feminism, nuanced not only by their race, class, and gender identities but also by genre. Future studies of black women jazz musicians and feminism can only benefit as age and generation are considered as well. Until we fully embrace the intersectionality of all these variables—including those of age, generation, and genre—our efforts to understand the challenges experienced by black women musicians of the twenty-first century will be compromised.

Notes

Part of this chapter is published with the permission of Adama Publications, Wilmington, Delaware.

I would like to express my heartfelt appreciation to Eileen M. Hayes, Ingrid Monson, Cornelia Fales, Maria Johnson, and Portia K. Maultsby for providing me with critical feedback on this chapter.

1. Audre Lorde, *Sister Outsider* (Freedom, Calif.: Crossing Press, 1984); Barbara Smith, *Home Girls: A Black Feminist Anthology* (New York: Kitchen Table/Women of Color Press, 1983); bell hooks, *Ain't I a Woman?* (Boston: South End Press, 1981). This study is based on research conducted in Philadelphia; Atlanta; Detroit; Washington, D.C.; Wilmington, Delaware; Seattle; Portland, Oregon; and St. Thomas, Virgin Islands (January 2000 to January 2002).

2. Guthrie P. Ramsey Jr., *Race Music: Black Cultures from Bebop to Hip-Hop* (Berkeley and Los Angeles: University of California Press, 2003); Eric Porter, *What Is This*

Thing Called Jazz? African American Musicians as Artists, Critics, and Activists (Berkeley and Los Angeles: University of California Press, 2002).

3. Darlene Clark Hine, "Rape and the Inner Lives of Black Women in the Middle West: Preliminary Thoughts on the Culture of Dissemblance," *Signs* 14 (Summer 1989): 912–20; Evelyn Brooks Higginbotham, *Righteous Discontent: The Women's Movement in the Black Baptist Church, 1880–1920* (Cambridge, Mass.: Harvard University Press, 1993), 185–229; Patricia Hill Collins, *Black Feminist Thought: Knowledge, Consciousness, and the Politics of Engagement* (Boston: Unwin Hyman, 1990; New York: Routledge, 1991).

4. A welcome recent addition to the literature is Wayne Enstice and Janis Stockhouse, *Jazzwomen: Conversations with Twenty-One Musicians* (Bloomington: Indiana University Press, 2005).

5. See Joan Morgan, *When Chickenheads Come Home to Roost: A Hip-Hop Feminist Breaks It Down* (New York: Simon & Schuster, 2000).

6. Porter, *What Is This Thing Called Jazz?* 149.

7. Ibid. By "under her own name," Porter refers to the fact that Lincoln married Max Roach in 1962.

8. Ibid.

9. Ibid., 153.

10. Shirley Scott, interview with author, Philadelphia, April 29, 2000. Shirley Scott died in 2002, just as these interviews were being completed.

11. Scott's solo career resulted in twenty-three albums for Prestige (1958–64), ten for Impulse (1963–68), three for Atlantic Records (1968–70), three for Cadet (1971–73), one for Strata (1974), two for Muse (1989–91), and three for Candide (1991–92).

12. The source for this information was on a page at the International Women in Jazz web site, http://66.421.215.116/iwjazz/newlook.cfm?itemCategory (accessed June 13, 2006).

13. Trudy Pitts, interview with author, Philadelphia, April 24, 2000.

14. Raye Jones, interview with author, Wilmington, Del., August 4, 2000. Jones is from Wilmington.

15. Fostina Dixon-Kilgoe, interview with author, July 7, 2005.

16. Jones interview, August 4, 2000.

17. Raye Jones, *Sistah Girl's Lament,* FVC Records.

18. Cathy Cohen, *The Boundaries of Blackness: AIDS and the Breakdown of Black Politics* (Chicago: University of Chicago Press, 1999), 70.

19. Lucinda Jügen, interview with author, St. John, Virgin Islands, July 20, 2000.

20. Hudson-Weems makes this argument in *Africana Womanist Literary Theory.*

21. See Eve MacNamara, *Women in Zimbabwe: An Annotated Bibliography* (Harare: Department of Sociology, University of Zimbabwe). See also Angela Impey, "They Want Us with Salt and Onions: Women in the Zimbabwean Music Industry" (Ph.D. diss., Indiana University).

22. Sherrie Tucker, *Swing Shift*, 57.

23. Raye Jones, interview with author, June 9, 2005.

24. Farrah Jasmine Griffin, *If You Can't Be Free, Be a Mystery: In Search of Billie Holiday* (New York: Free Press, 2001), 27.

25. Ibid., 28.

26. Tucker, *Swing Shift*, 57. See also Griffin's discussion in *If You Can't Be Free, Be a Mystery.*

27. Porter, *What Is This Thing Called Jazz?* 150.

28. Ibid.

29. Ibid., 151. Porter credits the following articles as indicative that the marketing strategy promoting Lincoln was successful: "Nightclub Reviews: Black Orchid, Chi," *Variety*, August 1, 1957, 55; "Music," *Time*, July 14, 1956, 45.

30. Tucker, *Swing Shift*, 57.

31. Ibid., 63.

32. Ibid., 57

33. Ibid., 53.

34. bell hooks, "Black Women: Shaping Feminist Theory," in *The Black Feminist Reader*, ed. Joy James and T. Denean Sharpley-Whiting (Malden, Mass.: Blackwell, 2000), 131.

35. Tucker, *Swing Shift*, 52–53.

36. Ibid.

37. Scott interview.

38. Sudler, cited in Collins, *Fighting Words.*

39. See Collins, *Black Feminist Thought*, 7.

40. Jones interview, August 4, 2000.

41. Porter, *What Is This Thing Called Jazz?* 149.

42. For a discussion of the contingent feminist identification of black women rappers, see Tricia Rose's *Black Noise: Rap Music and Black Culture in Contemporary America* (Hanover, N.H: Wesleyan University Press, 1994). See also Cheryl Keyes, *Rap Music and Street Consciousness* (Urbana: University of Illinois Press, 2002) and Gwendolyn Pough, *Check It While I Wreck It: Black Womanhood, Hip-Hop Culture, and the Public Sphere* (Boston: Northeastern University Press, 2004).

43. I am grateful to Maria Johnson for pointing this out.

44. Nancy Dawson, "Can You Sing Jazz? Perception and Appreciation of Jazz Music among African American Young Adults," in *African American Jazz and Rap: Social and Philosophical Examinations of Black Expressive Behavior*, ed. James L. Conyers Jr. (Jefferson, N.C.: McFarland, 2001), reports that most of the students were enrolled in African American Studies classes.

6

Women of the Association for the Advancement of Creative Musicians: Four Narratives

NANETTE DE JONG

If we don't have a history of jazz that deals with men
and women, masculinity and femininity, especially
the invisibility of women in jazz, we're going to have a
really bankrupt history of the music.
—Robin D. G. Kelley, "Talking Jazz"

The free jazz movement emerged in the 1950s and 1960s. Musicians
sought experimental approaches to sound, abandoning traditional modes
of musical harmony, rhythm, and meter in favor of creative independence
and freedom. Their approach represented a type of social liberation—an
unlocking of unfamiliar musical frontiers, a questioning and rejection of
musical norms. Motivations of "preserving music, Black music," guided
some musicians to organize into collectives, following the path of other Black
nationalists seeking positions of community and group strength.[1] The Chi-
cago-based Association for the Advancement of Creative Musicians (AACM)
was one such musicians' collective to emerge.

Prior to the free jazz movement, the music industry had identified jazz
through strict boundaries, and musicians wanting their music recorded were
obligated to conform. Because free jazz musicians challenged classification,
their music was harshly criticized. "If you can't define jazz, it doesn't exist,"
critics argued.[2] Musicians quickly realized that, if they were to gain creative

authority over their music, they would need to assume active roles in defining and producing their music. Members of the AACM promptly became their own booking and publicity agents; they created their own music-publishing centers, and they established their own music clubs.[3] Gradually, the AACM captured the interest of a few critics. The writings of critics—from journal articles to magazine commentaries—generally represented the organization through the work of its male members. Although women had been part of the AACM from early on, their contributions were often overlooked or misinterpreted.

Women of the AACM have faced double invisibility at the hands of music critics, elided in written accounts because of their gender and musical preference. In spite of leadership roles assumed by Rita Warford, Ann Ward, Amina Claudine Meyers, and others, a complete history of women in the organization has yet to be written. This chapter serves as an initial step toward writing women into the history of free jazz through the narratives of four musicians who were either affiliated with the AACM or actual members of the organization: Iqua Colson, Maia, Nicole Mitchell, and Coco Elysses. These women fuse their self-conceptualizations of race, gender, spirituality, and music to create hybrid aesthetics that transcend ethnic essentialism and identity politics. When viewed collectively, the narratives cited herein authorize new claims on experimental music, their distinct approaches confirming the depth to which personal style frames the parameters of free jazz. When viewed individually, the distinctiveness of their respective approaches to music is revealed, epitomizing, from a music perspective, Patricia Hill Collins's theory that "no homogenous Black woman's standpoint exists. . . . There is no essential or archetypal Black woman whose experiences stand as normal, normative, and thereby authentic."[4]

The AACM and the Making of a Jazz Canon

As AACM saxophonist Anthony Braxton pointed out, when the music industry "set an agenda for the music," limitations were imposed on creativity, expectations of musical style were set forth, and a perceived sense of tradition was established.[5] Theodor W. Adorno's essay "On Jazz," however problematic its final critique, exposed the costs of canon formation, by which selected critics ended up instructing "the adjustment of reality to the masses and of the masses to reality," promoting jazz styles in accordance to "commercial production and consumption," leaving jazz musicians "to yield more and more autonomy to the system."[6]

Music producers refused to record the new jazz music, worried it lacked commercial value, complaining, "We don't need the Elijah Muhammad type of thinking in jazz."[7] Critics questioned its legitimacy, dismissing concepts of musical freedom as mere gimmickry. Traditionalists were seldom converted, finding themselves unable or unwilling to hear avant-garde sounds as "by any stretch of the imagination musical."[8] The difficulties critics had in coming to terms with the music reflected the shortfalls of the classification system endorsed by the industry: critics' narrow vision of jazz could not accommodate the broadly diverse approaches pursued in free jazz. Controversy even emerged regarding what the music should be called. Leonard Feather categorized the new sound as *cosa nova* ("new thing") and jazz critic Stanley Dance referred to it as *nouvelle gauche* ("new, from the left"), yet it was the title of Ornette Coleman's groundbreaking album *Free Jazz* that emerged as the preferred choice among critics, used to define both the musical style and the movement.[9] The AACM, furthering its goals of self-representation, chose to distinguish the music with its own terminologies. Calling it *Great Black Music,* organization members confronted America's jazz establishment head-on, making their music immediately culturally distinct.

Because commercial recordings had become the principal venue by which jazz history was documented (and thus canonized), AACM musicians found themselves and their music entangled in capitalist regimes of music production and consumption. Without the possibility of recording and producing their music, they and their musical compositions faced certain obscurity. However, to record their music in accordance with the industry's standards and preferences meant that free jazz musicians would have to abandon critical creative endeavors. Part of solving this dilemma involved AACM members attaining a means by which to record their music.

AACM musicians rarely played in the "typical" jazz spots; they preferred to perform in small theaters, coffeehouses, churches, and outdoor parks. As a result, their music went generally unnoticed by the jazz public. Chuck Nessa, an employee at Delmark Records (a privately owned Chicago blues label),[10] reflects on a concert he attended by AACM saxophonist Roscoe Mitchell: "I ran backstage and spoke to Roscoe and said I wanted to talk about doing a record. As I remember he and [pianist and AACM cofounder] Muhal [Richard Abrams] came down the next day and we came to an agreement to do a record. I spent a lot of time with Roscoe, basically learning the music, because it was all new to me. I asked him who I should pay attention to because he was all I had heard of the AACM. He said Muhal of course, and [saxophonist] Joseph Jarman."[11]

Delmark recorded and produced AACM's first recording in 1966, *Sound*, featuring Mitchell and his sextet.[12] At the encouragement of Delmark owner Robert Koester, Nessa collaborated with the AACM on two other recordings: Joseph Jarman's *Song For* and Muhal Richard Abrams's *Levels and Degrees of Light*.[13] When Nessa began his own independent label in 1967 (named Nessa Records), he continued to produce recordings by AACM members, including trumpeters Lester Bowie (*Numbers 1 & 2*) and Leo Smith (*Spirit Catcher*), saxophonist Fred Anderson (*The Missing Link*), the Art Ensemble of Chicago (*People in Sorrow* and *Les Stances à Sophie*), and Roscoe Mitchell (*Old/Quartet, Congliptious, Nonaah, L-R-G/The Maze/S II Examples,* and *Snurdy McGurdy and Her Dancin' Shoes*).[14]

Meanwhile, Koester sponsored his own series of AACM recordings under his Delmark label, documenting the music of Jarman (*As If It Were the Seasons*), Braxton (*Three Compositions of New Jazz* and *For Alto*), Abrams (*Young at Heart, Wise in Time,* and *Things to Come from Those Now Gone*), saxophonist Kalaparusha Maurice McIntyre (*Humility in the Light of Creator*), trumpeter Malachi Thompson (*Timeline*), and the Art Ensemble of Chicago (*Live 1972*).[15]

Together, Delmark and Nessa recorded an AACM history and rewrote the jazz canon to include organization members. Important to this chapter, however, is the fact that none of these recordings featured women performers. When music critics began writing on the AACM, they relied on this limited—and gender-exclusive—recording history to guide their accounts. Women, as a result, found themselves in a Catch-22: due to their lack of recordings, they were omitted from critics' discussions; in being overlooked by jazz critics, their contributions remained excluded from even this contemporary amendment to the jazz canon. [*an absence*]

Jazz criticism, as it pertained to the AACM, came from two main philosophical camps. There were those critics, such as Ekkehard Jost and John Litweiler, who separated the musical aesthetics of the AACM from the political.[16] After a quick, almost conventional nod to the struggles of Black revolution, these critics moved directly into music analysis, providing lists of selected members that they in turn critiqued, often through musical transcription. Other critics, such as Amiri Baraka, Frank Kofsky, and Valerie Wilmer, connected the musical techniques of free jazz to Black cultural nationalism, thereby placing the AACM and Great Black Music squarely within the rhetoric of Black power.[17] Saxophonist Anthony Braxton captured particular interest from critics, several of whom have devoted books on his music, including Ronald Radano (*New Musical Figurations*), Graham Lock (*Forces in Motion*

and *Mixtery,* edited by Lock), Mike Heffley (*The Music of Anthony Braxton*), and Alun Ford (*Anthony Braxton*).

Although critics approached the AACM from different angles, almost all were intent to show that a large number of divergent personal styles had developed under the rubric of Great Black Music and that different philosophies of musical freedom had emerged as important among the musicians. The music's "heterogeneous formative principles" must be brought forward, said Jost, "after which we [the critics] can go on to discover general tendencies and trends."[18] Ironically, by omitting the women from their discussions, their goal to expose the complexities of free jazz is left unmet.

Traditional criteria of analyses simply are impractical when discussing the contributions of AACM women musicians. Women musicians remain largely unrecorded, their musical lives undocumented. Taking the lead from Sherrie Tucker in her work on all-women jazz bands, this chapter relies on oral narratives as a way to bring the women into the history of Great Black Music.[19] Their narratives provide valuable opportunities for retelling and reinterpreting jazz history, enabling us to take into account the complexities—"men and women, masculinity and femininity, especially the invisibility of women in jazz"—to which the creative world ultimately relates.

Iqua Colson

The AACM encouraged musicians to engage in their own unique process of self-discovery. For Iqua Colson, one of the earliest women members, that journey found aesthetic expression in the experimentation of the jazz avant-garde. Her explorations of free meter, free form, and group improvisation were reflective of the free jazz movement at large, and her training in classical piano and voice, as well as jazz, represented a mixing of musical aesthetics and ideologies that had come to define the AACM.

Colson entered Northwestern University as a classical pianist but changed her major to classical voice within the first year because her real intent was to become a jazz singer. She had become aware of the AACM through its recordings, which she carefully analyzed, critiquing the musicians' varied compositional techniques. Her interest in the organization and in genres of improvisation intensified when, as a singer, she joined a jazz band headed by Northwestern piano major Steve Colson (her soon-to-be husband). Saxophonist Chico Freeman, also a student at Northwestern, was likewise a member of the band. Balancing classical music studies with jazz was not an easy task, particularly at a university where the academic emphasis and expectations

were clearly on classical music. Transferring to Roosevelt University after her sophomore year, Colson finally found the academic freedom and support to explore a wider variety of musical genres, which she pursued with vigor.

At nineteen, she attended her first AACM concert: a performance by the Art Ensemble of Chicago, held on the University of Chicago campus. Colson recalls that entering Mandel Hall auditorium was synonymous with becoming part of a new and extraordinary world. Musicians "were running up and down the aisles, they were in costume; they had all these little instruments. It was a whole new thing."[20]

Colson quickly developed a rapport with other AACM musicians, including drummer Steve McCall and bassist Fred Hopkins. Colson recalls: "After joining the AACM, I spent time developing a sound with Steve in our band, The Colson Unity Troupe, which regularly included Wallace McMillan and Dushun Mosley. In this context we brought in various instrumentalists to perform with us, including AACM members Joseph Jarman, Kahil El'Zabar, Rasul Siddik, Chico Freeman, Henry Threadgill, Malachi Favors, Steve McCall, and Fred Hopkins ... and I sometimes performed with the AACM Orchestra—conducted by Muhal [Abrahms] and others—earlier known as the Experimental Band. ... I also was part of a band that Amina Claudine Meyers led. This band included other women as well."[21]

Some members held sessions in the home of Abrams. For Iqua Colson, sessions elsewhere became an extension of her training ground in creative music: "We would listen to and analyze the musical styles together. ... If we wrote music separately, we would always come together and discuss our choices. We discussed the history of the music, and the new directions we wished to take it."[22]

Colson experimented with new vocal techniques and developed talents in music composition. While her earliest works represented a more neoclassical approach, she soon cultivated a compositional style that was more complex and fragmented, the harmonies more dissonant and chromatic. Her approach to music resolution came not from the traditional return to a tonal center but out of sharp dissonances moving toward those less harsh. When Colson joined an ensemble headed by an AACM veteran, saxophonist Fred Anderson, her compositional style again changed, influenced by Anderson's unique conceptual approach to musical sound. "Every week we were working on sound," she explains. "It pointed me in new musical directions."[23] Colson's concepts of melody and harmony were even further displaced by her experimentation with timbre and textures of sound. She extended the concept of atonality by further experimentation with tone color. Articula-

tion, dynamics, changes in tempo, and choices in musical timbre emerged as pivotal elements in her compositions.

Because the tradition of avant-garde jazz included few women musicians, Colson wanted to be taken seriously by her peers as a competent musician. She points to the AACM goals (fig. 6.1) as a force enabling female and male unity within the organization. These goals of self-respect and self-definition, she argues, were conceived as prisms through which members could evaluate their own lives, better themselves and the community at large, and organize creative musicians into a single unit of power. Although male musicians predominated in the organization, the credo was conceived and organized by a group of men and women, including Peggy Abrams and Sandra Lashley, among others. Colson affirms: "The goals speak to the musician in general . . . [and] were written without reference to gender. . . .The goals are all-inclusive. The women would have similar concerns."[24]

During the late 1970s, Iqua Colson, along with Steve Colson, Kahil El'Zabar, and Douglas Ewart, planned and carried out the first International AACM Festival for the thirteenth anniversary of the AACM. Iqua Colson dealt with public relations and production, organizing and bringing in patrons as well

1. To cultivate young musicians and to create music of a high artistic level for the general public through the presentation of programs designed to magnify the importance of creative music.

2. To create an atmosphere conducive to artistic endeavors for the artistically inclined by maintaining a workshop for the express purpose of bringing talented musicians together.

3. To conduct free training programs for young, aspiring musicians.

4. To provide a source of employment for worthy, creative musicians.

5. To set an example of high moral standards for musicians, and to uplift the public image of creative musicians.

6. To increase mutual respect between creative artists and musical tradesmen (booking agents, managers, promoters, instrument manufacturers, etc.).

7. To uphold the tradition of elevated cultured musicians, handed down from the past.

8. To stimulate spiritual growth in creative artists through participation in programs, concerts, recitals, etc.

9. To assist other complementary charitable organizations.

Fig. 6.1. Statement of AACM Goals and Aims

as the international and local press. Later she was selected by the AACM to sit on the Board of Directors of the Jazz Institute of Chicago as the AACM representative.

After moving to New Jersey with her husband in 1982, Colson worked on select projects with the AACM and performed at numerous AACM events. In the years intervening, she has worked with an extensive range of prominent jazz musicians and other artists beyond the realm of the AACM.[25] Colson has remained active in the AACM, writing music and performing as soloist and as part of a duo with her husband Steve, also an AACM member. As a musical duo, the Colsons have traveled a profound musical and spiritual journey, their relationship a complex musical partnership to which the AACM provided a foundation for their mutual development. Colson continues to perform and write music. Her international performances have taken her to Africa, Asia, the Caribbean, and Europe. Iqua and Steve Colson have become attuned to each other's compositional sensibilities, aware that the transcendent potential in free jazz comes from using the music to reach goals of self-realization. The Colsons collaborate on everything from multimedia works to sextets, to duets and orchestral compositions. At the same time, Iqua Colson's success in arts education, grantsmanship, and arts management reflects her penchant for an ever-increasing expansion of her creative energies and her continued commitment to community development through the arts. Maintaining the core ideologies of the AACM jam session, she and her husband, in rehearsals today, "discuss the music, [and] the music starts to change—it evolves through [the exchange between] our two musical voices."[26]

Maia

Maia, active with the organization during the late 1980s and early 1990s, represents a second wave of women members of the AACM. Her myriad interests as a visual artist, playwright, poet, dancer, actress, and musician make it difficult to describe her as a musician only.[27] Maia adopted an "interdisciplinary approach" that recast the social criticism pursued by male members to contest racial discrimination with "revised themes of womanhood." As Maia has explained it, "Women have always been living in a male-run society. So we've learned to coexist with the men. But in coexisting, we face the challenges of maintaining an individuality separate from the men."[28]

Pointing toward new paradigms of gender and race, Maia created a supportive subgroup within the AACM through which to initiate "the woman

voice," an all-women AACM ensemble. Although not the first all-women ensemble in the AACM, Maia recalled, the "women needed a place to call their own. We needed a space to explore our creative spirits outside male realities."[29] Originally, Maia planned a flute ensemble, with hopes of first establishing a trio with flutist Nicole Mitchell and bassist Shanta Nurullah. The women named themselves Samana, a title that holds several meanings.[30] The word was introduced to them by Maia, who suggested that "mana" referred to bread from heaven. Mitchell was familiar with the word through reading of the writings of Herman Hesse, who used the term in his novel *Siddhartha* to refer to the various saints living in the forest. These saints, Mitchell specified, "do three things: think, fast, and pray. We felt connected to that! We wanted our music to be nourishment, to have healing aspects. 'Samana' fit us."[31] The name was adopted also because it reflected the individual names of the three women, taking the initials of their first names and intertwining the letters with three letter *As*.[32] Lastly, the women's attraction to *Siddhartha* reflected the changing nature of American religion during the 1980s and 1990s, meaning that they were open to considering the influence of East Asia–influenced spiritualities that had emerged in the Black community. For the women of Samana, the fusion of free jazz and spiritual transcendence represented yet another (and often overlooked) approach to musical freedom.

As more women showed interest in Samana, Maia, a "multidimensional expressionist," expanded the ensemble in efforts to include other performers.[33] Coco Elysses was enlisted to play percussion, including tympani and conga drums. While Mitchell continued as flutist, she also integrated her talents for dance, vocals, and visual artistry and joined Elysses on percussion. In addition to playing string bass, Shanta Nurullah became the group's world music specialist, playing instruments ranging from the Indian sitar to the Zimbabwean mbira, along with a variety of small percussion instruments. Aquilla Sadalla performed E-flat, B-flat, and bass clarinet, as well as violin, percussion, and vocals. Regina Perkins specialized in vocals and percussion, including djun-djun, djimbe drums, and shakeré.

The unique instrumentation and performance practices of Samana were nothing new to the AACM. A major stylistic feature of the organization throughout its history had been the expectation that musicians learn a wide variety of musical instruments with appropriate musical styles from different cultures and traditions in order to reflect hybrid concepts of self. Male members who played saxophone were expected not only to learn all members of the saxophone family but also to become proficient on the clarinet, bass clarinet, flute, piccolo, and a host of percussion instruments. Similarly, trumpet players were required to double not only on the fluegelhorn, bugle,

and piccolo trumpet but also on non-Western horns as well, including conch shells and horns made from elephant tusks. Historically, AACM members had integrated poetry and storytelling into their performances, an adopted tradition they equated with the *griots* of West Africa. For members of Samana, however, the motivation behind this multidimensional approach was different. Theirs represented a spiritual and musical sovereignty that challenged time-honored aesthetic binaries like male/female, secular/sacred, and East/West. By recognizing and encouraging the multiple roles of its members, Samana welcomed—even helped promote—plurality. Suggesting the uniqueness of the African American female experience, Maia explained, "We have so many dimensions within us. . . .Because our lives are interdisciplinary, you can imagine our performances—which ultimately reflect our lives, our experiences—will also be interdisciplinary!"[34]

Self-definition had long been a goal of AACM members, nurtured during the early years by Muhal Richard Abrams. Joseph Jarman remembered, "Muhal was the one who had all the practical experience and organizational skills, the one we all felt we could count on and respect."[35] Among those involved in Samana, Maia assumed the role of musical guide, and, as Abrams had coached the young players of the Experimental Band, she encouraged the women of Samana to express their identities through music. She facilitated rehearsals for which musicians would bring their own compositions and advocated for a stronger feminist ethos by encouraging the women to write in ways that would "keep [the focus] on us, on our life expressions."[36]

New compositional techniques emerged, of which the most important was based on the metaphor of a crossroads, representing the diverse experience of the African American woman musician facing an intersection of race, class, nationality, and gender ideologies. Maia pointed out that from the matrix of possibilities from which the women could draw musical, compositional, and personal inspiration, they had to forge a musical path that demonstrated independence. They showed the world that women would no longer allow society to dictate permissible paths. Explained Maia, "The ability to make a choice, live life, and then, according to the life lived up to that time, re-evaluate the choice and change that choice, is part of the female awareness process." Bringing that awareness into the music, performers participated in self-discovery processes, which in turn enabled the musicians to redefine themselves in relation to new, revised standards of jazz artistry. "We strengthened ourselves by acknowledging that we are African American and female, using our music to demonstrate all the complexities of what that really means," Maia said.[37]

Samana evolved into an official AACM group in 1995. Samana represented

what Patricia Hill Collins refers to as a "safe place," where "discourse potentially [could] occur . . . [and] Black women [could] resist the dominant ideology promulgated not only outside Black civil society but within African American institutions." Such situations were sought "because they represented places where Black women could freely examine issues that concerned us."[38] "I was just starting out," Mitchell explained, "trying to gain confidence, and this was a safe environment, where that special kind of chemistry between women could take place, where I wouldn't be questioned."[39] As part of Samana, Mitchell was able to experiment with musical techniques set forth by the AACM male members and begin exercising her own creative voice.

Although "such spaces become less 'safe' if shared with those who were not Black and female," Collins warns they run the risk of being dubbed "separatist" and "essentialist" by those excluded from them.[40] Such was the case with Samana, targeted for criticism by some. At first, Samana tried to compromise with the detractors, even inviting "Mwata and other male musicians to sit in with us on a tune, or even a concert."[41] But however brief their involvement, Maia contended, "the man's voice changed our direction." Thus Maia stood behind her conviction: "The AACM needed an all-women's group. There needed to be a place for the women to express themselves. . . . It was important for Samana to remain exclusively women."[42]

Niki Mitchell and Coco Elysses

When Maia moved to Los Angeles in the late 1990s to pursue a career in acting, Shanta Nurullah also moved to the West Coast. Slowly, Samana fell apart. Although the void created by Maia's absence contributed, in part, to the group's demise, the members themselves were much more philosophical about it. "Samana had its purpose in our lives," explained Coco Elysses. "It gave women of the AACM the opportunity to have a performance arena by which to develop our own unique voices."[43] As the women developed, "we grew up, we changed."[44] Said Mitchell, "Samana just kind of naturally started coming apart. People started growing in separate ways. Instead of growing together, we separated."[45] For Maia, Samana's collapse was difficult to watch: "The group is so important to me. It became my child. And it was difficult to say good-bye to it."[46]

The purpose of Black women's organizations was not to maintain exclusionary practices but to foster "a more inclusionary, just society."[47] For Niki Mitchell, performing in Samana was a way of celebrating music in which the woman's voice was central.[48] Also, Mitchell advocated that the woman's

voice become part of a dialogic process with AACM men. Women had long been expected to perform the musical compositions of men, Mitchell contended. It was now the men's turn to interpret the musical compositions of women. Soon thereafter, Mitchell started her own mixed-gender ensemble, Black Earth, a name she coined to "honor the feminine source that our lives depend on: Mother Earth."[49]

Mitchell wrote her compositions in ways meant to "join the male and female experience." In her composition "The Bath," she used less unusual timbres, quieter dynamics, and slower tempos to invoke "the female experience." With this approach to this particular piece, Mitchell seemed to revisit a feminist aesthetic prevalent during the 1970s that prescribed music compositional practices largely in terms of essentialist notions of women. Mitchell stated that she has "many other pieces that represent the strong forces of nature and offer a diverse presentation of moods and approaches." Following Gayatri Spivak's argument, however, Mitchell's setting of "The Bath" is an example perhaps of "strategic essentialism." By performing in a musical language that could be stereotyped as female, Mitchell was able to express a feminine identity that, if expressed otherwise, could have been misunderstood or gone unnoticed by music critics. Through her choice of musical language Mitchell moved into the male-dominated music discourse, revising the metaphoric crossroads to include both sexes at the point of intersection.[50] All men have a feminine side, Mitchell explained, and although her musical approach could be perceived as essentially "feminine," the themes she included in her compositions were not gender exclusive. Her music, she said, "demands an equal understanding of both the female and male experience. . . . I do believe there is a female aesthetic, but I also believe that there is a male energy in women; and a female energy in men."[51] "The Bath" exemplifies this approach. The music is "very slow and subtle, and it is more focused on beauty and space."[52] In Mitchell's analogy, the piece is "part of the female aesthetic . . . more appreciative of life's more subtle emotions."

Mitchell's Black Earth adheres to the organization's philosophy of Great Black Music. She serves as conductor and artistic director for this coed ensemble, which is dedicated to compositions written in her distinct style.[53] While other gender-mixed groups have existed in the AACM, Mitchell's group is unique in that it continues as one of the few organized and conducted by a woman musician.

In contrast to Mitchell, Coco Elysses was far less romantic in her assessment of Samana. She saw the all-women ensemble as a necessity to the AACM. Although she acknowledged strides made in elevating the woman's position

in free jazz, the struggle, she noted, is far from over. As case in point, she described her ongoing challenge to achieve recognition and inclusion as a woman hand drummer. While written accounts of women in jazz have generally concerned a select number of vocalists with little mention of women instrumentalists, those playing drums face particular scrutiny by critics. The drums have prompted associations with power and assertiveness—attributes more acceptable in society if linked to men. Women percussionists have intruded on that comfort zone. "I have found men struggling with women playing drums without sticks," explained Elysses. "It makes some men uncomfortable to have me play with open hands."[54]

The topic of women playing African drums is particularly complex. The custom of men playing the drums long dominated West African community life, explained Ghanaian musicologist J. H. Kwabena Nketia.[55] "African women sing and dance, but only African men play the instruments," wrote jazz scholar Frank Tirro.[56] Yet Linda Dahl, in her book *Stormy Weather: The Music and Lives of a Century of Jazz Women*, suggested that, while some professional music guilds within African societies excluded women musicians, others permitted participation, albeit restrictive:

> Though we can cite examples of women instrumentalists in various African societies—professional harp virtuosi in Uganda, fiddlers in Mali, the friction drummers of the Tuareng tribe, water drummers in East Africa, idiophone players in Ghana and Nigeria—it is not clear whether they constitute exceptions to the rule. It may be that in Africa, as in Europe, women musicians were more culturally acceptable as vocalists than as instrumentalists.[57]

Dahl's argument points to a claim similar to the one posed here against jazz criticism, mainly, that historical documents have not fully or clearly examined the role of African women musicians, and any discussion thereof prompts further reflection.

The complexities of women and African drumming become even more pronounced if contextualized within the diaspora. When descendants of numerous African nations found their way to the Americas as a result of the slave trade, they were forced to reinvent their lives in accordance with New World demands. Following the Middle Passage, some African traditions managed to continue; some were disregarded; and others were reinterpreted, maintaining or even extending perceived gender hierarchies. As example, many Afro-syncretised religions adopted restrictions against women playing consecrated drums in religious contexts. While some recent changes may have been made, enabling women to play drums in certain sacred settings, modifications have been few and slow in coming.[58]

Turning the discussion to women drummers and free jazz, complexities specific to the diaspora are further intensified. Free jazz had become a vehicle through which some musicians reclaimed an African sensibility. These musicians integrated perceptions of African cultural tenets into their musical approaches, excavating elements believed to reflect an African heritage. Because the process involved a mixing and choosing of customs and cultures, hybrid concepts of tradition emerged, some of which endorsed a restricted, even static, approach to African gender relations, privileging Black male authority. The custom of men playing drums was adopted as one accepted tenet of African culture. "It's [part of] an unspoken communication . . . formed out of a perception of African traditions," described Elysses.[59] As one of her contributions to experimental music, Elysses singled out musical performance aesthetics as a way to challenge male-dominated discourse, with performance practice itself serving as a vehicle of identity and a tool of resistance.

Samana attempted a reunion performance at the AACM's Thirty-fifth Anniversary Festival, held in the spring of 2000. However, when additional women musicians contacted the group, asking to participate, Samana again expanded, with Maggie Brown (vocals), Bethany Pickens (drums), and Ann Ward (piano and vocals) joining the group. Although the group took many ideas from Samana, its reorganization of members "allowed it to be different."[60] "It was no longer Samana," said Elysses. "It was something else."[61] Maia suggested the name Ye'Bindu, a Swahili word for "mother's pearl."

Elysses proudly stated that the premiere concert of Ye'Bindu was "a great event. It was so wonderful for the women to be together." She saw in the ensemble a renewal, part of the cyclic nature of women's ensembles in the AACM. First there was the Samana trio, which evolved naturally into Samana, the ensemble, from which was born that third group. "It wasn't Samana. It was as if Samana gave birth to Ye'Bindu. And we, in turn, embraced this new child wholeheartedly."[62] Since its premiere in 2000, Ye'Bindu has maintained only a limited performance schedule. Yet Elysses remains optimistic. Like Samana before it, Ye'Bindu offers a place for women musicians in the AACM. The group provided an arena in which AACM women could enjoy freedom of expression consistent with organizational principles.

Conclusion

Discrepancies in the current jazz canon are not easy to acknowledge or understand, precisely because jazz is closely tied to the music industry. In recording some musicians while disregarding others, the industry has provided

the listening public a slighted picture of creative music. While free jazz may receive small mention within that canon, and the AACM limited reference, the organization's women members remain lesser known, ultimately rendering "a really bankrupt history of the music."[63]

This chapter redresses the partial representations of free jazz through a discussion of four women musicians affiliated with the AACM, reconciling the gaps in the historiography of the organization with their narratives. I argue that the time has come to go beyond a general discussion of Black women musicians in avant-garde jazz. Complex paradigms are needed to explain the unique situation of women musicians performing the Great Black Music. The responsibility for discovering or creating productive analytical models that would best illuminate the experiences of women musicians rests with contemporary scholars and music critics. By questioning the utility of the "Great Man" approach to jazz studies, attention is drawn to the cultural and gender contradictions involved in the construction of the jazz canon. By creating new frameworks for assessing the contributions of Black women musicians in the AACM and other musicians' collectives, we can expand the parameters of creative music and address Great Black Music in its totality.

Notes

1. Horace Tapscott, quoted in Kofsky, "Interview with Horace Tapscott," 16. Pianist Horace Tapscott lived in Los Angeles and, in 1961, established the Underground Musicians Association, later termed the Union of God's Musicians and Artists Ascension (UGMAA), a musicians' collective that bore striking similarities with the AACM in its commitment to creative freedom.

2. Stanley Crouch, quoted in Howley, "Cold Fusion."

3. Radano, *New Musical Figurations*, 90–91; Litweiler, "Chicago's Richard Abrams," 41; de Jong, "Chosen Identities and Musical Symbols," 137–47.

4. Collins, *Black Feminist Thought*, 28.

5. Anthony Braxton, quoted in John Corbett, "Ism vs. Is," in Lock, *Mixtery,* 198.

6. Adorno, "On Jazz," 39–69.

7. Ira Gitler, quoted in Kofsky, *Black Nationalism,* 52–53.

8. Gitler, "Jazz Avant Garde," 33.

9. De Jong, "You Can't Kill an Organization," 136.

10. Delmark Records was established in 1953 as a blues music label, producing such artists as Magic Sam, Otis Rush, Roosevelt Sykes, Big Joe Williams, Arthur "Big Boy" Crudup, Luther Allison, and Sleepy John Estes.

11. Chuck Nessa, quoted in Bierma, "Nessa on AACM."

12. *Sound,* Delmark DE-408, 1966.

13. *Song For,* Delmark DD-410, 1966; *Levels and Degrees of Light,* Delmark DS-413, 1966.

14. *Numbers 1 & 2*, Nessa N-1, 1967; *Spirit Catcher*, Nessa N-19, 1980; *Missing Link*, Nessa N-23, 1979; *People in Sorrow*, Nessa N-3, 1969; *Les Stances à Sophie*, Nessa N-4, 1970; *Old/Quartet*, Nessa N-5, 1967; *Congliptious*, Nessa N-2, 1968; *Nonaah*, Nessa N-9/10, 1977; *L-R-G/The Maze/S II Examples*, Nessa N-14/15, 1979; *Snurdy McGurdy and Her Dancin' Shoes*, Nessa N-20, 1980.

15. *As If It Were the Seasons*, Delmark 417, 1968; *Three Compositions of New Jazz*, Delmark DS-415, 1968; *For Alto*, Delmark DS-420/421, 1968; *Young at Heart, Wise in Time*, Delmark DS-423, 1969; *Things to Come from Those Now Gone*, Delmark DS-430, 1972; *Humility in the Light of Creator*, Delmark DD-419, 1969; *Timeline*, Delmark DE-421, 1972; *Live 1972*, Delmark DE-432.

16. See Jost, *Free Jazz*, and Litweiler, *Freedom Principle*.

17. See Baraka, *Black Music*; Kofsky, *Black Nationalism*; and Wilmer, *As Serious as Your Life*.

18. Jost, *Free Jazz*, 10.

19. See Tucker, *Swing Shift*.

20. Iqua Colson, interview with author, by telephone, May 2000.

21. Iqua Colson, e-mail to the author, May 2000.

22. Ibid. In addition, Colson performed with other musicians in the Chicago area and worked in the groups of fellow AACM artists such as Roscoe Mitchell and Amina Claudine Meyers. She also performed with the Fred Anderson Sextet, which included Billy Brimfield, Hamid Hank Drake, Douglas Ewart, and George Lewis.

23. Ibid.

24. Ibid.

25. Iqua Colson has also worked extensively with artists outside the AACM, including David Murray, Reggie Workman, Amiri Baraka, Andrew Cyrille, T. S. Monk, Oliver Lake, Craig Harris, Makanda Ken McIntyre, John Carter, Bobby Bradford, René McLean, and John Blake.

26. Ibid.

27. Maia played a diverse range of instruments, including vibraharp, autoharp, cello, voice, flute, piccolo, and a wide variety of percussion instruments.

28. Maia, interview with author, by telephone, April 2000.

29. Ibid.

30. Prior to the establishment of Samana, there was an all-women ensemble, Sojourner, led by AACM singer Rita Warford. Sojourner never became an official AACM ensemble—it did not comprise the required AACM membership composition of two-thirds (correspondence between De Jong and AACM chairperson Douglas Ewart, 2006).

31. Nicole Mitchell, interview with author, by telephone, June 2000.

32. Maia interview.

33. Ibid.

34. Ibid.

35. Joseph Jarman, quoted in Davis, *In the Moment*, 181.

36. Maia interview.

37. Ibid.

38. Collins, *Black Feminist Thought,* 101, 110.

39. Mitchell interview.

40. Collins, *Black Feminist Thought,* 110.

41. Maia interview.

42. Ibid.

43. Coco Elysses, interview with author, by telephone, May 2000.

44. Ibid.

45. Mitchell interview.

46. Maia interview.

47. Collins, *Black Feminist Thought,* 110.

48. Flutist Nicole Mitchell has performed at numerous international venues (Paris, Moscow, Verona, Beirut, Rome, Guelph, Toronto) and has been recognized by *Downbeat* magazine in the critic's poll for Rising Star Flutist every year since 2001. In 2005, she was ranked first according to the poll.

49. Mitchell interview.

50. See Spivak, "Can the Subaltern Speak?"

51. Mitchell interview.

52. Ibid.

53. The ensemble's size ranges from three to ten players. As a ten-piece group, members include Mitchell (flute, piccolo, alto flute, poetry, vocals, and Autoharp), Wanda Bishop and Jim Baker (piano and vocals), Arveeyal Ra (percussion), Savior Faire (violin and viola), Tomeka Reid (cello), David Boykin (saxophone and clarinet), Tony Herrera (trombones and shells), Josh Abrams or Darius Savage (string bass), and Iyiola (dancer).

54. Elysses interview.

55. Nketia, *Music of Africa,* 8.

56. Tirro, *Jazz,* 38.

57. Dahl, *Stormy Weather,* 41.

58. See Amira and Cornelius, *Music of Santería;* de Jong, *Tambú and the Politics of Memory* (forthcoming); Fleurant, *Dancing Spirits;* McDaniel, *Big Drum Ritual of Carriacou;* and Velez, *Drumming for the Gods.*

59. Elysses interview.

60. Mitchell interview.

61. Elysses interview.

62. Ibid.

63. Kelley, "Talking Jazz."

Bibliography

Adorno, Theodor W. "On Jazz." Translated with an introduction by Jamie Owen Daniel. *Discourse* 12 (Fall/Winter 1989–90): 47.

Amira, John, and Steve Cornelius. *The Music of Santería: Traditional Rhythms of the Batá Drums*. Crown Point, Ind.: White Cliffs Media, 1999.

Association for the Advancement of Creative Musicians. *Statement by the Association for the Advancement of Creative Musicians*. Chicago: AACM, 1971–72.

Baraka, Amiri. *Black Music*. New York: William Morrow, 1967.

Bierma, Ron. "Nessa on AACM." *Rhythm & News*. http://www.delmark.com/rhythm .nessa.htm (accessed March 11, 2006).

Collins, Patricia Hill. *Black Feminist Thought: Knowledge, Consciousness, and the Politics of Empowerment*. Boston: Unwin Hyman, 1990.

Dahl, Linda. *Stormy Weather: The Music and Lives of a Century of Jazz Women*. New York: Limelight, 1989.

Davis, Francis. *In the Moment: Jazz in the 1980s*. New York: Oxford University Press, 1986.

De Jong, Nanette. "Chosen Identities and Musical Symbols: The Curaçaoan Jazz Community and the Association for the Advancement of Creative Musicians." Ph.D. diss., University of Michigan, 1997.

———. *Tambú and the Politics of Memory*. Bloomington: Indiana University Press. Forthcoming.

———. "'You Can't Kill an Organization': Musicians' Collectives and the Black Power Paradigm." *Jazzforschung/Jazz Research* 37 (2005): 133–44.

Fleurant, Gerdès. *Dancing Spirits: Rhythms and Rituals of Haitian Vodun, the Rada Rite*. Westport, Conn.: Greenwood Press, 1996.

Ford, Alun. *Anthony Braxton: Creative Music Continuums*. Devon, England: Stride Research Documents, 1997.

Gitler, Ira. "The Jazz Avant Garde: Pro and Con." *Down Beat,* June 1965, 33.

Heffley, Mike. *The Music of Anthony Braxton*. Westport, Conn.: Greenwood, 1996.

Howley, Kerry. "Cold Fusion: Stanley Crouch Wages Jazz by Other Means." *Reason: Free Minds, Free Market Online Journal*. http://www.reason.com/hod/kh062703 .shtml (2003).

Jost, Ekkerhard. *Free Jazz*. New York: Da Capo Press, 1981.

Kelley, Robin. "Talking Jazz: Live at the Village—Three Panel Discussions." National Arts Journalism Program, Columbia University. http://www.columbia.edu/cu/ najp/events/talkingjazz/transcript3.html (2001).

Kofsky, Frank. *Black Nationalism and the Revolution in Music*. New York: Pathfinder, 1970.

———. "Interview with Horace Tapscott." *Jazz & Pop*.

Litweiler, John. "Chicago's Richard Abrams: A Man with an Idea." *Down Beat,* October 1967, 23–26.

———. *The Freedom Principle: Jazz After 1958*. New York: William Morrow, 1984.

Lock, Graham. *Forces in Motion: Anthony Braxton and the Meta-Reality of Creative Music*. London: Quartet Books, 1988.

———, ed. *Mixtery: A Festschrift for Anthony Braxton*. Devon, England: Stride Publications, 1995.

McDaniel, Lorna. *The Big Drum Ritual of Carriacou: Praisesongs for Rememory of Flight.* Gainesville: University Press of Florida, 1998.

Nketia, J. H. Kwabena. *The Music of Africa.* New York: Norton, 1974.

Radano, Ronald M. *New Musical Figurations: Anthony Braxton's Cultural Critique.* Chicago: University of Chicago Press, 1993.

Shohat, Ella. "Talking Visions, Talking Art, Talking Politics: Ella Shohat on her Latest Book." *Fuse Magazine,* April 2001.

Spivak, Gayatri Chakravorty. "Can the Subaltern Speak?" In *Marxism and the Interpretation of Culture,* edited by Cary Nelson and Lawrence Grossberg, 271–313. Urbana: University of Illinois Press, 1988.

Tirro, Frank. *Jazz: A History.* New York: Norton, 1977.

Tucker, Sherrie. *Swing Shift: "All Girl" Bands of the 1940s.* Durham, N.C.: Duke University Press, 2000.

Velez, Maria Teresa. *Drumming for the Gods: The Life and Times of Felipe Garcia Villamil, Santero, Palero, and Abakua.* Philadelphia: Temple University Press, 2000.

Wilmer, Valerie. *As Serious as Your Life.* London: Quartet Books, 1977.

INTERVIEWS WITH THE AUTHOR

Colson, Iqua. May 2000.

Elysses, Coco. May 2000.

Ewart, Douglas. E-mail. March 2006.

Maia. April 2000.

Mitchell, Niki. June 2000.

7

Black Women and
"Women's Music"

EILEEN M. HAYES

A growing number of African American culture scholars have begun to devote attention to the significance of gender in black music;[1] still, with few exceptions, lesbian and gay subjectivities in performance have fallen outside of their purview.[2] The relatively recent focus on black women's musical experience, however, was a corrective to earlier discursive practices in which, as ethnomusicologist Kyra Gaunt relates, "blackness" was "overwhelmingly imagined, talked about, and personified through the experience of heterosexual black men."[3] In this chapter, I focus on black women's participation in the predominantly white, lesbian social field of "women's music," a network of music performance, production, and distribution companies that emerged as a subculture of radical feminism in the early 1970s. Women's music represents an underexamined but productive site for the performance of "black feminisms" by black musicians identifying variously as lesbian, bisexual, and heterosexual.

Examinations of "women's music" challenge disciplinary assumptions about relationships between musical style and musical genre. Women's music consists of myriad musical styles, yet as I argue in this chapter, proponents have well-formed opinions about the ideals that, when combined, lend women's music the coherency of a musical genre. A recurrent theme in the evolution of women's music is the need for self-identified factions of performers and consumers within this subculture of lesbian feminism to negotiate their collective identities based on race, ethnicity, and so on and their individual subjectivities. There is perhaps a normal tension between the bonds that unite members of a heterogeneous group and participants' desire for the recog-

nition of the various constituencies within that heterogeneity. Intensifying this conflict are the issues surrounding lesbianism from the perspective of mainstream culture; issues of "coming out" have a salience for women of color that is perhaps not experienced by white women to the same degree. Inspiring even greater cognitive dissonance for black women artists in particular, the emergent culture's separatist ethos contained the fodder for black women's subsequent critiques of the culture of women's music.

Black women have played and continue to play a significant role in women's music despite their relative small numbers. The highly acclaimed African American women's a cappella ensemble Sweet Honey in the Rock (SHIR) is by far the most well known and historically the first black women's ensemble to collaborate in performance with artists associated with the women's music network. Prominent black women musicians who have performed at women's music festivals or in women's music concerts in the past or present include Edwina Lee Tyler, Odetta, Linda Tillery and the Cultural Heritage Choir, Judith Casselberry/JUCA, Rashida Oji, In Process . . . , Deidre McCalla, Rachel Bagby, Laura Love, Toshi Reagon and the Big Lovely, Faith Nolan, Vicki Randle, Melanie DeMore, Ubaka Hill, Wahru Cleveland, the Washington Sisters, Mary Watkins, Kim Archer, Doria Roberts, Pam Hall, Urban Bush Women, Gwen Avery, and Casselberry and DuPree—to name but a few. In this chapter I offer reasons for the omission of black women from examinations of women's music and outline key issues that emerged from my ethnographic research on the politics of race and sexual identity within this sphere.[4] My interest, too, includes the set of factors contributing to the mutedness of black women's voices in women's music and the fact that this musical sphere has passed "under the radar" not only of those with a vested interest in "black women's studies" and African American music but also of those interested in black gay and lesbian studies and the scholarship of women's music.

The emergence in the 1970s of the women's music recording and distribution industry, controlled financially by women (Olivia Records was the first), corresponded with the development of feminist institutions throughout the country. The founders (including white musicians Cris Williamson, Holly Near, Meg Christian, Margie Adam, and Alix Dobkin) of women's music described the emergent genre as "music by women, for women and about women."[5] Up until the mid-1970s, observes women's music festival historian Bonnie Morris, "sexism still prevented most women from getting studio work as sound engineers or session musicians."[6] Musicians and activists, predominantly lesbian, sought to carve out a professional/social space in which women could give voice to lesbian sensibilities through music performance.

As Mary Celeste Kearney writes, "The separatist ideology of womyn's music is particularly resonant of the pro-woman ideology of early radical feminism which inspired many women to resist assimilating in male-dominated society and to create alternative institutions, relations and forms of cultural expression separate from the mainstream."[7] Boden Sandstrom, an ethnomusicologist and longtime sound engineer, observes that "eventually, women started to control the economic production of their new women's culture. Within the cultural feminist movement, this translated into, among other things, being in charge of the entire production of a musical event: the sound, the lights, the management, and the production."[8] Women-only music festivals (the National Women's Music Festival, or NWMF, was the first in 1973) became primary sites for annual gatherings that celebrated women in music, dance, theater, and the visual arts. By the 1980s, numerous women's music festivals had emerged; several burgeoned into ongoing enterprises. While events such as the Michigan Womyn's Music Festival (founded in 1976) are marked by the continuity of longevity, others have had shorter runs before ceasing operations.

Some festivals, such as the NWMF, are held on college campuses over four-day weekends, where attendees have access to residence halls and other amenities of the university. Outdoor events, such as the six- or seven-day Michigan Womyn's Music Festival and the Gulf Coast Womyn's Festival at Camp Sister Spirit, in Ovett, Mississippi, take place on privately owned land. In attempts to be sensitive to a host of needs, organizers often provide vegetarian meals, access for disabled women, sign interpreters for the deaf, and sliding-scale entrance fees. Historically, festivals offered workshops (on everything from "unlearning racism" to "car maintenance for women") that attempted to raise and resolve lesbian-feminist problems. Today, festival programing still includes numerous workshops, although in interviews, some women expressed feeling increasingly "put off" by those workshops and festivals they describe as "lacking in political content."

Feminist theorists remind us that the women's movement of the 1960s and 1970s was never an organized entity with a central administration; rather, it consisted of loosely organized groups and other committed individuals. Mainstream or "liberal feminist" organizations such as the National Organization for Women (NOW) "operated in the national political arena," whereas "radical feminism survived mostly at the grassroots in cities and towns around the country."[9] Sociologist Nancy Whittier writes that "organizations that identified themselves as radical feminist sought transformation rather than reform of existing social institutions."[10] Proponents of cultural

feminism, which emerged from radical feminism, believed "that they should actively make a separate female culture that seeks to revalue underappreciated 'feminine' traits."[11] Women's music exemplified the type of separate female culture proponents had in mind. In an article on the identity crisis in feminist theory, scholar Linda Alcoff defines cultural feminism as "the ideology of a female nature or female essence reappropriated by feminists themselves in an effort to revalidate undervalued female attributes."[12] She goes on to say that although scholars are in agreement that this strain of feminism is and was not homogenous, some cultural feminists tended toward "invoking universalizing conceptions of woman and mother in an essentialist way." Although this was done in a response to misogyny and sexism, Alcoff writes that those who do so are in danger of "solidifying an important bulwark for sexist oppression," the belief in an innate "womanhood" to which we must all adhere lest we be deemed either inferior or not "true" women."[13]

Numerous writers concur with Alcoff that cultural feminism had conflicting consequences. On the one hand, through cultural feminism, women gained unparalleled opportunities to experience esprit de corps with other women as they engaged in mutual support for their artistic and creative endeavors, listening to and performing lesbian and feminist-oriented music. On the other hand, the fact that cultural feminism was in part based on essentialist notions of women served to circumscribe and, later, contain the genre of women's music.[14] In other words, cultural feminism fostered a solidarity that gave definition to the movement that then proscribed the kinds and identities of women who participated. Seeking strains of cultural feminism in the writings of Latina and black lesbian feminists, Linda Alcoff reports that the writings of women of color have "consistently rejected essentialist conceptions of gender." Later, she nuances her suggestion, adding that she "has heard it argued that the emphasis on cultural identity by such writers as Cherrie Moraga and Audre Lorde reveals a tendency toward essentialism also."[15] While this might be true, what is important is that the writings of these feminists of color reflect a problematized understanding of the concept of woman.

In *Feminist Generations: The Persistence of the Radical Women's Movement*, social movement theorist Nancy Whittier argues convincingly that radical feminism, rather than having died out completely, lives on and, indeed, survived the so-called postfeminist age of the 1980s.[16] Women's music festivals held annually in the midwestern states, as well as in Virginia, Mississippi, and New Mexico, for example, are manifestations of the continuance of radical feminism that Whittier describes as "an identity that is constructed by activists, and is subject to debate and redefinition, as opposed to a historically constant ideology."[17]

Women's Music and the Contest for Definition

In spite of the frequently voiced declaration that women's music is "music by, for, and about women," the term itself is enigmatic. If one is unfamiliar with the expressive culture of this particular manifestation of lesbian feminism, how does one differentiate women's music from the broader rubric of "women in music" or, for that matter, "women and music?" The waters become muddier when we consider that even some musicians active in the first decade of the women's music network express disappointment that the network's roots in lesbian sensibilities could not be more publicly acknowledged.

White women's music veteran Sue Fink suggests that there is no women's music, "only women's music audiences."[18] Fink's formulation points to the potential productivity for audience research and reception studies in this field.[19] Although popular music studies owe much to literary criticism and to cultural studies, ethnomusicology offers the ethnographic approaches that have the potential to propel studies of women's music past textual analysis alone and toward wider contexts for interpretation.[20]

Longtime participants acknowledge the prevalent but objectionable association of women's music with the image of "white girls with guitar" or "wgwg." Referencing this association, lesbian culture critic Arlene Stein observes that by the mid-1980s, the plethora of women's music concert acts consonant with the soundscape of the 1950s and 1960s folk music revival provided evidence that women's music "had become firmly entrenched in what was, for the most part, a European [folk] tradition."[21] In contrast, veterans of the women's music community, such as Toni Armstrong Jr. and Asian American June Millington, maintain that the women's music circuit has always included a diverse profile in terms of both race and musical style. Armstrong, Millington, black musician Linda Tillery, and others negotiate the tensions between the predominantly white social field of women's music and the cultural diversity introduced by women of color who have played significant roles as performers, festival workers/volunteers, attendees, and organizers.

Research I conducted with attendees of women's music festivals (festigoers) suggests that proponents of the genre assess the boundaries of women's music using a set of symbolically significant features, few of which have anything to do with elements (e.g., harmony, melody, rhythm, etc.) typically associated with "music," that is, music as a "sound object." Rather, extramusical factors lend coherence to music associated with this network: feminism's concern with women's agency, the significance of women loving

women, and the primacy of females in women's lives. Perhaps these nonmusical issues are so prominent in uniting this music community because, as mentioned earlier, participants do not always agree on the types of musical styles that are consistent with women's music ideals.

The song texts of black musicians have addressed issues of freedom, justice, and concern for poor women—all of which complicate earlier conceptions of the genre that privileged concerns of gender and sexuality over those of race or other inflections. In an interview, I asked members of In Process . . . , an African American women's ensemble based in Washington, D.C., founded by Sweet Honey in the Rock, whether they thought of their music as falling under the rubric of women's music. One of the codirectors replied, "We still sing the same music that we sing everywhere else. The music that we sing is more about women's lives. It's about political struggles. It's about our tradition, so it's about us trying to be who we are."[22] Another member seemed determined to keep the signifier "women's music" open and to guard against its association with lesbianism exclusively or with a feminism that was raced white, thereby curtailing its relevance to women of color. Although these issues are not new to studies of black feminism, both second and third wave, scholars of women's music have not yet theorized these issues in terms of lesbian feminism or of black cultural politics.[23]

The inclusion of black women performers in studies of women's music necessarily expands the parameters of the genre as defined by earlier scholars, music festival audience members, and listeners.[24] My review of numerous recordings of black musicians connected with the women's music scene reveal their participation in myriad musical styles (e.g., blues, jazz, country, gospel, singer-songwriter, spirituals, neo-African drumming, Afro-Celtic). Moreover, a typology of songs by black performers reveals a collective repertoire that can be categorized as (1) songs with lesbian-feminist content, including love songs; (2) songs concerning oppression-resistance of all types; and (3) songs reflecting black women's cultural/political heritage.

Debates over the definition of women's music exhibit some of the same lines of tension precipitated by feminist scholarship on lesbianism in the 1970s and 1980s that tended to globalize and universalize its properties, merging them with qualities associated with femaleness.[25] According to women I interviewed, the term *women's music,* as deployed throughout the 1970s and 1980s, reinforced the notion of the universal woman, ignoring the specific ways that female-gendered experiences—including those of lesbian feminists—were inflected by race and class. African American women who began to affiliate with the women's music network brought with them a different

set of cultural values, including, for example, concern for the entire black community, which included women and men. To distance themselves from the association of women's music with a limited racial and ethnic politic, many musicians of color began to refer to themselves and to their politics as *women-identified*. The use of this term recalls also Adrienne Rich's suggestion that same-sex bonds among women—whether heterosexual, bisexual, or lesbian—be established in a mutual "woman-focused vision."[26] In her influential article, Rich, a white lesbian poet, implied that women's history was, to a great extent, the history of "compulsory heterosexuality." Written in 1980, Rich postulated that lesbianism could be understood in terms of two overlapping concepts: "lesbian existence" and "lesbian continuum." The former described female-female sexual behavior, while the latter referred to a range of affiliations and collaborations between women that did not necessarily have explicit sexual content.[27] Lesbian feminist critics later suggested that the term *woman-identified* drained lesbianism of explicit sexual practice, a charge that to this day has ramifications in lesbian feminist politics.

Throughout my discussions with musicians, performers deftly managed their own self-representations as we spoke about the terms *women-identified music* and *women's music*. Linda Tillery is an African American culture specialist, a singer, and director of Linda Tillery and the Cultural Heritage Choir (CHC). I asked Tillery whether she thought of the ensemble (its repertoire consists of African American spirituals and other traditional genres) she founded as "women-identified."[28] Tillery responded: "No more than Clara Ward and the Ward Singers. No more than the Caravans. It's women-identified in that what we are doing is bringing the kitchen table experience to the stage. That type of women-identification has existed in the black community since there was a table."[29]

In this exchange, Tillery highlights black women—indeed, black culture—as the "subject of women-identified music," referencing her ensemble's incorporation of repertoire with textual themes emphasizing racial concerns set to and drawing on traditional African American music materials. In doing so, she sheds light on two seemingly mutually exclusive definitions of "women-identifiedness." Interpreting Tillery's response through one lens enables us to situate black female a cappella ensembles such as the CHC within a performance realm emanating from a longer (and more broadly defined) tradition of women-identification in African American culture. The elusive quality of Tillery's response invites consideration of the idea that women-identifiedness is more than a reference to tropes of black women's bonding, both essentialized and real. By employing the metaphor of the "kitchen table,"

Tillery implicitly references Kitchen Table Press, cofounded in the 1980s by black lesbian writer Barbara Smith, a project undertaken for the purpose of publishing works by black women writers, lesbians in particular. In the latter interpretation, admittedly my own, the domestic realm, which the kitchen represents, is taken to include black lesbians. Tillery's ambiguous evocation of the "kitchen table experience" illuminates that the performance of female a cappella ensemble such as Linda Tillery and the CHC reflects black cultural aesthetic and ethos while speaking to a black women's culture differentiated by sexual orientation. For black musicians and consumers, the performance of traditional African American music performed a cappella in women's music contexts is a powerful enactment of black identity in a gendered frame.

The subject of feminism, especially as it applies to African American feminist sensibilities in performance, continues to produce debate among scholars and listeners/audience members. During the course of my fieldwork, particularly at times when I was "off duty" as a researcher, I occasionally described the focus of my study as "black feminist music." This unintended inexactitude on my part yielded informative outcomes. Many, especially those unfamiliar with women's music, assumed I referenced a wide range of popular mainstream black female recording artists, a proposition which led them to conclude that the focus of my study was much "too broad." Black lesbian writer Tonia Bryan brings to our attention various applications of the term *feminist,* reminding us that women-identified music spheres do not retain exclusive rights to this meld of politics and music:

> They are four black dykes up late on community radio. finally allowed to take over the air waves they're spinnin' tunes and talkin' about livin' in the life. afterwards one of them remarks that she would really like to see the show concentrate on more feminist oriented music. like joan armatrading. does HER feminism have room for patra's feminist's thighs? India's feminist house? Chaka's feminist come-back? mary j's feminist booty? Patti's feminist bi-curiousity/ ru paul's feminist falsies? Adeva's feminist attitude? tlc's feminist condoms? mc lyte's feminist make-over? swv's feminist nails? anita's feminist rapture? donna's feminist hot love? diana's feminist weave? WHOSE feminism is she talkin' 'bout anyhow? all I know is sometimes when I get tired of deconstructing, decolonizing, theorizing, strategizing and empowering, my girls bring me back from the edge. renew me with their words. stroke me with their soul. give me the strength to go on.[30]

Bryan alludes to another factor that complicates the terrain of concert programing at women's music festivals: in efforts to diversify concert rosters in

terms of politics, ethnicity, nationality, region, and musical style, acts such as Omeyocan, primarily a black women's band describing their music as "urban indigifusion," are invited to perform.[31] Such acts may or may not boast prior affiliation with lesbian or feminist political organizations or sentiments. "Who is" and "who is not" a feminist emerges as a matter of internal differentiation among lesbian audience members as different kinds of music become symbolic markers of difference.

"Sounding Back" and Black from Inaudibility

Current scholarship in popular music and African American studies provides clues as to the tensions inherent in the underrepresentation of black women in women's music. Though some of these tensions are not easily resolved, it nevertheless behooves me to mention them briefly.[32] The elision of African American women from narratives of women's music is paralleled by the marginalization of black lesbian musicians from traditional histories of African American music and accounts of black women's participation in social movements of the 1960s and 1970s. With rare exceptions, black women's contributions to this predominantly lesbian community are rendered invisible, even in collections theorizing black feminisms and the history of radical feminism.[33]

A complex set of reasons accounts for the neglect of these black women in the literature, but I offer two possibilities here. First, in spite of the "proliferation of difference" as celebrated in the politics of postmodernism, many scholars remain unwittingly preoccupied with the essential black and/or lesbian subject.[34] Pioneering edited volumes by Barbara Smith, Moraga and Anzaldúa, and others called attention to (what would later be referred to as) intersectionality—that is, attention to the interaction of at least two inflections—as an interpretive framework for understanding the contemporary relationship of lesbian and "racial" identities.[35] Yet in many circles, lesbian and gay identities are still excluded from traditional definitions of "blackness." Filmmaker Marlon Riggs explores these issues in *Black Is . . . Black Ain't* (1995), a project completed by Riggs's production staff after his death. At the same time, even when writers incorporate interviews with black performers of women's music into well-meaning narratives of the genre, they do so in ways that suggest that concerns of sexuality subsume "race."[36]

Much of the music and sexualities literature stops short of problematizing the mutually constitutive nature of sexuality and black racial identity. I offer one example of an institutional practice that has ramifications for studies

of black lesbian subjectivities and music. In "Pouring Out the Blues" (2004), ethnomusicologist Maria Johnson recounts that she was informed by an important academic journal producing a gay/lesbian issue that the focus of her research, contemporary black women blues performers, many of whom are lesbian musicians who have at one time been affiliated with the women's music community, "fell between two thematic stools—the 'ethnic' and the 'gay/lesbian'" and, therefore, was deemed inappropriate for the journal.[37] Drawing on the interrogations of black lesbian critics, Johnson observes, "What this type of thinking fails to account for is that black women are not either black or female; they are both black and female. The situation is compounded further for black lesbians who are black and female and gay."[38]

Anticipating Johnson's point by over two decades, black feminist critic Barbara Smith recalled the text of R&B singer Linda Tillery's "Freedom Time," in which she describes the positionalities of black lesbians as an example of "triple jeopardy."[39] Johnson's observation, which echoes similar remarks of prominent black lesbian critics, including Cheryl Clarke, Barbara Smith, and Audre Lorde, has a particular bearing on the recovery of black women's "voices" not only in women's music but also in black music studies. Interviews with black women musicians and with music consumers about African American performers illuminates black women's experiences as they bridge two different interpretive communities, each composed of many factions. For many black women, the experience of being a musician in women's music circles is one in which audience members may decide that she embodies no essence felt to be constitutive of either black or lesbian identity. Given the definition of women-identified music, this paradox illuminates the recurring issue of *which* women. Moreover, consumers might mobilize various variables in establishing parameters of inclusion in women's music, such as the performer's race, cultural heritage, musical style, and acknowledged or rumored sexual identity.

An observation by black sociologist Patricia Hill Collins begins to address the notion that, as related by Johnson, an article about black lesbian musicians would fall "between two thematic stools." Interrogating an underlying presumption that counterposes "gay/lesbian" to a marked ethnic identity, Collins writes, "As African American LGBT people point out, assuming that all Black people are heterosexual and that all LGBT people are White distorts the experiences of LGBT Black people."[40] Moreover, such comparisons misread the significance of ideas about sexuality to racism and race to heterosexism."[41]

I now offer an anecdote that illustrates a variant of the phenomenon Johnson describes in her article.[42] During the course of my research, black women musicians associated with the women's music circuit frequently reported that audience members regarded their acts as "not lesbian enough," even though, through performance, some musicians offer songs emphasizing the cultural diversity within the gay and lesbian community. An example of this is a song by In Process . . . called "Patchwork Quilt."

"Patchwork Quilt" might be appreciated for its interlocking harmonies, yet given that the song was issued in 1990, what becomes striking is that the lyrics concern the global ramifications of memory, HIV, and AIDS. As black political theorist Cathy Cohen notes in *Boundaries of Blackness: AIDS and the Breakdown of Black Politics* (1999), up until that time, only the predominantly white lesbian and gay community expressed willingness to talk about AIDS openly. She writes that while the AIDS epidemic increasingly became a disease of people of color, the literature, images, and general representation of the disease remained white. This occurred during a period when, among adult AIDS cases nationally, blacks were found to comprise almost 28 percent of all cases, more than double their 12 percent share of the population.[43] "Patchwork Quilt" complicates a focus on AIDS as a disease affecting white gay communities, revealing its relationship to formations of race, class, and nationality by linking the epidemic to communities in Africa, to the phenomenon of cocaine-addicted babies in the United States, and to relationships within extended black families. Black lesbian writer Jewelle Gomez recalls speaking at the Gay Pride rally in Central Park when the New York City section of the AIDS Quilt was dedicated. Describing the relationship between black lesbians and gay men as similar to "sisters and brothers raised on many of the same foods—some nourishing, some not," she observes: "The beautifully crafted quilt panels went on for what seemed like acres, and my brothers were there—the photos, the kente cloth, the snap queen accessories embroidered in black, red, and green."[44]

The second set of issues that contributes to the neglect of black women in the scholarship of women's music is that gay and lesbian studies as well as popular music studies have tended to privilege the sexual identity disclosure of the artists.[45] Ethnomusicologist Ingrid Monson remarks on the contradiction between the wide range of sexual practices in black communities, as in other communities, and the reluctance of many African Americans to discuss sexual orientation, particularly of musical artists: "There is considerable tolerance for alternative gender and sexual practices within African

American culture, yet there remains a taboo against public discussion of sexual orientation or the outing of performers in many African American musical communities—including jazz and gospel."[46]

In an article subtitled "Studies in Gay Male Politics and 1980s Pop Music" (2004), Aaron Lecklider suggests that "gay-cultural politics have been historically dominated, at least for much of the twentieth century, by questions concerning the 'outness' of central-cultural figures."[47] Lecklider cites Urvashi Vaid's statement that "until each gay and lesbian person tells the truth about his or her life—by coming out every day, everywhere, and in every situation—the heterosexual world will be able to deny the existence of homosexuality."[48] In response, Lecklider insightfully interjects that "focusing on this one speech-act has caused too many valuable cultural figures—not the least of which might be queer consumers—to be occluded from serious analysis."[49] Indeed, several black lesbian musicians granted me interviews but asked that I not disclose their identities in any publications that issued from my research. A violinist explained that she had to "make a living" and that since she gigged also for "musical theater and symphony orchestras," she had to keep her reputation intact. Drawing on Keith Boykin's *One More River to Cross: Black and Gay in America,* Patricia Hill Collins writes that "in part, because of a multiplicity of identities, African American gay, lesbian, bisexual, and transgendered individuals seem less likely than their White counterparts to be openly gay or to consider themselves completely out of the closet."[50] I would add that this is true even in the cases of black performers of "women's music."

The preoccupation of many popular music studies, with the notion of celebrity, also militates against a focus on women artists who function outside of the mainstream commercial music industry. Unlike musicians such as African American neo–folk singer Tracy Chapman, who performed at Sisterfire in 1984 and at the Michigan festival in 1986 and 1987, many of these artists do not have contracts with major recording studios and hence have not and most likely will not achieve success by industry standards.[51] Radio programs specializing in "urban" formats only infrequently broadcast women's music, which does not portend favorably for the wide dissemination of this music. Radio programs devoted to women's music, such as WPKN's *Amazon Radio,* are an exception to this rule.[52]

Early Interventions of Black Women in Women's Music

African American women activists in the 1970s brought to attention the short-sightedness of universalizing white women's experience. Evidence for this critique is visible in the emergence of independent black feminist organizations by women who found their issues unaddressed by a feminism based on white women's experience. In addition to their perspectives on race and gender inequity, black women who had been active in the New Left incorporated class analysis into their organizational framework. The term *New Left politics,* according to historian Sara Evans, refers to the fusion of "the personal and moral optimism of the southern civil rights movement with the cultural alienation of educated middle-class youth." Evans writes that "the intellectual mode that dominated the early years of the New Left operated to exclude women as leaders, and only those with roots in an older left tradition ever thought to raise the 'women question' before the mid-sixties."[53] The National Black Feminist Organization (NBFO), founded in 1973, articulated the need for political, social, and economic equality especially for black women. Within a year of its founding, the NBFO had a membership of two thousand women in ten chapters; similar groups followed in its wake.[54]

In 1974, a small group of activists calling themselves the Combahee Collective parted ways with the NBFO because of what they perceived as the organization's failure to address the needs of poor women and lesbians.[55] According to black political philosopher Joy James, the collective "took its name from the June 2, 1863 guerrilla foray led by the black revolutionary Harriet Tubman in South Carolina's Port Royal region that freed hundreds of enslaved people and became the first and only military campaign in the United States planned and executed by a woman."[56] In 1977, the Combahee Collective critiqued the notion of the universal woman in "A Black Feminist Statement," a prescient document that outlined the collective's concern with a class-conscious, feminist, antiracist politic.[57] Describing themselves as black feminists and lesbians, the collective rejected lesbian separatism and called for the elimination of homophobia. Black social movement theorist Robin D. G. Kelley observes, "The Combahee River Collective's Statement remains one of the most important documents of the black radical movement in the twentieth century."[58]

Shortly after the introduction of Sweet Honey in the Rock to the West Coast women's music scene, the Combahee River Collective transformed the statement's manifesto of black feminism into performance by co-sponsoring Varied Voices of Black Women, the first touring program of black perform-

ers of women-identified music.[59] The Varied Voices of Black Women toured eight cities in the fall of 1978. Featuring pianist Mary Watkins, bassist and singer Linda Tillery, poet Pat Parker, and singer Gwen Avery, the tour demonstrated that white lesbians were not the only ones creating a new women's culture: "Though the concert [tour] was first and foremost a celebration of Black lesbian feminist identity and culture, it was also an attempt to broaden the white feminist community's understanding of feminist and lesbian identity."[60] Although the tour failed to marshall the support of the predominantly white lesbian audiences of women's music, Varied Voices was a watershed event in the history of black women and women-identified music.[61]

The involvement of women of color altered the political geography as well as the soundscape of women's music. In her book *We Who Believe in Freedom*, Bernice Johnson Reagon describes the initial contact of Sweet Honey in the Rock with the West Coast women's music community in 1976.[62] Two years later, the members of SHIR became the first women of color to record on a women's music label when they issued the album, *B'lieve I'll Run On . . . See What the End's Gonna Be* on Redwood Records.[63] In 1982, SHIR founded Sisterfire, an urban venture and "one of the few U.S. [women's music] festivals open to men" as attendees.[64] Sisterfire was produced by Roadwork, a multiracial female production company, which, as Amy Horowitz notes, "produced dozens of concerts in Washington, D.C., booked thirty artists on 150 national and international tours, and provided a booking home for Sweet Honey in the Rock."[65] Black women artists who took the stage and thereby contributed to the Sisterfire "legacy" included guitarist/singer Elizabeth Cotton, Flora Molten, Tracy Chapman, Toshi Reagon, Alice Walker, June Jordan, the Moving Star Hall Singers, Lillian Allen, In Process . . . , Yolanda King, Atalla Shabazz, and Alexis DeVeaux.[66]

Bonnie Morris observes that Sweet Honey "took risks in being identified (whether locally, nationally, or internationally) with a 'women's music' cultural movement dominated by white lesbians."[67] Reflecting on the challenges in bringing a "multiracial" and "multicultural" festival to Washington, D.C., producer Horowitz recounts in Reagon's *We Who Believe in Freedom*, "The idea was born out of bold hopes and a special mix of naïveté and chutzpah. We knew we were taking a risk in producing a festival consisting solely of women performers to which the public (all genders and sexual orientations) would be welcomed. We were conscious of a lack of role models and a fundamental lack of skills in building multiracial institutions. . . . We were propelled by a sense of purpose."[68]

According to Horowitz, the festival was a "tempting ground on which to

unleash unexpressed disappointment and expectation." She notes Sisterfire's supporters included women who wished that "no men be allowed," white women who thought there was "not enough women's music (read White)," black women who thought there were "too many White women," straight people who wondered why there were "so many gay and lesbian people around," and festivalgoers who thought the performers were too politically oriented. She relates that a series of cultural/racial/sexual clashes at the festival proved "too heavy a load for the delicate suspension of the Sisterfire experiment."[69] The accumulated conflicts resulted in "a national boycott, fueled by some of the women's music press." Without the predominantly white women's music community's support, the festival ceased operations.

Signifyin' on Race and Heterosexual Address

In "Lesbians and Popular Music: Does It Matter Who Is Singing?" (1993), scholar Barbara Bradby uses her interviews with a group of Irish lesbians about women's music as a starting point "for looking at the role that popular music has been made to play in establishing and reproducing a particular lesbian community." Drawing on the work of Sally Munt (1992) and others, Bradby argues that questions of "authorship" are not generated simply through reference to song texts or elements inherent in the music, but are produced socially in interaction and embodied in turn in musical practices. The appropriation of mainstream popular music by lesbians is an interesting phenomenon through which to illustrate a number of interacting and overlapping processes, including one that Bradby identifies as "claiming mainstream musicians as lesbian." A performance by singer/songwriter Rashida Oji at a Michigan Womyn's Music Festival illustrates the reinterpretation by a black artist, in a predominantly white lesbian context, of music generally understood as originating from the white, heterosexual mainstream.[70]

In this performance, Oji led an ensemble of prominent musicians in a rousing rendition of the Carpenter's 1970s pop chart hit, "Close to You." Oji's pleading, gravel-voiced interpretation of the text infused the performance with an affect of longing that Karen Carpenters's original version did not suggest. Her vocal quality, combined with inflections reminiscent of gospel singing, worked to transform her performance into a sonic signifier of blackness. The emotional intensity of the performance was heightened as the transaction between Oji and the audience members took on elements of the gospel church. The stylized, self-conscious reaction of the predominantly middle-aged festigoers was an example of musical play at its best as women spontaneously

performed their roles as foils to the main actor. Audience members called out in response to her performance; others "swooned." A musician skilled in her craft, Oji "camped up" the moment for what it offered, intensifying the soul of her delivery as the audience's participation increased.

A number of factors, beyond Oji's skills, help explain why her interpretation of a Carpenters' song affected the audience so intensely. Bradby observes that for the women's music consumers she interviewed, the personal history in which "American lesbian music" figured was often the crucial period of their "coming out."[71] That prior to, and especially after, her death rumors circulated in women's communities that Karen Carpenter was a lesbian is not tangential to this discussion but part of the indeterminate mix. Oji's performance may be read as an aural tribute to Karen Carpenter and as a comment on the white pop musical styles (and the clean-cut, wholesome images of the "stars") generally associated with the music of the early 1970s. In Oji's transformation of the conventions of soul, secularized in decades past from their antecedent of gospel, lent sonic affirmation to the expression of lesbian desire.

Typical of the ambiance created during Oji's performance were several playful/serious exchanges I had with and overheard between black and white festival attendees departing the concert field after the afternoon's concert. The juxtaposition of Carpenter's text and the romantic liaisons (inter- and intraracial) suggested by Oji's performance had resonance for several women as they joked that they wished their "brown eyes could be blue," if only to win the singer's affection.

The transformation of "Close to You" from an innocuous pop tune to a rousing declaration of soul incorporated aspects of "signifying," a multifaceted black cultural practice that extends throughout the black diaspora. In his often cited work, *The Signifying Monkey: A Theory of African-American Criticism* (1988), Henry Louis Gates discusses the relationship between African and African American vernacular tradition through the art of signifying. Drawing on the work of Claudia Mitchell-Kernan, Gates writes: "Complimentary remarks may be delivered in a left-handed fashion. A particular utterance may be an insult in one context and not another. . . . The hearer is thus constrained to attend to all potential meaning carrying symbolic systems in speech events—the total universe."[72] Oji's performance illustrates the significance of visual and aural signifiers and context in the process of reception. The effect was a black performance very different from the original marketed by Karen Carpenter and her producers to the white heterosexual mainstream.

Black to the Future

Predictably, observers of the women's music movement have pondered its future now that its "golden age" (roughly from the early 1970s to the late 1980s) has passed.[73] Observes Arlene Stein: "The [mainstream pop music] terrain has shifted . . . from lesbian-identified music created in the context of lesbian institutions and communities to music that blandly emulates women's music, playing with signifiers like clothes and hairstyle in order to gain commercial acceptance, but never really identifying itself as lesbian."[74]

Although Stein's point is well taken, a "new" generation of black women musicians, festival organizers, and attendees are making their voices heard. Some of these artists identify with the identity politics of "queer" nation.[75] Many would argue that they are opening up a new range of sonic possibilities while maintaining links to past musical traditions and casting a wide net of liberatory politics. The enthusiastic fan bases for singer-songwriters Nedra Johnson and Doria Roberts—to name just two—are growing quickly, thanks in part to the proliferation of on-line newsgroups initiated by the artists. Multi-instrumentalist Johnson has performed not only at women's music festivals but also at jazz festivals in Europe and at Gay Pride events throughout the United States. Johnson's "Forever with Me" (on the CD *Nedra*), for example, speaks to the issue of gay marriage, which at least one black lesbian listener I spoke with interpreted to refer to lesbian commitments specifically because of the "two female vocalists" and the singer's reference to buying her partner a ring.[76] The issue of lesbian commitment ceremonies is one that, to my knowledge, the repertoire of an earlier generation of black women-identified artists did not address.[77]

Just as scholars of hip-hop are casting links between the "first generation" of black women rappers and those coming afterward, scholars of women's music are now in a position to examine the relationship between the micro-cohort of black performers represented by Linda Tillery and pianist/composer Mary Watkins and musicians of the next generation. How will the newer cohort of black women musicians be received in women's music communities?[78] Will future narratives about women's music reflect the subjugation of black cultural values exhibited in earlier accounts? Will black women in women's music be asked to choose between being black or lesbian (or queer), an issue explored by numerous writers?[79] Linda Tillery, self-identified as "middle-aged," observes that "while I'm not ready to step aside, I do have to allow for the generations of younger musicians who are emerging—women, in this instance, who have different ideas about how they

want to make music and how they want to perform it—just as I was at 22 and 23 years old, finding my way. These young folks have to do the same."[80] With myriad musical styles, a younger generation of musicians meets women who came of age during an earlier political moment. Through music performance, black musicians associated with the women's music circuit lend *audibility* to black women's experiences of race, gender, sexuality, and feminism. We can expect to hear more from them in the future.

Notes

This chapter expands on and revises some material from Eileen M. Hayes, "The Specificity of the Feminine: Black Women and Women-Identified Music," in *African American Music: An Introduction,* ed. Portia K. Maultsby and Mellonee V. Burnim (New York: Routledge, 2005), 541–58.

I would like to thank Portia Maultsby and Cornelia Fales for their insightful feedback on earlier drafts of this chapter.

1. See Tricia Rose, *Black Noise: Rap Music and Black Culture in Contemporary America* (Hanover, N.H.: Wesleyan University Press, 1994), 146–82; and Cheryl Keyes, *Rap Music and Street Consciousness* (Urbana: University of Illinois Press, 2002), 186–209. See also Kyra Gaunt's lucid discussion of the erasure of double-dutch from the collective memory of hip-hop in "Translating Double-Dutch to Hip-Hop: The Musical Vernacular of Black Girls' Play," in *Language, Rhythm, and Sound: Black Popular Cultures into the Twenty-First Century,* ed. Joseph K. Adjaye and Adiranne R. Andrews (Pittsburgh: University of Pittsburgh Press, 1997); and Sherrie Tucker, *Swing Shift: "All-Girl" Bands of the 1940s* (Durham, N.C.: Duke University Press, 2000).

2. For examinations of black racial identities, gender, sexuality, and music, see Maria Johnson, "'Pouring Out the Blues': Gwen 'Sugar Mama' Avery's 'Song of Freedom,'" *Frontiers: A Journal of Women's Studies* 25, no. 1 (2004): 93–100; and Maria Johnson, "'Jelly Jelly Jellyroll': Lesbian Sexuality and Identity in Women's Blues," *Women and Music: A Journal of Gender and Culture* 7 (2003): 31–52. See also Carmen Mitchell, "Creations of Fantasies/Constructions of Identities: The Oppositional Lives of Gladys Bentley," in *Homosexuality in Black Communities: The Greatest Taboo,* ed. Delroy Constantine-Simms (Los Angeles: Alyson Books, 2000), 211–25. Additional articles that address race and sexuality vis-à-vis black women's "voices" include Ellie M. Hisama's "Voice, Race, and Sexuality in the Music of Joan Armatrading," in *Audible Traces: Gender, Identity, and Music,* ed. Elaine Barkin and Lydia Hamessley (Los Angeles: Carciofoli, 1999), 115–31. See also Brian Currid's "'We Are Family': House Music and Queer Performativity," in *Cruising the Performative: Interventions into the Representation of Ethnicity, Nationality, and Sexuality,* ed. Sue-Ellen Case, Philip Brett, and Susan Leigh Foster (Bloomington: Indiana University Press, 1995), 165–96; and Martha Mockus, "MeShell Ndegeocello: Musical Articulations of Black Feminism,"

in *(Un)Making Race, Re-Making Soul: Transformative Aesthetics and the Practice of Freedom*, ed. Christa Acampora and Angela Cotton (SUNY Press, 2006).

3. See Gaunt, "Translating Double-Dutch to Hip-Hop," 148.

4. This chapter is based on research I conducted for my doctoral dissertation. In addition to participant observation at "women's music" festivals and concerts held in Michigan, Mississippi, California, Massachusetts, Washington, D.C., Indiana, and New Mexico, I interviewed numerous African American women performers and consumers of "women's music."

5. See Toni Armstrong Jr., "An Endangered Species: Women's Music by, for, and about Women," *HOTWIRE: The Journal of Women's Music and Culture* 5 (September 1989): 17.

6. Bonnie Morris, *Eden Built by Eves: The Culture of Women's Music Festivals* (Los Angeles: Alyson Publications, 1999), 6. Gillian Garr discusses the exclusion of women in the mainstream recording industry in *She's a Rebel: The History of Women in Rock and Roll* (Seattle: Seal, 1992).

7. Mary Celeste Kearney, "The Missing Links: Riot Grrrl-Feminism-Lesbian Culture," in *Sexing the Groove: Popular Music and Gender*, ed. Sheila Whiteley (London: Routledge, 1997), 218.

8. Boden Sandstrom, "Women Mix Engineers and the Power of Sound," in *Music and Gender*, ed. Pirkko Moisala and Beverley Diamond (Urbana: University of Illinois Press, 2000), 293.

9. Nancy Whittier, *Feminist Generations: The Persistence of the Radical Women's Movement* (Philadelphia: Temple University Press, 1995), 4.

10. Ibid., 5. See also Joy James, *Shadow Boxing: Representations of Black Feminist Politics* (New York: St. Martin's Press, 1999), 86–91.

11. Timothy Taylor, "The Gendered Construction of the Musical Self: The Music of Pauline Oliveros," *Musical Quarterly* 77, no. 3 (Fall 1993): 386.

12. Linda Alcoff, "Cultural Feminism versus Post-Structuralism: The Identity Crisis in Feminist Theory," *Signs: Journal of Women in Culture and Society* 13, no. 3 (1988): 408.

13. Ibid., 414.

14. While it is tempting to use the term *womyn's music*, as some writers do (see Mary Celeste Kearney), the spelling privileges reference to the Michigan Womyn's Music Festival over other women's music festivals held throughout the United States. The respelling of words ending in "-man" or "-men" emerges in lesbian discourses as just one of the issues addressed by those engaged in the study of "lavender languages." See William Leap, "Studying Lesbian and Gay Languages: Vocabulary, Text-making, and Beyond," in *Out in Theory: The Emergence of Lesbian and Gay Anthropology*, ed. Ellen Lewin and William L. Leap (Urbana: University of Illinois Press, 2002). I would argue that Bonnie Morris's Appendix B, "A Lexicon of Festivalese" (1999), contributes to the ethnography of communication in "women's music" communities as well. At the same time, I concur with William Leap, who suggests that lesbian-related text

making reflects issues of "opportunity, inequality, and privilege that need careful analysis in lesbian/gay contexts" (138). See also Julia Penelope, "Heteropatriarchal Semantics: Just Two Kinds of People in the World," *Lesbian Ethics* (Fall): 58–80.

15. Alcoff, "Cultural Feminism versus Post-Structuralism," 412.

16. Whittier, *Feminist Generations*, 2.

17. Ibid., 5.

18. "Sue Fink Interview by Toni Armstrong, Jr.," in *Lesbian Culture: An Anthology*, ed. Julia Penelope and Susan Wolfe (Freedom, Calif.: Crossing Press, 1994), 397.

19. See Julia Penelope and Susan Wolfe, eds., *Lesbian Culture: An Anthology* (Freedom, Calif.: Crossing Press, 1994), 392–402. Numerous ethnomusicologists have pointed to the need for more studies of reception in ethnomusicology; I am influenced here by a discussion Deborah Wong carries out in *Speak It Louder: Asian Americans Making Music* (New York: Routledge, 2004).

20. I understand these categories to be overlapping in some respects.

21. Arlene Stein, ed., *Sisters, Sexperts, Queers: Beyond the Lesbian Nation* (New York: Penguin Books, 1995), 100. Ironically, this style had already incorporated influences of post–World War II folk revival groups such as the Weavers, styles that reflected the influences of black performers such as American blues singer Leadbelly (Huddie Ledbetter).

22. Pamela Rogers of In Process . . . , interview with author, Washington, D.C. In Process . . . has performed at Sisterfire and at the National Women's Music Festival.

23. Feminist activists and theorists refer to the women's liberation movement of the late 1960s and 1970s as the "second wave" of women's activism, thereby acknowledging the contributions of the earlier, nineteenth-century suffragist movement. The term *third wave*, popularized by feminist writers such as Rebecca Walker, is a more recent formulation used to describe the encounters of a newer generation with the complexities of feminisms of the 1990s and beyond. See Rebecca Walker, "Becoming the Third Wave," in *Identity Politics in the Women's Movement* (New York: New York University Press, 2001), 78–80. Reprinted from *Ms.*, January/February 1992.

24. Karen Petersen, "An Investigation of Women-identified Music in the United States," in *Women in Cross-Cultural Perspective*, ed. Ellen Koskoff (Urbana: University of Illinois Press, 1987).

25. Shane Phelan quoted in Ellen Lewin, *Inventing Lesbian Cultures in America*, ed. Ellen Lewin (Boston: Beacon Press, 1996).

26. Adrienne Rich, "Compulsory Heterosexuality and Lesbian Existence," *Signs* 5, no. 4 (1980): 631–60.

27. Lewin, *Inventing Lesbian Cultures in America*. As a black feminist who had always identified as women-identified in the latter sense, this terminology was not new to me when I began research into this area.

28. At the time of our interview, Linda Tillery and the Cultural Heritage Choir was an all-female ensemble. Currently, the ensemble includes both men and women. Linda Tillery, interview with author, Oakland, California.

29. Linda Tillery interview. The Ward Singers consisted of Clara Ward (1924–73), her mother Gertrude, and her sister Willa. Later, the group expanded to include Marion Williams and Henrietta Waddy, at which time they performed under the name of the Famous Ward Singers. The Caravans of Chicago was a mixed-gender ensemble.

30. See Tonia Bryan, "In Tha Life, in Tha Closet," in *Da Juice: A Black Lesbian Thang*, special issue of *FIREWEED: A Feminist Quarterly of Writing, Politics, Art and Culture* (Toronto: Fireweed, 1995). Singers referenced include Joan Armatrading, India Arie, Chaka Khan, Mary J. Blige, Patti LaBelle, Ru Paul, TLC (a vocal group), MC Lyte, SWV (Sisters with Voices), Adeva, Patra (a Caribbean singer), Anita Baker, Donna Summer (?), and Diana Ross. Capitalization or lack thereof is intended by the writer, Tonia Bryan.

31. Omeyocan performed at Wiminfest 2003, in Albuquerque, New Mexico. Omeyocan is a politically concerned band but it is not lesbian-identified.

32. Throughout this chapter I experiment with my use of the term *women's music*. In Dee Mobacher's *Radical Harmonies* (video, 92 min., Woman Vision Productions, 2002), a documentary celebration of women's music by coproducers Boden Sandstrom, Margie Adam, and June Millington, black women musicians interviewed do not contest the use of the term as they did over the course of my research. Numerous reasons can account for this, but I have not explored this with the musicians themselves. My review of the film can be found in *Ethnomusicology,* Spring/Summer 2004. To order this valuable introduction to women's music, see the Woman Vision web site, http://www.woman-vision.org.

33. Barbara Smith's *Home Girls: A Black Feminist Anthology* (New York: Kitchen Table/Women of Color Press, 1983) is an exception. Angela Davis (1998) alludes to women's music in the acknowledgments to *Blues Legacies and Black Feminism.* She acknowledges black musician Linda Tillery and white musician Teresa Trull for providing "a contemporary link with the blues women whose legacies are at the heart of this book." Writers often mention Bernice Reagon and Sweet Honey in the Rock (see James, *Shadow Boxing,* 34), but they often stop short of situating the ensemble's relationship to the "women's music" circuit.

34. Stuart Hall, "What Is This 'Black' in Black Popular Culture?" in *Black Popular Culture,* ed. Gina Dent (Seattle: Bay Press, 1992).

35. See Smith, *Home Girls,* 1984; Cherrie Moraga and Gloria Anzaldúa, *This Bridge Called My Back: Writings by Radical Women of Color* (Watertown, Mass.: Persephone Press, 1981); and Cheryl Clarke, "Lesbianism: An Act of Resistance," in Moraga and Anzaldúa, *This Bridge Called My Back,* 128–37.

36. See Marlon Riggs, "Black Macho Revised: Reflections of a SNAP! Queen," in *Brother to Brother: New Writings by Black Gay Men,* ed. Essex Hemphill (Boston: Alyson Publications, 1991); Philip Brian Harper, "Eloquence and Epitaph: Black Nationalism and the Homophobic Impulse in Responses to the Death of Max Robinson," in *The Lesbian and Gay Studies Reader,* ed. Abelove et al. (New York: Routledge, 1993); Cathy Cohen, *Boundaries of Blackness: AIDS and the Breakdown of Black Politics*

(Chicago: University of Chicago Press, 1999); Ingrid Monson, "Music and the Anthropology of Gender and Cultural Identity," in *Women and Music* 1 (1997): 24–32; and Patricia Collins, *Black Sexual Politics: African Americans, Gender, and the New Racism* (New York: Routledge, 2004).

37. See Johnson, "Pouring Out the Blues," 93–110; reference is on page 93.

38. Ibid., 93.

39. Linda Tillery, "Freedom Time," Tuizer Music. Quoted in Smith, *Home Girls*.

40. *LGBT* means "lesbian, gay, bisexual, transgender."

41. Collins, *Black Sexual Politics*, 88.

42. Ibid.

43. Cohen, *Boundaries of Blackness*, 21.

44. Jewelle Gomez, "Wink of an Eye," in Afrekete, *An Anthology of Black Lesbian Writing*, ed. Afrekete (New York: Anchor Books, 1995), 134.

45. See Sherrie Tucker's important discussion of this issue as it pertains to her research with female members of swing bands, "When Subjects Don't Come Out," in *Queer Episodes in Music and Modern Identity*, ed. Sophie Fuller and Lloyd Whitesell (Urbana: University of Illinois Press, 2000).

46. Monson, "Music and the Anthropology of Gender and Cultural Identity," 28.

47. Aaron Lecklider, "Between Decadence and Denial: Two Studies in Gay Male Politics and 1980s Pop Music," *Journal of Popular Music Studies* 16, no. 2 (2004): 125.

48. Quoted in ibid., 126. Urvashi Vaid is the author of *Virtual Equality: The Mainstreaming of Gay and Lesbian Liberation* (New York: Anchor Books, 1995), 30.

49. Lecklider, "Between Decadence and Denial," 126. Perhaps Vaid decided not to address insights gleaned from Eve Sedgwick's "Epistemology of the Closet," an important article in which she addresses the metaphor of the closet and the phenomenon of "coming out."

50. Keith Boykin, *One More River to Cross: Black and Gay in America* (New York: Anchor Books, 1996). Quoted in Collins, *Black Sexual Politics*, 90. Increasingly, scholars have questioned whether, given the pressures gays and lesbians experience to assimilate into heterosexual society, the metaphor of "the closet" resonates as much with gay and lesbian experience today as it did in previous years. See also Collins's discussion of the metaphors of the "prison" (to describe the experience of racism experienced by black Americans) and the "closet" (to describe homophobia faced by African Americans) in her chapter titled "Prisons for Our Bodies, Closets for Our Minds: Racism, Heterosexism, and Black Sexuality," in Collins, *Black Sexual Politics*, 2004.

51. See Kearney, "Missing Links," 220. As Kearney suggests, when Tracy Chapman "experienced mainstream success in the 1980s," there was little acknowledgment of the role "women's music" played in setting the stage for later feminist music making. Amy Horowitz recounts Chapman's appearance in Bernice Johnson Reagon, *We Who Believe in Freedom: Sweet Honey in the Rock . . . Still on the Journey* (New York: Anchor Books, 1993), 192.

52. WPKN, Bridgeport, Connecticut.

53. See Sara Evans, *Personal Politics: The Roots of Women's Liberation in the Civil Rights Movement and the New Left* (New York: Vintage Books, 1980), 105.

54. See Paula Giddings, *When and Where I Enter: The Impact of Black Women on Race and Sex in America* (New York: William Morrow, 1984), 489.

55. Robin D. G. Kelley, *Freedom Dreams: The Black Radical Imagination* (Boston: Beacon Press, 2002), 148.

56. See James, *Shadow Boxing,* 76.

57. Combahee River Collective, "A Black Feminist Statement," in *Capitalist Patriarchy and the Case for Socialist Feminism.* ed. Zillah R. Eisenstein (New York: Monthly Review Press, 1979).

58. Kelley, *Freedom Dreams,* 150.

59. See Karen Kahn, *Frontline Feminism, 1975–1995: Essays from Sojourner's First 20 Years* (San Francisco: Aunt Lute Books, 1995); Smith, *Home Girls,* 1983.

60. Kahn, *Front Line Feminism,* 7.

61. Stein, *Sisters, Sexperts, Queers.* See *Radical Harmonies* for commentary by veterans of women's music, including Linda Tillery, June Millington, Gwen Avery, and Mary Watkins.

62. See Reagon, *We Who Believe in Freedom.*

63. Cynthia Lont, "Women's Music: No Longer a Small Private Party," in *Rockin' the Beat: Mass Music and Mass Movements,* edited by Reebee Garofalo (Boston: South End Press, 1992), 245.

64. Morris, *Eden Built by Eves,* 217. Notes Amy Horowitz in Reagon, *We Who Believe in Freedom,* "From this beginning in 1982, the festival grew into a two-day four-stage program with overnight camping and a marketplace of over two hundred carftswomen. Ten thousand participants shared in the sounds and sensations of a stunningly unique celebration" (192).

65. Horowitz in Reagon, *We Who Believe in Freedom,* 191.

66. Ibid., 193.

67. Morris, *Eden Built by Eves,* 218.

68. Horowitz in Reagon, *We Who Believe in Freedom,* 192.

69. Ibid., 193. Coming of age and into my identity as a black feminist activist in Philadelphia in the early 1980s, I missed attending the Sisterfire festivals held in the Washington, D.C., area. Consolation was purchasing *Sisterfire,* a recorded compilation of festival acts and having the opportunity to play it over and over again.

70. This performance was part of a "round robin" format in which a number of artists took turns sharing the spotlight on stage, 1995.

71. Barbara Bradby, "Lesbians and Popular Music: Does It Matter Who Is Singing?" in *Outwrite: Lesbianism and Popular Culture,* ed. Gabriele Griffin (Boulder, Colo.: Pluto Press, 1993), 148–71.

72. Henry Louis Gates, *The Signifying Monkey: A Theory of African American Literary Criticism* (New York: Oxford University Press, 1988), 81.

73. See Toni Armstrong Jr., "Midwife to the Culture: HOT WIRE" in *Happy Endings: Lesbian Writers Talk about Their Lives and Work,* edited by Kate Brandt (Tallahassee, Fla.: Naiad Press, 1993); Morris, *Eden Built by Eves;* and Laura Post, *Backstage Pass: Interviews with Women in Music* (Norwich, Vt.: New Victoria Publ., 1997). See Stein, *Sisters, Sexperts, Queers.*

74. Stein, *Sisters, Sexperts, Queers,* 106.

75. Numerous scholars have suggested that the rubric of "queer" often erases the experiences of women and people of color.

76. Nedra Johnson, "Forever with Me," *Nedra,* Big Mouth Girl Productions, 2005. I played this song for a woman as part of a "feedback interview" in which I elicited interpretations of songs by black performers of women-identified music outside the contexts of women's music festivals. This particular listener did not comment on Johnson's vocal quality (contralto), which might have also influenced her opinion.

77. See Ellen Lewin, "Why in the World Would you Want to Do That?" Claiming Community in Lesbian Commitment Ceremonies," in Lewin, *Inventing Lesbian Cultures in America.*

78. I am inspired to ask this question by the number of third-wave feminists who discuss how their conceptualizations of feminism differ from and are consonant with the feminism espoused by members of their "mothers'" generation. See Rebecca Walker, ed., *To Be Real: Telling the Truth and Changing the Face of Feminism* (New York: Anchor Books, 1995).

79. See Gregory Connerly's "Are You Black First or Are You Queer?" in Constantine-Simms, *Homosexuality in Black Communities.*

80. Quoted in Morris, *Eden Built by Eves,* 109.

Revisiting
Musical Herstories

8

Black Women in Art Music

TERESA L. REED

In spite of their underrepresentation in histories of Western art music, African American women have influenced every aspect of classical music production and performance. From the opera stage to the orchestra pit, from the composer's studio to the conductor's podium, the contributions of black women in this milieu bespeak far more than a love of music. While devotion to the art is indispensable to any artist's success, historically, black women have faced a unique set of circumstances in the highly politicized arena of classical music. These experiences yield a picture of what it means to be black and female in a white- (and male-) dominated cultural milieu. In this chapter, I survey black women's involvement in classical music in a variety of capacities: as organizers of clubs for the performance of art music, as writers/documenters of music histories, as teachers of music, singers, instrumentalists, composers, and conductors.[1]

The northeastern states are home to many of the nation's oldest free black communities and cultural institutions. By the 1790s, laws had been passed in Vermont, Pennsylvania, Massachusetts, New Hampshire, Connecticut, and Rhode Island that either prohibited slave trading, gradually emancipated slaves, or abolished slavery altogether. Although blacks in these regions enjoyed basic freedoms and opportunities much sooner than did their southern counterparts, they were still barred from many of the facilities and institutions accessible to whites. Consequently, by the first decade of the nineteenth century, New England blacks had already established their own civic and cultural organizations.

Despite developing their own communities, blacks in the Northeast sought

contextualize
assimulation of sv

equal status with whites, and some of their cultural and educational efforts were designed to foster their assimilation into mainstream society. The desire for assimilation motivated many to reject distinctively African aesthetics and to adhere, instead, to the European cultural values adopted by many white Americans. In the nineteenth century, black women promoted classical music energetically. Their involvement in clubs and organizations designed to provide blacks with classical music training constituted their effort to "uplift the race." In 1831, black women in Boston organized the Afric-American Intellectual Society, which sponsored concerts, lectures, and other cultural projects. In 1832, a similar organization, the Boston Colored Female Charitable Society, was founded. In the decades following Reconstruction, black women in Boston founded a number of organizations that provided substantial support to classically trained black musicians. These included the Phillis Wheatley Club (1886), the Ladies Harmony Circle (1891), and the Woman's Era Club (1894). In 1897, Mamie Hilyer founded the Treble Clef Club in Washington, D.C. The mission of the women in the Treble Clef Club was to champion the cause of "good music" in the homes of black Washingtonians. To this end, they held monthly meetings, regular performances, and an annual public recital. Hilyer was also active in the Samuel Coleridge-Taylor Choral Society and brought the score of Coleridge-Taylor's *Hiawatha* from England to the United States.

Black women also promoted classical music through their writings. In the 1880s, Lillian Alberta Lewis, a Bostonian, wrote several articles for the *Boston Advocate*. Writing under the pseudonym Bert Islew, Lewis praised black classical artists and promoted their concerts. Josephine St. Pierre Ruffin and her daughter, Florida R. Ridley, cofounded the *Woman's Era,* a monthly journal published from 1894 to 1896. Sponsored by the club of the same name, the journal initiated music scholarships for black students, and its arts and literary section reported the musical happenings of the black community. J. Hilary Taylor was founder and editor of the *Negro Music Journal,* in publication from 1902 to 1903.[2]

The history of black women in the pedagogy of classical music also dates to at least the late nineteenth century. A most significant contribution to American music theory pedagogy was Rachel Washington's *Study of Music Made Easy: Musical Truth.* Published in Boston in 1884, *Musical Truth* is one of the earliest music theory texts written by a woman (of any race) in the United States. Numerous black women offered studio instruction in voice and piano in the eastern states. Musicologist Josephine Wright reports that in Boston alone, there were no fewer than twelve black women who taught

private lessons in piano, voice, and organ during the late 1800s.[3] Harriet Gibbs Marshall founded the Washington [D.C.] Conservatory of Music and School of Expression in 1903. In 1937, she achieved her goal of founding the National Negro Music Center at the conservatory. The school remained in operation until 1960.

Eventually, mainstream institutions in the Northeast offered women and blacks opportunities to receive classical music training. Although Oberlin College in Ohio graduated its first black female student, Lucy Session, in 1850, opportunities for black women to study music were more plentiful in regions closer to the East Coast. In Boston, the New England Conservatory and the Boston Conservatory began admitting blacks and women in 1867; the Emerson College of Oratory's Department of Music and the School of Vocal Arts opened their doors to blacks and women in the 1880s, as did the Boston Training School of Music in 1891.[4] No doubt aware of longstanding traditions of musical excellence in nearby black communities, these institutions wisely invested in black talent at a time when most other schools would not. For blacks, acceptance at mainstream institutions—even if on purely musical rather than on social, moral, or political terms—suggests a degree of success for those who had hoped to use classical music as a vehicle for assimilation.

Prima Donnas and Concert and Opera Singers

The history of black women on the concert stage can be traced to Elizabeth Taylor-Greenfield, born in Natchez, Mississippi, in the mid-1820s. When Elizabeth Taylor-Greenfield performed, audiences responded in a variety of ways. Critics praised her voice, the range of which was said to rival both Jenny Lind's soprano and Luigi Lablache's bass.[5] Critics dubbed the self-taught soprano the "Black Swan," a racialized moniker that, according to today's standards, is demeaning. During this period, however, it was not unusual for the white press to assign famous black concert musicians stage names derived from the stage names of successful white singers (e.g., Sissieretta Jones/the Black Patti, Flora Batson-Bergen/the Colored Jenny Lind, Annie Pauline Pindell/the Black Nightingale, Rachel Walker/the Creole Nightingale).[6] Taylor-Greenfield was assigned the sobriquet "Black Swan" as the appropriated nickname of Irish soprano Catherine Hayes, the "Swan of Limerick," who was having a successful tour of the United States during the 1850s, when Elizabeth Taylor-Greenfield made her debut in Buffalo, New York. Given the pervasive segregation that kept most nineteenth-century whites woefully ig-

norant of the artistic and intellectual capabilities of blacks, such comparisons enabled white readers and potential white audience members to conceive of these black women in artistic roles that were previously unimaginable.

Along with the accolades reaped by Taylor-Greenfield's performances came vicious assaults on virtually every other aspect of her artistry and person. One reporter likened her low register to "a bride with a beard on her chin." Another commented on her size, estimating her weight "at between 275 and 300 pounds." Still others noted her awkward stage presence and deportment, calling her voice "more refined than her person." Mostly, however, it was Taylor-Greenfield's race that evoked commentary. Struggling to conjure an image of what in their minds was an incongruity—a black woman on the classical concert stage—writers described her physical features in demeaning ways. "The Swan is a plain looking, medium sized, woolly headed, flat nose negro woman," wrote one reviewer. Another described her features as "but slightly modified from the pure African lineaments—retaining the low forehead, the depressed nose, and the expansive mouth, without the bulbous labia."[7]

Despite being greeted by both public adulation and ridicule, Taylor-Greenfield traveled to England, refined her craft, and gave a command performance for Queen Victoria in 1854. Having triumphed before England's royalty, the former slave then returned home to an American public more willing to acknowledge her extraordinary gift. She devoted her later years to performance and private teaching in Philadelphia until her death in 1876.

In the fertile artistic climate of the Northeast, several African American "prima donnas" emerged to continue the legacy of Taylor-Greenfield. Marie Smith Selika (1849–1937) performed for President Rutherford B. Hayes, toured internationally, and gave a command performance for England's Queen Victoria in 1883. She later taught privately and died in New York at the age of eighty-seven. Flora Batson Bergen (1864–1906), a Washington, D.C., native, completed three world tours and gave command performances for New Zealand's royal family, Queen Victoria, and Pope Leo XIII. Matilda Sissieretta Joyner Jones (1869–1933) was born in Portsmouth, Virginia, but taken to Rhode Island by her parents in 1876, the year of Taylor-Greenfield's death. Sissieretta Jones sang for four U.S. presidents and for crowds of up to seventy-five thousand, and she toured internationally before dying penniless of cancer in Providence. Jones, as noted earlier, was given the moniker "Black Patti" in a nod to the reigning white prima donna of the period, Adelina Patti. Other black prima donnas of the period include Anna Madah Hyers (1855–1925), Emma Louise Hyers (1853–1890), Nellie Brown Mitchell (1845–1924), and Rachel Walker (1873–194?).[8]

Though by no means rich, these black women found the economic means necessary for their training in classical music. Even Taylor-Greenfield was assisted by the perpetual endowment of one hundred dollars a year provided by her former mistress. Sissieretta Jones's father was a minister with income from both the church and other jobs. Jones attended integrated schools and later studied privately at the New England Conservatory. For a time, Marie Selika enjoyed the patronage of a wealthy family who heard her perform in Ohio.

Segregation created painful tensions between these singers and their black audience members, who were routinely relegated to inferior seating or denied admittance to their concerts while white audiences were afforded regular seating. Doubtless, too, individual black singers experienced internal conflict about the circumstances in which their performances took place. When blacks in the Midwest were turned away from one of Taylor-Greenfield's concerts, the black press called her "an instrument of segregation."[9] Rosalyn Story relates this incident on the occasion of one of Sissieretta Jones's concerts in Louisville, Kentucky: "At a performance at the Masonic Temple Theater, blacks were not allowed on the orchestra floor but were permitted to sit in the balcony. The balcony filled up quickly while the orchestra floor was only half-filled with whites. Instead of allowing the overflow of blacks to occupy the remaining ground floor seats, the management turned them away. . . . Jones noticed the odd division and was furious."[10] After the concert, Jones told a reporter, "I felt very much disappointed. I never before had such an experience, and I could not help feeling it."[11]

The press's attention to the physical appearance of these black artists hardly veiled its bias in favor of "European" features and its distaste for "African" traits. Both Sissieretta Jones and Elizabeth Taylor-Greenfield exhibited a supposed African phenotype; the press seems to have been fascinated with the color of their skin, the size of their lips, and the texture of their hair. Having been schooled from youth in the genteel arts, however, Jones was spared much of the scrutiny given her older contemporary, Taylor-Greenfield. One Canadian reporter praised Jones for her choice of clothing, which gave "the dusky skin effective setting." He was equally impressed with her hair, which, "without ever a kink or curl, is coiled in a Grecian knot at the nape of the neck, showing a prettily shaped head."[12] The press had less to say about the appearance of Marie Selika, who, unlike either Taylor-Greenfield or Jones, had fair skin and long, straight hair. Like much propaganda of the period, pejorative remarks about dark skin and kinky hair were meant to diminish the black soprano's allure, her courage and talent notwithstand-

ing. Although she could sing, white journalists cited the soprano's "African" traits as proof that she could only approximate, but never quite attain, the goddesslike stature of a true "diva."

It is ironic that these black singers flourished at a time when the nation still staggered from the aftermath of Reconstruction. Demographic adjustments following the emancipation of the slaves made for unprecedented racial tension. The year 1876 marked not only the beginning of Marie Selika's professional career but also the year that black women armed themselves with clubs to patrol polling places on election day in South Carolina. The year 1892 not only marked Sissieretta Jones's performance for President Harrison but also the beginning of Ida B. Wells's lifelong antilynching campaign. While these prima donnas lived a world apart from the formerly enslaved and their descendants, they were hardly immune to the racial malaise hovering over the entire country.

The turn of the twentieth century ushered in an era of change and promise for black Americans. Many watershed events underscore the difference between life for African Americans in the 1800s and the promise of a new century. The year 1909 brought the founding of the National Association for the Advancement of Colored People; during World War I, black soldiers experienced a modicum of acceptance in Europe and returned home to challenge discrimination. W. E. B. Du Bois's militant voice supplanted, for many, the accommodationist rhetoric of Booker T. Washington. During the migration of the postwar years, droves of African Americans left the South for increased job opportunities and a better life in the North. Harlem became the center of the Black Renaissance of the 1920s and 1930s, during which the prolific creation of literary, theatrical, musical, and artistic works gave fresh and multifaceted voice to the black American perspective.

Contralto Marian Anderson was a product of this new era. Born in 1902, Anderson was a native of Philadelphia and heir to its rich musical legacy. The year of her birth loosely coincided with the decline of the pioneering black singers by the mid-1890s. Anderson grew up in the three-story home of her grandmother, where she had access to her grandmother's organ. An item of luxury rather than of necessity, the organ indicated a degree of financial security in Anderson's formative environment. Nevertheless, she received the financial support of her church to pursue musical study.

The founding of the National Association of Negro Musicians by Nora Holt in 1919 was a sign of growing African American interest in classical music. Within this organization, surrounded by the black elite of the classical music world, Anderson found a support denied earlier women. She was

particularly inspired by the famous tenor Roland Hayes, and in turn, she would mentor others.[13] In 1921, Anderson received the organization's first scholarship.[14]

Despite accolades from luminaries such as conductor Arturo Toscanini, who described her voice as "such as one hears once in a hundred years," Anderson frequently encountered racial prejudice. Unlike artist and activist Paul Robeson, who greeted racial prejudice with unprecedented outspoken-ness, Anderson endured innumerable situations with quiet resolve; she was not demonstrably politically active during her career. In her autobiography, however, she relates an instance of racism she experienced in her efforts to seek musical training:

> That music school no longer exists in Philadelphia, and its name does not matter. I went there one day at a time when enrollments were beginning, and I took my place in line. There was a young girl behind a cage who answered questions and gave out application blanks to be filled out. When my turn came she looked past me and called on the person standing behind me. This went on until there was no one else in line. Then she spoke to me, and her voice was not friendly. "What do you want?" I tried to ignore her manner and replied that I had come to make inquiries regarding an application for entry to the school. She looked at me coldly and said, "We don't take colored."[15]

Anderson also describes the perils of touring in segregated America and the embarrassment of being confronted with separate and unequal accommo-dations in the public sphere.

As was the case with her predecessors, Anderson's increasing celebrity status at times led to difficult choices that created tension between her and black audiences. After touring Europe in the 1930s, Anderson returned to the United States. Describing her struggle in choosing between her black American accompanist, Billy King, and the white accompanist, Kosti Vehanen, who played with her in Europe, Anderson said, "The issue went deeper, and I was aware that, whatever the decision, it would be open to misunderstand-ing and would be criticized by some. If I did not use Billy King some of my own people might be offended. And particularly in the South, where I knew I would be singing, people might take offense that a white man was serving as my accompanist."[16]

The European press was fascinated with the color of Anderson's skin. In one review, a Norwegian journalist described her as "dressed in electric-blue satin and looking very much like a chocolate bar." Another paper said she appeared like café au lait. Anderson took these remarks in stride, however,

and attributed them to the naïveté of a people unaccustomed to African Americans.[17]

Anderson used the classical concert stage to celebrate her black American heritage. While performing in Salzburg in 1935, she ended a typical concert with a set of Negro spirituals. It has since become customary for black singers to include spirituals either as part of the program or as encores to their performance. Although Anderson's narrative does not document a strong political activism, she is perhaps most famous for her historic performance in 1939, which became a dramatic symbol of triumph over racism. Barred by the Daughters of the American Revolution from performing in Constitution Hall, the soprano's well-wishers arranged for her to sing on the steps of the Lincoln Memorial on Easter Sunday 1939 before a crowd of seventy-five thousand. While she did not assume the posture of an activist, Anderson's performance ranks among the most often cited symbols of achievement and triumph for blacks in America.

The roster of Marian Anderson's successors includes Anne Brown, Camilla Williams, Dorothy Maynor, Abbie Mitchell, Lillian Evanti, Leontyne Price, Martina Arroyo, Mattiwilda Dobbs, Grace Bumbry, Shirley Verrett, Barbara Hendricks, Kathleen Battle, Jessye Norman, Leona Mitchell, Marvis Martin, and others whose accomplishments are treated extensively in Rosalyn Story's *And So I Sing: African American Divas of Opera and Concert* (1993).

Since 1980, black divas have integrated the opera stage to the extent that their presence is no longer considered a novelty. Black women have found opportunities in opera by portraying heroines of color in Verdi's *Aïda*, Gershwin's *Porgy and Bess*, and Meyerbeer's *L'Africaine*. Although the tragically streetwise, drug-addicted Bess now recalls familiar racial and gender stereotypes, the role of Bess has been an important vehicle for employment and opportunity to the black women who have portrayed her. Particularly noteworthy are those who have triumphed in nonblack character roles. In 1946, for example, Camilla Williams made history when she sang the title role of *Madama Butterfly* with the New York City Opera. More recently, Jessye Norman has achieved acclaim for her portrayals of Wagnerian operatic characters.

Instrumentalists, Conductors, and Composers

The history of black women instrumentalists in classical music is relatively unknown. By contrast, black classical vocalists have been highly visible historically, both because of the theatricality intrinsic to singing and because

of the attention given to their racial distinctiveness. During the nineteenth century, the participation of black women in orchestral music—both as performers and conductors—was determined as much by gender circumscription as by racial discrimination. As musicologists have attested, gender proscriptions determined the types of instruments that were deemed appropriate for women to play. In his study of the images of eighteenth-century European women and music, Richard Leppert notes that "in the course of the eighteenth century . . . girls and women were for the most part restricted to two types of instruments, keyboards and plucked strings." He states further that "the music females made, and were expected to make, was either tolerated or valued largely to the degree to which it kept within the bounds of the ideology of domesticity."[18] These attitudes extended to American women of the nineteenth century, as this anonymous writer makes clear in an 1895 issue of *Scientific America*:

> The most capable and intelligent of women can never become factors in any orchestra of any serious aims. . . . Her physical incapacity to endure the strain of four or five hours a day rehearsal, followed by the prolonged tax of public performances, will bar her against possible competition with male performers. . . . There are dozens of young women who play well enough for an orchestral place. But even were a mixed orchestra of men and women together a condition probable enough to consider, about how many works of novelty and magnitude in a year would the ordinary woman find herself physically equipped to carry through rehearsal? Not more than a third, probably, of what men are able to do.[19]

To circumvent this discrimination, American women began organizing their own "all-female" instrumental ensembles. In 1884, Marion Osgood established what she claimed was America's first ladies' orchestra in Chelsea, Massachusetts. The ensemble of approximately ten women played in and around Boston and the Northeast and remained in existence for about ten years.

All-female orchestras composed of black women soon followed. Some of the earliest of these had male leadership. Around 1904, Major N. Clark Smith, a renowned professor and bandsman, organized the Young Ladies Orchestra. About the same time, Southern University's William J. Nickerson organized and directed the Nickerson Ladies Orchestra. Late in the 1930s, a W. H. Wooten directed the Outer South End Community Orchestra in Boston, another group comprised of black females.

Black female orchestras with female leadership included the Martin-Smith School Ladies' Staff Orchestra in New York, which was established around

1915 and directed by Mildred Gassaway Franklin, and Madam Corilla Rochon's Ladies Symphony Orchestra in Houston, founded during the same period. Annie Malone, founder of the Poro School of Beauty Culture in St. Louis, organized the Poro College Ladies Orchestra early in the 1920s. Although St. Louis was known for jazz during this period, D. Antoinette Handy states that "the prevailing attitude of cultured blacks suggests that this group's repertory was limited to the more 'elite' literature."[20]

During the 1930s and 1940s, black women in "elite" (read: classical) instrumental ensembles were less well known than those in the female dance orchestras and jazz bands that were prevalent during this period.[21] While ensembles such as this one were popular during the 1930s and 40s, this period also witnessed the weakening of race and gender barriers for black women seeking inclusion in white orchestras. History makers at this time include violinist Dorothy Smith, who became the first black member of the Cleveland Women's Orchestra in 1937, violinist Sylvia Medford, the first African American to integrate the Brooklyn Symphony Orchestra in 1949, and timpanist Elayne Jones, who joined the New York City Ballet and Opera Company Orchestras in 1949. Twenty-three years later, Jones became the first African American, male or female, to secure a principal position in a major American symphony orchestra when she competed successfully against forty others for the position of timpanist with the San Francisco Symphony Orchestra.

Although she was a player of international stature, and although maestro Leopold Stokowski endorsed her musicianship, Jones's career in San Francisco followed with much disappointment. At the end of her first season, Jones stated in an interview, "It's been a long struggle against two prejudices and it isn't over yet. . . . I had to prove that music could be played by anyone who loves it. . . . It's been a terrible burden because I always felt I had to do better, that I wouldn't be allowed the lapses other musicians have."[22] In 1974, Jones and the only other minority instrumentalist in the orchestra, Japanese bassoonist Ryohei Nakagawa, were denied tenure. Newspapers across the country reported the incident, alleging possible race and gender discrimination. The press also reported the lawsuits that followed, through which Jones sought upward of $1.5 million in damages. In a show of camaraderie, Leontyne Price and Shirley Verrett were among those in a committee assembled to lend support to Jones. Jones was never compensated, however, for what many believed to be a flagrant act of racism and gender bias.

Bassoonist Margaret Dudley also had disappointing encounters with the American orchestral establishment. Dudley received her bachelor of music

education degree from the University of Michigan in 1971. Her private instructors included Charles Sirard and Lyell Lindsey of the Detroit Symphony and John Price of England's Royal Philharmonic. She held the position of first bassoonist in several orchestras during the early 1970s, including the Detroit Metropolitan Orchestra, the Detroit Women's Orchestra, the Colorado Philharmonic, and the Teatro Lírico Opera Company of New York. Despite these credentials, Dudley relates an instance of race discrimination she encountered early on in New York:

> I auditioned for one of America's leading music festival orchestras. One official, who had not heard my audition, said that I could get a scholarship if I applied as a student, because they were given out to black students who hadn't had the right education. This, despite my holding degrees from America's leading schools of music. There followed soon after a similar experience. In this case, I was told that if my teacher had interceded, I would have gotten the position. By this time, I was finished with New York City.[23]

In 1973, Dudley received a scholarship to the Institut des Hautes Études Musicales in Montreux, Switzerland. In recent years, she has remained in demand as a bassoonist and has found her musical prospects more attractive in Europe than in the United States.

Several black women concert pianists came into prominence in the second half of the twentieth century. Philippa Duke Schuyler, who began performing in public at age four, won several competitions sponsored by the New York Philharmonic Young People's Society and performed internationally with the world's top symphony orchestras. Schuyler also composed several symphonic pieces and published books on various subjects, all before her untimely death in 1967 at the age of thirty-four.[24] A close contemporary of Schuyler, Armenta Adams Hummings, also began her public career as a concert pianist when she was a child. After debuting at New York's Town Hall in 1961, she graduated from Juilliard with a master's degree in 1962.[25] Soon thereafter, she received numerous invitations to perform with orchestras throughout the world.[26] Natalie Hinderas began studying piano at six years of age with her mother, a pianist who had taught at both the Cleveland Institute of Music and the Oberlin Conservatory. Hinderas later studied at Juilliard and embarked upon a performing career that championed the piano music of black composers such as R. Nathaniel Dett, John W. Work, William Grant Still, and George Walker.[27] A much-sought-after teacher, Hinderas went on to influence the next generation of black classical pianists.

Composers

While the works of Bach, Beethoven, and Brahms are staples of the traditional repertoire, the canon is expanding to include the music of male and female composers of various ethnic backgrounds. This movement toward musical diversification can be attributed to two factors: the growth of an increasingly diverse audience for concerts of classical music and the activism of music scholars within the academy. Cultural diversity in music scholarship and performance has, in some circles, become politically expedient as well as economically prudent.

African Americans and white female composers in the nineteenth century worked without the benefit of an enlightened public sentiment in their favor. Trapped by social taboos into immutable roles of domesticity, nineteenth-century women who succeeded in publishing literary and artistic works often did so under male pseudonyms to conceal their identities. Speaking of white American women composers of the nineteenth century, Adrienne Fried Block writes:

> Although women were widely accepted as composers for the parlor, the composition of art music was a skill considered appropriate only for men. Women, critic George Upton wrote in 1880, should be content to function as men's Muses or inspirations. Furthermore, a prevailing theory, social Darwinism, placed women lower on the evolutionary scale than men, incapable of creating high art because they lacked intellectual ability. Hence there was serious doubt that women could create art music of real value under even the most favorable conditions.[28]

Similar appraisals of black intelligence permeate nineteenth-century literature. Misconceptions about the intelligence of (white) women and African Americans created a virtually insurmountable barrier for any black woman aspiring toward "serious" composition in the 1800s. In the twentieth century, this barrier would succumb to Florence Price, the first black female composer of distinction.

Born in 1888 in Little Rock, Arkansas, Price received her earliest musical training from her mother, an accomplished soprano and concert pianist. She graduated in 1906 from the New England Conservatory, where her teachers included Frederick Converse and George Chadwick. Price continued her studies at the Chicago Musical College and the American Conservatory of Music and later taught at Shorter College in Little Rock and Clark College in Atlanta. Price's achievements included Holstein Prizes in 1925 and 1927, a

Wanamaker Award in 1932 for her Symphony in E Minor, and a Wanamaker honorable mention in 1939 for her Sonata in E Minor.

Like the works of William Grant Still and William Dawson, her contemporaries, Price's compositions exhibit the fusion of Western European formal structure with black American ethos. The first movement of the piano Sonata in E Minor, for example, is a conservative rendering of sonata-allegro form. Its introductory bars are even mildly reminiscent of the opening measures to Beethoven's *Pathetíque* Sonata. The principal themes of the sonata, however, are primarily pentatonic, which accounts, in part, for its distinctively folk character. Price was a prolific composer, and the black idiom is salient in her other piano works, art songs, choral pieces, and orchestral compositions. The Chicago Symphony Orchestra's performance of Price's Symphony in E Minor in 1933 was one of three important premieres for black composers during the years of the Harlem Renaissance. The other two were the premiere of William Grant Still's *Afro-American* Symphony in 1931 and William Levi Dawson's *Negro Folk* Symphony debut in 1934.

As a woman, Price's road to recognition was seemingly paved with its own unique struggles. In 1912, she married an attorney, Thomas J. Price, with whom she had three children. After the lynching of a black man in their hometown of Little Rock, the Prices, along with other black families, moved to Chicago in 1927. After their arrival in Chicago, Florence Price befriended Estella Bonds, a musician and the mother of Margaret Bonds. Price's presence in the home of Estella Bonds was highly opportune for young Margaret, who studied piano with Price and composition with both Price and William Dawson. Margaret Bonds also worked as a copyist for Price, Dawson, Noble Sissle, and Will Marion Cook whenever their works were performed in Chicago.

Margaret Bonds's close association with Florence Price and with the many other black artists in the Bonds's circle of friends paved the route for her to become a distinguished composer in her own right. After high school, Bonds attended Northwestern University, where she completed a bachelor's degree and a master's degree in music by age twenty-one. She then moved to New York and enrolled in Juilliard, where she continued private study of composition and piano. When Bonds approached Nadia Boulanger for composition lessons, the world-renowned pedagogue refused her so as not to corrupt or misdirect what she perceived to be Bonds's unique compositional voice. Mildred Denby Green writes, "She did not understand how to develop Bonds's talent. She told Bonds that she should continue composing as before, and advised her not to study with anyone or to study fugue. Bonds

later felt that Boulanger's genius as a teacher was quite evident in her refusal to accept her as a student because in her style, a combination of European techniques and black improvisation so strongly prevailed that further study of European traditions might have stifled her."[29] Having been immersed in African American history and literature since childhood, Margaret Bonds worked in an idiom indicative of her commitment to the black aesthetic. "The Negro Speaks of Rivers," for example, is a setting of a poem by Langston Hughes. The poem describes the presence of black people in various parts of the world, and her music paints aural imagery of the narrative. Although through-composed, the music employs a "river" motive that serves to unify the entire piece.[30]

Successors of Price and Bonds include Julia Perry, whose works consist of both compositions in the black idiom and those featuring twentieth-century techniques; Evelyn Pittman, many of whose compositions can be described as black history lessons set to music; and Lena McLin, whose works frequently reference the black gospel style. Unlike the singers, instrumentalists, and conductors, black female composers have remained relatively anonymous to the public during the creation and performance of their works. To the lay person, the composer's name reveals only gender, not ethnicity. Yet Price, Bonds, and their successors have chosen to assert their ethnic identities through their compositions by boldly incorporating spirituals, folk melodies, jazz, and gospel in their music. In addition, they have drawn upon black history and literature for inspiration.

Black women have yet to wield the baton as principal conductors of major orchestras on a full-time basis. As of the publication of her book *Black Conductors* (1995), D. Antoinette Handy had not identified a regular African American female conductor of an "established" ensemble. She does, however, cite several black women who have guest conducted with some of America's major orchestras. Pianist, composer, and conductor Margaret Harris first came to national prominence as the conductor and musical director of *Hair* in 1970. At that time, music journalist Catherine Contos speculated that Harris was "the highest paid musician on Broadway."[31] Since *Hair,* Harris has guest conducted more than ten major American orchestras, including the Chicago Symphony, the American Symphony, Grant Park Symphony, Los Angeles Philharmonic, the Dayton Philharmonic, and Opera Ebony.

Cuban native Tania León has held several major appointments, including music director of the Dance Theatre of Harlem, music director of the Alvin Ailey American Dance Theatre, and music director of the Brooklyn College Orchestra. She has guest conducted numerous major orchestras, including

the Buffalo and Brooklyn Philharmonics, the Cleveland Institute of Music and Juilliard School of Music Orchestras, and the Beethovenhalle Symphony Orchestra in Bonn.

Both León and Harris were born in 1943, and both had orchestral conducting debuts in 1971, yet each brings a unique perspective to the profession. Harris stated in a *U.S. News & World Report* interview that she found "being a black woman no handicap in a field that is largely dominated by white males."[32] Yet she acknowledged this rarity at the same time as she acknowledged being the first black woman to conduct a major American symphony orchestra as her proudest achievement.

Identifying her ethnicity as multicultural, Tania León has stated that she resents categorization and prefers not to be labeled a "black" or a "female" conductor. Still, León is identified regularly in the literature as a black conductor, composer, and arranger.[33] Her international experiences have afforded her a perspective that values cultural diversity, and her eclectic musical tastes reflect her preference for artistic inclusiveness. The late Arthur Mitchell of the Dance Theatre of Harlem is routinely credited for encouraging León to conduct. Prior to Mitchell's intervention, León had considered conducting taboo for a woman.[34]

A younger contemporary of Harris and León, conductor Kay George Roberts was born in 1950 in Nashville, Tennessee. She was the first woman and the second African American to earn the D.M.A. degree in conducting from Yale University. During the 1975–76 season, Roberts made her professional debut as a guest conductor of the Nashville Symphony. She has since conducted numerous major orchestras, including the Bangkok Symphony Orchestra in Thailand, the Dayton Philharmonic, and the Cleveland Symphony Orchestra. As part of her mission to provide training to young musicians, Roberts has also been active with several high school and youth orchestras around the country. Like León, she prefers to avoid the label "black, female" conductor and wishes only to be recognized for her credentials.

Conductors Harris, León, and Roberts recognize the scarcity of well-known works by composers of color relative to the abundance of familiar pieces by Western European composers. To help correct this imbalance, each has made it her mission to program the works of composers of color alongside more familiar pieces from the European canon. This type of programming not only responds to the public's demand for familiar music but also underscores the traditional view that a classical artist (in this case the conductor) is legitimate only to the extent that he or she demonstrates mastery of the European music literature.

Conclusion

Many of the women cited in this discussion have used classical music performance to affirm their African American identities. Conductors Harris, León, and Roberts have used their power and influence to bring the music of women and people of color into the public's awareness. Singers have incorporated spirituals and other works by black composers into their recitals, and black women have infused their compositions with idioms reflecting African American musical styles and sensibilities.

From Elizabeth Taylor-Greenfield to Kay George Roberts, black women have achieved legitimacy and respect in the classical arena. As Elayne Jones would attest, however, superior musicianship is no guarantee against discrimination. For Jones, joining the San Francisco Symphony Orchestra was much like integrating an all-white neighborhood in the pre–civil rights South. For many, her very presence represented an unsettling disruption of the status quo.

If the narrow-mindedness of the classical establishment has contributed to the music's decline, however, then cultural, ethnic, and gender diversity may be its salvation. Music educators, administrators, and other participants in the classical tradition must be willing to challenge the common perception that classical music belongs to an exclusive society of elite white males. Although their contributions are frequently overlooked, black women have been stakeholders in this artistic tradition at least since the nineteenth century. Black women artists must market their talents more aggressively to educational institutions, orchestras, and opera companies committed to attracting a more diverse patronage. Furthermore, they must make it a priority to educate and mentor younger generations of black female artists, and they must encourage them to perform, compose, and conduct the kinds of pieces that celebrate their own unique identities and experiences. These celebrations of diversity will not only revive and perpetuate the art form but also further the place of African American women in the classical music tradition.

Notes

1. While a comprehensive treatment of black women in classical music is beyond the scope of this discussion, I cite a number of sources that include more detailed biographies and chronologies.

2. See Josephine Wright, "Black Women in Classical Music in Boston during the Late Nineteenth Century: Profiles in Leadership," 373–407, and Doris Evans McGinty,

"Black Women in the Music of Washington, D.C., 1900–1920," 409–50, both in *New Perspectives on Music: Essays in Honor of Eileen Southern*, by Josephine Wright and Samuel A. Floyd Jr. (Warren, Mich.: Harmonie Park Press, 1992).

3. Wright, "Black Women in Classical Music in Boston," 393.

4. Ibid., 375.

5. Jenny Lind and Luigi Lablache were celebrated singers of the nineteenth century. The comparison between Taylor-Greenfield and these two is cited in Rosalyn Story, *And So I Sing: African-American Divas of Opera and Concert* (New York: Amistad, 1993), 21.

6. See Lynn Abbott and Doug Seroff's *Out of Sight: The Rise of African American Popular Music, 1889–1895* (Jackson: University Press of Mississippi, 2002) for further discussions about individual artists cited in this section.

7. Story, *And So I Sing*, 21–23.

8. Rachel Walker's date of death is unknown.

9. Story, *And So I Sing*, 21.

10. Ibid., 13.

11. Ibid.

12. Ibid., 4.

13. In March 1941, Anderson received the ten-thousand-dollar Bok Award for 1940. This award recognized individuals for their notable contributions to Philadelphia and the surrounding community. Anderson used the funds to establish a scholarship program for young singers.

14. As early as 1906, Harriet Gibbs Marshall had the vision of establishing a national organization for black musicians. Clarence Cameron White and Nathaniel Dett tried to establish such an organization between 1916 and 1918, but the organization was actually brought into fruition through a 1919 meeting called by Nora Holt in her home. Henry Grant of Washington, D.C., was the NANM's first president, and Holt served as vice president.

15. Marian Anderson, *My Lord, What a Morning: An Autobiography by Marian Anderson* (Madison: University of Wisconsin Press, 1956), 37–38.

16. Ibid., 160.

17. Ibid., 141.

18. Richard Leppert, *Music and Image: Domesticity, Ideology, and Socio-Cultural Formation in Eighteenth-Century England* (New York: Cambridge University Press, 1988), 147.

19. *Scientific America*, November 23, 1895, 327. Quoted in D. Antoinette Handy, *Black Women in American Bands and Orchestras* (Metuchen, N.J.: Scarecrow Press, 1981), 22–23.

20. Handy, *Black Women in American Bands and Orchestras*, 71.

21. See Sherrie Tucker's *Swing Shift: "All-Girl" Bands of the 1940s* for a discussion of the black and multiethnic jazz ensembles that flourished during the 1940s (Durham, N.C.: Duke University Press, 2000).

22. Handy, *Black Women in American Bands and Orchestras,* 152.

23. Ibid., 142.

24. For an in-depth discussion of Phillipa Duke Schuyler's fascinating life history and performance career, see Kathryn Talalay's *Composition in Black and White: The Life of Philippa Schuyler* (New York: Oxford University Press, 1995).

25. *Southern's Biographical Dictionary,* s.v. "Armenta Adams Hummings."

26. Hummings is currently on the piano faculty of the Juilliard School of Music.

27. At the time of her death, Natalie Hinderas (1927–87) was a full professor of music at Temple University in Philadelphia. She is widely acclaimed for her recording *Natalie Hinderas: Piano Music by African American Composers,* Composers Recordings, 1992.

28. Adrienne Fried Block, "Women in American Music, 1800–1918," in *Women and Music: A History,* ed. Karen Pendle (Bloomington: Indiana University Press, 1991), 160.

29. Mildred Denby Green, *Black Women Composers: A Genesis* (Boston: Twayne, 1983), 50.

30. Ibid., 53–54.

31. D. Antoinette Handy, *Black Conductors* (Lanham, Md.: Scarecrow Press, 1995), 214.

32. Ibid., 316–18.

33. Christine Ammer, in *Unsung: A History of Women in American Music* (Westport, Conn.: Greenwood Press, 1980), notes that Leon "resists categorization. She does not want to be identified as a woman, a black, Hispanic or Latino, but just as a musician, composer, or conductor."

34. Ibid.

9

Leontyne Price:
Prima Donna Assoluta

ELIZABETH AMELIA HADLEY

I am here and you will know that I am the best and
will hear me. The color of my skin or the kink of my
hair or the spread of my mouth has nothing to do
with what you are listening to.

—Leontyne Price, *Time,* January 14, 1985

Soprano Leontyne Price made her public singing debut in Virgil
Thomson's *Four Saints in Three Acts* in New York in 1952, the year that the
civil rights movement was "in dress rehearsal" for the "Second American
Revolution." In the years following, Price's performances in the quintessen-
tial European art form would receive the highest accolades. Through operatic
roles from Gershwin's Bess to Verdi's Leonora, Price delighted audiences
worldwide; at the same time, Price's achievements in the gilt-encrusted, "hal-
lowed" halls of opera inspired African Americans and other people of color
to pursue careers in the predominantly white field of classical music.

From her earliest years, soprano Leontyne Price paid homage to the pio-
neering efforts of contralto Marian Anderson (1897–1993), whom she first
encountered as a child when her mother took her to a recital: "It was Marian
Anderson. I decided then I wanted to be her."[1] Years later, at a 1982 perfor-
mance at the annual convention of the Daughters of the American Revolution
(DAR), Price entered the stage to a packed house, prefacing her performance
of an aria from Cilea's *Adriana Lecouvreur* with the acknowledgment of
history's memory. She characterized Anderson, whose 1939 performance
on the steps of the Lincoln Memorial after being barred by the DAR from
Constitution Hall, "as a shining inspiration, a national monument, a mag-
nificent artist, and a *truly* great American."[2]

This chapter focuses on the personal and performance histories of Leontyne Price, who, following her auspicious debut, broke the de facto color barriers of opera houses around the world. With few exceptions, scholars have yet to examine the intellectual histories of African American musicians in classical music, especially those in the "vocal high arts," and shed light on their role as social activists in the predominantly white, or white-coded, sphere of opera.[3] This essay is offered as a corrective to both classical and black music histories in which biographies of singers such as Marian Anderson have achieved a type of canonical prominence while others, such as that of Price, have been eclipsed. At first glance, the fight for equality does not speak as loudly in Price's narrative as it does in the narratives of black musicians in other genres. But such an assessment is short-sighted. Amid the backdrop of the movements for black liberatory struggle of the 1960s and 1970s, the narrative of Leontyne Price demonstrates that discourses that allude to opera's deracination (see the familiar claims of "color-blind" casting) run counter to the lived realities reflected in the career trajectories of Price and others. Compensatory histories of black women artists in spheres that are outside of those typically associated with "black music" are underrepresented in the literature but are as relevant today as they were twenty years ago. Price not only influenced countless numbers of younger African American singers of classical music but also, through black racial identification, appealed to African American consumers of music who, though not necessarily opera enthusiasts, appreciated the significance of Price's gifts to the rarified field of opera and supported her through concert attendance, television program viewing, and album purchases. As a theater scholar, musician, and self-described "fan" of Leontyne Price, my own assessment resonates with that of public radio host Roger Cooper in his declaration that Price's "is a voice that not only soared into the heavens and caught the attention of the angels, but it also reached down into the ghetto and found me."[4]

Raised in the segregated south, Price received support, love, and respect from both the black and white communities. Born Mary Violet Leontyne Price on February 10, 1927, in the predominantly black community of Laurel, Mississippi, Price's musical talents and self-confidence were nurtured, from childhood, by her family and neighboring community. Her mother, Kate (Baker) Price was a midwife, and her father, James A. Price, a carpenter employed at the local sawmill. Both sang in the choir at St. Paul's Methodist Church, and Price grew up attending choir rehearsals in addition to church on Sundays.

Price's earliest recollection of music was listening to her mother sing "in

'a lovely lyric soprano voice' as she hung the laundry to dry."[5] As a toddler, Leontyne performed "concerts" on her toy piano for her mother, who, recognizing her proclivity for music, hired Mrs. Hattie Mcinnis, a local music teacher, to teach the three and half year old piano at the rate of two dollars a lesson or in exchange for laundering clothes.[6] Leontyne excelled in piano and, when she was older, played for the church choir. Another influential adult in Leontyne's childhood was her "Big Auntie" Everlina Greer, who worked as a maid in the home of Elizabeth Wisner, and the Chisholms, an affluent white family residing in a suburb of Laurel. Leontyne occasionally met her auntie there, and while waiting, she sang and played with the Chisholm daughters. Subsequently, the Chisholms employed Leontyne to sing recitals at social gatherings with Mrs. Chisholm accompanying at the piano. As her reputation spread, Leontyne found her talents in demand at social events throughout the community. Eventually, the Chisholms sought the Prices' permission to contribute to Leontyne's advanced vocal lessons.

After graduation from high school, Price attended the historically black Central State College in Wilberforce, Ohio, in preparation for a teaching degree in music. Upon hearing her sing, activist/vocalist/actor Paul Robeson (1898–1976) became convinced of her promise. To encourage her further study, Robeson sponsored a benefit performance; its proceeds, together with additional financial support from the Chisholm family and a four-year scholarship, enabled Price to attend the Julliard School of Music from 1949 to 1952.

At Julliard, Price studied with former concert singer Florence Page Kimball, initiating an alliance that blossomed into a friendship of mutual respect. Under Kimball's tutelage, Leontyne studied the classics, contemporary French songs, and opera roles. From Kimball, Price learned to "sing on [her] vocal interest, not on the principal" and to dress appropriately for performance.[7] Kimball remained Price's devoted teacher, coach, and friend until her death in 1977. Later, Price characterized their affiliation as "the most important relationship of my life. . . . Like sex, it was pure chemistry."

In 1952, American composer and music critic Virgil Thomson "discovered" Price in her role as Mistress Ford in Julliard's student production of Verdi's *Falstaff*. At the composer's request, Price debuted as St. Cecilia in Thomson's *Four Saints in Three Acts* (1927) at the International Arts Festival in Paris the same year.[8] Thus began Price's ten-year barrage of the world's great stages. As a result of her success in *Four Saints,* Ira Gershwin cast Price as Bess (with William Warfield as Porgy and Cab Calloway as Sportin' Life) in his 1952 revival of *Porgy and Bess.* Price's Bess has been described as "the incarnation

of sensuality."[9] Initially advertised as "An American Folk Opera,"[10] *Porgy and Bess* toured the United States bringing its music to audiences around the country, catapulting the production into America's best-loved opera and realizing Gershwin's dream that it "appeal to the many rather than to the cultured few."[11] The all-black cast, which garnered the critical acclaim that had eluded the 1935 production, was rewarded with a two-year international tour, sponsored by the U.S. State Department, with performances in Vienna, Berlin, London, Paris, and Russia. Price's triumph in the role of Bess was documented by national and international reviews and acclaimed by European audiences, who demanded the extension of scheduled performance runs.

Emerging into the wider world as a younger singer, especially while touring with the company of *Porgy and Bess* in the early 1950s, Price was far from immune to the social inequities of Jim Crow. Even while audiences from Texas to Chicago embraced her performances, Price encountered discrimination in terms of accommodations and transportation. Not until the conclusion of her international tours in 1953–54 did efforts to desegregate find support from the U.S. Supreme Court, which, under pressure from the civil rights movement, ruled unanimously in *Brown v. Board of Education of Topeka* (1954) that separate facilities by race were unconstitutional. As much as any other factor, Price's early interaction with Paul Robeson, and her mother and father's political activism as members of the National Association for the Advancement of Colored People (NAACP) in Laurel, framed her political consciousness.

In the aftermath of the successful *Porgy and Bess*, engagements with an international array of orchestras and conductors followed. In 1954, Price made debuts at New York's Town Hall in the premiere of Samuel Barber's *Hermit Songs* with the composer as her accompanist, in Boston with Charles Munch and the Boston Symphony, in Philadelphia with Eugene Ormandy and the Philadelphia Orchestra, and at the Chicago Lyric Opera in a performance of Verdi's *Aïda*.[12] Three years after her Chicago debut, in 1958, renowned conductor Herbert von Karajan, who exclaimed that her voice "gave him goose pimples," cast her again as the Ethiopian princess Aïda at the Vienna Staatsoper. Her 1960 performance as Aïda at Teatro alla Scala (La Scala), prompted one Italian critic to exclaim, "Our great Verdi would have found her the ideal Aïda."[13] Subsequently, Price portrayed Aïda at Verona, Vienna, Covent Garden, the Städtischen Oper in Berlin, and other venues. Verdi's *Aïda* would become her signature opera.

Parallel to her intercontinental recital tours, opera debuts, and performances under the conductorship of world renowned maestros, Price fulfilled

several engagements with the NBC-TV Opera Company, including Pamina in *The Magic Flute* (1956) and Donna Anna in *Don Giovanni* (1960). It might be argued that 1955 was a significant year for black women in musical and political spheres. Amid vociferous opposition, Anderson "stood" on the stage of the Metropolitan Opera, the first time for a black soloist. In the South, seamstress Rosa Parks, secretary for the Montgomery, Alabama, chapter of the NAACP, "sat down," refusing to relinquish her seat to a white person, an act of civil disobedience that helped initiate the Montgomery Bus Boycott. The same year, Leontyne Price became the first African American to sing opera on television in the National Broadcasting Company's (NBC) production of Puccini's *Tosca*. Price's performance in the title role was triumphant and critically applauded, in spite of formidable opposition from sponsors and cancellations from local affiliate stations. The reviews from this early production brought her successive television engagements for several years (1955–58, 1960, 1962, and 1964). Later Price would say of this experience, "Casting a Negro in the role . . . created quite a rumpus. . . . Bess was a good preparation for Tosca. . . . Both were strumpets, only Tosca dressed better."[14] Price made several recordings and signed an exclusive contract with RCA in 1958.

The legacy of Marian Anderson, the first black singer to perform with the Metropolitan Opera, is most clearly exemplified in Price's relationship with New York's Metropolitan Opera House.[15] In 1960, Sir Rudolph Bing offered Price a contract with the Met, where she debuted as Leonora in Verdi's *Il Trovatore*.[16] Perhaps "signifying" on Langston Hughes's memorable essay, "The Negro Artist and the Racial Mountain" (1926), in which the author admonishes black artists not to forsake their black heritage in the attempt to achieve success as "Americans," Price said later of her debut that "it was the first operatic mountain I climbed, and the view from it was astounding, exhilarating, stupefying."[17] Price's performance elicited an unprecedented forty-two minute ovation that secured her place as one of the Metropolitan's leading sopranos, earning critical accolades. "Her Leonora proved to be a remarkable portrayal of a woman in whom dignity struggled with desperation and in whom grief somehow shone more movingly through a profound sense of repose," one critic wrote. "The amalgam of qualities made her fourth-act aria, 'D'amor sull'ali rosee,' a dramatic as well as technical triumph. It was perhaps the most wildly applauded moment of the present Met season."[18] In addition to Leonora, Price's first season at the Met included performances as Aïda, Cio-Cio-San in Puccini's *Madama Butterfly*, Donna Anna in Mozart's *Don Giovanni*, and Liu in *Turandot*.[19]

For all her national and international celebrity, for Price, the most extraor-

dinary moment in her career was her return home to Laurel, Mississippi, where she gave a recital on March 18, 1960. The integrated unity among the audience moved her to express, "It wasn't the best I've ever sung—I was too choked up emotionally to do my very best. But I think that concert represented a great deal of progress for a little town in the deep South. For an hour and a half, we weren't white or black. We were just human beings together."[20] As Price gazed into the audience during her performance, she could see two important women in her life sitting together, gazing admiringly at her from the front row—her mother and her "mother confessor" and sponsor, Mrs. Chisholm, who declared, "I feel God has favored us more than most by allowing us to participate . . . in Leontyne's career. I think someone with a talent like hers is one of God's chosen creatures." Clearly, for Price, the experience of returning home to loved ones and others who validated her existence, her gift, and self-preservation surpassed all the worldly experience and praise she had accumulated.

Price continued to receive rave reviews. Comparing her performances as Leonora and Cio-Cio-San, a critic for *Time* magazine noted that "the Butterfly she unveiled . . . was, in contrast to her Leonora, a creature that lived on the surface of emotion—tentative, vulnerable but never mawkish. In the last act, when Soprano Price enacted the difficult suicide with a dignity that many a famed soprano is unable to muster, Cio-Cio-San ceased to be a quaintly pathetic figure and became what she rarely is—a truly tragic one."[21]

In 1961, music editors and critics designated her "Musician of the Year." The following season, Price opened as Mini in Puccini's *La Fanciulla del West*, making history once again as the first black to open a season at the Met.

By 1964, Price was in constant demand as a vocalist, commanding an estimated fifteen hundred to twenty-five hundred dollars for each performance. Critics reviewing performances participated in a discourse that exalted Price's singing talents while describing her success in racialized terms. In 1964, for example, critic William Bender began his review with a laudatory observation: "Operatic directors the world over either build their plans around Leontyne Price these days or wish they could. When Rudolf Bing of the Metropolitan Opera and Herbert von Karajan of the Vienna State Opera plan their schedules, they want to know when Miss Price is available and what they can get her to sing. At the Met, for example, she is a star attraction during the current gala World's Fair season."[22] But he continued: "It was in New York that Miss Price got her first two big breaks—a role in Virgil Thomson's *Four Saints in Three Acts* and the part of Bess in the famous 1952–53 revival of *Porgy and Bess*. She got them because she was a Negro, but it is hard to see how

such a singer could have been stopped, regardless of her race."[23] Almost ten years later, at the height of her career, another critic commented on Price's phenotype in regard to her portrayal of a Japanese character: "The soprano transcends the outward trappings of the role. She is obviously never going to look very Japanese, although she handles the stylized movement dictated by the Japanese stage director, Yoshio Aoyama, smoothly enough. What she has is her own extraordinary dignity and an inward dramatic power that floods the stage and is almost palpable."[24] Racialized comments such as these are uncommon in reviews of white opera singers in nonwhite roles.

At the close of 1964, President Lyndon Johnson awarded Leontyne Price the Presidential Medal of Freedom, the country's highest civilian honor, exclaiming that "her singing has brought light to her land."[25] In 1966, when the Metropolitan Opera moved "uptown" to Lincoln Center, Bing selected Leontyne Price for the role of Cleopatra, the first-century Egyptian queen, in Barber's *Anthony and Cleopatra,* a work explicitly commissioned for the opening of the new opera house. Subsequently, predominantly white critics and audiences celebrated Price as the "prima donna assoluta." In homage to those who had preceded her at the Met and perhaps as a means of inserting herself into the intellectual history of European opera, Price observed in an article in *Life* magazine, "The ghosts from the old house—Caruso, Flagstad—all those folks—have moved uptown, too. When I'd look up at the gold ceiling, there they'd be, swingin' around, saying to me, 'Lee, you mess it up and we'll take care of you!' "[26] Price's comment belies the physical dangers that she experienced as her performances challenged the racialized status quo of the opera world. Scholars have described in detail how the social climate of the 1960s affected not only well-known black leaders such as Malcolm X (1925–65) and the Reverend Martin Luther King Jr. (1929–68) but also countless numbers of ordinary black men and women whose lives were threatened by violence as they worked to secure voting rights, conduct peaceful demonstrations, and carry out their roles as officials in social and civic organizations. Price's life was likewise threatened during her preparation for the opening of the Met at Lincoln Center, a locale tacitly accepted as the dominion of white divas.

Price celebrated black culture and music, spreading its influence to unfamiliar audiences in all parts of the world through the inclusion of African American spirituals in her recitals. "Black folklore," she said,

> is so much a part of the entire heritage of this country. It is the spiritual heartbeat of America. From it trials have been withstood, problems have been solved,

roots have been strengthened, progress has been made. If I can accept the challenge of doing the German Lied or the French chanson, I always insist that audiences listen to our exquisite folklore. There is no reason why a white artist can't sing spirituals either, for that matter. . . . I am a chauvinist about American artists . . . because I think we are extraordinary professionals. I think nationalism in music has been outgrown. I am not speaking only of myself because I am of a darker hue, but of all Americana artists who are readily accepted all over the world singing the music of many countries.[27]

As a public figure, Price seized every opportunity to denounce racism and articulate her rejection of tokenism in the business. She was outspoken in her gratitude to those who had preceded her, especially Marian Anderson, whom she emulated in "her professionalism, uncompromising standards . . . persistence, resiliency, undaunting spirit and will."[28]

Leontyne Price's final role at the Metropolitan Opera was Aïda. She retired from the stage in 1985, in excellent voice. Noting that the performance was Price's 193rd at the Metropolitan, critic Donal Henahan observed that "in her most taxing aria, 'O patria mia,' there were powerful reminders of the Price that we remember best and want to remember, a Price beyond pearls."[29] At curtain, a captivated audience applauded for almost half an hour. For Price, the timing and rationale for retirement were carefully considered. "If you are involved in opera and have committed a great deal of your time to important Opera houses, you cannot do anything else," she explained. "Initially, I was trained to be a recitalist, and I am happy to be so deeply involved in it again. . . . The luxury of my success these days is to be able to do exactly what I wish to do when I wish to do it. Why not? At the same time it promotes my vocal longevity, because I'm always eager to perform; I'm not struggling to perform; I'm enjoying the fruits of my own pioneering."[30] In another interview, implying that some singers retire from public performance "too late," she confides, "I'm trying to exhibit good taste. I prefer to leave standing up, like a well-mannered guest at a party. My mother always told me to leave a little bit of dessert on the plate to show good breeding . . . and that's how I'm going to handle this . . . no trumpets. I'll be gone—and no one will notice it."[31]

In contrast to her characteristic understatement of her own significance to the field, Price's exit was noticed by a capacity crowd of four thousand at New York City's Metropolitan Opera House, and additional millions watched a live telecast from Lincoln Center. Having officially ended her opera career, she then performed a farewell recital at the Memorial Hall in Chapel Hill, North Carolina, on November 24, 1997. Before singing a single note, Price was

greeted with a two-minute standing ovation, after which she sang composi-
tions by Verdi, Strauss, and Handel, as well as several traditional spirituals.
The eclecticism of her program inspired a reviewer to marvel at the breadth
of Price's talents:

> Price sang a wide variety of songs, including extremely difficult arias, operatic
> pieces . . . and even some spirituals. But this diva is at home when singing
> opera. It doesn't matter what language they are in. She sang difficult Italian,
> German and French pieces with complete ease. She had such a remarkable
> command of every language. . . .
>
> It's quite difficult to pinpoint some exact song in which Price was at her best.
> Every song was full of majestic grace. But Verdi's "Pace, Pace mio Dio," from
> *La Forza del Destino* was particularly moving. Ending on a perfect piercing
> high C, the song was a journey up and down the scale and Price accompanied
> every moment with wide movements and facial expressions. The German
> pieces were just as compelling.[32]

Price's Influence on the Next Generation

Just as Leontyne Price was inspired by the career of Marian Anderson, Price
too serves as role model to numerous people of all ages, color, and genders.
Mezzo-soprano Denyce Graves relates a personal experience that demon-
strates Price's influence in the lives of young opera aspirants: "When I was in
high school, a classmate and I discovered Leontyne Price. We locked ourselves
in a room. We cut all our classes. We listened to her sing Puccini arias over
and over and over and over. And I was so proud of her."[33] Though Graves
and her friend were unfamiliar with the repertoire Price sang, it was enough
that they knew who Leontyne Price was and that she "sang songs and spiri-
tuals and all kinds of stuff that we were working on, and we identified with
that. And I thought, 'Someday I'm going to be like Leontyne Price.' She was
the one."[34] Baritone Jubilant Sykes recalls, "I was in junior high when I went
to see Leontyne Price sing. . . . She was doing some Mozart arias and then
she did some spirituals and I went, 'Wow!'"[35] And lyric spinto soprano Reri
Grist remembers Price as one of the few who were kind to her during her
early days on the opera stage: "I . . . remember a moment in San Francisco
in Un Ballo in Maschera [when] the great, great Leontyne Price . . . was a
great stage friend and a wonderful colleague. I still choke up at the sounds
this woman was capable of making. And I had the privilege to stand on the
stage with her as she sang."[36]

Colleagues, friends, aspiring opera singers, critics, and neighbors speak of Leontyne Price as a noble and talented human being. Soprano Barbara Hendricks, an international opera star, acknowledges, "I didn't have the burden of representing an entire race the way that Leontyne Price must have felt. Marian Anderson prepared the way, but Leontyne Price was the first internationally known black opera star recognized both at home and abroad. I felt much freer than she had been able to be and I feel an enormous gratitude for her and others, such as Grace Bumbry and Shirley Verrett. I didn't feel as much pressure as they did and I benefited from the doors that they opened." Opera singer Jessye Norman counts Price, along with Marian Anderson and Joan Sutherland, as primary among her role models. Beverly Sills, friend and colleague, publicly acknowledged Price in a keynote address as "the greatest dramatic soprano of my time. . . . The black, beautiful Leontyne Price."

Price's unrivaled talent and gracious comportment earned her principal roles in Italian, German, and French—roles which had until that time been assigned to white divas. She sang opposite established white stars such as Placido Domingo, Sherrill Milnes, Luciano Pavarotti, Franco Corelli, and Marilyn Horne. Black artists who went through the now-opened door of the Metropolitan Opera House include Grace Bumbry (1961), Martina Arroyo (1965), Reri Grist (1966), Shirley Verrett (1974), Kathleen Battle (1985), Leona Mitchell (1988), Jessye Norman (1989), and Denyce Graves (1995).

Price is generous in her support of beneficial causes and aspiring vocalists. She has given benefit recitals for the NAACP, the New York Philharmonic Pension Fund, and for the United Negro College Fund. Moreover, she has sponsored benefits for the Harlem School of the Arts and the Arts in the Schools Project devoted to providing affordable arts education to Harlem children.[37] In a gracious gesture, Price participated in a benefit concert for the University of Mississippi, the institution that had formerly denied her admission.[38] Finally, she has established the Leontyne Price Vocal Arts Scholarship, sponsored by the National Association of Negro Business and Professional Women's Clubs, enabling young men and women to pursue careers as classical vocalists.

Capstone to a Career

Price has ventured out of retirement twice since 1998, on both occasions for public service. The first was a reading of her book based on her signature opera, *Aïda,* to groups of students from Public School 180 and from an elementary and middle school in Harlem.[39] The second event was the 2001 Concert of Remembrance at Carnegie Hall, where Price sang "America the

Beautiful" in memory of those lost and wounded during the September 11, 2001, attacks in the United States.[40] Throughout her career, Price has undertaken similar acts of service, and her talent and generosity have been acknowledged at the highest levels of government. She was invited to sing at the White House through the administrations of four presidents, performing at state occasions such as the signing of the Egypt-Israel Peace Treaty, a welcoming ceremony for Pope John Paul II, a private ceremony honoring Prince Charles and Princess Diana of Great Britain, and dinner with Queen Elizabeth and Prince Philip on the *Britannia* in New York Harbor.[41]

Price is the recipient of numerous honors, including the NAACP's Spingarn Medal (1965), an honor intended, first, to publicly acknowledge to the nation individuals of distinguished merit and achievement among American blacks; second, to serve as reward for such achievement; and third, to inspire the ambition of children of color. In 1980, Price received the Kennedy Center Honor for Lifetime Achievement in the Performing Arts. In 1985, she was awarded the Handel Medallion, presented by the mayor of New York as the highest official honor awarded to individuals for their contributions to the city's cultural life. In that same year, Price became the first recipient of the National Medal of Arts for her contributions to the excellence, growth, and support of the arts in the United States. She was awarded the Order of Merit from Italy for her contributions to Italian music.

Although the prima donna assoluta has retired, listeners can take advantage of her more than one hundred recordings; she is the recipient of eighteen Grammy Awards from the National Academy of Recording Arts and Sciences. Narratives detailing the positive influence Price's performances have had on young audiences are legion; mine is one example. Initially captivated with Price's comportment, my young friends and I were mesmerized by her voice, the effect of which was to inspire us to believe all things were possible. Price's singing transported us from our humble environments to places we could only dream about and strive to reach. It is no surprise that in an analogy comparing her to a rare and precious instrument, Leontyne Price has been called the "Stradivarius of sopranos."[42]

Notes

1. Anthony Tommasini, "Leontyne Price Reads Her Book Version of 'Aida' and Sings for Schoolchildren," *New York Times,* May 30, 2000.

2. See the film *Aida's Brothers and Sisters: Black Voices in Opera.* Most moving is a videotaped performance of Price singing at the Ninety-first Continental Congress of the DAR in Washington, D.C; David Garvey, pianist.

3. See Rosalyn Story's *And So I Sing: African-American Divas of Opera and Concert* (New York: Amistad, 1993).

4. "Leontyne Price—Voice of the Millennium," Nebraska Public Radio Network (NPRN), February 3, 2001, Roger Cooper, host.

5. "A Voice Like a Banner Flying: Leontyne Price," *Time*, March 10, 1961, 1–4.

6. Ibid.

7. Michael Walsh, as reported by Nancy Newman, "Leontyne Price: What Price Glory," *Time Magazine*, January 14, 1985.

8. Libretto by Gertrude Stein (1874–1946).

9. Allen Hughes, "Another Major Step for Leontyne Price," January 1961.

10. Eileen Southern, *The Music of Black Americans* (New York: W. W. Norton, 1971), 441.

11. "It Ain't Necessarily Appealing," *Toronto Star,* April 11, 1999, Sunday edition, 1.

12. Susan Heller Anderson, "Leontyne Price—Still the Diva," *New York Times,* February 7, 1982, late city final edition, 1.

13. "Stunning Last Role Showed that Price Can Still Hit Peak," *San Diego Union-Tribune.* January 7, 1985, D-6.

14. "Leontyne Price, Her 'Annus Mirabilis,'" source and writer unknown.

15. Anderson was introduced to the Metropolitan Opera by Sir Rudolph Bing.

16. Thus Price became one of four Black artists (the others being baritone Robert McFerrin and sopranos Mattiwilda Dobbs and Gloria Davy) who had starred in major roles since Marian Anderson had sung on the opera stage, a locale tacitly accepted as the domain of white divas. Although Price was the seventh Black to debut at the Met, she was the first to attain "superstar" or "diva" status in opera throughout the world.

17. Nan Robertson, "Farewell Role for Price: Verdi's 'Aida' at the Met," *New York Times,* December 31, 1984.

18. "Voice Like a Banner Flying."

19. While touring with the Metropolitan during this period, Price played a number of European venues (La Scala in Milan, the Staatsoper in Vienna, and Altes Festspielhaus in Salzburg) and made several major studio recordings.

20. Richard Schickel, liner notes, *Leontyne Price: Arias from Il Trovatore, Madama Butterfly, La Rondine, Tosca, Turandot,* LPZ10888, RCA,1961.

21. "Voice Like a Banner Flying."

22. William Bender, "Leontyne Price: Portrait of a Prima Donna," May 3, 1964, http://home.wanadoo.nl/gregquast/portraitprimad.html.

23. Ibid.

24. Raymond Ericson, "Triumph for Miss Price: Soprano Gives Emotionally Shattering Performance in Met's 'Butterfly,'" *New York Times,* September 1973.

25. "Diva's Date with Destiny: Leontyne Price Opens New Met," *Ebony,* December 1966.

26. "Price, on First Performance in New Metropolitan Opera House," *Life*, September 30, 1966.

27. Freeman Gunter, "Leontyne Price: The Voice of Passion," *Mandate*, June 1985.

28. Richard Green, "Music, Civil Rights Worlds Mourn Anderson," Associated Press, April 8, 1993.

29. Donal Henahan, "Met Opera: Price Sings in Farewell," *New York Times*, January 1985.

30. Joseph McLellan, "Leontyne Price: Sharing Live with Aida," *Washington Post*, c. 1985.

31. Robertson, "Farewell Role for Price"; Walsh, "Leontyne Price."

32. "Soprano's Vocal Perfection," November 1997.

33. Robert Wilder Blue, "denycegraves.com: The 21st Century Diva," *USOperaWeb* 2, no. 2 (Spring 2002), http://www.usoperaweb.com/2002/april/graves.htm (accessed June 26, 2006).

34. Marilyn Milloy, "Diva [Denyce Graves]," *Essence*, September 1996, 84.

35. Errol Nazareth, "Good Reason to Be Jubilant: Sykes Set on Living Up to His Name," *Toronto Sun*, Friday final edition, October 3, 1997, 58.

36. Robert Wilder Blue, "Reri Grist: One of a Kind," in "American Opera at the Met: Part II," *USOperaWeb* 3, no. 1 (Spring 2003), http://www.usoperaweb.com/2003/spring/grist.htm (accessed June 26, 2006).

37. "Diva's Date with Destiny."

38. Bill Zakariasen, "This Price Is Right: Celebrated Soprano Knows Her Musical Mind!" *Daily News*, September 14, 1982.

39. Tommasini, "Leontyne Price Reads Her Book Version."

40. Leontyne Price biography, http://www.notablebiographies.com/Pe-Pu/Price-Leontyne.html.

41. "Priceless," *Opera Now*, January/February, 1997, 22–23.

42. "Leontyne Price—Voice of the Millennium."

10

Harriet Gibbs Marshall
and Three Musical Spectacles

SARAH SCHMALENBERGER

By the turn of the twentieth century, the majority of black American women with degrees in music had earned them from northern institutions. Harriett Gibbs Marshall (1869–1941), Oberlin Conservatory's first black woman graduate, completed the equivalent of a bachelor's degree in music in 1889.[1] Marshall began her career as a pianist, but she also became a pioneer in African American music education. Believing that students from the southern states deserved an opportunity for formal study in a conservatory setting, Marshall opened the Washington Conservatory of Music and School of Expression in Washington, D.C., in 1903.[2] Despite its sanction of racial segregation, at the time the nation's capital was a thriving cultural center for educated black Americans. Education, and especially a musical education, enabled many African American women to create viable career choices for themselves in an era marked by a racial and gender oppression.[3] Founded to help its students and faculty overcome these obstacles, the Washington Conservatory was a private, black-owned institution that offered a curriculum of courses in music theory, history, pedagogy, applied music instruction, and oratory/elocutionary skills.

Formal musical training in the United States at this time was limited to music of the European classical tradition.[4] Moreover, American social practices promoted the fine arts as a means of cultivating Victorian ideals of "true womanhood" and feminine moral virtue. It is not surprising, then, that black women professionals such as Marshall perpetuated this tradition through their own careers.[5] As the founder and president of the Washington Conservatory, Marshall hired college-educated musicians and teachers—all

of them African American and many of them women—to teach and perform works of the European classical canon.[6] Like most music schools at the time, the conservatory had a student body that was predominantly female; hence, black American women were uniquely poised to wield significant influence upon the development of musical culture in the United States.

Marshall's training, concert programs, and other materials from the Conservatory indicate that she accepted the Western European tradition as a valid model for her school's course of study.[7] However, while she cultivated the European classical repertoire at her school, she also developed a course of study that transcended the canon. As early as 1910, she began to promote the Washington Conservatory's mission to preserve and promote the rich heritage of black music. The increasing emphasis Marshall placed upon the study of black music is evident in the numerous music spectacles she created to promote her school. These grand spectacles served to raise funds for salaries, scholarships, and facilities. More important, they also became a strategy toward the campaign for which Harriett Gibbs Marshall is best known—the circulation of a black musical aesthetic among the greatest number of people. Over time, the result was a forum in which black musicians, patrons, students, and audiences could interact and collaborate with one another. These forums stemmed from initiatives designed primarily to increase enrollment and patronage. From a practical standpoint, Marshall created musical spectacles in order to solicit financial support for her conservatory, which could not subsist on tuition fees and regular concert proceeds alone.[8]

The three spectacles discussed in this essay—*Three Periods of Negro Music and Drama, The Last Concerto,* and *A Masque Musical*—were affiliated with ambitious fund-raising campaigns for the school. On one hand, the topics of each spectacle displayed a grand vision of African American achievement, hope, and unity. On the other, as a promotional tool, the spectacles underscored Marshall's agenda to depict her conservatory programs as unique and exclusively capable of fostering an in-depth awareness of black music making. As one of the first institutions of its kind to advocate the study and performance of black concert music, the Washington Conservatory had to appear impressive in its claims to provide both a comprehensive and innovative curriculum. As will be shown, the drama and pageantry of the spectacle genre enabled Marshall to delineate a cohesive ideology of black music making that would foster enough interest among the public to encourage its financial support and enthusiastic backing for the conservatory.[9]

Much of the ambition that drove Marshall to set (and achieve) such ambitious goals for herself and others stemmed from her adherence to racial

"uplift," a movement of social reform through upward mobility that had its genesis in the nineteenth century. With tenets rooted in social Darwinism, for blacks, uplift signified racial pride and progress.[10] W. E. B. Du Bois (1868–1963), a leading advocate for the paradigm of uplift, exhorted black Americans to pursue high intellectual, cultural, and political ideals. As Du Bois defined it, the attainment of uplift depended upon the generosity of educated, upper-class blacks who would share their knowledge (as well as their access to opportunity) with rural, poor, or uneducated African Americans:

> From the very first it has been the educated and intelligent of the Negro people that have led and elevated the mass.... Can the masses of the Negro people be in any possible way more quickly raised than by the effort and example of this aristocracy of talent and character? The Talented Tenth rises and pulls all that are worth the saving up to their vantage ground.... The best and most talented of [our Negro] youth must be schooled in the colleges and universities of the land.[11]

As an educator and institution builder, Marshall was a member of what Evelyn Brooks Higginbotham calls the "Female Talented Tenth," educated black women who were committed to uplifting their communities through teaching.[12] Women of this generation and upper/wealthy-class orientation described their work in terms of uplift rhetoric. Marshall and her colleagues, after receiving formal education themselves, then committed themselves to preparing the next generation of black men and women to succeed in the music business.

As a career professional, Marshall modeled a life-style option that historically had been largely denied to black women. Consistent with the philosophy of uplift, Marshall's visibility as a successful performer, educator, and business owner was the result of media she used to contradict negative, stereotyped images of black women and men.[13] Marshall included her picture and photographs of prominent black musicians on Washington Conservatory concert programs as visual representations of black success in concert music.[14] Furthermore, the accompanying descriptions of individuals suggestively equated black success with national success, which, she argued, was crucial to promoting a sense of universal brotherhood between the races.[15]

For Marshall, the propagation of black music was the primary objective of the Washington Conservatory and, as such, was her contribution to racial uplift. Mission statements published in conservatory publicity materials, correspondence, and concert repertoire document the valorization of the emerging black concert music tradition. With increasing clarity, Marshall

articulated a perspective of black music making through pageantlike events that thematized black pride, unity, and equality. With each event, she reinscribed the legitimacy of her pedagogical agenda, her emphasis on black professionalism, and her musical values. With each new spectacle, Marshall presented a different perspective of her knowledge and experience of black music. By "lifting up" the merits and presence of black music, and by encouraging the participation of black women in music, the Washington Conservatory enabled its teachers, students, and patrons to address issues of race and gender.

In her programming and publicity on behalf of the Washington Conservatory, Marshall created an alternative discourse that challenged negative representations of black Americans and their music. By generating positive images of black musicians through concerts celebrating black music making in the United States and elsewhere, she asserted an ideology of racial equity. Marshall's deeds, however, can not be seen as an uncomplicated carrying out of a nascent civil rights agenda in the cultural sphere. While it is true that tenets of racial uplift, such as "progress" and "upward mobility," galvanized the social advancement of some blacks, at the same time, this philosophy's assumptions of social evolutionism resulted in its collusion with the internal logic of the oppression of the working classes.[16]

Grounded in racial uplift, Marshall's founding of the Washington Conservatory is firmly within a black women's activist tradition as outlined by numerous U.S. sociologists. The Washington Conservatory of Music and School of Expression prepared women and men for meaningful work as musicians, teachers, and articulate community leaders, career paths that could facilitate self-actualization and self-definition. Sociologist Patricia Hill Collins cites this type of work as paradigmatic of the concerns that black women had about their lives and communities at that time.[17]

That Marshall created a "safe space" for women to learn skills toward career development and toward developing intellectual skills was a powerful contribution to the liberation of black women at that time.[18] For African American women in particular, a formal education helped them challenge racist stereotypes. Prejudiced beliefs that black women were sexually promiscuous, lazy, and uneducable were prevalent at this time, and as a result many women suffered from abuse and unemployment. The rapacious advances of white males upon black women who worked as domestic workers in white homes was a very real danger as well. |

The idea to construct large-scale events grew out of changes Marshall had been implementing into the school curriculum and repertoire between 1910

and 1920. Brochures and letters soliciting donations after 1910 indicate that arranged spirituals were used to teach harmony at the school. With increasing frequency after 1911, concerts at the Washington Conservatory included compositions by black composers Samuel Coleridge-Taylor (1875–1912), Harry Thackar Burleigh (1866–1949), and Robert Nathaniel Dett (1882–1943) alongside works by the more familiar European composers. Commencement recitals for 1912 and 1913 featured, almost exclusively, works by black composers. A commencement program and course bulletin from 1913 noted a new course offering "Negro music from its origin to the present."[19]

Special guest artist recitals at the Washington Conservatory from around this time included performances by the Afro-American Folk Singers directed by Will Marion Cook (1869–1944) and a presentation by black pianist and music historian Maud Cuney-Hare (1874–1936). Cuney-Hare, well known as a music critic for the *Crisis* magazine and, later, the author of the definitive text *Negro Musicians and Their Music* (1936), gave a lecture recital titled "The Illustrated Musical Progress of the Negro Race."[20] Without a doubt, these guest performance events complemented the new historical focus on black music evident elsewhere in the curriculum. However, the impetus for Marshall to create a musical spectacle may have come from W. E. B. Du Bois, who served on the advisory board of the Washington Conservatory.

In 1911, Du Bois began to compose a folk drama about black history in the hopes of encouraging his fellow African Americans to acknowledge and appreciate their cultural legacy.[21] In 1915, he presented this work in Washington, D.C., as a pageant titled *The Star of Ethiopia*.[22] This spectacular, parade-like epic, which Du Bois had presented earlier in other cities under different titles, traced the genesis and development of black culture from its beginnings in ancient Egypt and Africa to the present.[23] In order to raise money for the event, Du Bois organized a guild of donors and participants, and Harriett Gibbs Marshall was listed on the program as contributing to the musical component of the pageant.[24] Six years later, she would devise her own historical drama, one that depicted the diversity of African American musical history.

The musical spectacles under examination here depict stages in Marshall's developing musical aesthetic, which grew out of the tenets of racial uplift. *Three Periods of Negro Music,* the first major spectacle she produced, was performed in New York City on April 24, 1921, and in Washington, D.C., on May 22, 1922. It was the boldest and most comprehensive testament of the conservatory's commitment to black music as a historically grounded repertoire. *Three Periods* also represents the founder's most ambitious financial

campaign, a goal of one hundred thousand dollars to establish a National Negro Music Center.[25] Almost fifteen years passed before Marshall staged her next spectacle, a documentary about Samuel Coleridge-Taylor's life and works titled *The Last Concerto.* This event, performed December 4, 1936, adopted the Western European historical narrative of a singular composer's oeuvre while incorporating non-Western idioms. This spectacle and other events suggest that Marshall had begun to develop a larger, more global perspective of musical culture informed by criteria beyond traditional uplift principles.

A Masque Musical, the last spectacle Marshall designed, was presented first on June 1, 1937 and again three years later on November 28, 1940, three months before she died. Subtitled *Music, the Golden Tie of Nations, Masque* depicted a panoramic view of musical traditions throughout the world. As such, it seems to have reflected the multiethnic principles of the Baha'i faith that Marshall had come to espouse. Together, these spectacles chronicle Harriet Marshall's transformative journey from teacher to entrepreneur to, eventually, multiculturalist.[26]

Three Periods of Negro Music

By the time Marshall presented *Three Periods of Negro Music* in 1921, the Washington Conservatory had been open for nearly twenty years, and yet it still operated on a precariously slim budget. Seeking to create a national endowment fund, Marshall hoped that the musical narrative of *Three Periods* would impress would-be donors of the importance of her school's mission. Marshall combined music, oratory, costume, dance, and drama to project an image of black music making as a comprehensive form, evolving toward the same structural "sophistication" as Western European art music. Although her event was held indoors (and therefore was technically not a pageant), it was a musical spectacle worthy of comparison to the kind of positive propaganda that Du Bois aimed to present with his pageants depicting racial pride. By presenting black music as "evolving," Marshall managed to situate it as part of the established European canon. *Three Periods* demonstrated Marshall's skillful adaptation of an existing structure, the "history of music," to introduce and legitimize a new group of works and practitioners into those works. Her historicizing narrative was a signal expression of her strategy to create a place for African American participation in Western European art music.

As seen in the program (figs. 10.1 and 10.2, pp. 218–19), Marshall grouped

the music for *Three Periods* into categories labeled "African," "Ante-bellum," and "Modern." Performers for the "African" period wore costumes, sang songs, and recited legends indigenous to the African continent. Selections for this period were further classified as either "primitive" or "developed." The "Ante-bellum" period was simpler in design: six songs represented the pre–Civil War era, half of which were sung "in dialect." The "Modern" period was the longest of the sections, consisting of twelve musical selections which included Burleigh's solo arrangements of spirituals as well as his original art songs. Except for the two pieces for cello, the entire program of *Three Periods* was comprised of African or African American music.

In the first period of "African" music, the scenes and the music included programmatic annotations that depicted a society less complex in industry and structure. The six songs which represented the entire "Ante-bellum" period, negligible in comparison to the richly described (if not overly romanticized) African scenes, constituted the shortest section of the whole program. These two periods set up a kind of musical default mode whereby the third and final period of Negro music would be seen as the logical fulfillment of expected progress.

The music of the "Modern" period was therefore endowed with great cultural significance. Many of the works absorbed, topically if not musically, the folk motifs of the previous two periods. The well-known selections from Coleridge-Taylor's *Hiawatha* exemplified the assimilation of the Native American "other" into classic forms.[27] The rhythmic and motivic elements of Dett's "Juba Dance," a character piece for piano, showed an affinity for southern black practices of songs and games from the African continent.[28] Burleigh's arrangements of "Deep River" and "Go Down, Moses" in the final period of the program affirmed that Negro spirituals could be elevated into the cultivated tradition as well.

Three Periods of Negro Music and Drama was a grand spectacle of black achievement in music, a veritable history lesson on African American musical genealogy.[29] Its tableau of progress was a musical expression of racial uplift that argued for black historical and cultural legitimacy on its own terms.[30] The progressive "program" of *Three Periods* outlined a developmental telos toward current practice. This resembled the Western European paradigm of music history, which had been constructed as a succession of eras or "periods." Implicit in this approach was an assumption that the representative music from each period marked an evolutionary advancement in compositional technique. In the case of this spectacle, Marshall's narrative purported to demonstrate that African Americans had attained a type

of cultural sophistication through a musical manifestation of racial uplift.[31] Undoubtedly, Marshall valued *Three Periods* for its potential to illuminate what she believed to be the greatest example of racial progress in music, the ability to write in the European idioms of concert music. The hierarchy of Western European concert music was foundational to Marshall's narrative as she advocated for the inclusion of new works and new practitioners in the dominant musical tradition in the United States.

Marshall's paradigm of musical progress not only acknowledged that African Americans had a vital past but also demonstrated that the past thrived in the present. Moreover, some of the "Modern" period compositions demonstrated the competency of black musicians to write and perform in Western European idioms without reference to their unique musical heritage. For example, Burleigh's song "The Warrior" (1917) was a ballad about a soldier leaving home for duty abroad, a subject relevant to the experiences of many Americans at the time it was written. An even newer work, "O My Love" (1919), was performed near the end of the program, and it, too, did not draw upon any known indigenous idioms. Black music making, as depicted in this period, thus embraced the duality of local and cosmopolitan expression that Marshall celebrated as evidence of a unique talent and tremendous achievement.

Shortly after the New York performance of *Three Periods*, a review in *Musical America* described the purpose of the event and concluded that the "program proved a most eloquent appeal in behalf of the black man's art and revealed splendidly the proficiency of African music."[32] Indeed, *Three Periods* seems to have been Harriett Marshall's announcement that black musicians had "arrived" into the mainstream of the concert music tradition as viable practitioners who also possessed unique musical perspectives. Just as black American politics, culture, and intellectualism were reaching a zenith of rhetorical independence, Marshall's spectacle seems to have mirrored these processes as she characterized black musical expression as viable on its own terms. Despite her success, Marshall seems to have turned her attention away from the cause of racial uplift after this spectacle. She moved to Haiti soon afterward and did not return full time to the Washington Conservatory until 1931, seemingly changed in her perspectives about the world, if not music.[33]

When Marshall returned full time to the Washington Conservatory in 1932, she resumed her previous diligence for raising money for her school. However, a dance recital that year foreshadowed the changes she would make in future spectacles. The exact catalysts for these changes are unknown, but in the ten years that had passed since the staging of *Three Periods*, Marshall had undergone many personal experiences that may have influenced not only

PROGRAM

PART I.

AFRICAN

ALL African Kings are held in great veneration. Before making a request it is customary to chant a eulogy, reciting the King's power, his illustrious ancestors, and to all the African symbols of strength, such as the Thunder, the Lion and the Crocodile. Having done this, the Headman begs the King to order an interpreter to speak to this vast crowd of strangers, and to himself consented to sing for them. And then calls upon the other members of the tribe to contribute something that will describe an of these goods. He, himself, will describe an Elephant Hunt,—how finding the elephant in the forest or beside the lake, they shot him with their arrows and cut up the meat and bore their trophies home.

CHARACTERS

CHIEF Mr. Plaatje, *East Africa*

HEADMANMr. Kamba Simango. *(Graduate of Hampton and Student of Columbia.) East Africa*

MOTHER OF CHIEF Miss Kathleen Easmon, *West Africa*

INTERPRETER Miss Anola Miller *West Africa*

THE WIDOWMary Ellen Johnson, Victoria White, Deborah Stubblefield, Eliatha Stubblefield, *West Africa*

WIVES

WARRIORSMr. Edmond Lucas, Mr. Dennis Smith, Mr Robert Boyd

SCENE I.—*Primitive*

Song, "Chamalebvu," from East Africa
Eulogy of the King, chanted in the Zulu language
West African dance, accompanied with native instruments.
Chili lo—Lament from East Africa

After the Battle"
Where shall I find one like Ba-ra-nvu?
He it was who brought me to goodly things

The Elephant Hunt—chanted in the Chindu language.

SCENE II.—*Developed*

"Shrmandazi," The Land of Shadows
Plastic Interpretation of an African Legend

"Only souls who reach that lone together need again—and find the twilight fair."
With finger words ringing in her ears, Zynola, the young bride of a forgotten warrior, slowly steals into the forest and, full of the joy of life, the forest flowers attract her, but she tries in vain to forget the gloomy "House of dying" and the lonely inmate there. Presently, she learns the untoward footsteps of those who bear the body back to the village and involuntarily she breaks into the funeral dance of the tribe. She then slowly follows the procession only to remember "Her life has but begun and all the days and nights of Shrmandazi lay before her in mute and joyless sum." She turns back to the village and music and dances so sees the dagger which must have dropped from the dying chief's hand. It is a call from the beloved Dead. There is but one answer. And that night in the village they sang until the dawn of Shrmandazi. "Lost in thy name the Land of shadows, Land of meeting Land of all the time."

MUSIC: K. COLERIDGE-TAYLOR—Transcribed and arranged by Helen Hagan.

PART II.

ANTE-BELLUM IN AMERICA

Women's Jubilee Quartette

Scene 1.
Returning from workNegro Folk Songs
Evening Devotion
Some One Knocking at the Door Florence Cole Talbert

Scene 2. In dialect
Ode to Night
Cradle Song
Good-nightFrom Dahram Days in Dixie. Operetta. Libretto, T. J. Houkhaman, Music, A. Russell Wooding

PART III.

MODERN

Florence Cole TalbertSoprano
Maryum TullyPianist
David MartinCellist
Mammy P. MoonContralto
C. Sumner WormleyBaritone
Margaret PortieReader

Herald of the New Age, Selected—Fifty YearsJames Weldon Johnson

Dunvey—Miss Kathleen Hilyer, Miss Wenonah Boud, Miss Helen Combs, Miss Agnes Hall, Miss Laverne Gregory, Miss Leethain Jennings, Miss Celestine Harris.

Chorus:
a. By the Shores of Gitche GumeeHiawatha—S. Coleridge-Taylor
b. Spring SongFlorence Cole Talbert

John TastersDett
 Miss Susanna Tully

a. Deep River
b. Go Down MosesBurleigh
 Miss Meena P. Moon

Concerto No. 1 Op. 33St. Soens
DavotivalePepper
 David T. Martin, Jr.

Trust Art RisenS. Coleridge-Taylor
The WarriorDr. R. Nathaniel DettBurleigh

Address—

Oh My LoveBurleigh
Just a Lil WhileStewart
Love's AwakeningJ. Rosamond Johnson
 Florence Cole Talbert

N. B.—Each number of the above program is by Negro Composers excepting two for cello.

Fig. 10.1. Program for *Three Periods of Negro Music,* 1922

Three Periods
in
Negro Music

African Ante-bellum Modern

under auspices of

National Negro Music Center

with

FLORENCE COLE TALBERT
Detroit

KATHLEEN EASMON C. KAMBA SAMANGO
West Africa East Africa

DAVID I. MARTIN, Jr.
New York

SUMNER WORMLEY WOODING JUBILEE
QUINTETTE
MARGARET FORTIE
Philadelphia

Lincoln Theatre

Saturday, May 6, 1922
8 P.M.

Prices $1.50, $1.00 & 75c

Tickets on sale—Conservatory of Music, 902 T St., N. W., and Lincoln Theatre.

NOTE: This extraordinary production will bring together a group of the very best Negro artists in the world. It is seldom that so many truly great concert stars are assembled in a musical concert of any kind, most especially in an elaborately historical production such as "Three Periods in Negro Music" which virtually captivated New York last spring when produced at the fashionable Town Hall on West 43rd Street before one of the most representative audiences that ever witnessed a Negro musical production in that city.

PROLOGUE
"A Dream of Art"

African Plastique ———— Edna Guy

PART I
"THE DREAM"

1. POLONAISE IN E MAJOR ———— Liszt
 Sonoma Talley

2. (a) HULLO ———— Crisp
 (b) GIVE A MAN A HORSE HE CAN RIDE ———— O'Hara
 William C. Elkins

3. AFTER A GAUGUIN ———— Music by Strickland
 Edna Guy

4. (a) GO, MARY AND TOLL DE BELL ———— Spirituals
 (b) LET ME RIDE
 William Elkins and the Dextra Singers

5. LULETA'S DANCE ———— Music by Ring
 Edna Guy

PART II

1. (a) DON'T BE WEARY, TRAVELER ———— Coleridge-Taylor
 (b) BAMBOULA
 Sonoma Talley

2. "GIMME YO' HAN'" ———— Spiritual
 Edna Guy's Group

3. (a) SWING LOW, SWEET CHARIOT ———— Spirituals
 (b) MARCH ON
 William Elkins and the Dextra Singers

4. (a) "WEEPING MARY" ———— Spirituals
 (b) "GIT ON BOARD, LIL CHILLUN"
 Edna Guy

5. JUBA ———— Music by Dett
 Edna Guy's Group

6. WHERE IS HE ———— Spiritual
 William Elkins and the Dextra Singers

EDNA GUY GROUP: Ellen Allen, Aminta Campbell, Millicent Green, Lolita Green, Wanda Woodson, Lenora Roy, Rudolph Chapman, James Miner.

Fig. 10.2. Program for *Three Periods of Negro Music*, 1922

her musical aesthetic but also her strategy to promote black music making at her school.[34]

Around 1931, Marshall appointed Edna Guy as a dance instructor at the conservatory. Guy, who explored "exotic" topics through her work as a dancer, choreographer, and dramatist, presented a dance and music concert in 1932 titled *Birth of Inspiration* (fig. 10.3). Performed in New York City to generate scholarship funds for the conservatory, the event combined interpretive dance with arranged spirituals and folk songs.[35] A year later, Guy gave a recital at the Washington Conservatory that included several selections from this previous event. An excerpt from the program booklet notes several aspects of expressive culture that were inspired by "East Indian" culture (from areas which today are regarded as South and Southeast Asia), including a Hindu devotion before Buddha, a popular dance from the streets of Madrass (now Chennai), and a figure from the temple of Angkor-Vat.[36] Music from this region of the world had never before been presented at the Washington Conservatory.

Descriptions of the works on *Birth of Inspiration* and Guy's 1933 recital seem similar to the annotations on the *Three Periods* program, specifically in their classifications of "primitive" music. It is not clear the extent to which Edna Guy influenced Marshall's interest in presenting music and dances from this region, nor is it known exactly what sparked this new interest.[37] Whatever the reason, the musical selections for this recital marked a significant departure from anything that had been performed at Marshall's school. This concert may have provided her the impetus to consider further revising her perspective of black music in order to include expressions not as clearly Western European in idiom.

It seems that Marshall began to experiment with broadening her depictions of black concert music the year after Guy's recital. In 1934, the Washington Conservatory staged a performance of an operetta, *The Gitanos* (Op. 26, 1898), by Samuel Coleridge-Taylor, at the Frederick Douglass Memorial Home in Anacostia, near Washington, D.C.[38] The opera's plot revolved around a young Spanish lady and a group of female gypsies from Andalusia. Previously, Marshall had presented only *Hiawatha* and several African-derived works of Coleridge-Taylor. With *The Gitanos,* she may have been trying to present the Afro-British composer as capable of expressing cultural idioms beyond those of Sierra Leone and England. Two years later, Marshall included this operetta in *The Last Concerto,* a spectacle reminiscent of *Three Periods.*

Fig. 10.3. Excerpt from program for *Birth of Inspiration*, 1932

The Last Concerto

Marshall wrote the script for a dramatic musical spectacle about the life and music of Coleridge-Taylor titled *The Last Concerto*.[39] Its performance in 1936 was planned as a benefit for the Coleridge-Taylor Memorial Fund, which was actually a renamed version of her endowment campaign fund from 1921 to 1922. With a goal of raising five thousand dollars (more modest than the goal of one hundred thousand dollars for *Three Periods*), Marshall resumed the campaign to establish her long-awaited archive and research annex, the National Negro Music Center.[40] Although records are inconclusive as to the amount of money brought in from this spectacle, the total gained from all her fund-raising events was enough for her to post a sign reading National Negro Music Center on the Washington Conservatory building in 1937.[41]

Like *Three Periods, The Last Concerto* reflected its creator's perception of what was distinct about black musical expression. While the former presented a broad history of black music, *The Last Concerto* was based on a more focused narrative about a singular, representative figure within the history of black concert music (figs. 10.4 and 10.5). Who better to monumentalize than an individual whose prolific contributions to several different genres and styles qualified him as a veritable "black Beethoven"? The research precipi-

..Program..

PART I

PROLOGUE
Madame Lillian Evanti

Overture ------ String Ensemble

"THE GITANOS" ------ Samuel Coleridge-Taylor
Washington Conservatory of Music
Miss V. Josephine Muse, Director of Group

CHARACTERS

Isola, a young Spanish lady ------ V. Josephine Muse
Zitella, queen of the Gitanos ------ Hazel Carey
Beatriz, attendant maiden ------ Inez Nichols
Dancer ------ Harriet Clark
Senoritas: Misses Mabel Ellison, Jane Ways, Sylvia Mayo, Sadie Hamilton and Ruby Powell.
Gitanos: Fannie Jernagin, Nettie Barlow, Olive English, Geraldine Ellison, Ada Rich, Nellie Jackson, Mary Morton, Julia English, Marion Lewis, Dorothy Lewis.
Scene: An orange grove in Andalusia.
Time: Summer.
LEGEND—

PART II

The Life of Samuel Coleridge-Taylor

ACT I

EARLY PROMISE

CHARACTERS

Samuel Coleridge-Taylor ------ Ferrol Gibbs
Mrs. Alice Taylor Evans, his mother— Mrs. Phyllis Terrell Parks
John Evans, his step father ------ Francis M. Settle

Colonel Herbert A. Walters, his benefactor---Samuel Popel
Scene: The kitchen of a humble home in Waddon Road, Croyden, England.
Time: Winter of the year 1884.

ACT II

COLLEGE DAYS

CHARACTERS

Samuel Coleridge-Taylor ------ J. Richmond Johnson

Fellow Classmates:

William J. Read	Clyde Glass
John Warner	Frederick S. Perry
Charles Draper	Oswald Chisolm
William Y. Hurlstone	Barnett Rhetta

Scene: Studio in the Royal College of Music, West Croyden, England.
Time: Winter of the year 1897.

Musical Interlude

"Hiawatha's Wedding Feast"—Poem by Henry W. Longfellow
Musical Setting by S. Coleridge-Taylor
Miner Teachers College Glee Club
Miss Marie C. James, Director

CHARACTERS

Hiawatha ------ Lawrence Whisonant
Minnehaha ------ Thelma Dale
Pau Puk Keewis ------ Beatrice Boyd Martin
Chibiabos ------ Obelton Holmes
Iagoo ------ Virgil Hamilton
Chorus ------ Miner Teachers College Glee Club
Scene: A clearing in the forest by the lake shore, on a tranquil summer evening.
LEGEND—

Fig. 10.4. First page of the spectacle program booklet, *The Last Concerto*, 1936

ACT III

ROMANCE

CHARACTERS

Samuel Coleridge-Taylor ——————— Emmerr Booker

Mrs Jessie Coleridge-Taylor, his wife—
Mrs. Elsie Fletcher Nichols

Gwendolyn ⎫ Their Children ——— Juanita Welch
Hiawatha ⎬ ————————————— Raoul Bryant

Mary, the maid ———————————— Dorwatha Watkins

Scene: Living room at number thirty, Daynall Park, South
Norwood, Croyden, England.

Time: Summer of the year 1909.

MUSICAL INTERLUDE

"A Tale of Old Japan"—Poem by Alfred Noyes.
Musical setting by S. Coleridge-Taylor.

Armstrong High School and Washington Conservatory of
Music.

Directors: Mrs. Estelle Pinkney Webster, Mr. Ernest Amos
Miss V. Josephine Muse.

CHARACTERS

Yoiki Tenko, the painter —————————— Clarence Jacobs

Kimi San, his niece ————————————— Therese Atkins

Sawara, his pupil ————————————— Virgil Hamilton

Fishermen and their wives: Chauncy Brown, Henry Houston,
Virginia Hewlett, Olive English.

Chorus: Armstrong High School.

Scene: The Garden of Yoiki Tenko, in the time of the peony
flower.

ACT IV

THE LAST CONCERTO

CHARACTERS

Same as in Act III

Scene: Sitting room at Hill Crest, Norbury, London Road,
Croyden, England.

Time: Autumn of the year 1912.

FINALE

"FAREWELL, HIAWATHA"

THE LAST CONCERTO

Incidental Music

Act I—Violin Solo, "Tarantelle" ——————— Hans Sitt
Ferrol Gibbs

Act II—Violin Solo, "African Dance No. 4"—
S. Coleridge-Taylor
J. Richmond Johnson

Act III—Vocal Solo, "Thou Art Risen, My Blessed."
Vocal Solo, "Sweet Evenings Come and Go, Love."
S. Coleridge-Taylor
Emmerr Booker

Act IV—"Deep River" ————————————— H. Burleigh
Howard Glee Club

Violin Solo, Andante from "Concerto in G Minor, Op. 80"
S. Coleridge-Taylor
Irving Lean

Dancers from Mabel Jones Freeman's Studio.
Juanita Welch, Beatrice Boyd Martin, Harriet Clark.

Fig. 10.5. Second page of the spectacle program booklet, *The Last Concerto*, 1936

tated by an event of this kind speaks to the kind of pedagogical initiatives that the proposed National Negro Music Center would support.[42] In dramatizing her ideas and views through spectacle, Marshall made more visceral the outcome of her school's fund-raising activities, namely, a research annex to the Washington Conservatory.

In *The Last Concerto,* Marshall skillfully depicted a "life and works" narrative of Samuel Coleridge-Taylor using structure and techniques typical of most historical accounts of Western European masters of art music. She arranged the musical selections somewhat chronologically within a four-act sequence that included a prologue, an interlude, and a finale:

PROLOGUE: *THE GITANOS* **(OP. 26, 1898)**

Act I—Early Promise: "Tarantelle" from *Petite Suite* (Op. 77, 1911)

Act II—College Days: *Hiawatha's Wedding Feast* (Op. 30, 1898); *African Dance for Violin* No. 4 (Op. 58, 1904)

Act III—Romance: "Thou Art Risen, My Blessed" from Songs of Sun and Shade (1911); "Sweet Evenings Come and Go" from *Six Songs* (Op. 39, 1899)

Interlude: *A Tale of Old Japan* (Op. 76, 1911)

Act IV—The Last Concerto: "Deep River" (Burleigh)

Finale—Farewell Hiawatha: "Andante" from *Concerto for Violin* (Op. 80, 1912)[43]

If prior events (*The Gitanos* and *Birth of Inspiration*) indicate Marshall's growing interest in the music of other cultures, then perhaps her inclusion of *The Gitanos* and *A Tale of Old Japan* reveals attempts to revise the image she had of Coleridge-Taylor to complement her changing musical perspective. The selected repertoire appears to represent a composer who took musically diverse journeys through Asia, Spain, Africa, England, and Western Europe. Taken together, these events of the 1930s can be interpreted as nascent stages of a more worldly, cosmopolitan rhetoric that Marshall developed in the final years of her life.

A Masque Musical

The last spectacle Marshall created was *A Masque Musical,* first produced in 1937. Like the other spectacles, *Masque* was a grand celebration of African American music making that featured artists in drama, dance, and, of course, music. The program from the original production has not been located, but a review from the *Washington Tribune* lists—amid lengthy descriptions of

costumes and participants—some of the selections which were included, ostensibly, to represent the following countries:

France: early "Troubadour music"
Alaskan Eskimos: a dance to "native bell rhythms"
Japan: excerpts from the *Mikado* and *Tales of Old Japan*
Russia: "None But the Lonely Heart," "Prelude in G minor" (Rach-
 maninoff)
East India: "The Temple of Shiva" (with pantomime)
Spain: "Estuiantina," "Tango Moderne"
America: "Steal Away" (with pantomime), "Juba Dance," "I Love Life"

These selections should not be interpreted as comprising a comprehensive list of the concert's repertoire. Given the newspaper's account of the extensive performing forces involved, the review seems to have been more a social review than a musical critique.[44] A program booklet from the *A Masque Musical* performance from November 1940 (fig. 10.6) lists many more nations than the 1937 event. However, this list seems a peculiar assortment of countries chosen to evoke distinct national or ethnic expressions. Although her rationale for choosing these particular nations can not be determined, it is possible that Marshall consulted two different sources to choose what nations to present for this spectacle.

By the time Marshall presented *A Masque Musical* for the first time, in 1937, several books on the origins of black music were in print, from collections of spirituals and black folk songs to quasi-historical surveys and scholarly monographs.[45] All of these could have influenced her choice of which African countries to include in her spectacle. Two authors she knew personally, Maud Cuney-Hare and Shirley Graham, made particular references to Liberia, Puerto Rico, Spain, and Egypt in their research. Cuney-Hare's book, *Negro Musicians and Their Music* (1936), included extensive discussions of African music and African musicians.[46] Shirley Graham, a fellow Oberlin alumna, had worked for a brief time at the Washington Conservatory during 1934.[47] Her philosophy about African American music history mirrored that of Marshall, and the two maintained a close correspondence for several years.[48] Graham's master's thesis from Oberlin College, "The Survival of Africanisms in Modern Music" (1935), may have inspired Marshall to consider incorporating her younger colleague's views of how black musical culture drew upon traditions in Liberia and Spain, two countries represented on *A Masque Musical*.[49]

Another probable resource that Marshall consulted in choosing countries

for *A Masque Musical* were the biannual world reports published by members of the Baha'i faith, a religion she had embraced in 1912. Although there is no direct evidence that Marshall sought to present an exclusively "Baha'i perspective" in her spectacle, it is notable that *Baha'i World* yearbooks from the 1930s contain reports on activities throughout the world that, with the exception of Mexico, include all of the countries Marshall included on the program. This is not altogether unusual, as religious organizations often attempt to promote their ideology in other countries. Nonetheless, *Baha'i World* yearbooks make numerous references to Persia, a country featured in Marshall's spectacle. Although Persia did not compare politically and eco-

Fig. 10.6. Program excerpt from *A Masque Musical*, 1940 (and on facing page)

The National Negro Music Center

PRESENTS

A MASQUE MUSICAL

"MUSIC, THE GOLDEN TIE OF THE NATIONS"

John Wesley A. M. E. Zion Church

14th and Corcoran Sts., N. W.

———

THURSDAY EVENING, NOV. 28, 1940—8:15 P. M.

———

STAFF

Mr. Robert T. Murray III Promoter
Miss Rebecca Gillison Director of Program
Mrs. Anita Anderson Assistant Director
Miss Lucia Mae Pitts Ushers and Auditorium
Mr. William Sherman Smith Chairman, Ticket Committee
Mr. David Lear Stage Manager

MUSIC COMMITTEE—Mrs. Gladys Gomez, Chairman; Mrs. Sadie Hamilton, Miss Josephine Muse, Mrs. Elsie R. Shanwell, Mr. John Hoskins.

SYNOPSIS

The Goddess of Music calls upon Life and Love to aid her in her great work in the world. She tells them her mission is to give to all peoples the art of Music, that they may have a means of expressing the innermost feelings of their hearts. Life and Love readily join with her to accomplish this God-given mission. Many Nations are called upon to assist in the work.

MUSIC

Music of the Nations

Soloists

Male Quartet under the direction of Mr. Robert Hamilton
 Charles Burke
 Miss Yvonne Campbell
 Miss Naomi Gordon
 Miss Willie Burton

Pianists
 Mrs. Elsie R. Shanwell
 Mrs. Georgoria F. Goins
 Mr. William Sherman Smith

Organist Mrs. Sadie Hamilton

A MASQUE MUSICAL

MUSIC, THE GOLDEN TIE OF THE NATIONS
By Harriet Gibbs Marshall

CAST

Goddess of Music Miss Rebecca Gillison
Life—St. Augustine's Miss Marie Cotton
Love—John Wesley A. M. E. Zion Miss Stephanie Spottswood
Country and Church— Leader

1. EUROPE
 Russia—Metropolitan A. M. E. Miss Mamie Johnson
 Spain—Mt. Airy Baptist Miss Naomi Gordon
 England—Zion Baptist Mrs. Irene Brannock
 France—Tenth St. Baptist Mrs. Frances Jenkins
 Holland—Third Baptist Miss Elaine Bradic
 Italy—Young People's Dept. N. N. M. C. Charles Burke

2. AFRICA—
 Liberia—Mt. Moriah Mrs. J. H. Randolph
 Abyssinia—Mt. Carmel Baptist Miss Bertha Monroe
 Madagascar—Mt. Jearrel Baptist Miss Theodora Raines
 Egypt—Ebenezer Methodist Mrs. Beatrice Smith

3. ISLANDS OF THE SEAS—
 Haiti Mademoiselle Andree Lescot
 Porto Rico—Mt. Gilead Baptist Miss Vivian Fleet

4. ASIA—
 China—Vermont Avenue Baptist Mrs. Josephine Baskerville
 Persia—First Baptist Delores Devault
 Japan—Union Wesley A. M. E. Zion Miss Willie Burton
 India—Howard University Group Mrs. Howard Thurman

5. SOUTH AMERICA—
 Brazil—Asbury Methodist Miss Minnie Hall

6. NORTH AMERICA—
 Mexico—Twelfth St. Christian Robert Gooden
 Uncle Sam and His Children
 Emblem of Liberty—Tabor Presbyterian Miss Lois Johnson

God Bless America Cast and Congregation

Presentation of Prizes

Award—Courtesy of Mayer & Co., Lifetime Furniture, 419 Seventh Street Northwest.

Fig. 10.6, cont'd.

nomically with the other nations in the program, it may have been significant to Marshall spiritually as the birthplace of the Baha'i religion.

In the 1940 program booklet to *A Masque Musical,* a "Synopsis" given as the meaning or purpose of the spectacle seems to be a metaphor for the philosophy of the Washington Conservatory's founder: "The Goddess of Music calls upon Life and Love to aid her in her great work in the world. She tells them her mission is to give to all peoples the art of Music, that they may have a means of expressing the innermost feelings of their hearts. Life and Love readily join with her to accomplish this God-given mission. Many Nations are called upon to assist in the work."[50] Although she likely did not see herself as a "goddess of music," Harriett Gibbs Marshall had nonetheless performed "great work" through her mission to establish a music conservatory. She had also "called upon the assistance" of many in her work, not of nations but other black women and men, so that all could enjoy the benefits that her institution aspired to cultivate.

Marshall's expressions of racial progress and identity in music can best be interpreted as a negotiation with the dominant white culture's hierarchical classification of music. She utilized its structure in order to create and celebrate an emerging black cultural aesthetic. She became increasingly assertive about her ideas, beginning with elaborate commencement recitals to showcase this emerging repertoire. *Three Periods of Negro Music and Drama* illustrates her skillful adaptation of an existing narrative and the history of music, thereby ushering in and legitimizing a new group of works and practitioners into the Western canon. Her historicizing narratives became her signal strategy to create a place for African American participation in the Western European art music canon.

Marshall's lifelong dream had been to establish an institution that would acknowledge and celebrate the vitality of black music in America. She believed in her vision to expand the Washington Conservatory into a National Negro Music Center that supported archival work, concerts, and textbook publications. With *Three Periods,* she shared her vision in hopes of convincing others to help her make it a reality. *Last Concerto* and *A Masque Musical* were extensions of that vision, a call to acknowledge the global, universal phenomenon of music and the contributions of people everywhere to it.

No single individual can create a "canon" of musical repertoire. Nonetheless, Harriett Gibbs Marshall was a significant proponent of the emerging tradition of black concert music in the early twentieth century. She was the first to endorse, as an institutional credo, themes of racial progress and musical evolutionism through a curriculum and historical narratives intended to imbue

black music with artistic worth and legitimacy. She sought to inculcate in her students an awareness and appreciation of black Americans who performed, taught, and composed concert music. Especially through the pageantry of dramatic spectacle, Marshall reconstructed and reenergized the repertoire, so that it would be considered a viable component of the Western European tradition. This is arguably the most remarkable facet of her legacy, as few women of this period received recognition for their intellectual contributions, much less for their perspectives on musical history and meaning.

Marshall's story, and the story of the Washington Conservatory of Music and School of Expression, demonstrates how black women professional musicians negotiated race and gender during the early twentieth century. The institution remained open after Marshall died, closing finally in 1960. Additional research may reveal the contributions of other teachers and students at the conservatory who carried forward the mission of racial uplift through music. The legacy of the conservatory is the model of success and perseverance exemplified by Harriett Gibbs Marshall through her life and work.

Notes

1. Oberlin did not confer bachelor degrees in music until 1904; Marshall's degree was conferred retroactively.

2. I am indebted to the late Doris Evans McGinty, professor emeritus of Howard University, the leading published scholar on Marshall and the Washington Conservatory. This chapter is informed greatly by her research, which can be found in the following sources: "As Large as She Can Make It: The Role of Black Women Activists in Music, 1880–1945," in *Cultivating Music in America: Women Patrons and Activists Since 1860,* ed. Ralph Locke and Cyrilla Barr (Berkeley: University of California Press, 1997), 214–36; "The Black Presence in the Music of Washington, D.C.: 1843–1904," in *More than Dancing: Essays on Afro-American Music and Musicians,* ed. Irene V. Jackson (Westport, Conn.: Greenwood Press, 1985), 81–105; "Black Women in the Music of Washington, D.C., 1900–20," in *New Perspectives on Women in Music: Essays in Honor of Eileen Southern,* ed. Josephine Wright with Samuel Floyd Sr. (Warren, Mich.: Harmonie Park, 1992); and "The Washington Conservatory of Music and School of Expression," *Black Perspective in Music* 1, no. 1 (Spring 1979): 59–74.

3. In the mid-nineteenth century, sisters Sarah Moore Grimké and Angelina Emily Grimké were early feminists and abolitionists (white) who argued that the black woman shouldered a double burden of race and sex. This became widely referred to as the "Grimké Argument."

4. See Lawrence Levine, *Highbrow Lowbrow: The Emergence of Cultural Hierarchy in America* (Cambridge, Mass.: Harvard University Press, 1986); and Michael Broyles,

Music of the Highest Class: Elitism and Populism in Antebellum Boston (New Haven, Conn.: Yale University Press, 1992).

5. Many African Americans enthusiastically supported Marshall and her school. For example, W. C. Handy donated music from his publishing house and wrote many encouraging letters to Marshall. Mary Church Terrell, W. E. B. Du Bois, and Booker T. Washington were among the first to endorse publicly Marshall's institution. Even the celebrated African English composer Samuel Coleridge-Taylor visited the school and was impressed with Marshall's work. With these names and others featured prominently on school promotional items and stationery, Marshall circulated her agenda to promote black social and cultural progress through music.

6. During the initial years of the Washington Conservatory's existence, there was an intense effort to establish institutional credibility. Marshall hired teachers with college degrees and documented performance experience in order to assure the public that hers was a reputable school with standards (and morals) above reproach. Records from the Washington Conservatory indicate that at least seven teachers were on staff to teach the music and elocution courses and many others were hired ad hoc to perform as guest artists and lecturers. Charter members of the music faculty included the famed vocalist and teacher E. Azalia Hackley and the virtuoso violinist Clarence Cameron White. Coralie Franklin Cook, who became a notable public speaker, oversaw the School of Expression for many years. During the nearly sixty years of its operation, several other notable professional musicians and teachers contributed to the institution's legacy.

7. Concert programs, course bulletins, advertisements, correspondence, and financial and other records from the Washington Conservatory have been preserved as the Washington Conservatory of Music Records, archived in the Manuscript Division of the Mooreland-Spingarn Research Center, Howard University, Washington, D.C. (hereafter cited as WCM Records). Additional archival research for this project was conducted at the Oberlin College Archives, Oberlin, Ohio, as well as the Schomburg Center for Research in Black Culture, New York City.

8. Financial records of the Washington Conservatory reveal a balance of both black and white supporters, and letterhead stationery from the school shows an integrated board of management, advisory council, and trustees. Several patrons who held high-visibility positions in the city or in national organizations allowed Marshall to list their names on school publicity, which further enhanced its credibility.

9. An exclusively black staff and prerogative may have limited Marshall's opportunities for acquiring substantial or consistent financial support. Institutions for African Americans that had a white administration generally received more funding than those run exclusively by blacks. George Foster Peabody, for example, gave one hundred dollars annually to the Washington Conservatory compared to the twenty-five thousand dollars he gave to install a pipe organ at Hampton Institute, a black school under white management. Moreover, Marshall faced a double prejudice because of her gender, which in the case of financial and administrative matters could have been

perceived as a liability. Perhaps this is why Marshall solicited endorsements of white city commissioners who spoke favorably about her business credibility. Although the conservatory's administrative networks were fairly integrated in terms of race, gender, and class, Marshall nonetheless had executive authority over running the school as a distinctly African American institution.

10. Racial uplift had its genesis in the nineteenth century, when African Americans adopted the tenets of social Darwinism to define a policy of self-help in education, economic self-sufficiency, and civic responsibility. An especially useful summary of uplift principles that synthesizes a variety of sources can be found in the introduction and first chapter of Kevin Gaines, *Uplifting the Race: Black Leadership, Politics, and Culture in the Twentieth Century* (Chapel Hill: University of North Carolina Press, 1996).

11. W. E. B. Du Bois, "The Talented Tenth," in *The Negro Problem: A Series of Articles by Representative Negroes of Today,* ed. Booker T. Washington (New York: James Pott, 1903), 38.

12. Evelyn Brooks Higginbotham, *Righteous Discontent: The Women's Movement in the Black Baptist Church, 1880–1920* (Cambridge, Mass.: Harvard University Press, 1993), 19–21.

13. The National Association of Negro Women summed up expectations of uplift work in their motto, "Lifting as we Climb," meaning that those who received an education or opportunity were obliged to assist others who were struggling to acquire similar opportunities.

14. Leading by her own model of success and authority, Marshall promoted her school as cultivating the highest standards of professionalism and success. In addition to noting the number of college-educated individuals who taught or performed at the conservatory, she cited enrollment figures as proof of the viability of her pedagogical initiatives. A 1912 course bulletin reported that of the twenty-five hundred total students who had attended the Washington Conservatory since 1903, forty had graduated from the college-level courses. These graduates joined the ranks of professionally educated teachers who established the infrastructures of a music education system for African Americans.

15. A brochure from 1910 (WCM Records) specifically states Marshall's belief that the promotion of a professional class of black musicians would "soften the asperities of racial antithesis" and "bespeak the universal brotherhood" that would "resound to the strength and greatness of the nation."

16. Tera Hunter details how some proponents of racial uplift, primarily middle- and upper-middle-class blacks, were so captivated by the rhetoric of uplift ideology that they sought to distance themselves from working-class black dance and the blues performed in dance halls, particularly in the urban South. See Hunter's "'Sexual Pantomimes,' the Blues Aesthetic, and Black Women in the New South," in *Music and the Racial Imagination,* ed. Ronald Rodano and Philip V. Bohlman (Chicago: University of Chicago Press), 145–66.

17. Patricia Hill Collins, *Black Feminist Thought: Knowledge, Consciousness, and the Politics of Empowerment* (New York: Routledge, 1991), 142, 43–48, 91–93. The interventions of black feminist writers in the early 1980s are foundational to contemporary theories concerning the intersectionality of race, gender, and class: Audre Lorde, *Sister Outsider* (Trumansberg, N.Y.: Crossing Press, 1982); Gloria T. Hull and Barbara Smith, *But Some of Us Are Brave* (Old Westbury, N.Y.: Feminist Press, 1982); bell hooks, *Ain't I A Woman?* (Boston: South End Press, 1981); Barbara Smith, ed., *Home Girls: A Black Feminist Anthology* (New York: Kitchen Table Press, 1983).

18. Collins, *Black Feminist Thought*, 95. See also Paula Giddings, *Where and When I Enter: The Impact of Black Women on Race and Sex in America* (New York: William Morrow, 1984); Higginbotham, *Righteous Discontent;* and Stephanie Shaw, *What a Woman Ought to Be and to Do: Black Professional Women Workers During Jim Crow* (Chicago: University of Chicago Press, 1996). Higginbotham discusses the "politics of respectability" that black women engaged in at this time and the idea that church and cultural activities were areas in which they could challenge prevalent stereotypes (*Righteous Discontent,* 187).

19. Box 112, WCM Records.

20. Maud Cuney-Hare, *Negro Musicians and Their Music* (Washington, D.C.: Associated Publishers, 1936; Da Capo Press, 1974). For several decades, this book was the leading resource on black music history, perhaps not championed in depth and breadth until the publication of *Music of Black Americans* by Eileen Southern in 1971.

21. Articulating a positive racial lineage was a crucial matter to African Americans at this time. Nationwide, legalized discrimination—Jim Crow—thwarted opportunities for economic advancement and perpetuated social discrimination. Asserting that the future of the race depended on a black-informed historiography, many educated blacks established academic disciplines in African and African American history. Historian Carter Woodson began the critically acclaimed *Journal of Negro History* (est. 1916), while writers associated with the Harlem Renaissance movement facilitated the growing independence of African American thought regarding racial heritage and vision. To Du Bois, the pageant was one of the most effective ways of promoting these new initiatives, although he failed to generate any substantial financial profits from *Star of Ethiopia.*

22. The dates of performance were October 11, 13, and 15, 1915.

23. The struggles that Du Bois encountered with *Star of Ethiopia* foreshadowed what Marshall would encounter with her own spectacles. Although Du Bois managed to organize twelve hundred participants and secure most of the money for the production ahead of time, he failed to meet his goal of producing the spectacle ten more times (in other cities) and using the proceeds to establish an independent branch of the American Pageant Association. Nevertheless, tens of thousands witnessed his pageant, and the resounding critical acclaim for his efforts no doubt inspired people like Marshall to produce similar events. An account of the genesis of *Star of*

Ethiopia, and the script for it, can be found in James V. Hatch and Ted Shine, *Black Theatre USA: Plays by African Americans, the Early Period, 1847–1938,* rev. ed. (New York: Free Press, 1996), 86–92.

24. A copy of this program was sent to me by Lawrence Schenbeck, who is working on a book on black music and racial uplift. Schenbeck also delivered a paper on the pageant, "W. E. B. Du Bois's Musical Aesthetic and The Star of Ethiopia," at the Sonneck Society for American Music meeting, Fort Worth, March 1999.

25. Marshall never came close to raising that amount. However, through successive campaigns she raised enough to open the National Negro Center some time around 1937.

26. Many thanks to Dr. Josephine Wright for suggesting this tripartite interpretation of Marshall's life.

27. Other examples of the Western European compositional representations of folk motifs include Mozart's "Turkish" references in some of his symphonic works and Debussy's representation of Afro-American rhythmic motifs in "Golliwog's Cakewalk" from *Children's Corner.*

28. "Juba Dance" was the final movement of a suite titled *In the Bottoms,* published in 1913.

29. Numerous and extensive records for the campaign and spectacle can be located in several boxes of the WCM Records.

30. The benchmark publication of this shift in thinking is Du Bois's *Souls of Black Folk,* first published in 1903. Du Bois also wrote several essays for the nationally circulated black magazine *Crisis* and participated in the founding of the National Association for the Advancement of Colored People (NAACP), which launched legal defenses against white supremacists' actions.

31. Marshall believed that black music overall was a cohesive and distinct musical tradition worthy of cultivating as an evolving art form, similar to how Western European traditions had drawn upon folk traditions. Both Du Bois and Woodson served on advisory boards of the Washington Conservatory for several years, and their names and quoted endorsements of the conservatory appeared on letterheads and in publicity. Marshall had long encouraged black Americans to refine their musical skills by means of professional pedagogical methods. Since 1910, she had asserted that a program of study in black music would instill within students an awareness and appreciation of their unique musical heritage, a goal which her school was uniquely designed to fulfill. Marshall seems to have used this first spectacle to outline a plan for attaining the kind of "progress" in her race that Du Bois and others envisioned.

32. "Musical America, April 30, 1921," excerpted from Doris McGinty, "The Washington Conservatory of Music and School of Expression," *Black Perspective in Music* 7/1 (Spring 1979): 66–67.

33. Marshall moved with her husband, Capt. Napolean B. Marshall (U.S. Army), to Haiti, where he served as a cultural attaché until 1928. It is not clear when they returned to the United States. Records indicate that he set up a law practice in New

York in 1929 and died in a Bronx veterans' hospital in 1933. It is not clear in what capacity Marshall worked with the Washington Conservatory during this time, but after 1933 it seems that she had returned full time.

34. Although she was far too distant from the Washington Conservatory to direct it, she nonetheless managed to remain active. She helped establish a girls vocational school while she was there, and she studied Haitian culture and music. She wrote a book about her experiences, *The Story of Haiti*, which was published in 1930 by the Christopher Publishing House in Boston. An unpublished manuscript titled "Women of Haiti" reflects her efforts to chronicle the achievements of Haitian women. Correspondence in the WCM Records suggests that Marshall was also promulgating the Baha'i religious cause in Haiti. Marshall had become interested in this faith around 1910 and became a member in 1912.

35. Box 112-48, WCM Records. Additionally, Guy gave an illustrative discussion of "Primitive Plastique," which was presumably an interpretive lecture on African artifacts.

36. Madrass, now Chennai, is on the southeastern coast of India in the state of Tamil Nadu. Angkor, Angkor Borei, and Angkor Vat are all sites in areas where Buddhist principles are practiced. Marshall may have known of these areas because of her Baha'i faith. Baha'i tenets are inclusive of Buddhism, Hinduism, Christianity, Judaism, and Islam.

37. Specifically, Marshall may have read the numerous reports in the Baha'i World yearbooks which described the pilgrimages of American Baha'is to discover the Persian and Eastern roots of their religion. Many such pilgrimages were reported through official Baha'i publications in the United States. For example, the 1928–30 yearbook of *Baha'i World* (vol. 3, New York) includes numerous pictures from travelers and members from the Arab and "Eastern" regions of the world.

38. WCM Records. Originally, its performance had been scheduled for August 15, 1934, to commemorate what would have been the composer's fifty-ninth birthday. At the time, it was believed that Coleridge-Taylor's total works numbered fifty-nine discrete compositions. For reasons unknown, the performance of *The Gitanos* was rescheduled for September 6. Goeffrey Self, *The Hiawatha Man: The Life and Work of Samuel Coleridge-Taylor* (Brookfield, Vt.: Ashgate, 1995), 287–327, lists in his Appendix of Works far more than fifty-nine compositions.

39. As with other large productions, Marshall called upon several performing forces to produce this event. Choirs from local schools, local music teachers, actors, dancers, and musicians all collaborated in the project. The written program for *Last Concerto* lists the many performers and patrons involved. Financial records (WCM Papers) show that Marshall organized teams of solicitors, scheduled keynote speakers, and circulated numerous publicity items in order to generate financial support for the event.

40. McGinty, "Washington Conservatory," 68. A flyer from the Association for the Development of Negro Music (Box 112-9, Box 112-10, WCM Records) reports

the financial objective for the 1935–36 year as three thousand dollars. The flyer also states that the association intended to spend two years' time to collect monies for the Center for Negro Music. Presumably, the memorial fund was included as part of this two-year plan, although the written program does not specify this is the case. The flyer mentions that members of the association believed that the "leaders of this movement" in New York would provide some sort of matching funds or more to finance the center's "larger development" of a publication component. The New Yorkers were never named, nor is it clear whether the matching funds materialized.

41. Marshall used a different fund-raising strategy in the 1930s, organizing semiannual fund drives for several years. Perhaps the smaller-scale fund drives spread out over more time and the lesser amount was due to the Depression.

42. McGinty, "Washington Conservatory," 38, reports that when Marshall officially opened the center, she had acquired over three hundred works by black composers for the library. See MSRC Guide to Sheet Music in their inventory of collections from Alain Locke, Washington Conservatory, and Arthur Spingarn Collection, bound vols. 8–60.

43. The violin concerto was one of Coleridge-Taylor's last works; he wrote it for the famous American violinist Maud Powell.

44. "Ten Nations Represented in Masque Musical," *Washington Tribune*, Saturday, June 12, 1937. Augusta Andrews, reporter for the *Pittsburgh Courier*, also reviewed the event in the edition for Saturday, June 5, 1937. A photograph of one of the costumed performers was in the *Pittsburgh Courier*, June 12, 1937.

45. See, for example, the book reviews and listings of literature on black music and musicians in the *Negro Year Book* encyclopedias published by the Tuskegee University Press.

46. Cuney-Hare, *Negro Musicians and Their Music*, identified several strains of black musical expression from several different countries, many of which correspond with those listed on the *Masque Musical* program, namely, Egypt, Haiti, Puerto Rico, and Spain. Cuney-Hare also cited two individuals whom Marshall knew from staging *Three Periods of Negro Music and Drama:* Kamba Simango from East Africa, who played the Headman in the African scene, and Natalie Curtis Burlin. Burlin not only lobbied support for the New York performance of *Three Periods* but also published several essays on African and African American music.

47. Box 112-50, Box 112-48, Box 112-5, WCM Records. In the 1934 spring term, Graham gave a lecture-recital with two other Oberlin students at the Washington Conservatory. She taught music history and composition during the summer term. She also coached the performers for the production of *The Gitanos.*

48. Oberlin may not have been the only connection between Graham and Marshall. In 1928, Graham gave a talk on the value and significance of spirituals and black vernacular music at a Baha'i conference on racial amity in Green Acre, Maine. Louis Gregory reported in the *Baha'i World Biennial International Report*, vol. 3, 1928–30 (175–76) that Graham's presentation "was a rich medley of the history and philoso-

phy of what is distinctly Negro Music." Letters from Graham to Marshall in the WCM Records (Box 112-5) do not mention anything about religion, nor has it been established if Graham adhered to this faith. Her lecture in Maine may have simply been a professional opportunity. Furthermore, the Baha'is were actively courting African American membership during the 1920s and 1930s.

49. Graham's master's thesis (Oberlin College, 1935) contains an extensive discussion on the significance of Liberia to musical culture in Africa and America. Furthermore, her opera *Tom Tom* (1932) was considered by many to have portrayed an extensive account of African and African American music.

50. Program for *A Masque Musicale,* Box 112-43, WCM Records.

Contributors

ELIZABETH AMELIA HADLEY is an associate professor and former chair of Africana studies at Simmons College (1997–2003). She is the author of *Bessie Coleman: The Brownskin Lady Bird,* the first full-length study of the early-twentieth-century African American aviatrix. Hadley's book was optioned by acclaimed filmmaker Euzhan Palcy. A specialist in black theater, film, and media, her essay "Eyes on the Prize: Reclaiming Black Images, Culture, and History" appears in *Struggles for Representation: African American Documentary Film and Video.* "Sapphires, Spitfires, Sluts and Superbitches: Aframericans and Latinas in Contemporary Hollywood Film" was reprinted in *Critical Readings: Media and Gender,* 2003. She was an invited guest and speaker for the Oxford Roundtable, Oxford University, England (2003) and was the Jane Watson Irwin Distinguished Chair in women's studies at Hamilton College (2003–4). She is the author of numerous publications and the recipient of multiple awards, including the Rockefeller (1994–95) and Fulbright (1989–90).

EILEEN M. HAYES is an assistant professor of ethnomusicology in the College of Music at the University of North Texas. Her research interests include African American music, feminist theories, gender, and sexualities. She is the author of a chapter on black women and women-identified music in Maultsby and Burnim's *African American Music: An Introduction.* Currently, she is writing a book-length manuscript on race and the politics of sexual identity in "women's music." Most recently, Hayes was the recipient of the Ford Foundation Postdoctoral Fellowship for Minorities, 2004–5, during

which time she was in residence in the Music Department of the University of California, Riverside.

MARIA V. JOHNSON is an associate professor of ethnomusicology in the School of Music at Southern Illinois University, Carbondale. A blues performer, Johnson's essays on women's blues and on African American women's literature as performance have been published in *Black Orpheus: Music in African American Fiction from the Harlem Renaissance to Toni Morrison* and in a number of journals, including *African American Review; Arkansas Review: A Journal of Delta Studies; Women and Music: A Journal of Gender and Culture;* and *Frontiers: A Journal of Women Studies.* She is currently writing a book on the tradition of uppity women's blues.

NANETTE DE JONG is a senior lecturer at the International Centre for Music Studies, University of Newcastle. Her research broadly explores the African diasporic experience through the combined lenses of music and culture, emphasizing the cultural continuities and adaptations contributing to the construction of African/Black identity. She has published on avant-garde jazz and Caribbean music, appearing in such journals as *Latin American Music Review, Black Music Research Journal,* and *Jazzforschung/Jazz Research.* Recently awarded the Fulbright, she extends her research by tracing the transatlantic journey of Afro-Caribbean and jazz rhythms returning to Africa through globalization.

INGRID MONSON is the Quincy Jones Professor of African American Music at Harvard University. She is the author of *Saying Something: Jazz Improvisation and Interaction,* which won the Sonneck Society's Irving Lowens Award, and *Freedom Sounds: Jazz, Civil Rights, and Africa, 1950–1967.* She is also editor of The African Diaspora: A Musical Perspective.

CHARLES I. NERO is an associate professor of rhetoric and theater and teaches African American and American cultural studies at Bates College in Lewiston, Maine. His most recent essays about literature and film appear in *Camera Obscura; Public Culture;* the *Journal of the History of Sexuality; Out in the South;* and *Black Queer Studies: A Critical Anthology.* He was a National Endowment for the Humanities Fellow at the Schomburg Center for Research in Black Culture (2005–6). Currently, he is writing a study about black gay literature in the twentieth century.

DEBORAH SMITH POLLARD is an associate professor of English literature and language and humanities at the University of Michigan, Dearborn, where she also serves as director of the African and African American Studies Program. She earned her Ph.D. in American studies at Michigan State University as a King/Chavez/Parks Fellow. Her book *When the Church Becomes Your Party: Essays on Gospel Music at the Turn of the Twenty-first Century,* is forthcoming. For more than two decades, Smith Pollard has produced one of the largest free outdoor gospel concerts in the country, the Motor City Praisefest. Since 1994, she has served as host/producer of *Strong Inspirations,* a gospel radio show on Detroit's WJLB. Smith Pollard was named Gospel Announcer of the Year for the twentieth annual Stellar Gospel Music Awards (2005).

GWENDOLYN POUGH is an associate professor of women's studies and writing at Syracuse University. She is the author of *Check It While I Wreck It: Black Womanhood, Hip-Hop Culture, and the Public Sphere.* She has published in a variety of journals and anthologies, including *Colonize This! Young Women of Color on Today's Feminism* and *College Composition and Communication.*

TERESA L. REED is an associate professor of music in the School of Music at Tulsa University in Tulsa, Oklahoma. A native of Gary, Indiana, Teresa Reed received her bachelor's degree from Valparaiso University in 1987, her master's degree from Tulsa University in 1990, and her Ph.D. in music theory and African American studies in 1997. She has given talks on African American music both around the United States and abroad. Reed is the author of *The Holy Profane: Religion in Black Popular Music.*

SARAH SCHMALENBERGER is an assistant professor of music at the University of St. Thomas in St. Paul, Minnesota, where she teaches music history and horn. She holds a Ph.D. in musicology from the University of Minnesota, where she completed a dissertation on African American women in art music during the early twentieth century. Schmalenberger holds two master's degrees in music, the first in music education from the University of Michigan and the second in music history from West Virginia University. She earned her bachelor's degree in music education and horn from the Capital University Conservatory in Columbus, Ohio. Schmalenberger remains active as a freelance musician in Duluth, playing both modern horn in the Lake Superior Chamber Orchestra and baroque horn in the Early Music Orchestra at the College of St. Scholastica.

LINDA F. WILLIAMS is an ethnomusicologist and jazz saxophonist. She received her Ph.D. in folklore and ethnomusicology from Indiana University and a Master of Music Performance from University of Michigan, Ann Arbor (1977). As an associate professor, she has taught music, African American studies, Steel Pan and Jazz Band ensembles extensively at Bates College, Mt. Holyoke University, and Cheyney University. Her scholarship focuses on the transatlantic influences of African American culture and its impact on music and politics abroad. As a jazz saxophonist, she has performed widely in Zimbabwe; Cape Town, South Africa; the Caribbean; and the United States. She has been a recipient of two Fulbright grants; served on the Board of Evaluators for the National Endowment of the Humanities; served as an adjudicator and clinician judge for the Lionel Hampton Annual Jazz Festival in Moscow, Idaho; and published compact discs, major articles and book reviews. Presently she resides in Chicago, Illinois, as an independent scholar and researcher.

Index

Italicized numbers refer to illustrations.

The University of Illinois Press
is a founding member of the
Association of American University Presses.

Composed in 10.5.13 Adobe Minion
with Meta display
by Jim Proefrock
at the University of Illinois Press
Manufactured by Sheridan Books, Inc.

University of Illinois Press
1325 South Oak Street
Champaign, IL 61820-6903
www.press.uillinois.edu